ART OF THE PACIFIC

ART OF THE PACIFIC

Photographs by Brian Brake

Conversations by James McNeish

With commentary by David Simmons

HARRY N. ABRAMS, INC., PUBLISHERS, NEW YORK
in association with Queen Elizabeth II Arts Council of New Zealand

Designed by Wendy Harrex and Lindsay Missen

Library of Congress Cataloging in Publication Data

Brake, Brian, 1928-
 Art of the Pacific.

 Bibliography: p.
 Includes index.
 1. Art—Islands of the Pacific. 2. Art, Primitive—
Islands of the Pacific. I. McNeish, James, joint
author. II. Simmons, D. R., joint author. III. Title.
N7410.B7 709'.01'1099 79-17411
ISBN 0-8109-0686-4

Library of Congress Catalog Card Number: 79-17411

© Queen Elizabeth II Arts Council of New Zealand 1979

Published in 1980 by Harry N. Abrams, Incorporated, New York,
in association with Queen Elizabeth II Arts Council of New Zealand
Printed and bound in Japan

Contents

Note: The conversations are with living people and are from tape recordings. The names of speakers have been changed. The text as a whole is an edited version of the original.

Preface

When Albrecht Durer went to Brussels, in August 1520, he saw there some of the plunder which had been sent back to the King of Spain by his adventurers in Mexico. He wrote in his journal, 'All the days of my life I have seen nothing that rejoiced my heart so much as these things, for I saw amongst them wonderful works of art, and I marvelled at the subtle genius of men in foreign lands.' No doubt Durer's interest was also quickened by the intrinsic value of the objects he saw (recorded by him as 100,000 florins) but his reaction is clearly that of an artist responding immediately to the work of other artists from a culture he had never encountered before. It is tempting to wonder if he might have recorded a similarly generous tribute to the art of the Pacific, had he been around to see examples of it some three and a half centuries later. Would that sensitive eye have discerned the subtle genius to be seen in a dance paddle from Easter Island, a stone pounder from Tahiti or a New Zealand feather box? Somehow it seems quite possible. But in the event he may not have seen them at all, since such works were sent to Europe not as treasures, but as specimens destined for natural history museums, as curiosities to illustrate tales of exotic travel, and as bogey men flourished as trophies of the battle of righteousness against dark adversaries.

The curiosity that stimulated the European advance into the Pacific had nothing at all to do with art; neither scientific enquiry nor missionary zeal are particularly responsive to aesthetics. In the Pacific the combination of both has led to the paradox of an art more studied by science, more assaulted by theology, and less known than almost any other of an equivalent scope and richness. The purpose of this book is to reveal to a wider audience some of the treasures to be found in New Zealand's museums. It is intended to redress, to some extent, the undeserved obscurity which descended on these works and to restore them to a continuum of Pacific culture — a culture in which a food pounder in its own way was required to participate in things of the spirit as much as an ancestor figure or a household god.

Art of the Pacific was initiated by the late Dr William Ball Sutch, chairman of the Queen Elizabeth II Arts Council of New Zealand, 1972 to 1975. It was a venture enthusiastically endorsed by the then Prime Minister, the late Norman Kirk. The nature and scope of the publication should in some small way serve as a tribute to the vision both men shared about New Zealand and the Pacific.

The Arts Council is indebted to the authors, Brian Brake, James McNeish, and David Simmons, for their enthusiastic realization of the project; to Trevor Bayliss, Helmut Einhorn, Stuart Park, the late Roger Duff, Betty McFadgen, and David Simmons for their assistance in the selection of items to be illustrated in the book; to the trustees and staff of New Zealand's museums for their cooperation; to Air New Zealand for their contribution; and to Wendy Harrex of Oxford University Press and Dr Michael Volkerling, the Council's Director, who have steered the work to publication.

HAMISH KEITH
Chairman, Queen Elizabeth II Arts Council of New Zealand

Acknowledgments

In preparing the conversations I received help from a variety of sources, not least from the subjects themselves. Their cooperation and patience, often at awkward moments, made the field work for me a considerable pleasure. Since they are anonymous I cannot thank them publicly as I would like to, but I hope that some of the pleasure at least has been mutual.

I am grateful for the guidance and help of: Sue Baereleo, George Kalkoa, Bob Makin, Keith Woodward, of Vila, New Hebrides; John Gina, Hugh Paia, Ministry of Culture and Education in Honiara, and Walter and Janice Starck, of San Cristoval, Solomon Islands; Tom Craig, director National Arts School, John Haugie, director Department of Cultural Affairs, Arthur Jawodimbari, Luke Sela, deputy-director Department of Information, all of Port Moresby, Papua New Guinea. I owe thanks to Air Niugini for help with internal travel. Especially I am indebted to William Takaku, of Bougainville, and Augustin Hughie, of Langalanga Lagoon, Malaita, who interpreted for 'Rules are for everything' and 'Sharks are human' respectively; to Otto Nekitel, University of Papua New Guinea, who translated 'Rules are for everything'; and to an old friend and colleague, Giselle Schenirer, of Auckland, whose supervision of my blundering French and the attendant translation has enhanced 'It is they who are the savages'. I am also grateful to Angela Busby of Wellington for helping to transcribe the tapes, to Margaret and Peter Thoday of Melbourne, Australia, who made my first and subsequent visits to Papua New Guinea that much richer, and to Raewyn Whyte for an introduction she has by now, I expect, forgotten. Projects like this, even small ones, require many allies and of these the greatest by far is, as usual, my wife.

JAMES McNEISH

Introduction

The story of Pacific art began half a million years ago or more when early man reached China and Indonesia. Modern man followed, with Australoid people moving into New Guinea from Indonesia probably about one hundred thousand years ago. They settled Australia forty thousand years ago. In New Guinea the only firm dates go back about twenty-six thousand years but these are from the mountainous interior, not from the coast which must have been the area first settled. The settlement of Australia and New Guinea is paralleled on the other side of the Pacific by the peopling of the Americas. In Australia, man faced giant kangaroos and wombats, in America it was mammoths.

Australoid people provided the main element of the populations of early Australia and New Guinea as well as the various refuge groups of so-called 'negrito' people in south-east Asia, the Phillipines, and Malaya. They have often been described as hunters but archaeological evidence is growing that, like their counterparts in Europe and the Middle East, they may have turned to herding and animal-breeding as well as some form of agriculture by the end of the last glacial period (about 9000 B.C.).

This pattern of settlement can be traced linguistically. What may be the Australoid languages are spoken mainly in Australia and in New Guinea. It is difficult to be certain as the forty or so languages of Australia have been isolated for so long that even their relationship to each other is doubtful. A similar situation exists with the more than four hundred separate languages of New Guinea.

With this colonization of the Pacific forty thousand years ago, the first Pacific art was produced. It is very possible we shall never know what it was like. Perhaps in the future there will be finds rivalling those of the Magdalenian cave paintings in Europe. In the meantime, the stone objects which have endured tell us about the utilitarian crafts but little of the art. Probably ceremonial pieces produced for ritual occasions were mainly made of wood and, like their modern counterparts in most of Melanesia, had a very limited life.

Any Pacific population ranges between the Australoid physical type and the Mongoloid. The Mongoloid populations of the Pacific can be traced to south-east Asia and perhaps south China. From there they moved through Indonesia into the highlands of New Guinea about ten thousand years ago, taking with them the pigs and probably agriculture of south-east Asia. The more unified and recent Austronesian family of languages is spoken in the areas they inhabited: south-east Asia, Indonesia, and the islands of Melanesia, Micronesia, and Polynesia.

The last great movement of people into the Pacific before the arrival of Europeans was that of a small group speaking an Austronesian language. They came from the offshore islands of the Bismarck Archipelago, the Solomon Islands and New Hebrides. These ancestors of the Polynesians began the settlement of the vast extent and tiny islands of the Pacific Ocean. They developed the outrigger canoe and the art of sea-voyaging and in about 3000 B.C. were moving into all the islands from the Solomons to the New Hebrides. Despite their sea-oriented way of

life, these people were farmers. They were also traders, developing an efficient trade network which moved obsidian by a series of stages from New Britain. In addition they produced a very fine stamped pottery which is now called Lapita from the site where it was first found in New Caledonia.

Sometime after 2000 B.C. one-way voyagers of the Lapita culture settled in New Caledonia and Fiji. To make the journey of almost nine hundred kilometres they had probably invented the double-hulled voyaging canoe. From Fiji they spread to Tonga and Samoa in about 1000 B.C. Their pottery changed and finally fell into disuse in west Polynesia in about the year nought. Sometime before 700 A.D. the eastern islands of the Pacific were finally settled by canoe from Samoa.

The geometric patterns of Lapita ware can be linked to tapa designs (see 77), to Samoan buttock and thigh tattoo, to the decoration of Tongan clubs (see 73) and to the carving designs on Austral Island ceremonial paddles (see 90). One Lapita sherd from the Reef Islands of the Solomons is decorated with a face mask which is the same as that found in areas of Melanesia (see 50) and which is often used in Polynesian sculpture (see 75).

No art is produced outside a social context and to approach an artist's works one needs to know a little of the culture to which they belong. Unfortunately, the history of many Melanesian and Polynesian works found in museums today, and of some of those illustrated in this book, is often not known. European explorers in the Pacific were the first collectors but they have left us the barest glimpse of the cultures that, by their very presence, they were destroying. They were followed by traders seeking stores in Pacific harbours before voyaging to China or, later, searching for cargoes of sandalwood and *bêche-de-mer* to sell there.

The sealers and then the whalers also called into Pacific ports for supplies, or to recruit cheap labour for their ships. Many of the older works in museum collections were acquired by such men, to remain in their families until they reached a museum with only the vaguest of attribution. Even when the exact point of collection is known there may be no available description of the cultural context, use or function of the work. And when knowledge about the culture at a later period is available it may be that the items collected are no longer in use, the culture having changed as a result of European contact.

Missionaries were the next collectors. They had a vested interest in denying any virtue to the society they were seeking to change. Dress, behaviour, social life and custom were sacrificed to their idea that a good Christian was a good European. To the missionaries, the Christians in the local population could be recognized by their top hats or other items of European apparel. The images and artifacts made by the people either had to be destroyed or used as illustrations of 'heathen' idolatry to raise funds back home for the missionary endeavour (see 87). Thus collection by missionaries was as haphazard as that by explorers, traders, sealers and whalers. Another group of collectors was that of colonial administrators.

Collection in this manner is described as being ethnographic, that is, the items are collected

from cultures in which they are being used at the time. But Pacific items have also been collected through archaeology. Pieces recovered from the ground, from caves or swamps, often provide a picture of art forms from earlier periods than the ethnographic collections.

The major collections from which the works have been drawn for this book are the Lord St Oswald Collection, the Edge-Partington Collection, the W.H.O. Oldman Collection, and the general collections of the museums of New Zealand. These include items from the H.G. Beazley Collection and the Wellcome Medical Museum, as well as from such collectors as K.A. Webster.

The Lord St Oswald Collection is in the National Museum, Wellington, where it was received in 1912. It mainly results from the purchase of items from Bullock's Museum in London in 1809. The Bullock Museum included many items of Cook provenance, some purchased from the earlier museum of Sir Ashton Lever.

J.R. Edge-Partington was an English collector and recorder whose collection was purchased in 1925 by Auckland Museum. Edge-Partington was collecting from about 1876 until the sale of his collection. The objects were collected in Great Britain and belong to the trader - whaler - missionary era.

W.H.O. Oldman was a dealer and collector of Pacific artifacts in London. He was a later contemporary of Edge-Partington and sold his collection to the New Zealand Government in 1948. It is now distributed among the museums of New Zealand. Oldman was the dealer who was associated with the sale of the London Missionary Society collection, part of which was purchased by the British Museum.

The K.A. Webster collection of Maori items is now in the National Museum. Webster was a New Zealander who, until his death, was especially interested in repatriating items of note to New Zealand. At one stage he was an adviser to small English museums who wished to reduce their holdings.

These collections are of English origin. The oldest museum in New Zealand was established in 1862. This was much too late for assembling early items from any part of the Pacific. But the explorer, trader, whaler or missionary origin of many of the early artifacts brought back to New Zealand by repatriation means that there is little information about the people who made them.

This book is divided into two sections, Melanesia and Polynesia. It quickly becomes apparent as one glances through the second section that most of the Polynesian works included are at least two hundred years old. Almost everywhere in Polynesia the indigenous art entered a drastic decline as the ritual or ceremonial and utilitarian objects lost their function as a result of European contact. Some arts enjoyed a brief efflorescence as tourist goods in the early nineteenth century (see 81). A few developed with the stimulus of new tools (see 148) and are still flourishing today.

The works which appear in the Melanesian section are more recent. But while the time scale

of European impact in Melanesia is different, the effect is the same. In many Melanesian cultures the change to Christianity and to tourist carving is taking place now. But at least today it is possible to document the changed nature of art and its uses. While one can begin to appreciate items outside their original social context for their aesthetic qualities, they do become more meaningful when their context is known. A piece of work may be initiated through the creative impulse of the artist, but at some stage its form and content are determined by the conventions of the cultural group. It is the conventions which vary from society to society. In most societies, naturalism or abstraction are meaningless distinctions: provided the conventions governing art are followed, either type of representation will be accepted.

In the Pacific cultures a creative artist in carving, painting, song, or dance is recognized as having special qualities and it is possible to gain great prestige by one's art. If a work is well made, fits into the culture, enhances the prestige of the owner or social group, then it also enhances the standing of the artist and their family. The work of the artist emphasizes the importance of the social system. There may be certain areas where an artist is not free to impose individuality. These are the conventionalized symbols which have become part of the meaning and purpose of the art form within that culture. There is no set of rules which can be transferred from one society to the next and such judgements as 'primitive' or 'tribal' in referring to non-European art have little meaning apart from the implication that the person using them cannot understand the cultural conventions of that particular art form.

Thus artists and their work are an integral part of the social fabric as long as the myths, traditions and values of their society are maintained. With a change of cultural values, art can become debased into commercial production. An artist who understands his own traditions and who works within them may produce valid forms but persuaded by dealers to replicate older forms he becomes bored, careless, and produces crude tourist items.

Nevertheless, changing social systems and the shattering of traditional values may also allow the emergence of a new kind of artist, one who explores his own ideas, expresses his own individuality and portrays his own values. The artist becomes a link in the anchor chain which determines the drift of the society. The expression of his ideas in his art may encapsulate those in society at large. Identity can be lost in a changing world, art can give it back.

Even if we understand only a little of their work, the self-respect and mana of the peoples whose art is portrayed in this book is clear. Successive attacks on the religious and social fabric of Pacific societies have damaged the context of that mana but the new artists rising out of the chaos of conflicting values and conventions are making images and symbols in which can be seen a rebirth, not only of art, but of social pride.

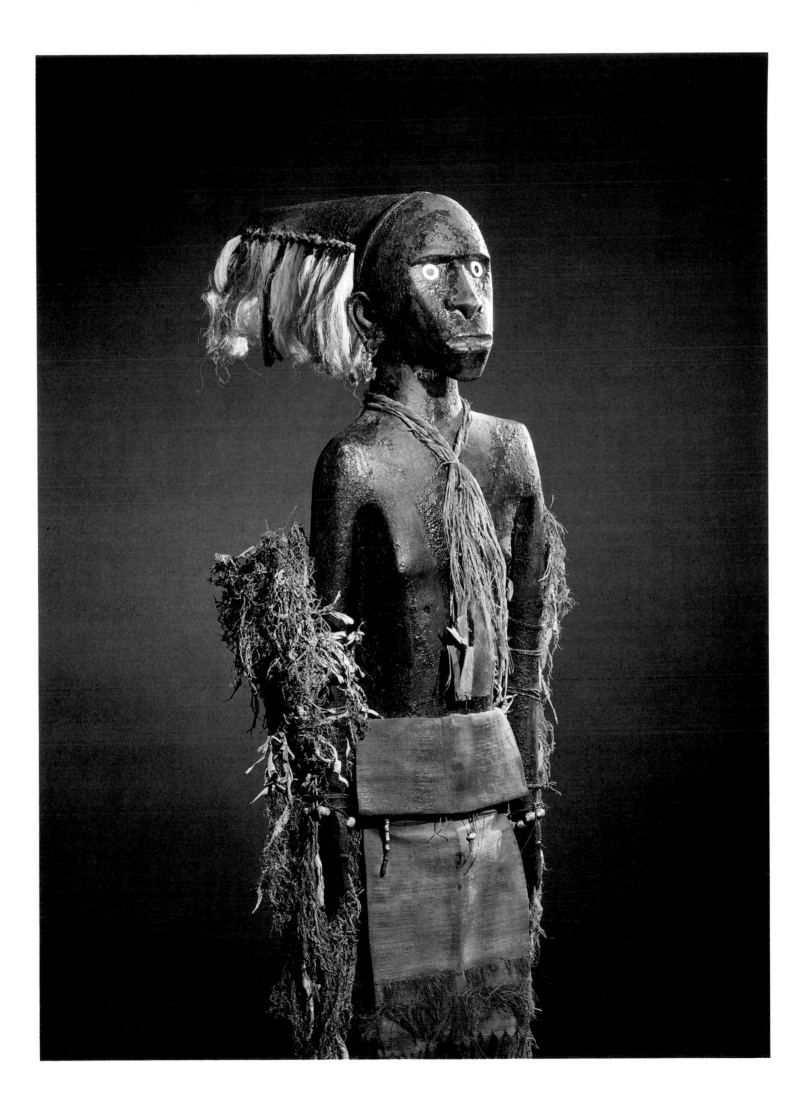

Melanesia

New Guinea and all the other islands stretching east to the Fiji group form the geographic region of Melanesia. It is a vast area, covering millions of square kilometres of land and sea, with the terrain varying from the mountains and river valleys of New Guinea to high volcanic islands and low coral atolls. Most of the year the weather is warm and humid, with the high rainfall which fosters lush vegetation. In New Guinea there is a wide range of animal and bird life. Everywhere the coastal and sea resources are abundant.

The cultures, languages, and even physical appearances of the peoples of Melanesia vary utterly. But there are some common cultural beliefs, although to each of these there will always be exceptions. In general, the world is understood to include man and the spirit dimension. Spirits of recently dead important ancestors are part of the social group. These spirits, as well as spirits which were not originally human, are propitiated with gifts of food, especially during important celebrations marking birth, initiation, marriage and death. Spirits can be benevolent or evil, in accordance with their treatment during ritual or private behaviour.

In ritual celebrations masks are used to represent the ancestors or spirit beings, totemic animals, or merely to produce a sense of awe. Often during initiation boys have to prove themselves worthy by resisting the menacing presence of masked beings.

Masks and other ritual materials are usually stored in the men's house (also a spirit house), which is often set apart from the village. The initiated men sleep, eat, and talk there, and most of the decisions on matters affecting the community will be made by the men in the house. Women are excluded. Sometimes they have their own house.

Village leadership is based on the men's house. Senior members who are rich in pigs and bracelets give great feasts. If these cannot be matched, they become the 'big men' of the village. In some areas a big man gathers followers and builds a men's house with a dance floor. He then issues a challenge by offering a rival a lavish feast and gifts. If the rival cannot respond in kind he loses his prestige and followers. In some places, like the New Hebrides, there is a much more structured system of grades in society.

Wealth is acquired by rearing pigs. In some areas the upper canines of pigs are removed to allow the lower ones to develop into a spiral or complete circle. A curved tusked pig is highly valued as a trade item or as the centre-piece for a feast. Such pigs are often fed with premasticated food by the wives of the big men. A man intent on increasing his prestige will take more than one wife so that he can rear more pigs. Having many wives is thus a further condition of wealth. Pigs can be used as currency to obtain imperishable wealth. Shell beads, shell or feather money-belts, bracelets and other manufactured items all have a value expressed in pigs.

Wealth and prestige are also acquired by organizing and participating in an exchange network or trade ring. The formal ritual exchange between the big men is regarded as the most important element of this. The exchange of useful items has little prestige value, although it does supply sought-after goods. An example is the Kula ring of the Massim area in New Guinea. The big men of different villages exchange spondulus shell necklaces against conus shell bracelets. These are for display on racks. At an informal level pottery is exchanged for wooden bowls, and so on through the whole range of items available.

Some areas are famed for particular products. For example, Tami Island (in the Huon Gulf, Papua New Guinea) bowls are sought after and traded as far as the Solomon Islands, about four hundred kilometres away. Similarly, some of the Polynesian atoll groups of the Solomons have little to offer a ring than their skill in building and sailing canoes. Not only their canoes but also their expertise have become trade items.

There are many trade networks within Melanesia. When they operate between island communities they are based on easily obtainable landfalls. If there is no wide gap between islands the rings may cover quite long distances. Thus a series of exchanges from community to community across land can shift an item far from its source. The *kina* (pearl) shells which are part of the ceremonial dress of the highland people in Papua New Guinea come from the coast about two hundred kilometres away.

In this way the outer limits of a trade ring can link very different groups. Linguistically and culturally Melanesia remains an utterly diverse area. In the east it fades into Polynesia, in the north-east into Micronesia. No clear lines may be drawn on a map to show its boundaries and within the region even distinctions made in the broad terms of major language families can mean the division of tiny islands.

Santa Cruz Islands

Four volcanic islands form the Santa Cruz group within the Solomon Islands. Nearby are a number of Polynesian groups in the Reef Islands, Taumako (Duff) Islands, and Tikopia with whom the people of Santa Cruz trade. Within the Solomons area the Santa Cruz culture is quite distinct.

Note: inch measurements appear in the Catalogue, p.236.

PAGE 13
1. Detail of a wooden carving of the shark god Menalo, in ceremonial dress. Height: 126 cm. Man and shark are believed to share a common ancestry, with the shark spirits living in harmony with man. The spirits show themselves in the sea as sharks with human heads and hair. There are stories of shark spirits in human form coming ashore and mixing with the local people. Menalo is one of the chiefs among the shark gods. *Otago Museum*

2. Detail of a carved wooden food bowl. Length: 72 cm. The bowl was used by priests when they shared food with shark spirits while invoking their aid or advice. The islanders obtain information about fishing, the weather, and other matters from the spirits. The spirits also act as guardians of the people and do not harm them. The carving represents a pig. *Auckland Museum*

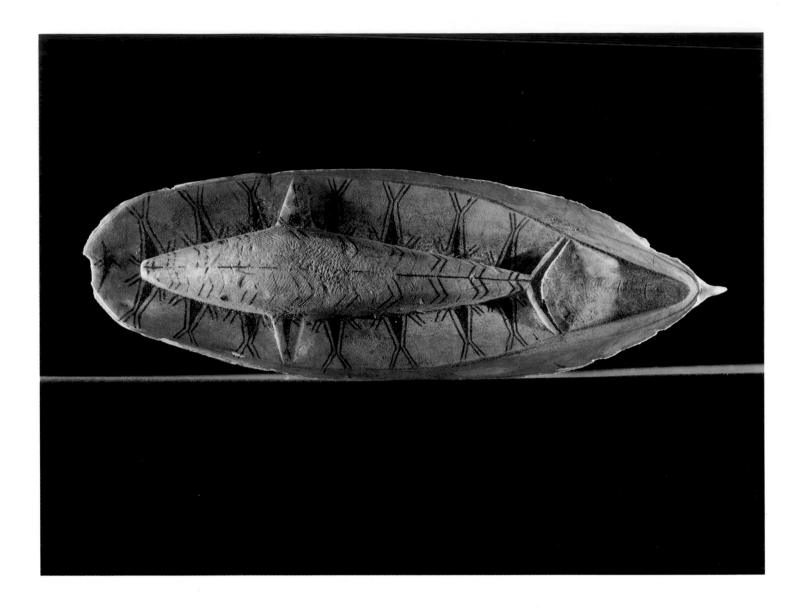

3. Shark spirit carving of cuttlefish shell. Length: 22.3 cm, c.1930. Shark spirits are also known in Polynesia but are not usually represented in art. In Santa Cruz and the south-east Solomons they are represented as sharks, or as part-man, part-shark. *Auckland Museum*

4. Shark god as man, carved in wood. Height: 39 cm. *Otago Museum*

NEXT PAGE
5. Shark god figure, carved in wood with shell decoration. Height: 40 cm, late 19th century. Such figures can also represent important ancestors. With the support of a powerful spirit a man can gain power and prestige. The figurines are a visible sign of this special status. *National Museum*

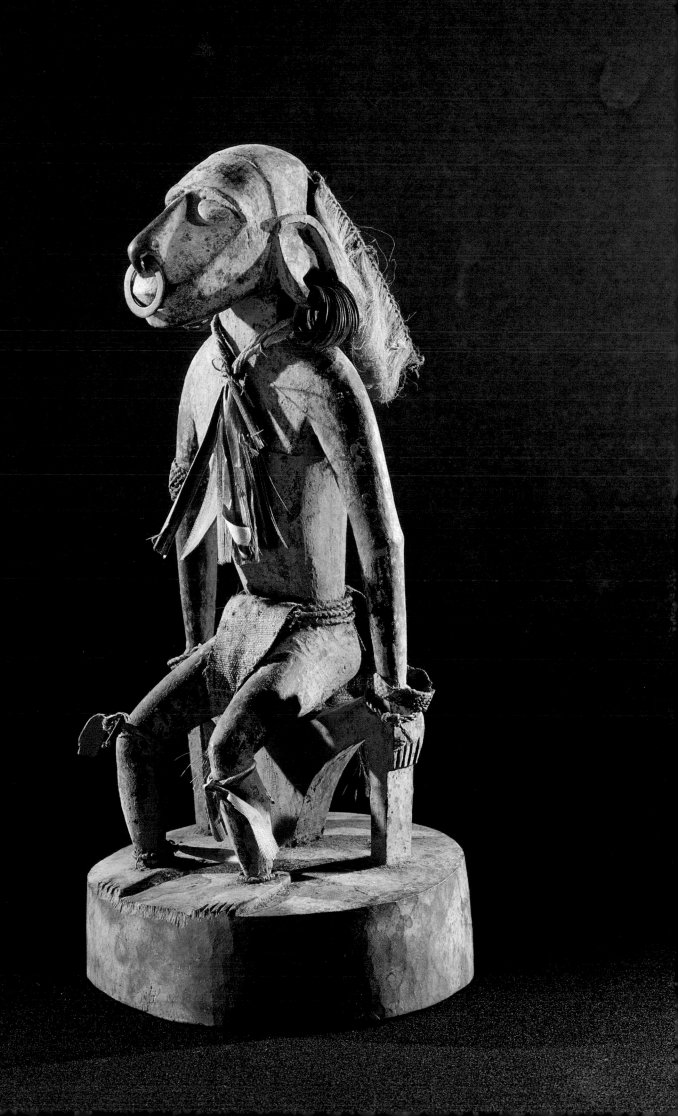

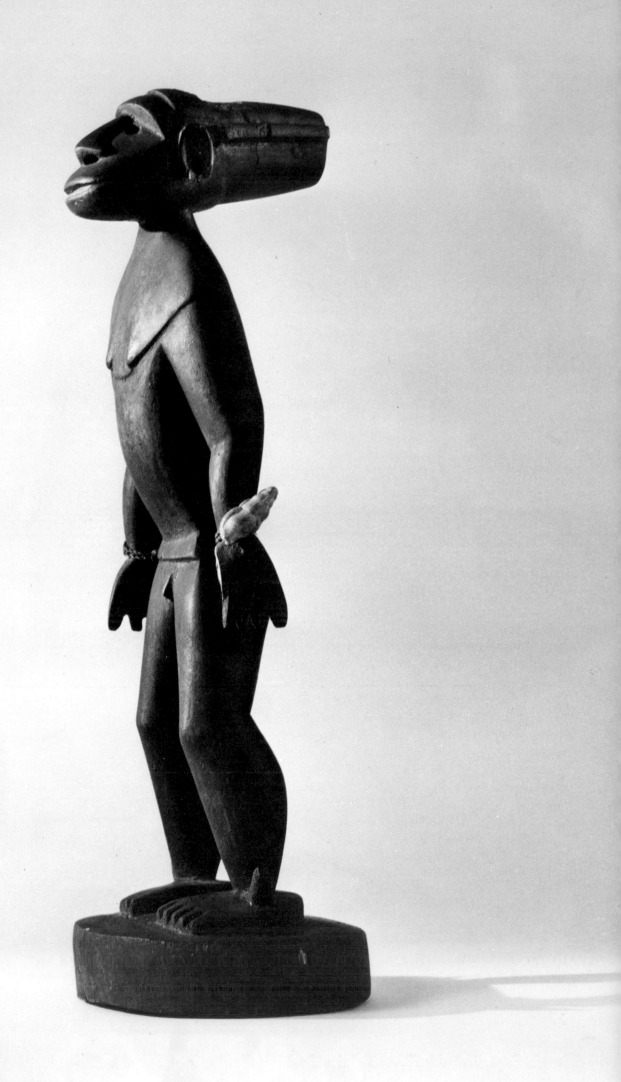

Sharks are human

A fisherman's house built over water, on a lagoon in the Solomon Islands.
The conversation is in a mixture of place-talk and pidgin English, through an interpreter.

About three years ago I was fishing for barracuda, I was catching them in the night, and a shark took my line. I drew in the line close to the canoe and tied it round my waist and paddled ashore pulling the shark behind me. I pulled the shark onto the beach and took the hook out, I did not cut the line. I cut the hook away at the mouth. Then I helped the shark back into the sea. He was not biting me.

Frightened. What was there to be frightened of?

I wanted to save the shark, yes. But I wanted to save my line too. I saved the line *and* the hook.

All the fish that are in the sea here we can eat – sailor fish and boar fish and sea slugs and bonito and trevally and barracuda. Dolphins too. But not shark. Sharks are human. To us a dolphin is just like another fish. A dolphin is not a shark.

If an outside man comes here and catches a shark we do not harm the man but we keep away from him. We do not have anything to do with him. We never fish for sharks. He is a person with us. We are related. The other ones we do not eat are rays and crocodiles because they are related to us too.

Oh sharks can save people, yes. I know of two cases. In one case a cutter boat broke in two and was smashed out there in the open sea. There were four people in the boat, two were salt water people like us and two were bush people. The two bush people were lost. The other two people were taken – guided, yes – by the sharks to Florida Island and were safe. The sharks did not touch them, only guided them. They helped them swim to the island. The sharks do not help the bush people because the bush people don't believe in the spirit. They are not related.

He sits at a table with one foot tucked under. He is small and lithe, his teeth blackened by betel-nut juice. He chews betel-nut, throwing the husks through the open window into the tide.

His name is Moses. The house belongs to his brother and is one of thirty or so in the village, the village in turn one of several villages which fringe the points of the lagoon. On the table is a bunch of artificial flowers.

The house is built of sago palm directly over the sea. Whenever the conversation is interrupted by a downpour the brother gets up from the table and lowers the window shutters. When the rain is over he props them open again and the breeze blows through.

The lagoon makes a crescent in the frame of one window. In the scoop of the crescent: a small port, market and the government station. Behind are the hills rising to the interior.

I don't know how old I am. I was born on Auki Island, that one over there. Some people can tell their age by remembering back to the cyclones. I tell my age from the time the first district commissioner was here, Mister Paddington. My brother tells his age from the time of the next

British commissioner, Mister Bell. Mister Bell was speared in 1927 and my brother Willie then aged fifteen or sixteen. When Mister Paddington came he held a Christmas party at the government station and I was a small boy then. But I am not sure when that was, so I don't know how old I am exactly.

I can remember back the days but I am not quite sure – like I was dreaming.

We name the nets after the spirits. Actually, my nets are named after my grandfather. He was a fisherman. We haven't always been fishermen. We used to live in the bush, but a long time ago our ancestor – the leader of the group – came down from the bush and lived by the shore. Since then we have always been fishermen.

My father is buried on Auki Island. We used to bury people sitting up, with the head and shoulders left above the ground. But we don't do that any more. I stood close to my father when he was dying and I asked him to bless me with the fishing he had. When I die my son will come and stand close to me and I will bless him so that he will have the luck I had.

The fishing used to be better than it is. Sometimes we collect spiders from the bush, I mean spiders' webs not spiders – they are sticky, gummy, yes, and we use them for bait. This is for the long-tom fish; it is a long-snouted fish like a swordfish. We wind the web round a stick, like this, round and round into a ball, and when it is nice and webby we take it off and make a loop and smoke it on the fire. Then we make a kite and fly it on the wind. You need two lines. There is one man in the canoe holding a line to guide the kite and another line is running from the kite to the bait. The bait is running on the face of the sea. The fish takes the bait . . . No, there's no hook. This is the hook, the web. It's gummy. The fish bites, and it sticks in the fish's mouth.

I don't know how many long-tom fish I have caught like this. Too many. On a good wind one man can catch a hundred fish.

People on Auki still use kites, on Laulasi too. Laulasi is another island. You cannot see it from here. Laulasi is where the shark priest lives.

Now I am getting older, I have to hunt and hunt for fish. I fish at night with a torch made of coconut leaves tied together. It makes a small light. But now with the new method, they say it is better. They use pressure lamps. They say they catch more that way. The big light scares all the fish away and when I come with my torch there aren't any fish left.

Better? Better for them, yes. But for people like me, it is worse.

Children belonging to the brother come in and out constantly by the ladder steps. A neighbour enters and sits in the open doorway. He wears a khaki shirt and round the neck a St Christopher.

Moses' brother, Willie, offers the neighbour his lime pot. Like the man with the St Christopher, Willie is a Christian – Protestant, although his wife he says is Catholic. Willie and the neighbour listen to Moses and nod in agreement, from time to time passing him the lime pot.

Moses chews betel-nut constantly, sweetening it with lime, or he chews on the betel leaf which he

rolls into a spill between smooth satin-pink palms. Whenever I catch his eye he looks up, embarrassed, and chuckles.

Is it safe for you to swim in the sea? Yes it is safe. Of course there are sharks, but it is not dangerous. On the other side, on Guadalcanal, the sharks attack people, but not here. Here you are protected. What happened was that a long time ago a shark, the one that my tribe follows, came out of a woman. The woman gave birth to that shark, yes. We say 'came out of'. Ever since then my people worship the shark, and the sharks stop attacking people in the lagoon. The spirit of that woman entered into the shark, therefore when we worship the shark we are worshipping the old people. It is a belief that was in us before. We can talk to the sharks. We can call them. We don't call them by name, we talk to the spirit as a human on land and transfer the spirit to the shark. We talk to them when there is a sacrifice.

The priest makes the sacrifice, he sacrifices a pig. The shark priest, yes. He is the one who controls the area. The sharks can come in but they can't attack anybody. The priest makes it safe.

He strangles the pig. No, not strangle. He ties a string round the snout and the pig cannot breathe. He says a prayer as the pig is dying. On the island there is a channel where the sharks come and a stone where he makes the sacrifice over the channel. First he kills the pig, then he cooks it, then he cuts it up and divides it for eating. There are no women there. We eat the meat and the priest calls the sharks with an offering of the same meat – so we share the same spirit.

Oh, the sharks come in! They come right in, almost onto the beach. The last time we called the sharks – my brother was there, everyone was there, women, children, everybody, we were all in the water with the sharks, talking to them and patting them on the back. Nobody was harmed.

Nobody has ever been harmed by a shark in this lagoon. I never heard of a case of injury except one – a man came down who was not from here and he went fishing and got lost. He was a man from the bush.

Women and children are paddling small dugout canoes to and from Auki Island. One canoe, laden with produce, arrives beneath our window, paddled by a tiny girl and an old woman. The old woman has pendulous breasts, close-cropped hair and smokes a pipe. She unloads taro, mangrove fruit, a wicker basket of sweet potatoes, a white cat. She bails the canoe and drags it up beneath the props of the adjacent house. Then she enters the tide and washes herself, ducking up and down in the water to the level of her chin, the pipe still in her mouth.

Yes, the priest still makes the sacrifice. He sacrifices to all the sharks. To us, the shark is known as *the* shark. We call to all the sharks that come here. The white shark, the black-tip shark, the grey reef shark, the shark-like-the-whale, the hammer head shark, the tiger shark, the shark-

with-no-proper-teeth. They are familiar to us, we never eat them. We adore them.

Willie the brother has left the table and is helping his wife, Maria.
 Maria is an ample taciturn woman in her forties. She has ginger hair which is common to many people in this part of the Solomons. She sits on the floor behind us, heating tiny circular discs of shell on stone. When the stone grows cold small boys take it outside in tongs and bring in a fresh hot stone. The shell discs are in half a coconut, already pierced. Maria takes them out one by one, watches them turn from black to salmon pink on the stone, then flicks them onto a mat. She is making shell-money.

I used to dive for shells but I don't any more. The shell-money is our native money, we use it to trade for pigs or for food, and we use it for the bride-price. Every day people are out diving on the reefs for oysters and clams. The black shell is oyster and when you heat it, yes, like Maria is doing, it changes colour. We break up the broken shell into round pieces – like this, my brother will show you. That is only roughly round, you can see, but now we have to grind it smooth. Woman's work? Yes, and man's work too. We use a paste to grind it and that makes the shell smooth and properly round. We can do eight or ten pieces at a time. First we grind them, then we drill the hole and thread them on a string, then we grind them a second time. The smaller the discs are the better they are. More valuable, yes.
 This armband – my brother made it. You can see how small the discs are. How small? I don't know measurements. As small as a baby's little fingernail? A dwarf baby, yes. As small as a dwarf baby's little fingernail. It is an armband.
 The red shells are the most valuable of all. We can't find them in the lagoon any more. We have to trade for them from other parts of the Solomons. No, no, he is not just showing you the armband. He wants you to have it . . . He wants you to have it for an ornament. I don't have any ornaments myself, otherwise I would give you one.
 I have a St Christopher. I wear it whenever I feel like it. I quite like to wear it. It is very nice.

Singing has been coming from a neighbouring house. It rises in volume and then stops. A man's voice is heard. We go out.
 Between the houses on fresh palm leaves a double line of money is laid out – mostly Australian dollar bills. There is some shell-money in belts, including red shell-money. 'Bride-price', Willie the brother explains, although the bride-to-be – whose father will receive the money and distribute it – is not present. All the villagers have gathered. They listen while a man, hoarsely shouting, calls out bill by bill and belt by belt the price. It comes to $160.
 Moses and Willie are critical of the currency displayed. When Willie married, he says, the line was twice as long and it was all shell-money.
 Moses' son, Christian, says when he married there was no shell-money or money of any kind. This is because his wife's church, one of the two churches in the village, has proscribed the ceremony of

bride-price. Christian adds, sadly, 'So I got her free.'

Presently betel-nut is distributed and we go back inside. Christian shows me on the wall a newspaper cutting about the new national provident fund which everyone should pay into but doesn't because, he says, nobody understands what the fund means. Beside the cutting is a picture of Princess Anne's wedding and beside that, a yellow card. The card says MALARIA ERADICATION PROGRAMME.

Tomorrow when you come back we can visit the island.

Why did my people come there in the first place? Did I not tell you? They came down from the bush. To escape the malaria? I don't know. It was twelve generations ago. It was not malaria, it was fighting. The first man who came down collected some coral from the reef and at low tide he made a platform of coral out in the lagoon. On it he put a house. Soon more people came there bringing more and more coral and put houses beside him, one by one, until a whole island is built up out of the water. That is Auki Island. They live there to escape from the bush people.

They live the same as we do, by the fishing and the shell-money. It is an artificial island, yes. I was born there, my family was born there – all my children. But some died. One died from the sickness we call *manu*, he fell in the sea and was drowned. One died from another sickness. Another died very young when my wife could not give milk. The last one died from burns, it fell into the fire.

I will tell you why we left the island. When I was a small boy a monsoon came, very high wind, and water covered the island. We had to leave. Everybody escaped by canoe and came here to the mainland. When the water went down, we moved back again. I told you I can tell my age from the first British commissioner, Mister Paddington. Mister Paddington is the first thing I can remember. Then there was an earthquake. That is the second thing I remember. In the earthquake half the island broke off and fell down in the sea, the houses on that side were all destroyed. So we move away again. After the earthquake we returned to the island and made new houses. The houses are made like this one but we have to bring more coral from the mainland for the foundation. The coral is in boulders and some of it is crushed, and we cover it with sand and earth to make small gardens.

The next thing I remember is a cyclone. Everything destroyed again. Once more we come ashore to land but this time I stay here with my family. Some of us are frightened to go back. Some go back, yes. Those who go back are alright till the next cyclone. I don't know when that was – my son knows: 1967. Augustin says it was in 1967. After 1967, they move back to the island again.

Again? Again. They are still there.

One hundred, two hundred – I don't know how many live on the island now. Our relations are there. There are several artificial islands in the lagoon, some big, some small. Laulasi where the high priest lives is a bigger island.

The priest controls not just sharks; he controls storms too. When we go fishing we sometimes sing a chant to the wind to make it calm the seas – we tell the wind to go somewhere else. But it does not always work. It works for the priest. The present priest is a new priest. His name is Bosikoru. When the old priest died, Bosikoru was appointed to take his place but he refused or he did not bother to take up his duties – I don't know the whole story. My brother says Bosikoru did not bother to learn the prayers and rites. And the people were angry at him. Then a cyclone came – no, not the first cyclone, not the second one. *Another* cyclone. The one they call cyclone Ida. Everybody got some damage but the worst damage was where Bosikoru lived. Bosikoru had three houses. His three houses fell down in the sea and were destroyed. After that, Bosikoru agreed to take up his duties and become the priest.

Since then, no more cyclones.

– Malaita, Solomon Islands

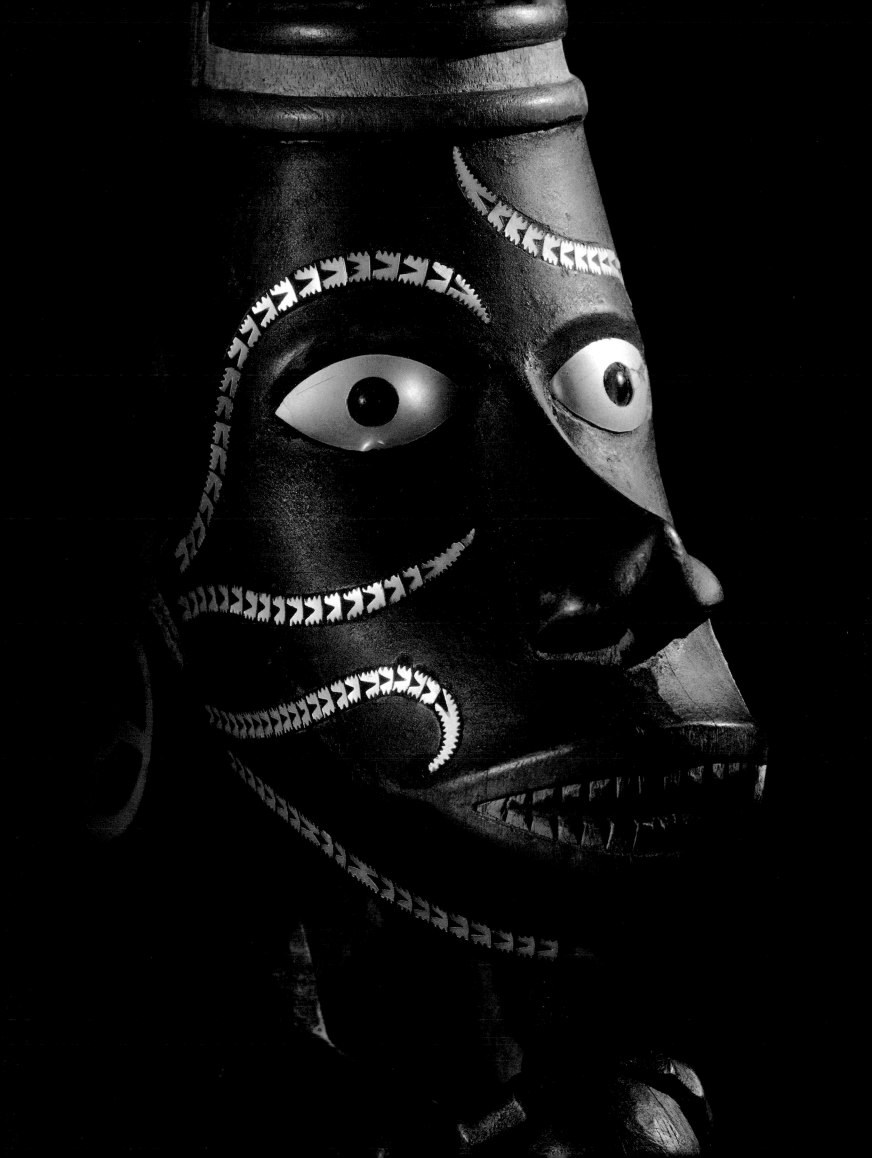

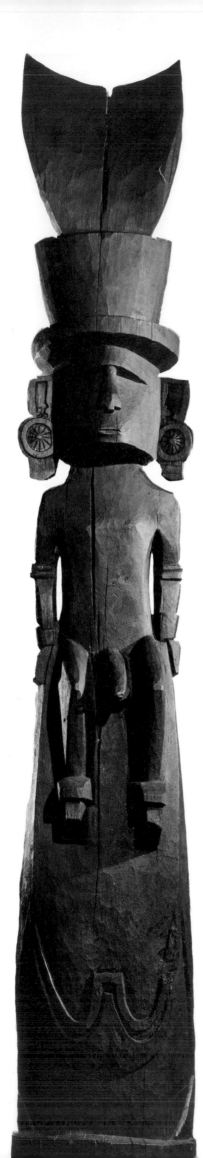

Solomon Islands

The main Solomon chain includes a number of large islands (Bougainville, Choiseul, New Georgia and Malaita in the north, and San Cristoval and Ysabel in the south) and many small islands. The people settled the islands over thousands of years and so there is great diversity in language and culture. Extensive trade networks have contributed to contact between the five major cultural areas.

PREVIOUS PAGE
6. Detail of canoe front piece of wood inlaid with pearl shell, from Bougainville. Length: 31 cm, c. 1850. Shell inlay work is a feature of the art of Bougainville and of the south Solomon islands of San Cristoval and Santa Catalina. These figure-heads are placed under the prow when the large single canoes are prepared for an expedition. *Auckland Museum*

7. Wooden support post from a bonito canoe house, south Solomons. Height: 287 cm, c.1920. The canoe house is also the men's house and is therefore the main ceremonial building in the village. Bonito fishing requires the cooperation of man and spirits, especially those of the drowned. These spirits direct the men to the bonito. *Auckland Museum*

8. Detail of ancestor figure, carved in the style of Roviana, north Solomons. Height: 72.4 cm, c.1900. *Auckland Museum*

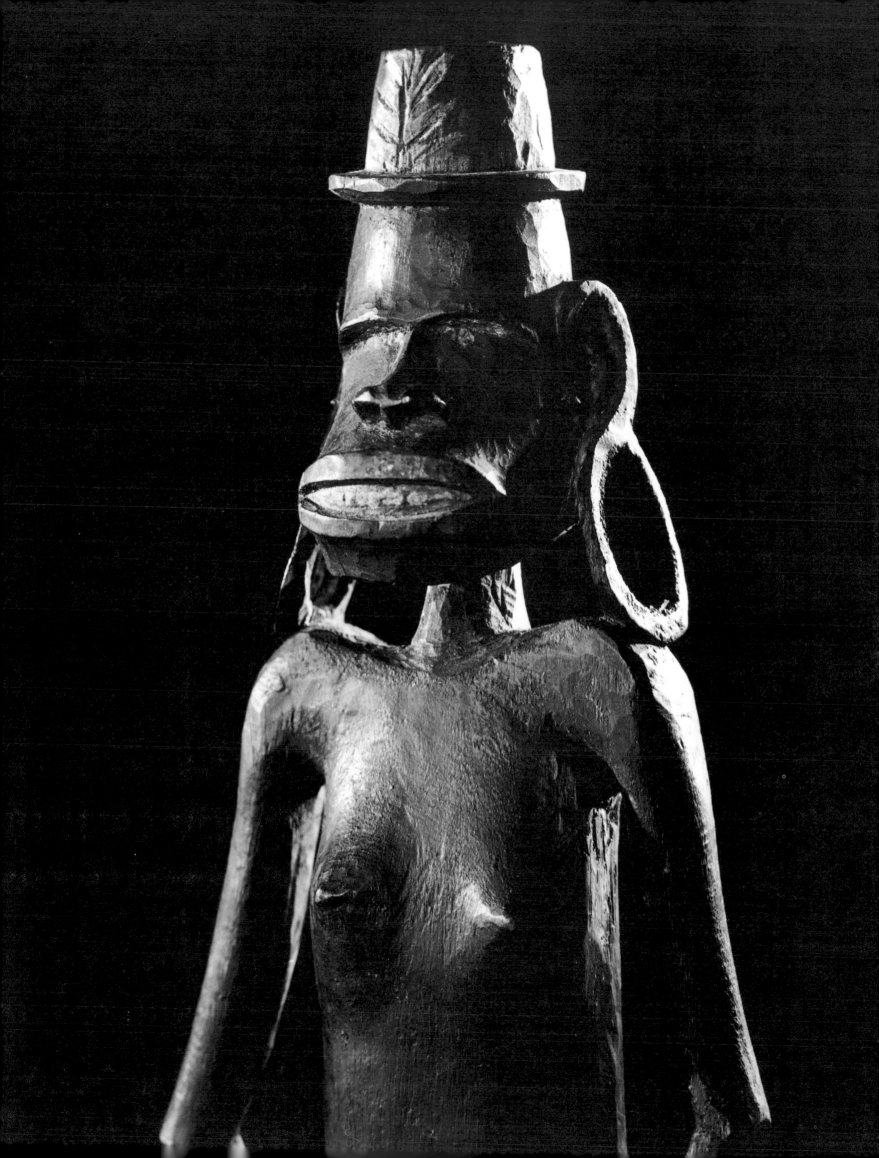

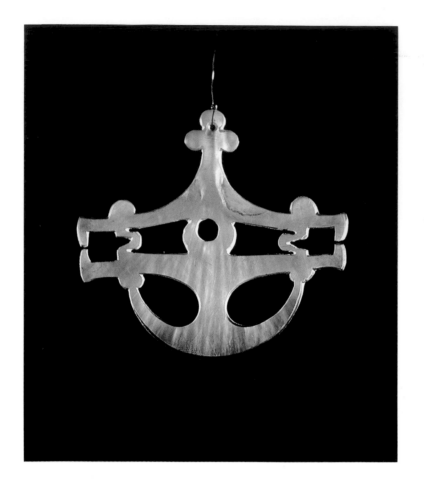

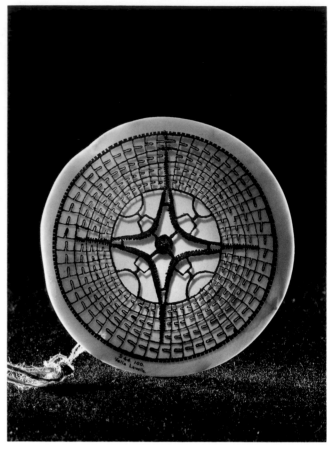

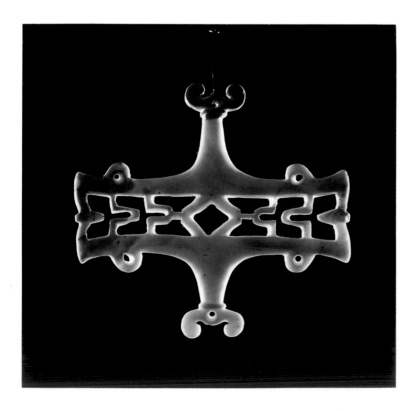

9. Breast pendant of pearl shell fretwork. Height and depth: 7.6 cm, c.1910. As with all the work shown here, the shell was fretted out with string and sand. *Auckland Museum*

10. Clam shell pendant from Roviana. Dimensions: 9 x 7.5 cm, c.1930. Fine fretwork *kapkap* (men's forehead ornament) of turtle-shell are also made in Roviana. *Auckland Museum*

11. Kapkap from Vella Lavella. Diameter: 12 cm. This is composed of two discs fixed together by a central knotted cord. The front disc is of turtle-shell, about two or three millimetres thick. The backing is of clam shell. *Otago Museum*

12. Clam shell plaque with dancing figures, from Choiseul. Height: 39 cm. These plaques were used to close the entrance of a model hut in which the skull and personal ornaments of a dead chief were placed. The hut was then put in a cairn. Often the skull was decorated with clam shell discs. *Otago Museum*

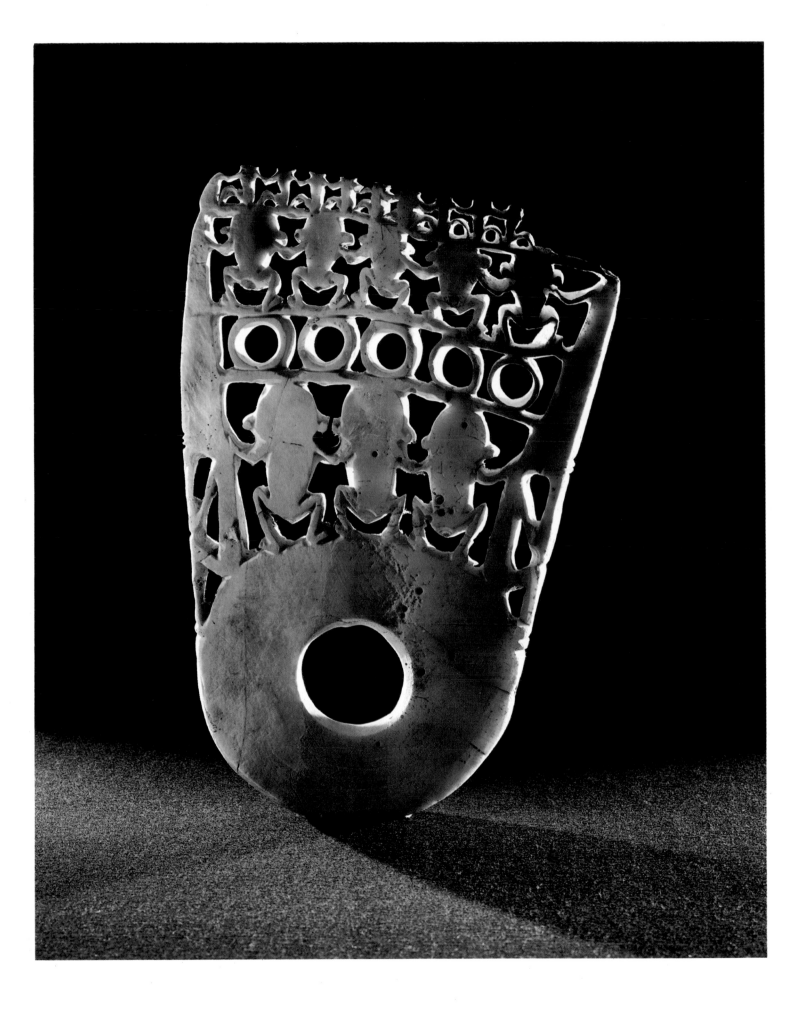

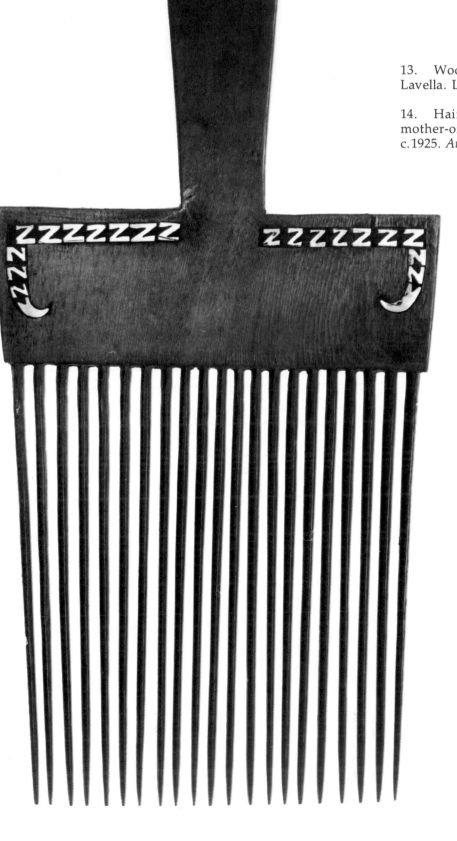

13. Wooden comb inlaid with shell, from Vella Lavella. Length: 17.5 cm, c.1930. *Auckland Museum*

14. Hair combs made of black palm wood with mother-of-pearl inlay. Lengths: 44.5, 27, 40.1 cm, c.1925. *Auckland Museum*

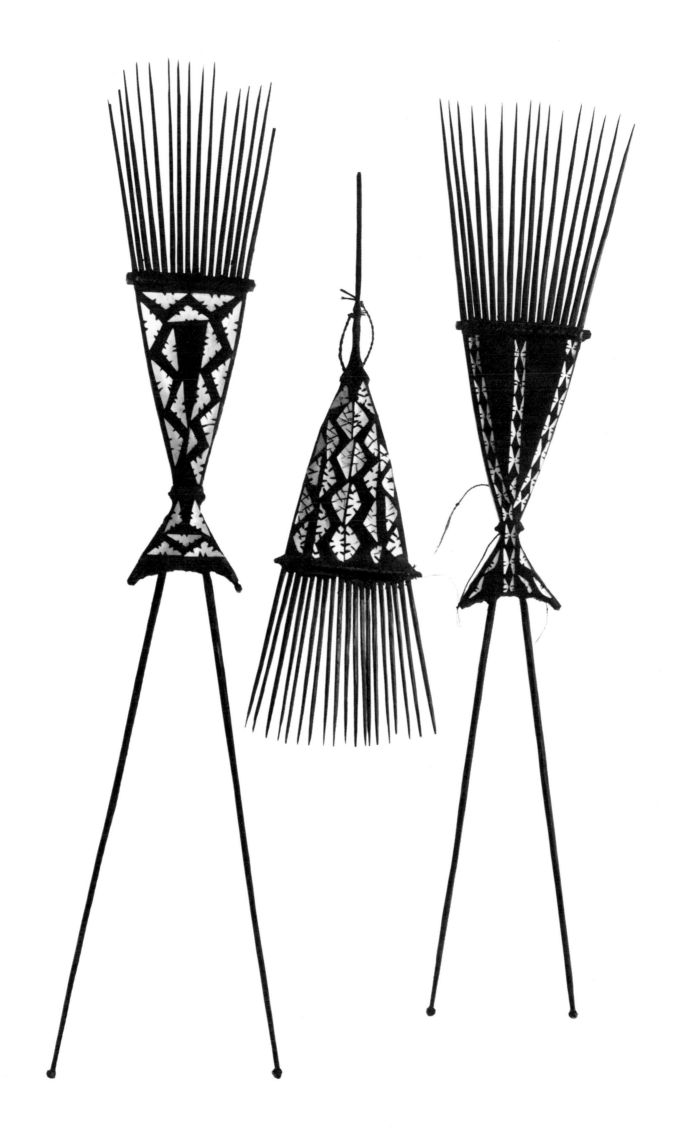

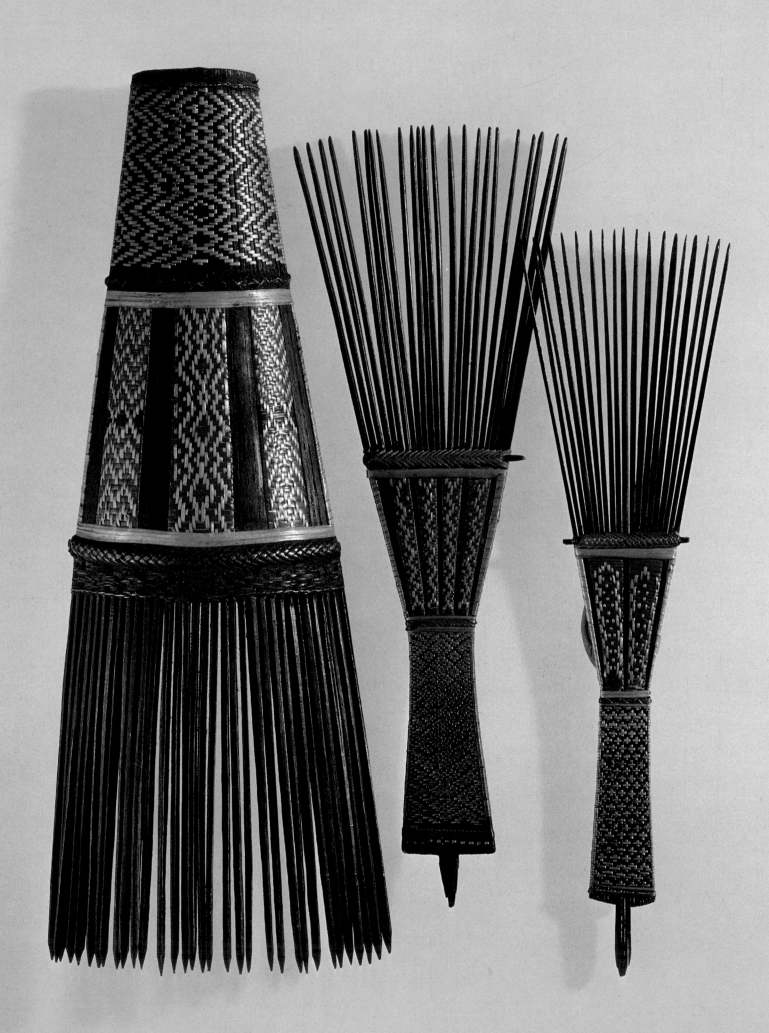

15. Combs made of mid-ribs from palm leaves bound together with fine plaiting, from Mala. Lengths: 21.2, 18.6, 17.2 cm, c.1900. *Auckland Museum*

16. Basketwork shield decorated with fine plaiting and sewn-on shell pieces, from Nggela Island in the south Solomons. Length: 65 cm, c.1880. This was a ceremonial dance shield. *Auckland Museum*

NEXT PAGE
17. Head-rest in the form of a male figure in copulating pose. Length: 88.3 cm, height: 33.7 cm, 1916. There is only one leg as the carving was made from a hardwood tree trunk with angled side branch. *Canterbury Museum*

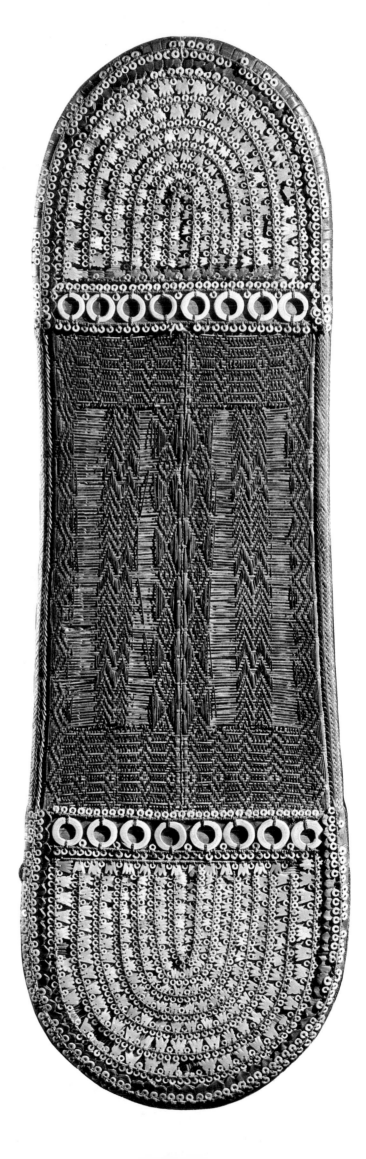

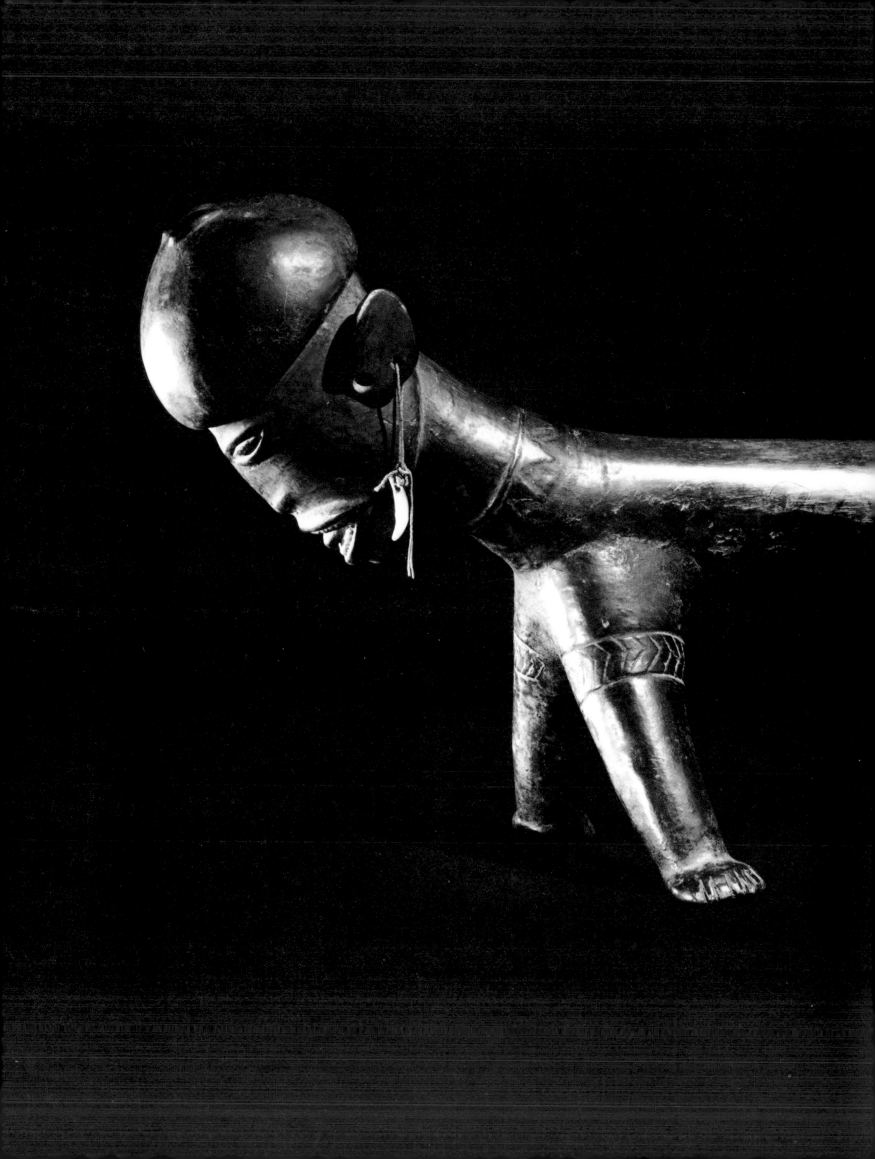

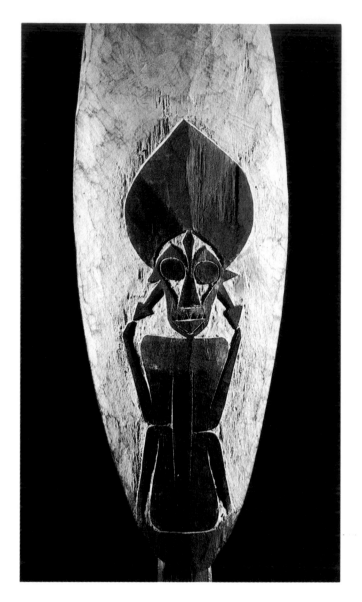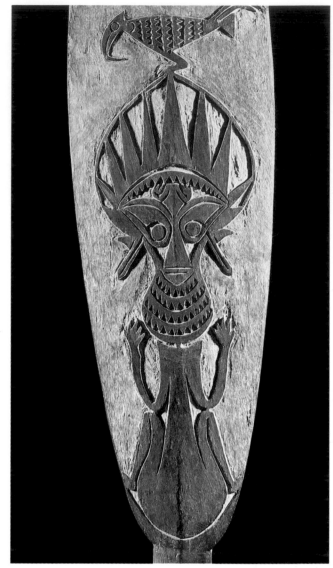

18. AND 19. Buka Island, just north of Bougainville, is noted for its low relief carving. The characteristic style is of a crouching human figure wearing a headdress, as on these two paddles. (18) Length: 154 cm, late 19th century. (19) Length: 183 cm, early 19th century. Similar figures are carved on the gunwales of plank-built single canoes. The bird on the head of the figure (19) indicates that he is connected with the spirit world, that is, that he is an ancestor. *National Museum, Hawkes Bay Art Gallery & Museum*

20. Carved paddle from Santa Isabel, south-east Solomons. Length: 125 cm. It depicts a narrative about bonito fishing. The spirits of those drowned at sea direct the fishing by telling their living companions when to go out. In the carving they appear above the canoe (to the right of the frigate-bird) and again, below the pattern of the waves, holding a bonito. *Otago Museum*

NEXT PAGE
21. Etched clam shell forehead ornament from Malaita. Diameter: 14 cm. The designs are of frigate-birds, representatives of the ancestors' spirits. The arrival of frigate-birds in a village during annual mortuary ceremonies means that the ancestors have come to take away the spirits of the newly-dead. *Otago Museum*

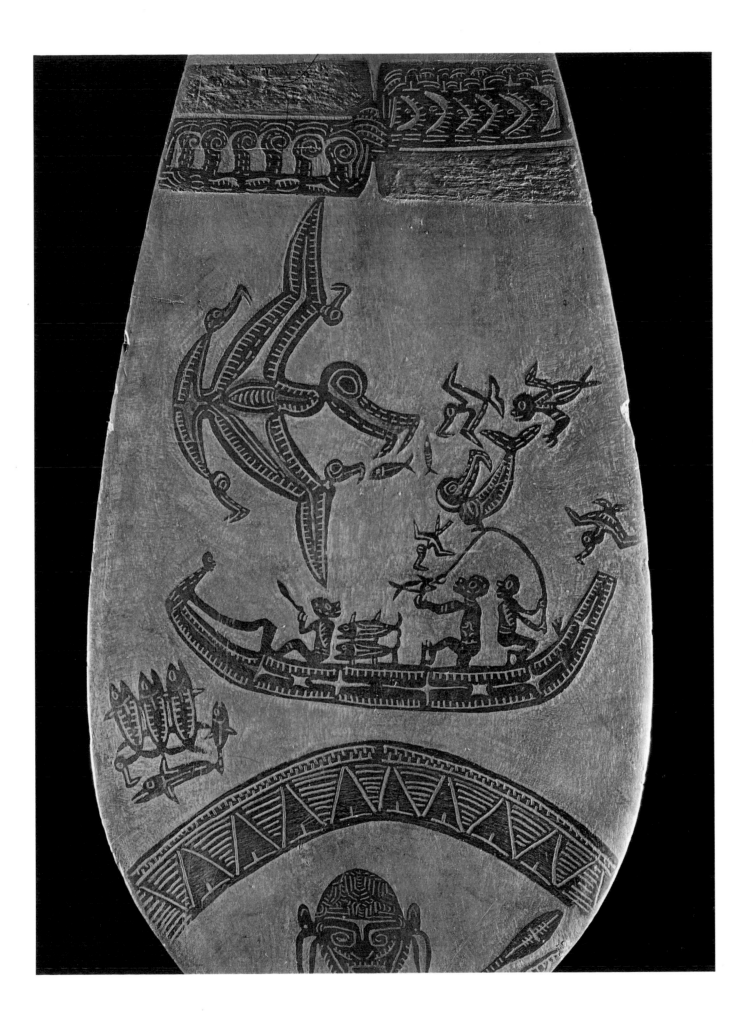

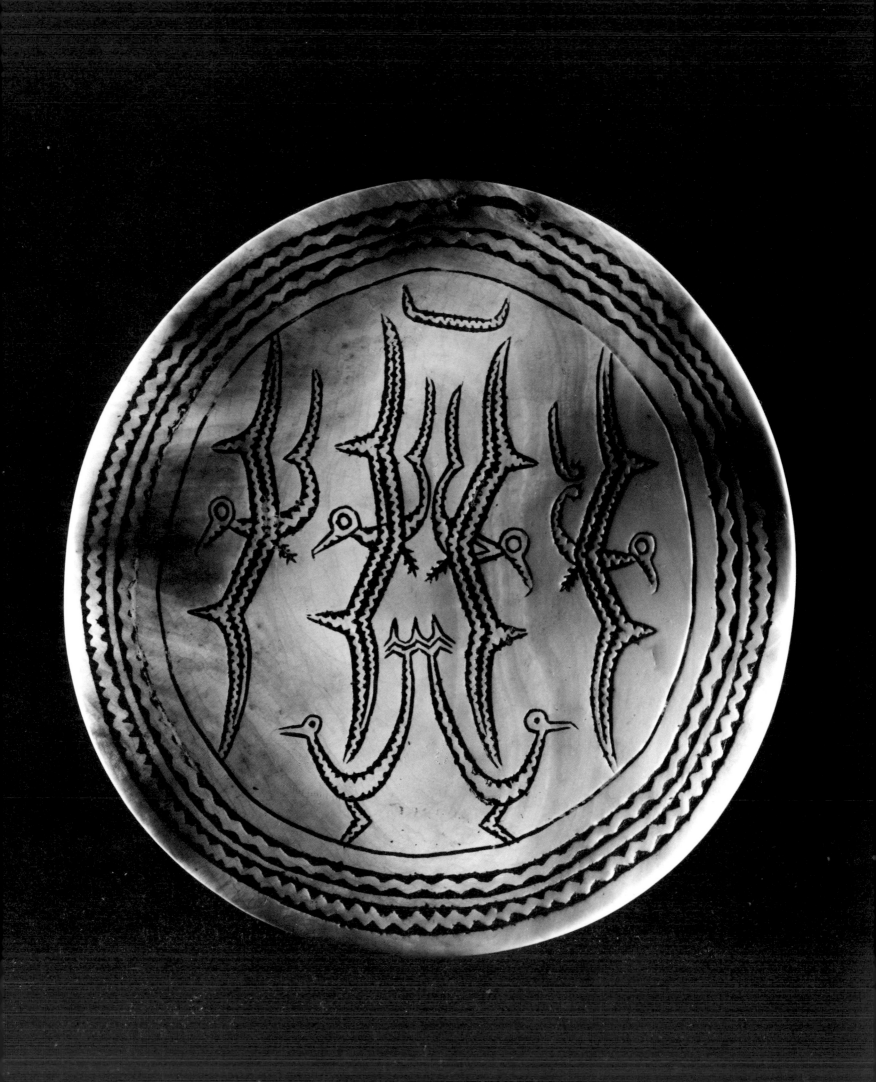

An educated black man

The conversation takes place in Honiara at a time, late 1976, when the British are handing over after eighty-three years of protection. We talked first in Benedict's office where he wore bare feet, even though he is clerk to the Legislative Assembly; later at his home. He struck me as one who had emerged from Christianity, as from a Swedish prison, 'better than he went in'.

The experiment with the Gilbertese refugees, some seven thousand of whom have been imported since the 1960s, illustrates a minority problem which is found in different guises all over the Pacific.

Are we contented?

We haven't got nuclear interference. We keep our customs and our ecology intact, we keep our land. There are no alienated lands in the Solomons. The Americans have gone; the French never butt in; we get our independence from the English. And we have no mineral resources. We are lucky.

I don't know about contented. My people back home are contented. I am working now in town as a clerk. If you sack me, okay. I go back to my village. I have just spent a holiday in my village in the Shortland Islands with my wife Margaret. In two months I did not spend one cent. We lived on taro and yams, tapiocas, bananas, wild pig – fish *plenty*. We're salt water people, our home is full of islands. We swim every day. No suicides – that suicide business is unknown to us. No ulcers; we don't have those. At home I'm very contented.

But my people are worried by all this talk of independence. 'Look,' I say, 'it will not affect you. You are already independent.' As a child growing up in the Shortlands I was always independent. Now, the moment I come to Honiara, I have to listen for this bell, for that bell. (Excuse me, while I answer the telephone . . .) Now I am very much *de*pendent.

Political independence is a very funny thing. To me it just means who sits on that chair and who sits on this: a white man moves out and a black man moves in. It is just changing chairs.

Independence means that the politicians want my people to breed cattle – 'Now you must breed cattle like the white man.' I discourage it. I tell my people this is bad and I stop them from doing it. 'It's not necessary,' I say. So far my people are not being torn apart. With independence comes development, but they preach only the good side, they never explain how it will erupt on the way of life. At the last Assembly in Honiara the oldest member of the House stood up and said the people must be given gas. Gas! 'Man,' I thought, 'this is getting out of hand.' People want firewood, not gas. In my place we've got firewood to burn – trees everywhere! I was very disappointed in this member. But I'm only a clerk, so I shut up my mouth.

I open it though over the question of Gilbert Island refugees. The Gilbertese are a small group of people living among a bigger group of people, they are Micronesian. There's Polynesia, Melanesia and Micronesia. Micronesia is miles and miles from us but there are thousands of Gilbertese in the Solomons now – they got light skin and straight wavy hair. My hair is kinky but they got long straight hair like the Chinese. They came here when their crops failed after a bad drought, but then when they began to take jobs in town the Solomon

Islanders got upset because they don't like the competition.

I was still in school when I heard these Gilbertese were coming. The English government asked the chiefs to help the refugees, but in my place only my father offered to give them land. 'It's a normal move,' I thought. My father told the chiefs, 'Look, these people are in trouble. They got no land, no crops, no water – we got to help them.' He was talked down – 'If you give them land, you'll never get it back.' Actually my father said he wasn't *intending* to get his land back and anyway there was plenty of land for everybody. But he was talked out of it. In the end the English brought them in and settled them on spare land where they fished and learned to make gardens the Solomons way. But the Gilbertese were isolated from us, living apart.

Later when the English said they were leaving, Solomons people got greedy. They told the Gilbertese, 'All that land you are sitting on is not spare land at all, it's ours. It belongs to us. So you get off.'

'This is bad,' I thought. I have left the village now and I can see there is tension growing between the two people. I can see the Gilbertese are in trouble and I remembered what my father said. So I have an idea – I have the idea that the Gilbertese should come into the villages and be part of the community. The two peoples must come together and intermarry. Why not? I thought I might set an example.

I was working in the government and one day my boss said to me, 'Time you got married.' He sent me to this school nearby – 'There's some good girls there, Benedict.' I was laughing my head off, but I did as he said. 'Nothing happened,' I told him when I got back. 'I met a girl with long straight hair, but I didn't do anything.' 'You silly fool. Go back and try again.' This time he sent me there with a film projector. I showed them films. I said to this girl with long straight hair, 'I'm looking for a wife.' See, with us there is no courtship. You just find a girl and that's it.

'I'm looking for a wife. What about you?'

'I'll think about it,' she said.

And that's how it was. We arranged the wedding date for Christmas.

My people didn't like it when I told them I was marrying a Gilbertese girl. Margaret being a foreigner and on top of that not of royal blood, because that is how they saw her – a foreigner and a commoner. 'She'll leave you,' they said. 'She'll divorce you.' The Gilbertese have different customs and one of them is divorce. We have no divorce and no courtship but once we are married it's for life. My people take marriage seriously – a man who leaves his wife in my place is considered almost a dog.

And then Margaret, on her side, is afraid because of *our* customs. 'You must be very careful how you sit,' I told her. 'When you come to my place you must be careful how you sit and how you rest. If you want to rest, put up the blinds.' It is for morality. In your European custom you knock before entering. We don't knock, we just make a noise and walk in.

Margaret isn't used to it. This sort of thing it scares her to death. She knew she was in for a hard time, but we both agreed to try.

When I came home all my brothers and uncles confronted me. 'She's lazy,' they said. 'Lazy and loose – all Micronesians are loose. She'll be lazy and then she'll leave you.' 'All right,' I said. 'You prove to me this girl will leave me and I won't marry her.' Of course, they couldn't prove it.

We were married at Christmas time. Margaret's people brought food and my people cooked it and we ate it together. People gathered for the wedding feast from all the villages around. This was the example I was trying to set. Mine was the first inter-marriage in our district. Now whenever I take her home people are falling over Margaret in a big fuss. They love her. They treat her like a noblewoman and the funny thing is, because I have been educated out and forgotten many things, that when I do something wrong Margaret will say, 'Benedict, you mustn't *do* that.' She has to correct me. Margaret knows more about our custom now than I do.

The trouble between the two people still goes on and I am still opening my mouth about it. 'What right have you got to kick them out?' I say – because some of my people have the bright idea they can grab the land the Gilbertese are on and keep it for themselves. 'By what right?'

I was told by my grandmother not to kick people around and as a member of a chiefly line I must respect that. Also I trained once to be a priest and I got the insight that you must think religiously at the same time as thinking earthly. The earth is here for the use of man, so what right have we got to keep our land and say to the Gilbertese 'it's not for you'? If people are hard up and the land is for using, *use it* – that is my driving principle. I cannot take the land with me when I die.

The thinking has changed. This idea about possessing land has come with Western influence – but this is a custom of private ownership which we have not got. People are thinking 'mine, mine'. But we have not that word 'mine'. 'Mine' is for small things, but 'ours' is for land. Land is for everybody.

In our true custom we are socialistic. We own nothing for ourselves. The chief will own plenty, but that plenty is for the use of the people. It becomes like a trust. So if you are a chief you are bound to help others.

Some customs we still keep and they are harder than yours – take this prison thing you have got. If you do something wrong in the West you go to prison. A prison to us is just a game: the man is hidden away and given free meals and he does not suffer socially at all. In my place the man is *kept* in the village. All the time at the back of his head he knows, 'Everyone is talking about me.' That really gets into his bones and humbles him. He is not cast out but he *is* an outcast.

Nowadays many Japanese businessmen are coming to my village and we welcome them like friends. Most people count their age from the date of the last hurricane, but with me it is the arrival of the Japanese during the war. I was eight. I was going to a wedding in a canoe and I looked up and the sky was full of Japanese planes. Next thing, Japanese warships everywhere.

In my place there was no bad treatment — they left the women and children alone and they paid in kind, so when the Japanese come back to Shortlands today we welcome them in their own language. We call them *Wantok*.

Wantok is a friend, someone from your own place or who talks your language. This morning you heard me say to a man who came to the house 'Hullo *tentok*', meaning 'you-man-from-a-language-far-away-but-you're-still-my-friend'. Tentok, because that man is not from my place. You will never see a Shortlands man in this house unless I invite him – that's the custom. That's the respect that lives.

My son Christopher is already looked upon as a future leader. We have two children – Christopher is six and the girl, three. There were three more children but they died. Margaret has a bad history with children. Now, if Christopher or the girl gets even slightly sick, Margaret sees before her the scene of one of the dead ones and she becomes very weak.

In my place we never say 'a child is born'. We say 'visitors have arrived'. It is considered a bad omen to say 'a son is born' because that is tempting the spirits.

Maybe in a few generations we will forget the village customs and the village life altogether. Once you leave and come to town you're a no-good man. 'Oh, he's working for the white man,' people say. That is what they say behind my back about me, even though the white man I am working for has become a black man. People are not even aware now who is the white man and who is the black man.

It's true. I've become a townsman – a no-good man. I am already so Christianized my custom belief is gone.

I'm very disappointed with my people, because they have lost the art of decorating their canoes. In the Shortlands we go walkabout in the reefs (you go walkabout on land – we do it on canoes) and when I was small you could see six or seven outrigger canoes being built and decorated at the same time – big sailing canoes. The making of canoes was a social occasion.

Highly decorated, our canoes and paddles. My father used to cut decorations all along the canoe edge and whiten it with lime; charcoal for black. Later we found a purple colour from yam. My father was a kind of artist and he had to be paid, both in kind and in respect. He would never make a canoe for a commoner. When the canoe was finished he would take it on a journey to all the surrounding villages and receive gifts and feasting wherever that canoe went. Everybody got involved.

The Roviana people would decorate their canoes with war gods, but we never did that. No war gods on our prows. We would do like we do in our houses and put maybe a frigate bird or a fish like a grille fish – that's the kind with its head cut off, as if to say 'Be careful, or you'll end like me.' That fish or bird or thing we put on the prow, it's warning you how to behave, it's not there for you to look at and admire – it's there for a purpose. Really, it's for protection. It means, 'Wherever you are going, the ancestors will look after you.'

That protection cult or ancestor cult, we believe in it; it's part of the religion. Religion and magic – are they the same? I don't know – I never thought about it. How do you distinguish?

There was a time when Margaret was getting out of her mind. In her mind she kept seeing the dead scene of one of the children she lost. It is so strong that she sickens herself. We were living on a hill at the time and at night she would get up and run all the way to the bottom. Many times she did this and she was running *nowhere.* Usually when something is wrong she calls in her own people. Gilbertese people are very good at curing; they use coconut oil and massage. Your arm-bone break, they put it back straight. No smell, no nothing, and your arm as good as before. But this time she was getting so thin and I was getting so worried I took her home to Shortlands and called in a bush doctor from Bougainville. Custom doctor.

He came with his bottles and he tested to see if Margaret has custom-illness or doctor-illness. 'Oh yes, you've got custom,' he said. Next he sent me into the bush to cut a bamboo cane – he told me the one to cut. I was very suspicious and I cut the wrong one deliberately, but he noticed and stopped me. 'O.K.,' I thought. 'If that's the one the spirits want.' I watched him. He didn't touch it; he chewed some betel-nut and cleaned the rings of the bamboo with a knife and sterilized it with the juice of the betel-nut – sprayed it with his spittle. He gave Margaret something to drink and said, 'That's killed it.' 'Killed what?' I said. I questioned him the whole time. 'Killed the poison,' he said. 'Someone has used a medium.'

Medium, see, like someone has put a stone for you to walk over, or used food or smoke to act as poison. But in Margaret's case it was a stone.

'Now I'll remove the stone,' he said. He ran the bamboo cane along her body and I heard a stone rattle inside the bamboo, drmmp. We all heard it, drmmp, inside one of the bamboo compartments. 'It's a trick,' I said, but he took a knife and opened the compartments one by one and he found a stone. Margaret has never been sick since.

So I don't discard our custom altogether. Maybe the hand of God is with him, this custom-curer, maybe not. Who can say?

It was quite a big stone. I keep it at home in a bottle with a cork on top. He gave it to me to keep, but first he put the stone in oil so it doesn't become alive again.

People say we are becoming Christianized. But I have the impression that even the most educated of my people still believe in custom. I have the impression that Christianity does not go very far under the skin.

See, our girls – bare breasts (I get very cross about this). When I was in school, all bare breasts. Lovely. After I came back from town, covered up. 'What's the matter,' I said. 'Afraid somebody will bite them?' Funny thing. As soon as they get married, bare breasted again.

I see it this way. We have this idea that to be civilized you have to have cover up: shirt and trousers and I don't know what. Sometimes if I have to go to the Legislative Assembly I will get

up in a shirt or a shoe, but otherwise I come to the office as you see me now, in my bare feet. 'But you're a high government officer!' people say. I say, 'You go to hell.'

To be civilized has nothing to do with what you are wearing. And to be educated is a different thing altogether from being civilized. Which is more important? Education is more important.

I say, 'You people must be educated. But you must be educated *black man*.' To me the educated man is the one who is educated out in the world, and then comes back and still recognizes his custom.

You said to me when we met, 'Am I contented?' I was born in 1935 and I left my village in '49. I went to New Guinea, to Phillipines, to Bougainville and now I am in Honiara, capital of the Solomons. Personally I would like to go back to my village. I could have my garden, my canoe, my spears. I like to keep the custom. But again I like to live as all men do – this life in town I *also* like. Actually I'm just baffled between these two civilizations, these two ways of life. I don't know what I am.

– Honiara, Solomon Islands

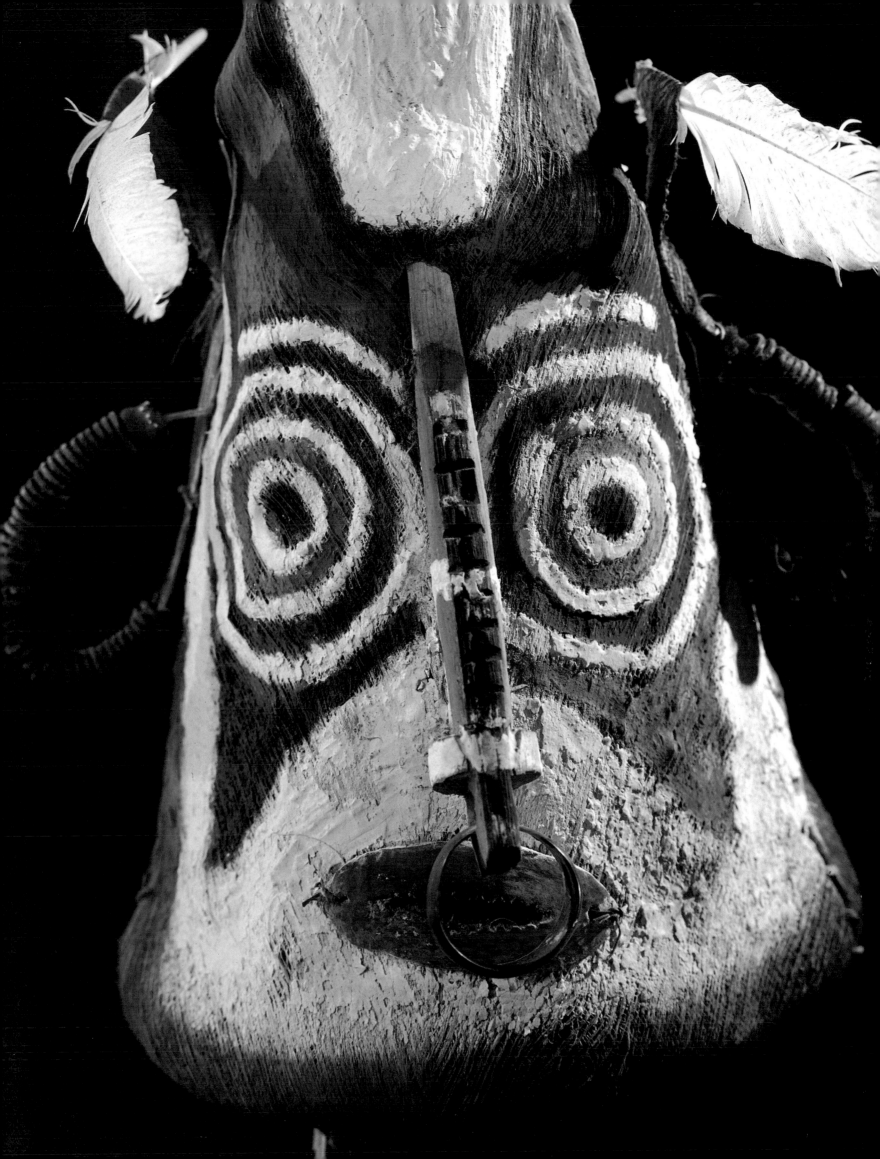

New Ireland, New Britain, and the Admiralty Islands

These islands are part of an archipelago lying in a curve to the north of New Guinea. Distances between the groups are not very great and so there is a good deal of trade and cultural exchange. But language and culture are as diverse in each area as in any other part of Melanesia. New Britain, for example, has at least four major cultural groups (the Siassi, Baining, Sulka, and Tolai), all of whom produce notable art works as part of their ceremonial life.

PREVIOUS PAGE
22. Dance mask from western New Britain (Siassi culture). Height: 104 cm, 1940. The mask, made from fibre and feathers, was worn by the *tumbuan* (a spirit figure) in ceremonial dances. The dancer's body would be entirely hidden with green leaves and brightly-coloured seed pods. *Auckland Museum*

OPPOSITE
23. Chalk figures used to represent the dead in funeral ceremonies, southern New Ireland. Height: 20 cm (largest), 19th century. *Otago Museum*

NEXT PAGES
24. Female chalk figure, southern New Ireland. Height: 41.5 cm, c.1890. These figures are temporary dwelling-places for the deceased person's spirit. After the mortuary ceremonies the figure is broken and the spirit must leave the area and join the ancestors. *Auckland Museum*

25. Wooden dance wand. Length: 27 cm. The theme is bird and snake. The bird represents the spirit world, the snake the mortal. There is constant conflict between these two and this is the condition of man. *Otago Museum*

26. AND 27. Wooden dance wands with bird motif. Lengths: 45.5 cm, 53 cm. These are carried by a masked dancer to indicate whom he represents. *Otago Museum*

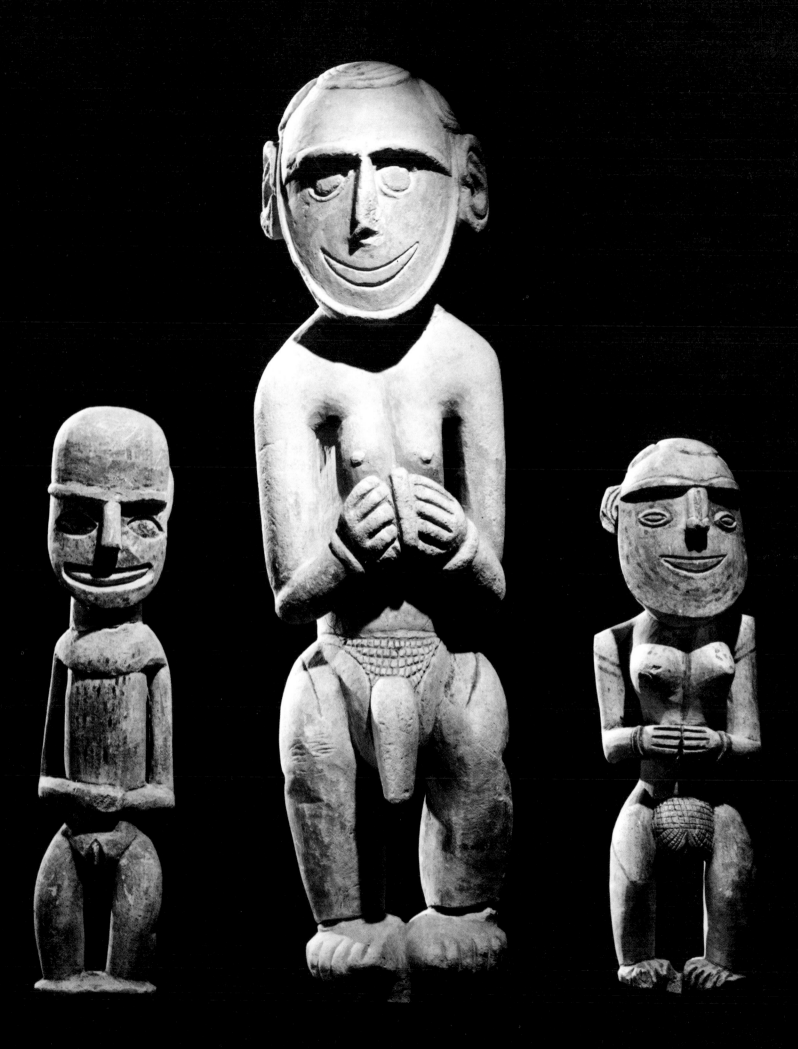

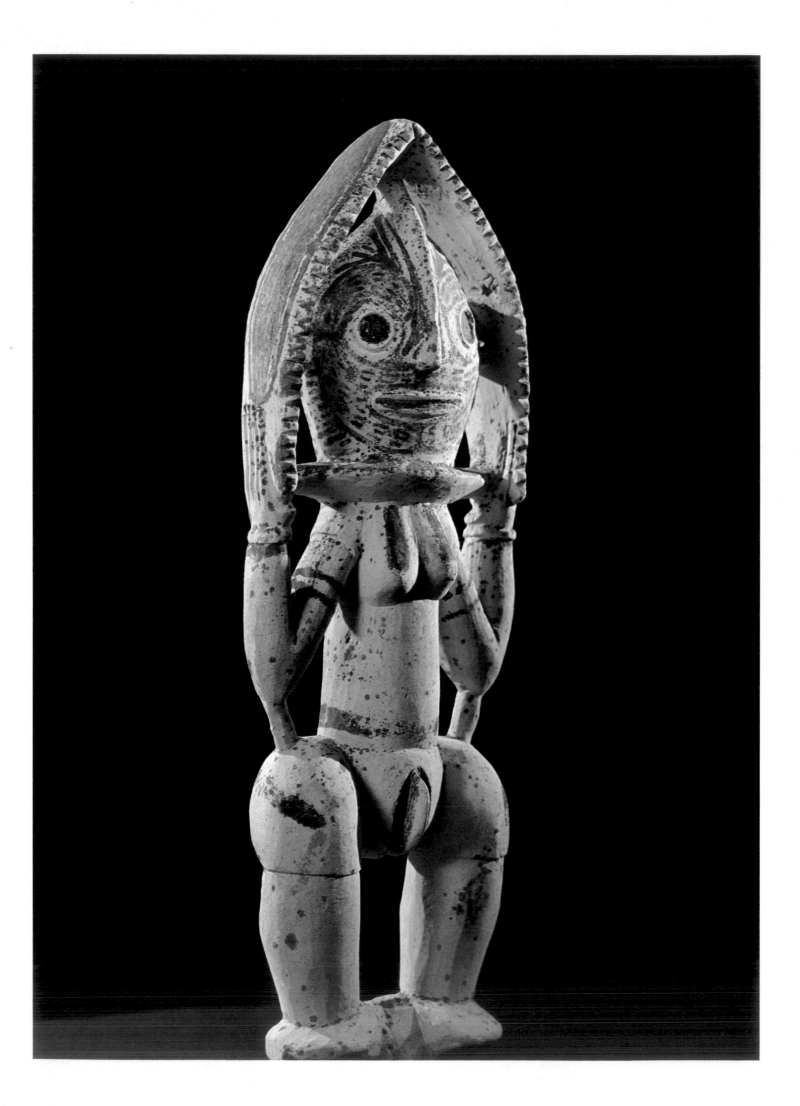

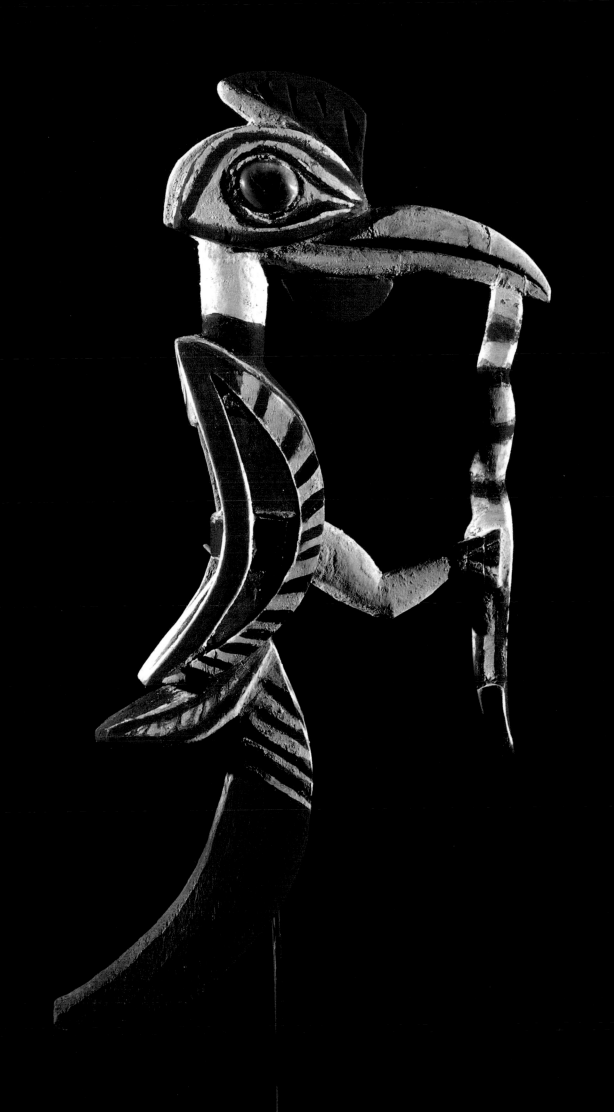

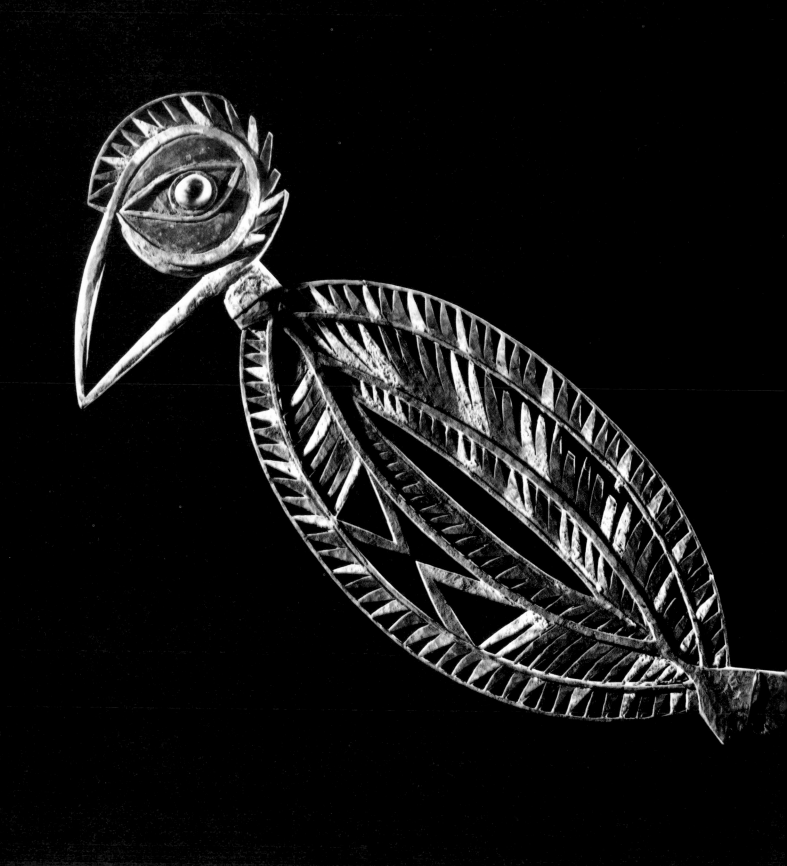

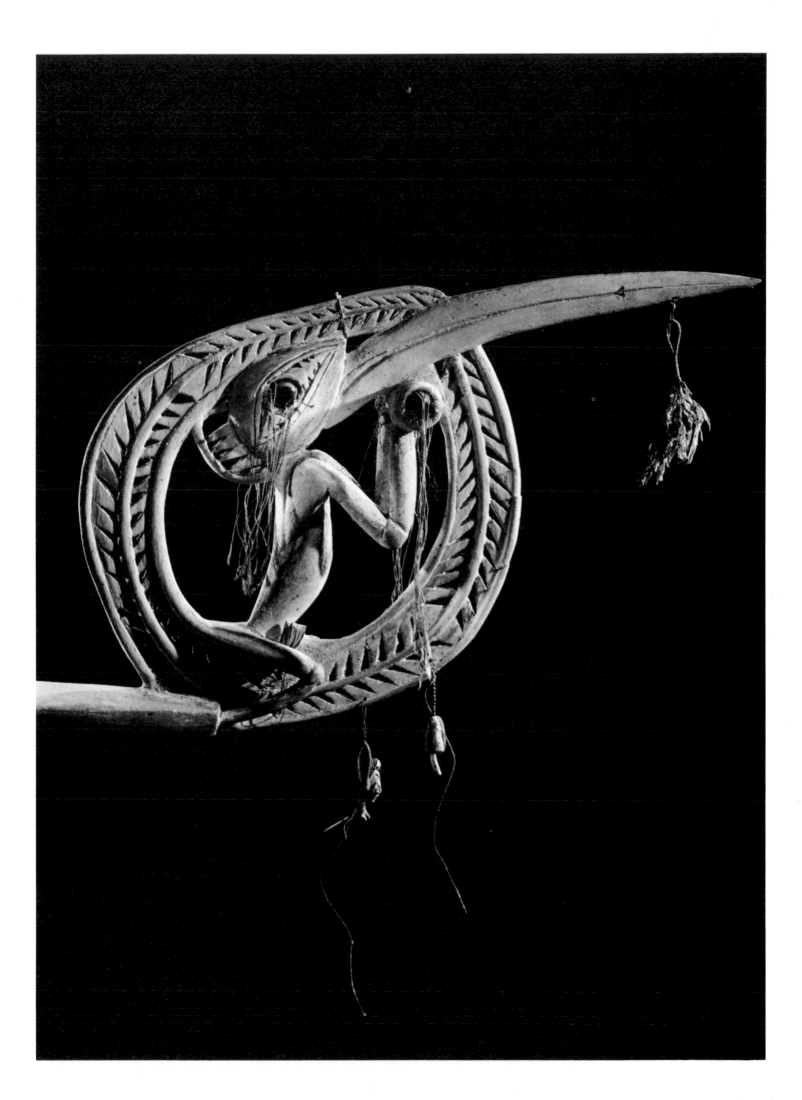

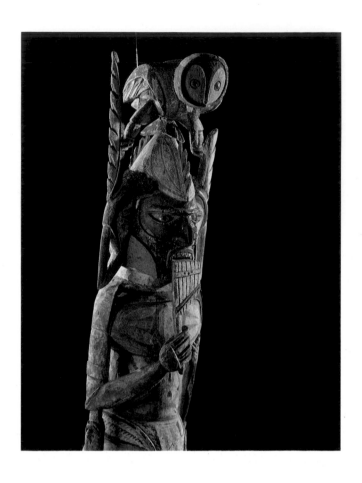

28. Detail of *malanggan* carving of ancestor with a bird on the head (an indication that the ancestor belongs to the spirit world), from northern New Ireland. Height: approx. 117 cm, 1922. The malanggan is a commemorative feast for dead people and for the ancestors. It is held when totemic ancestors return to the villages to take away the spirits of the recently dead. Malanggan carvings are made and displayed in a specially built open-fronted house with a lintel board such as that in 29. Carving designs are each peculiar to a family. The three main motifs are birds, snakes, and men. *Auckland Museum*

BELOW
29. Carved lintel (see 28). Length: 142 cm, c.1920. The bird represents the spirit world. *Auckland Museum*

OPPOSITE
30. *Tatanua* mask used in ceremonies associated with the malanggan. Height: 44 cm. It is also used in ceremonies when the myths of the ancestors are acted out and so become part of the present day. The designs for these masks are again the particular property of a family group. *Otago Museum*

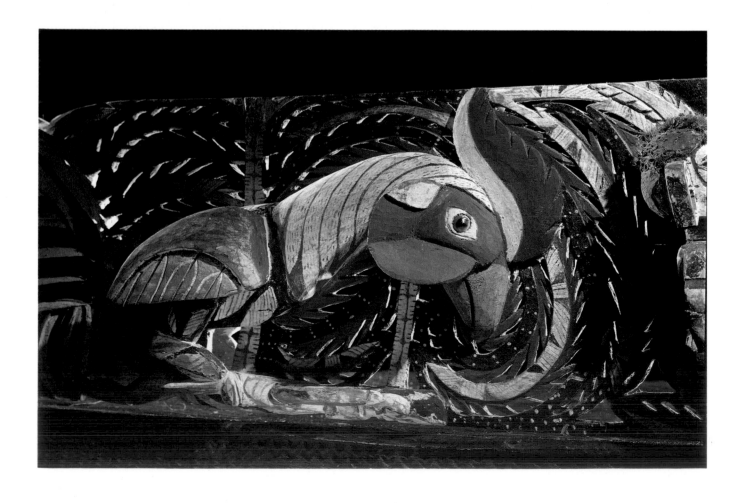

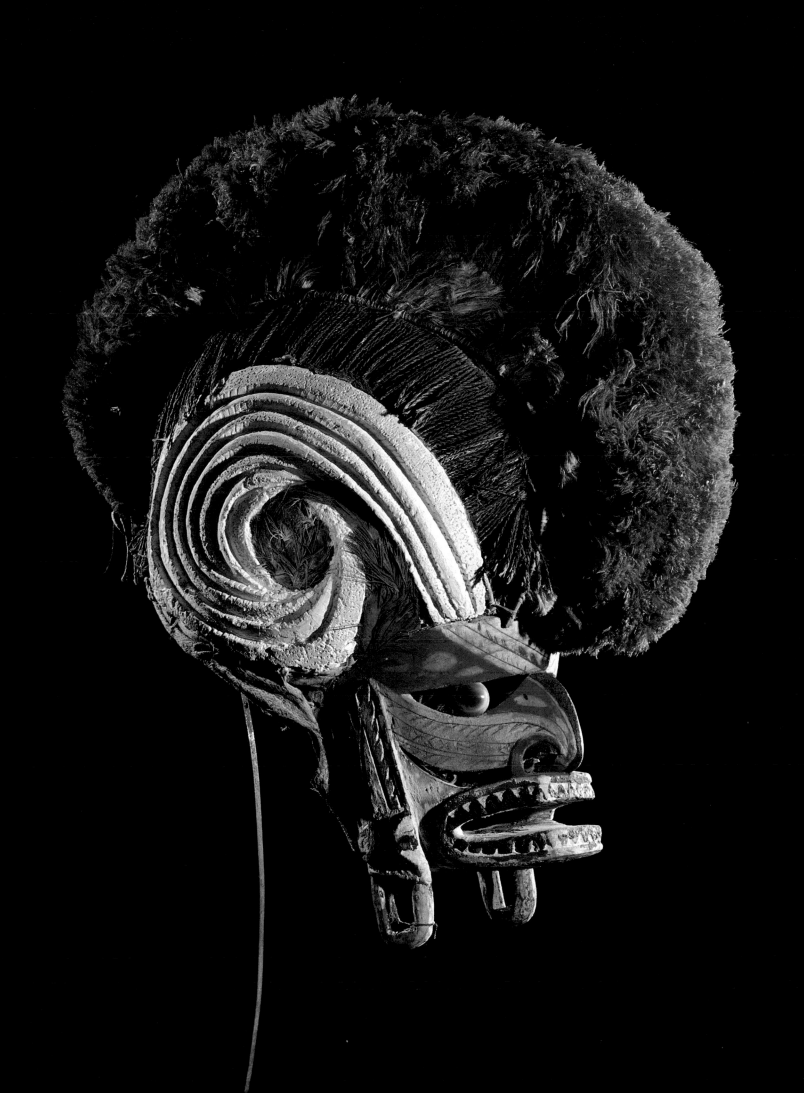

31. Canoe prow from the Anchorite Islands
(north-west of the Admiralty Islands). Length: 46.3
cm, mid 19th century. The theme is bird and man. Art
styles in this area are influenced by the Micronesian
styles of the inhabitants of the nearby Hermit and
Anchorite Islands. *National Museum*

NEXT PAGES
32. Wooden ancestor figure from the Admiralty Is-
lands. Height: 107 cm, c.1880. *Auckland Museum*

33. *Marandan* dance mask from Big Tabar Island
which lies between New Ireland and New Britain.
Height: 47 cm, c.1920. This mask is carved from wood.
Similar black face masks are used on some of the
malanggan figures in New Ireland. *Auckland Museum*

34. Canoe stern-post from the Hermit Islands
(north-west of the Admiralty Islands). Height: 43 cm.
On top of the prow are two lizards, one with a curled
tail; the overall shape of the stern-post seems to repre-
sent a lizard's tail. The two major surface decorations
are the spiral patterns derived from a lizard's tail, and
the series of diamonds (some with an indented design
in the centre). Spiral designs and fine surface decora-
tion are a feature of the art of the Hermit Islands,
which is influenced by Micronesian styles. *Otago
Museum*

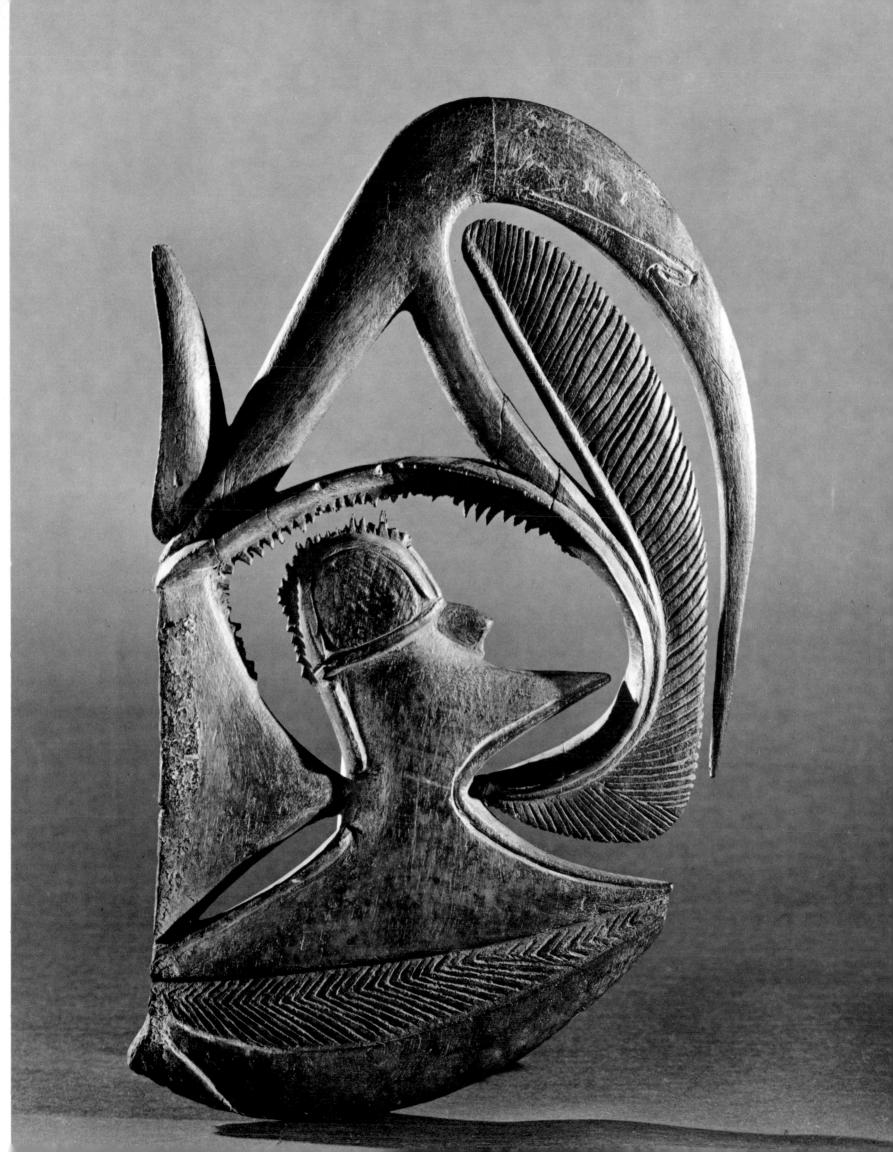

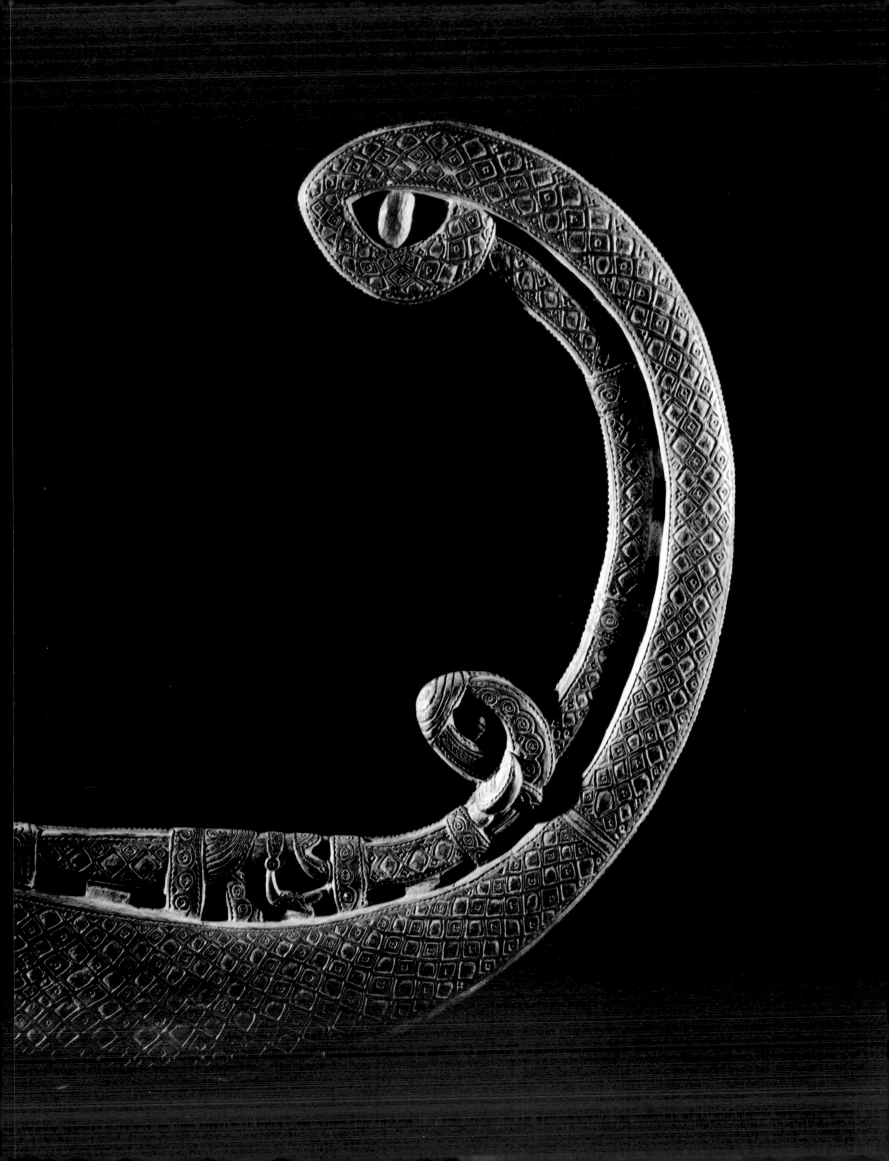

More on the gaining side

In a pagan land the priests are happy. But Father Gunther, a thirty-six-year-old Anglican priest, is taciturn and sad almost to the point of melancholy. We sit bare legged in the Papuan sun – in a car, on a beach, in a restaurant and in Bishop's House on a bluff overlooking Port Moresby bay where he is living while preparing to become a teacher in a theological college.

On the eve of independence (1975) there were thirty-seven different Christian denominations in Papua New Guinea, or twelve thousand six hundred and ninety-nine missionaries and catechists for a population of a little over two million. The missions remain. Probably no people has been force-fed so much Christianity so quickly to so little avail.

My father was not a cannibal, although his people were. He never took part in a tribal fight, but once when they brought in a victim and butchered him – for meat – my father was given one of the testicles to eat. He was a baptized Christian but he ate it. My grandmother gave him the testicle – she plucked it out and gave it to him in front of everyone, so he had to eat it.

This is the sort of thing I disapproved of. I had to stamp on it.

In the village where I grew up we had a custom called *kariga usini*, moon play. When the moon was big we would go down to the beach, boys and girls together, and make a fire and hit each other with sticks – just for fun. Maybe when you were playing a girl would invite you to sleep with her. Then we had dances and songs for the taro feasts – the songs described how to love a woman and how to play with a woman. These customs had been handed down from generations and when I was training for the Anglican church I realized that they were wrong, because they were spoiling the Christian message I would have to teach. So I stamped on them.

Actually I didn't have to ban the moon play, because by the time I was baptized the moon play was already banned.

The bush church in my village was divided something like the Old Temple in Jerusalem – at the bottom were the 'catacombs' where the heathens sat and the front part was preserved for the Christians. I was not baptized for several years so I had to sit at the back in the heathen part. When I was finally baptized I felt very happy, because I had ascended from the catacombs at the bottom.

Although the moon play had been banned, the young people went on with it in secret. If they were caught they were whipped and the girls had their hair cut so the top of their head was marked in the shape of a cross. I agreed with this punishment. How else could we stop the moon play?

The raising of pigs was banned. Pigs drop *pek-pek* – excreta – all over the villages and it was not good for the health of the people. Taro dances were banned. Courtship ceremonies were banned. I agreed with all this banning because I had left my primitive religion behind me.

I went to a church school called Martyrs Memorial High School – free education. If it had not been free I could not have afforded to become a priest. My parents were just village people; they couldn't afford anything. I was privileged. I had one tooth-brush and two school uni-

forms. One uniform was a red loincloth with strips of calico which hung over your bottom, but properly made with the school badge at the edge. The red was for ordinary wear, and I had a white loincloth for Sunday services. Of course I had no blanket. A man who is now a minister in Parliament used to sleep beside me and we would just cover ourselves with a bag, a crepe bag. That was my blanket.

One reason that I agreed to ban our customs was because I was frightened to disagree with the Bishop. At school I used to hide from him so as not to get a bashing. If you wear a loincloth your behind is bare and the teachers would just bash you on the backside. One of our pupil teachers slept with a girl – another pupil teacher – and they were brought into the church and beaten in front of everyone. The girl had a thin underwear, calico only, and was beaten on the backside. Six strokes, and the boy got twelve. Later the girl had her hair cut in the shape of a cross.

I accepted everything I was told to accept and I condemned everything I was told to condemn. But then later when I went to theological college I met a man from Canberra who shocked me by saying, 'What is wrong with your own customs and values? Why don't you teach some of *them*?' It was an eye-opening remark. A group of us got together and discussed it with him afterwards. It was the first time I'd thought about it.

'Otherwise,' he said, 'you will lose everything.' To me, it was new day.

I was twenty-six when I became ordained. By that time I knew how important my own customs were. By that time I did not condemn anything.

Now the churches are realizing their mistake. They are beginning to hear the cry of the people and trying to revive the customs – the songs are sung in the churches and the dances are danced in the churches with drums and conch shells and rattlers, all dressed out in traditional dressings, but of course in the love songs you cannot sing the word 'love'. Instead of traditional words they substitute liturgical ones.

Many things the churches are bringing back are the same things they threw out. In trying to revive them in a new way they think it is being different, but it is the *very thing* that they banned a long time ago. I told this to my Bishop the other day, Bishop George – he is the one who did most of the banning. He laughed. He just laughed and said, 'Forgive me.' He is the one I was so frightened of.

At my church school I was never punished, but not because I never did anything wrong like sleeping with a girl. I just wasn't found out.

In my place in Papua we have no custom of letter-writing, so if you want to be with a girl you have to go and sleep in the girl's house. I used to go round with a gang of seven looking for girls. You wake her up secretly and give your name and hope she will like you and invite you to sleep with her. Later if you both want to get married you tell the family.

There was another way, and that is when the girl comes to your house. Our houses are built

above the ground and she comes up the ladder. Now if your parents find her and like her, they go and pull the ladder away – that indicates the girl is finished: she got up into your house and she stays. There are lots and lots of ways.

When you visit the girl in her house you have to be clever enough to open the door quietly. Very often the door is just tied up with string. Or you make an arrangement with the girl and come through a hole in the floor boards. One girl I liked lived in a house built over the sea and it was easy to get in because her father was away fishing in the night and the door wasn't locked. I just sneaked in and got in the bed. Mother there, brothers there, sisters there, all of us together in the big room. But this girl had a bed on a platform especially built for her on top. And she had a mosquito-net so we were safe in there. Nothing happened between us.

One reason is that there's no privacy in that house. Everyone is in the room together. Because you sleep with a girl doesn't mean you are having any sexual relationship – it is just going and sleeping with a girl. This girl I mentioned was attracted to me, but there was no obligation to get married. Because – well, you never know. You may not be the only one sleeping with her. And in this case her parents were not aware that I was sleeping with her. As I say, nothing happened.

This is something our elderly people at home talk about. In the past when they did this, very few pregnancies. Now they just wonder why the girls get pregnant so quickly, although they don't sleep together like they used to.

If I had not become a priest I might today be – what? Probably just a gardener in my village. But, you know, many village boys who had nothing when I was small now run cattle and trade stores, they grow cash crops, have their own trucks and businesses, and they are living a good Christian life. The churches are full. But there is a tension now. There are money problems and drinking problems. When I think back to after the war when the new ways were introduced, I see the people are confused between the old ancestor gods and the new God, and this is why I have gone back into training. I want to find a way of helping them to keep their culture and fuse it together with the new Christian values.

I often say that the missionary has failed because he brought his superior values and dumped them on top of the man and said 'Take it.' He made this place a battleground. He lived on his mission station at a distance and instead of trying to fuse the two cultures he kept the upper hand. So you get two levels of living. For example if a man had fought his wife and wanted to talk to the priest, he had first to worry in his mind *how* he would talk. Had to dress up nicely and wash his teeth – wash his teeth, yes, because he chews betel-nut and feels inferior. Betel-nut was sinful. It was thought to be a drug. On the mission where I was I would never chew a betel-nut in front of my Bishop. Now? Well now I do it in front of the Bishop all the time. Just come in with my mouth full of betel-nut.

Same thing with the banning of pigs. Pig-raising was *completely* banned. Now the pig, which to you means just a sausage or a canned ham, has a value which is intermeshed with the

people's whole world view of life. It highlights all the big festivities. You cannot be initiated without having pig meat. You cannot get married without pigs because pigs are the major part of the bride-price. There are a dozen ways in which pig-raising was fundamental to the whole of Papua New Guinea.

I could say, fundamental to the whole of Melanesia.

So when they stopped breeding pigs the whole culture began to shake? Yes. Shake, but not break. It didn't break because pigs came back. Pig-raising was brought back, the people insisted. I don't know how it is they succeeded because in other places they haven't succeeded – in places like Tonga the Christian religion has taken over completely. But here, although the local councils and the missionaries kept on saying 'bad, bad, bad', the people just wouldn't give in. I don't know what word you use to describe us, but we are not so quickly taken in by something new. What do you call it in English? Papua New Guineans have idiosyncrasy or something?

At first they obeyed everything without question. But then, they felt no good – in themselves. When pigs were banned it is like a shock in the system. So they say, '*I like* doing this.' All right. They go away and keep on doing it. If only one person does it, no good. But when a whole community is bringing back pigs! So they won this battle.

What about the culture as a whole? I don't know, because I find it difficult to define this 'culture'. The other day I read Kluchon the American anthropologist to see what he said. And I found sixty definitions of culture. I find it difficult to define because it can be unique – my dialect for example is unique. Or it can be universal.

I think culture is like a game of football – one man cannot take part alone. Our culture is a social function. Our dancing, our art, our magic, even our sorcery is social: it includes everything and it is all associated with the social wants of man.

It's a system of values which works for itself, for the people. And so is Christianity. If you think of Christianity, they are both in themselves systems of values.

About two weeks ago in the Anglican synod we discussed polygamy.

Now there is no question about where the church stands. The church's view is that for a Christian man to have more than one wife is illegal – if a converted Christian takes a spare wife the children shall not be baptized. I had the impression (of course he did not say anything hasty) that the Bishop thought this too. I don't know what Christ said about it. You say Christ wasn't even *interested* in the question of polygamy? I am not sure about that. My view is that when a man is married to a woman, they should stick to one another till death do them apart.

I am against polygamy becoming legal? Yes. As a Christian I am against it. As a Papua New Guinean? Well as a Papua New Guinean I have to follow my instinct and my instinct says, 'Go and get more wives if you want.'

There is a clash. I am aware of this and I know there is a tension within me, but this is

because there is a tension in my people. Despite what I have said, I think Christianity has been with the people more than against them. A couple of years ago when Michael Somare told the Australians who were leaving, 'We now have the job of rebuilding some of the values which have been lost or destroyed by a Western cult called christianity', I did not agree with him. I think our Chief Minister was wrong. I mean there is merit in what he said, but there is also merit in what I say – that our system of values in Papua New Guinea is so very very *comprehensive*, it jeopardizes all the time the church's efforts to Christianize the people.

Christianity is here to stay and like anything else it is both gaining and at the same time losing. But it is more on the gaining side.

All right, let's look at it another way. In this part of the country there are say forty thousand Anglicans and only about one fifth would reject Christianity and follow the old ways. I mean, consciously reject.

What about subconsciously? You mean how many would come to communion yet go away and continue to worship the ancestor gods anyway? Oh well. Maybe another two fifths. So already that is a majority who follow the old ways and not Christianity? Quite true. After a hundred years of Christianity – quite true. When you put it like that I have to say the old values are more on the gaining side.

But the people have little education. This is part of the confusion.

Still, I say, the two cultures will meet. And if I am preaching to a ten-year-old boy I will present both sides. No, no, I am not confusing him further. If I don't do this, if I don't give him both sides, when he grows up he will put me in the same category as I am putting my old teachers. I know very well that the two things cannot meet together overnight; it is very very impossible. In the very very end, it may be possible.

The only two things I find that do not meet are the spirits, the power of the two spirits. What value has this ancestral spirit of the people? And what value the power of God? Everything else can meet but not these two. Take the sorcerer who the people still believe in. The sorcerer can punish people for adultery. You can even say he can do what God cannot do – he can punish people on the spot. But I was thinking . . . A hundred years ago, because God was not *taught*, you cannot say He was not here at work. Can you? So maybe He was helping the sorcerer. The sorcerer was working as an agent to God.

It's possible that if Christianity had never come I might now be dead from sorcery. But most probably I would just be a gardener back in my village. Sometimes I wish I hadn't had all this head-work. I find there are many useful things that people are doing at home and sometimes I get angry that I am not back there doing these things. I feel this when I go home.

I hope to be married soon and my people would like to give me a big ceremony with sing-sing and feasting, but you see it can cost up to three thousand dollars for the bride-price and dancers and so on. So I don't think so. I cannot afford to go home and be married in the traditional way.

Of course I still have my traditional shell-money, necklaces and things like that. I keep them as heirlooms? Not at all. I keep the necklaces for dancing. Some are made from dog's teeth or pig's teeth. Some from snails, shells, plants from the bush . . . some from flying fox. When I go home in the dancing time I take out my stuff and decorate myself; paint my face and put the tapa cloth on. Last Christmas I went dancing around wearing all these things.

I have a set of things specially made for me and my brothers have theirs and the children theirs. One of my brothers looks after them for me when I am away. He keeps them dry and takes them out in the sun – this is the custom. He does the repairs too. These things are kept in a box which is locked. You have to be very careful not to let the cockroaches go in.

– Port Moresby, Papua New Guinea

New Guinea

On the mainland of New Guinea some seven hundred completely separate languages are spoken. Often people living in one valley need an interpreter to talk to their neighbours in the next. The cultural life is similarly diverse. But there are certain ideas which are held in common: the importance of pigs as a source of wealth and prestige to their owners; the importance of the spirit world and the ancestors which influences every action in daily life; and the system of achieving leadership, wealth and prestige through war, oratory or conspicuous display of goods.

Broad divisions can be made between the people of the highlands, the people of the major river systems (Sepik, Fly, Purari, Markham, etc.), the coastal people, and the dwellers on the offshore islands who are traders. Barter, ceremonial trade systems and networks link many of these people together even though culture and language may be utterly different. Today in the urban areas members of all these groups live together along with Europeans, Chinese, and other immigrants.

35. Decorated pot made in the village of Zumin, upper Markham River. Height: 18 cm, 1973. The pots are made by coiling, supplemented by paddle and anvil techniques. They are then fired upside-down on an open fire. There are a number of pottery-making villages in the upper Markham area, each with their own distinctive style of open-fired pottery. The Chambri Lakes region (see 36-38) also has a strong pottery-making tradition. *Auckland Museum*

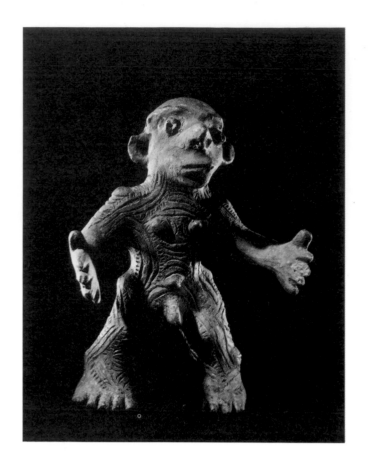

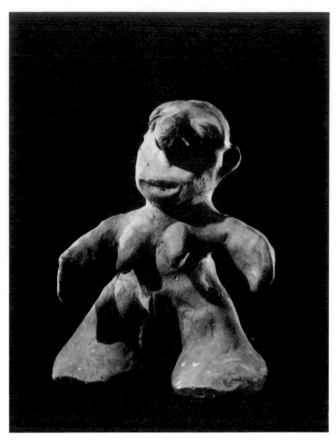

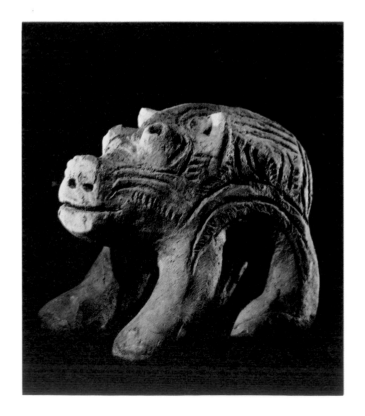

36., 37. AND 38. Pottery pig, and male and female pottery figures made by the Marawat people of Dimiri village, Sepik River. Length of pig: 16 cm, height of figures: 22 cm; all 1973 *Auckland Museum*

OPPOSITE
39. Carved figure in the lower Sepik River style. Height: 18 cm, c.1900. It is in the same realistic style typical of the area as the mask in 45. This figure was the handle for a container lid. *Auckland Museum*

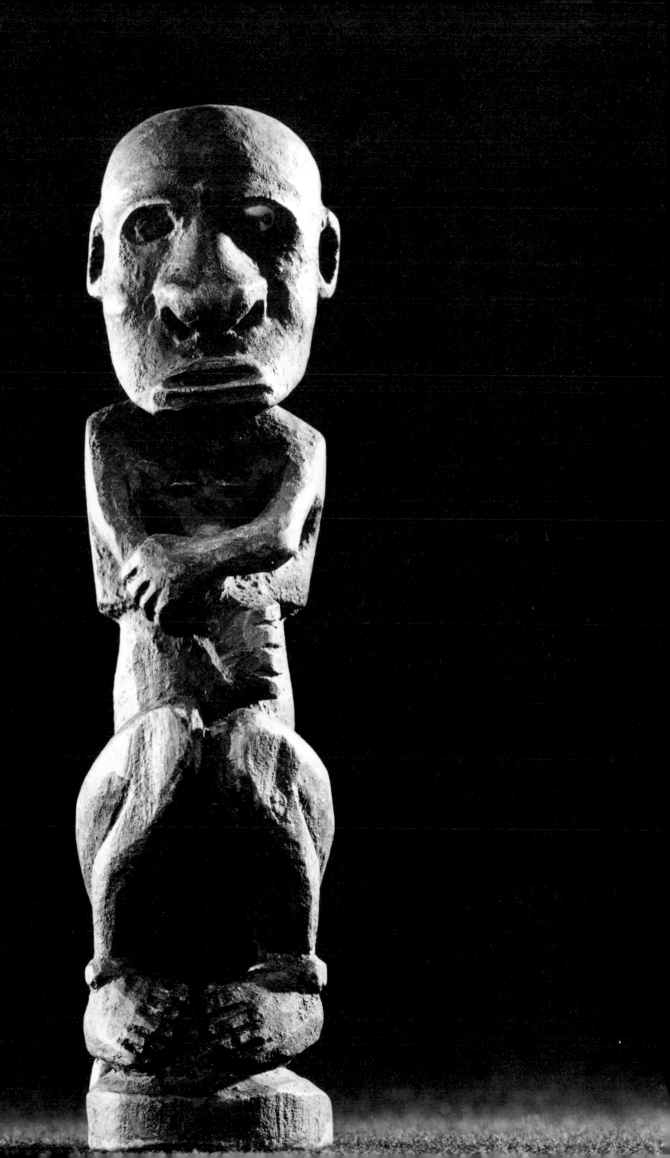

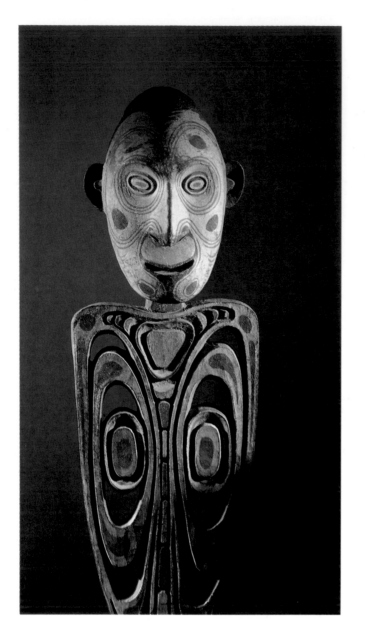

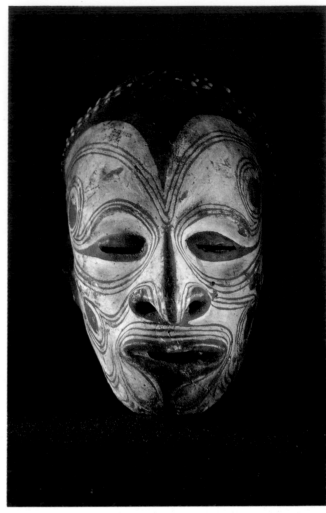

OPPOSITE
42. Detail of a wooden food suspension hook from a men's house, middle Sepik River. Height: 151.5 cm, c.1900. The face is painted, eyes are of cowrie shell, and human hair is attached to the head. *Auckland Museum*

40. Food suspension hook from a men's house, middle Sepik River. Height: 71 cm. This is a carved representation of a modelled and painted skull. *Otago Museum*

41. Skull moulded with pottery and painted, by the Iatmul people of the middle Sepik River. Height: 26 cm. These heads, adorned with ornaments and surrounded by shell or feather decorations, are displayed on poles behind a barrier where women can see them. The display has a ritual fertility role. The skull used can be that of an ancestor or an enemy. Where it is an ancestor's it may also be used during funerary ceremonies, placed on top of a model body and again decked with ornaments. *Otago Museum*

NEXT PAGE
43. Basketwork mask from the Iatmul area on the Sepik River. Height: 53.5 cm, c.1880. The mask represents a totemic ancestor and would have been the property of a warrior who had killed an enemy. Such masks are kept in the men's house and are worn by their owner on ceremonial occasions. This mask was probably painted with brilliant yellow, blue, white and red ochres mixed with clay. *Auckland Museum*

44. Basketwork mask in the form of a full-sized crocodile representing a totemic ancestor, from the Sepik River area. Length: 223.5 cm. These masks are used in initiation ceremonies when myths about the origin of the group are retold. *Otago Museum*

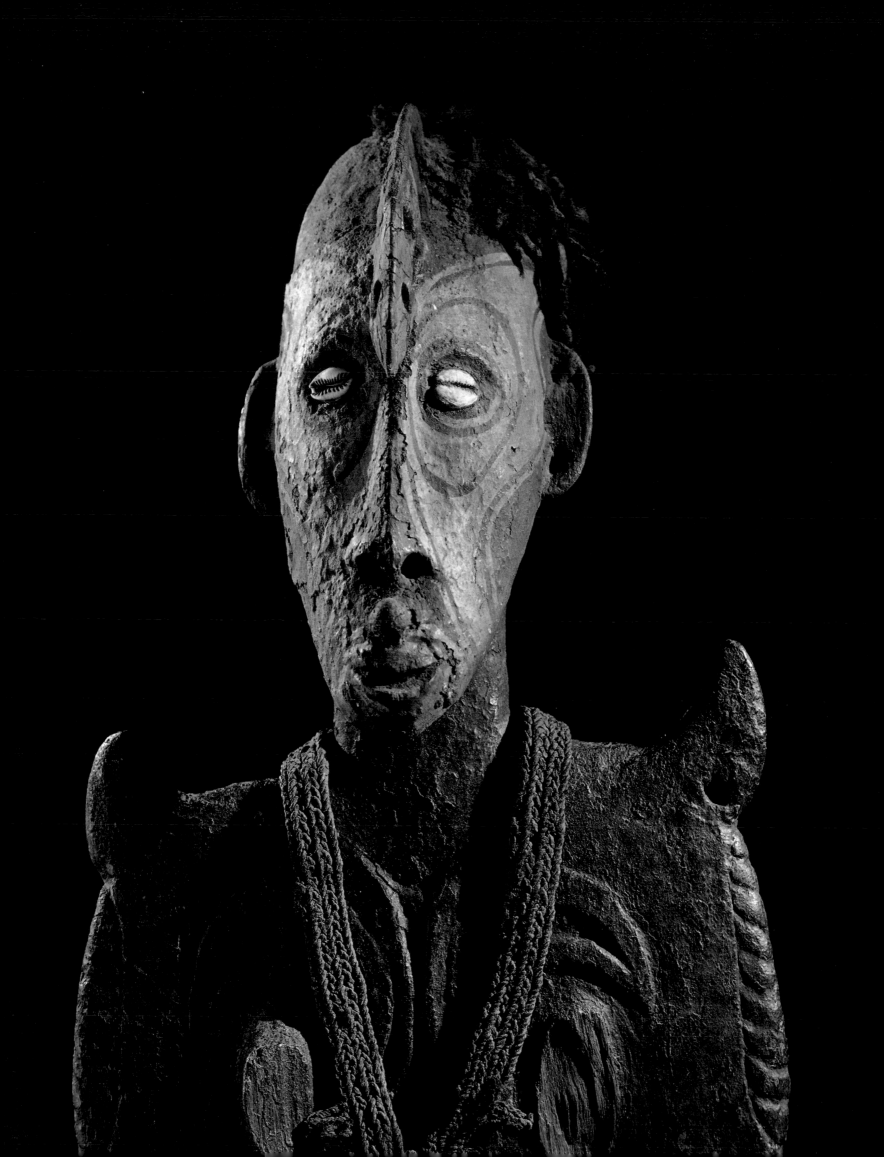

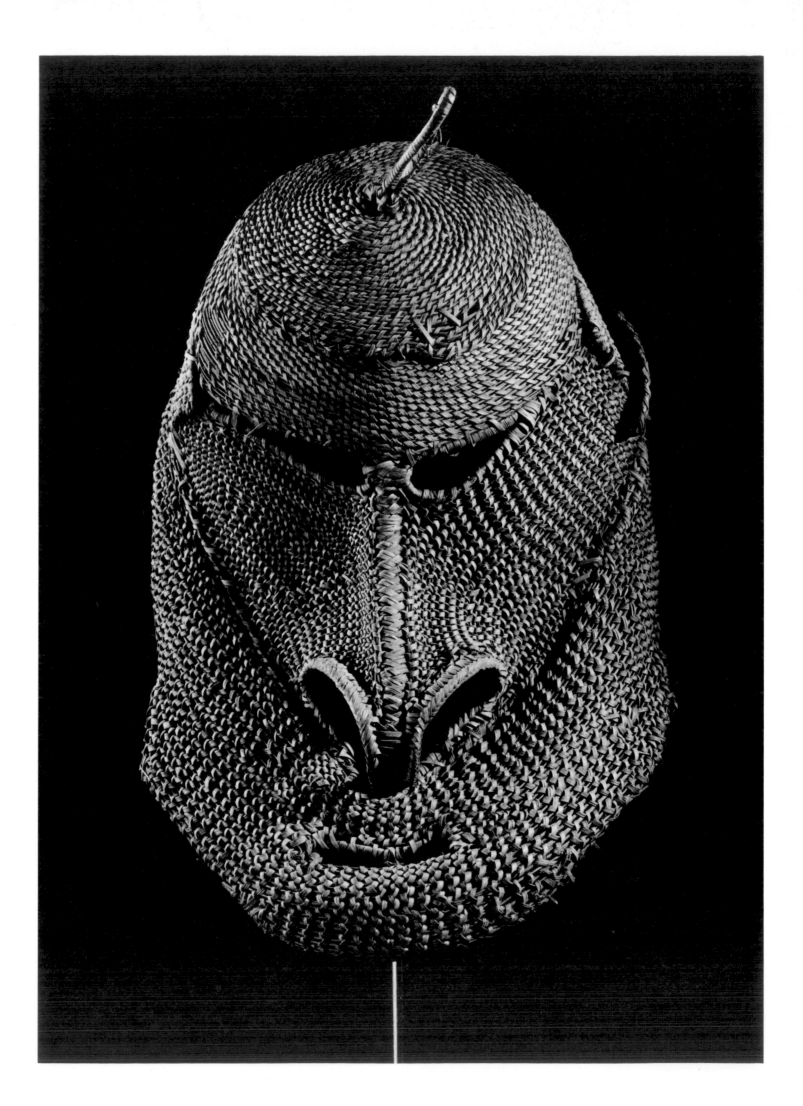

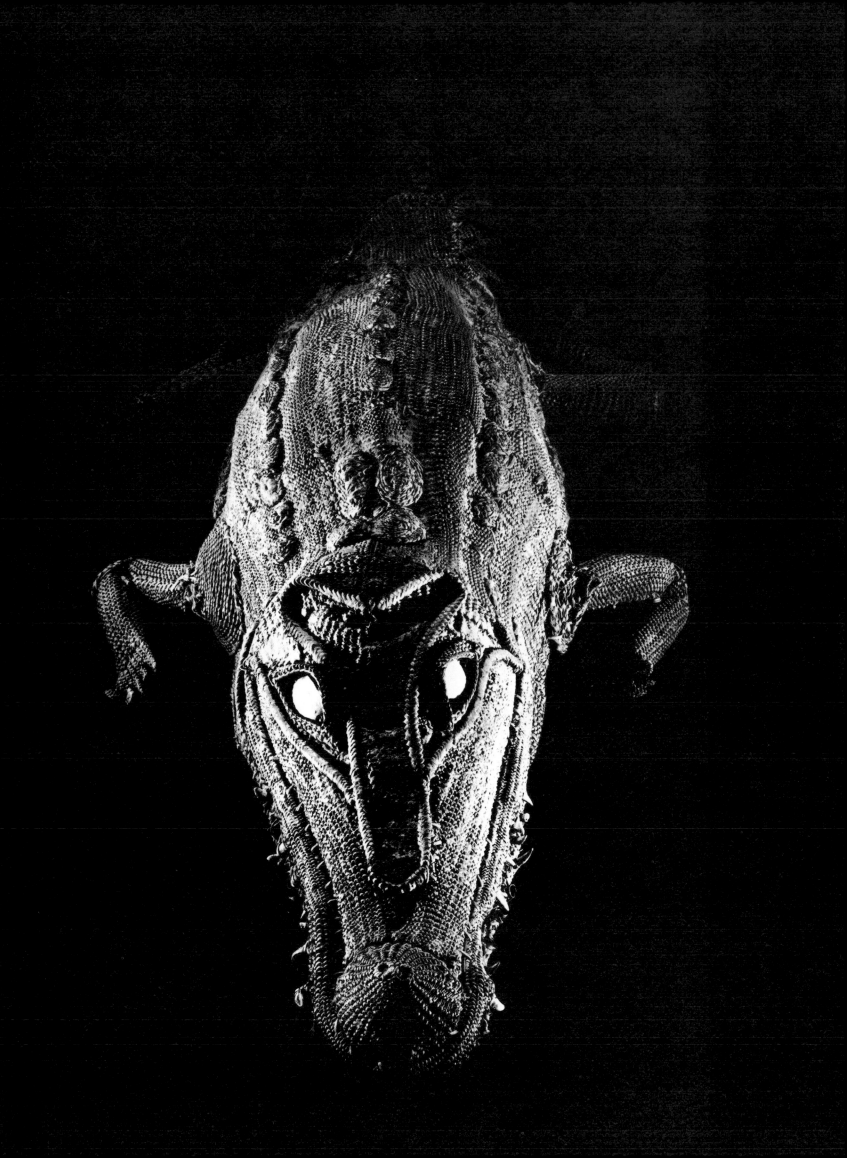

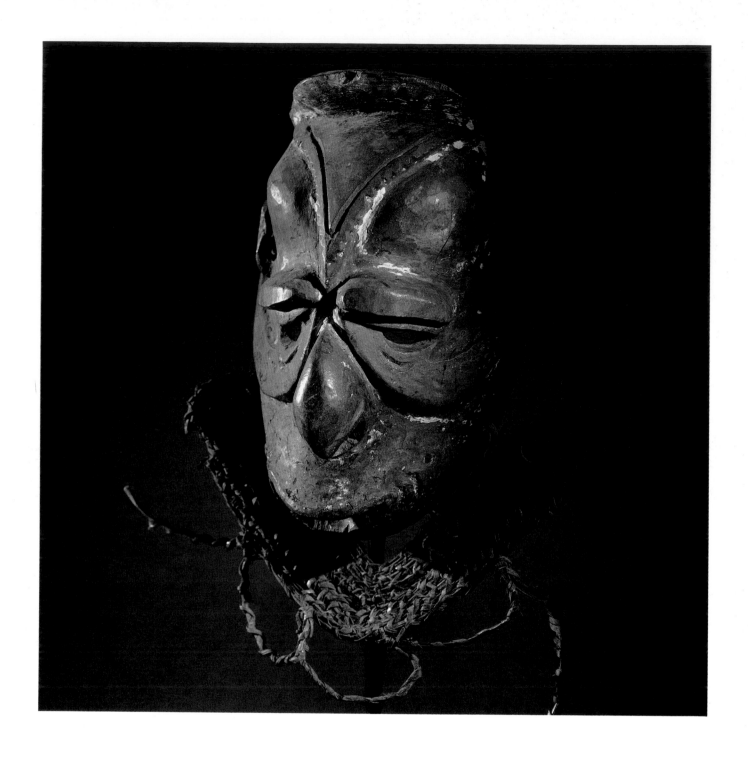

45. Wooden mask with rattan fringe, from Wogeo Island near the Sepik River. Height: 29.2 cm, c.1900. It represents one of the ancestor spirits who harass young boys undergoing initiation. The boys are required to overcome their terror and resist the attacks of the spirits to show that they are now men. The mask would be worn with brightly-coloured pods and a grass covering hiding the wearer. *Auckland Museum*

46. Painted wooden mask, Sepik River area. Height: 63 cm, c.1880. It is a spirit decoration for a men's house. *Auckland Museum*

NEXT PAGE
47. Detail of *mwai* mask made of wood, shell, seeds and pig tusks, by the Iatmul people of the middle Sepik River. Height: 71 cm. The mask represents a totemic ancestor and is for use on public occasions. It is a representation of more secret forms seen only in the men's house by initiated men. *Otago Museum*

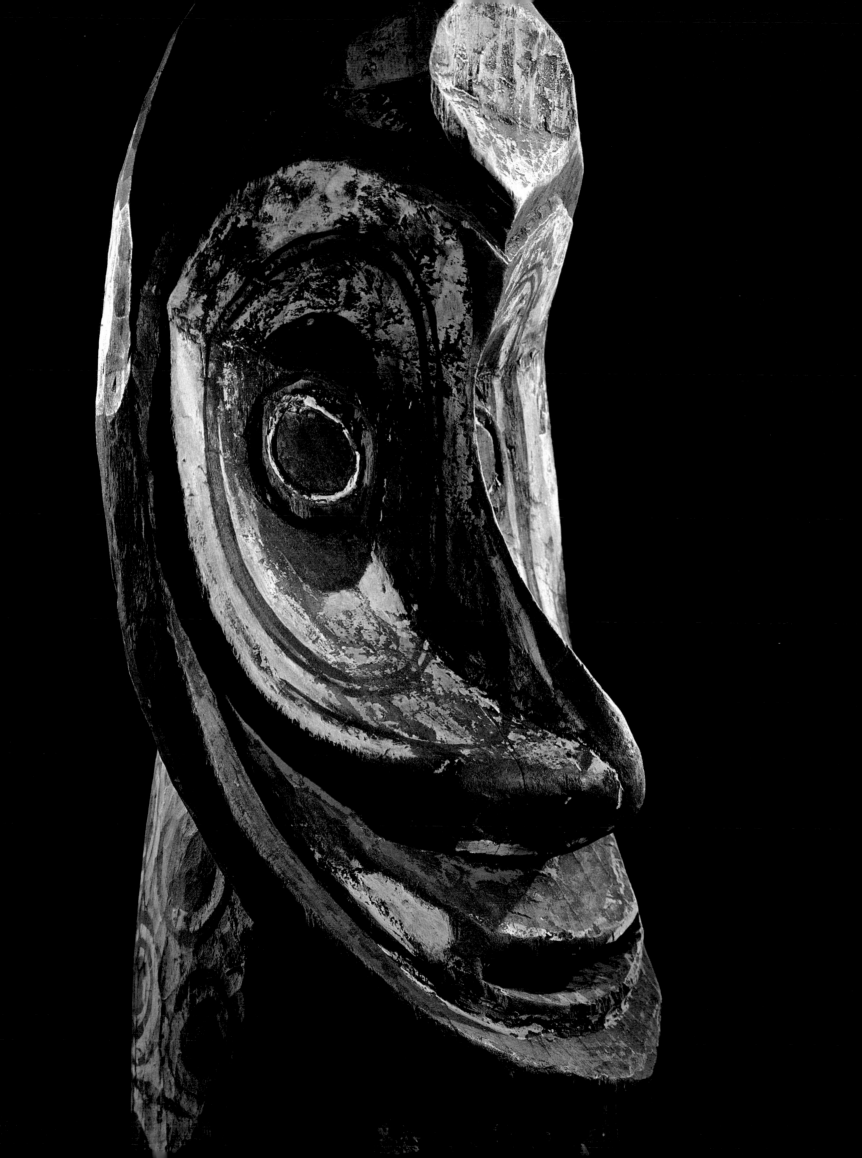

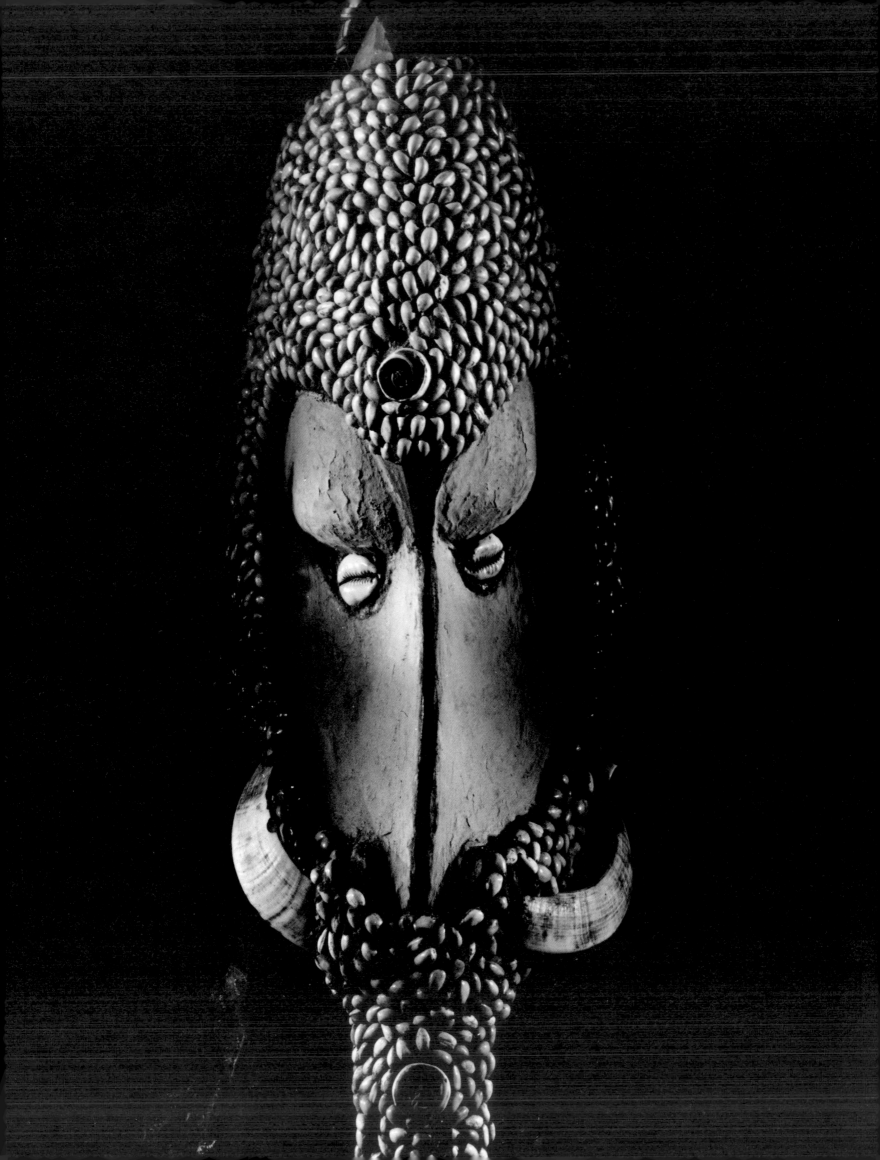

Rules are for everything

August is small, neat, clean-shaven and soft-spoken to the point of seeming insubstantial, a shadow. He is in charge of a team carving a ceremonial drum. He moves noiselessly about the village·at the National Arts School, Port Moresby, where we sleep. Apart from our conversations in his room at night I seldom see him. His room is bare. I remember nothing in it save some letters from his wife and children, a change of trousers and a tape-recorder which we bought for his son Albert before I left.

The conversation is in pidgin.

I never went to school. I just picked up some words, but I don't know much about reading and writing. To go to school in my village you had to paddle for one hour up the river. There was no school in my place at all. When the first school came to my village I was too big to go, so I never became a schoolboy. I became a policeman instead. I was fifteen.

I was a very young policeman. Some Australians came into the village and stood us up in a line and they pick me out. I am only a little fellow and I only come up to the man's tummy and I am not very old but I am very smart, so they pick me out. They picked out three of us. This was after the war.

During the war bombs came on our village and machine guns, oh bom-bom. Burn the houses down. Australian planes, American planes, I don't know – but the Japanese are everywhere and the planes bomb the Japanese and so they bomb us. People are killed. Oh bom-bom. Explosions. Running. I ran too. The Japanese, they kill my people also. They killed seven. These seven were helping the Americans. There was an American plane landed on the lake – it was a plane that lands on the face of the water – and these seven went out to the Americans and took them food and told them where the Japanese were. The Japanese were living in our village. One of the seven was my uncle. One day he went out to sell pigs and the Japanese stopped him. They picked him out with the other six men and they dug a big hole and stood them on the edge of the hole and then chopped them. Chopped them up with the bayonets, their heads fell off.

I didn't see the killing, I only saw them being carried away afterwards. I didn't know what the fighting was about.

This scar on my arm? It's two scars, but it's not from the war. I have a lot more scars across my back. See? This scar is from my initiation when I became a man. Alright. A group of young boys is initiated with feasting before we can enter the *haus tamburan*. They laid me down across a canoe and cut me with a blade . . . a blade or a bamboo knife, I don't remember. One of my uncles held me down. Oh afraid. I was screaming. We were all screaming. Twenty of us screaming at once. Alright. The elders work away with the knives and all the village comes to see, and then we enter the haus tamburan and meet the spirits. Afterwards they rubbed oil to heal the cuts.

We stayed in the haus tamburan for one month. Haus tamburan is everything of ours that we have. It is where we adore our ancestors. It is the spirit house. The spirits are there in the shape

of carvings, of masks, of ornaments, of tusks, of arrows, of spears, of canoes, of skulls, of drums, of shields, of gourds, of flutes. Magic flutes, yes. We keep our magic there and the women and children are not allowed to see. In the spirit house are special beds – platforms, alright – for the flutes to lie on, and I was taught to blow them and play the stories that they tell. Some of the flutes are so big it takes two men to blow them. While I was being cut I heard the voice of the magic flutes. I used to think the flutes were the spirits talking but when I was being cut I saw the men in the bushes blowing them. 'Oh yes,' I thought. 'That's the flutes.' They told us that the voice of the flutes would help us forget the pain, but all it did was to help me remember it.

Outside the spirit house is a fence and a mound where victims are buried. The woman cannot go inside the fence. What would happen if a woman went in by mistake? She couldn't. She wouldn't. But if she did? It is hard to imagine. Alright, she would be killed straight away. That is what happened. A woman went in and she was speared, shot through with a spear. That was a long time ago.

During the war the old spirit house was destroyed but we saved the flutes. Now we have a new spirit house.

After the war I went off to Moresby and became a policeman. They told me Port Moresby was a nice place to live. 'Oh alright, it's a nice place to live.' When I finished being a policeman I went home and became a carver.

In police they train us mark time, form lines, form fours, rifle drill. This fellow-pastime-called-Drill. Bayonet on. About turn. Double march, slow march. After one month, slow march. Salute flag. Pastime-salute-flag, salute flag belong Queen. Salute flag belong Queen every day sunset. Sun he go down, flag he go down. Good fellow pastime.

They made me a guard and I guarded the houses of the Europeans. They gave me six dollars, that's all, in three months. Alright, finish. I run away home to my village.

I used to hang around the village watching the carvers at work, then I would take a knife and go into the bush and carve small faces on pieces of wood. 'Oh, very good,' the carvers say. Then my father showed me how to carve. Everybody is a carver in my place. My father used a stone axe and pigs' tusks and the teeth of rats and flying fox to make the decorations – this is to make a *garamut*. A garamut is a talking drum, a talking split-log drum. To hollow out the log for the garamut my father showed me how to blow fire through a bamboo tube. A garamut that is properly carved will take a year to make.

The first garamut I made was in Angoram. On it I carved a crocodile. The crocodile is one of the ancestor spirits. The first crocodile was so big he swallowed a woman (when she was alive) and then he came to my village and vomited her out again. That is how the tribe began. That crocodile was so big it made the river rise up. If you come to my place you will see that the river still rises up. That is why the houses are built on stilts. In the river are birds with legs like stilts, white birds. They live in the reeds. It is not a very big river but in some places it is as big as a

lake. And our canoes and talking drums are carved like a crocodile. The name of my garamut is Maiumgaban.

That is the name of my family's garamut. It is the name of a man that has been changed into a bird that flies in the bush. The bird is called hornbill and the drum is made from *kwila* wood. The man who makes the drum also selects the wood, and he calls out the name of the garamut, 'Maiumgaban', to the tree before he chops it. When he has finished the garamut he calls the name again and tells it how it came about, how it is from the tree in the bush and from the bird; he tells it its own story. Then he breaks open a coconut and pours the milk over the garamut so it will talk loud and clear.

Then celebrate. Oh singing, dancing – everybody. Kill pigs. All day, all night. The garamut too is celebrating, because he is happy.

In the spirit house beside the garamut there are clay pots to put food in. The food is for the garamut. Suppose we don't feed the garamut. But we *have* to feed the garamut.

My father was an elder, but that doesn't mean I am an elder. To be an elder I have to be a carver of garamuts and masks. I keep all my father's tools and masks.

Some things we lost. A European came looking for our carved things and the people sold him these things. But I say, stop. So we stop. We don't sell these things any more. We did not know what we were selling. There was one missus came before the war and she did not take away carvings, she took away stories. The same as you are doing. This lady lived with my father. After the war she came back . . . Big *pela?* Eh. You say the name. Ah, now I remember. Big pela, short pela? – that's her. American missus. My father looked after her. Big pela, short pela, fat pela, missus.

When I was small my father made me a mask, but that was not the first thing he gave me. The first thing he gave me was the figure of a small man. I don't know why he gave me that. The next thing he gave me was a small spear. We used to throw the spears at objects and imagine they were men. Then we made carvings of men and threw the spears at the carvings. This was so if a village attacked us we would know how to fight back.

I did not have to fight but my father did. If he caught a man and made him prisoner he would cut him up and burn the body, but he would keep the head and bring it back in his hands and carry it round the village. He shows everyone the skull and he tells everyone the story of the fight. He has to do this. Sometimes he gives the name of the head – the name of the man who was inside the head before he was killed – to one of his sons. I don't know if that is how I got my name but that is the custom. Then he puts the skull in the spirit house. When I was small the spirit house was full of skulls. They are still there.

I don't like fighting. Once some people came to my village to talk about land. It was land belonging to our tribe. Alright, dispute. Arguing, shouting, oh bang. Big fight, fight in morning, fight in afternoon, fight in night-time until policeman come. Fighting stop then.

Next thing, prison – prison three months. Alright. Prison alright . . . I liked the fighting and I liked the prison but I liked being in the fighting more than being in the prison.

When I was small very much fighting, very much danger. Nobody can leave the village. Then the missionaries come and stop the killing. Oh very good thing too. 'Oh good,' I thought. 'Now I can travel.'

One day a schoolteacher called Tom found me and said come to Goroka. I travel to Goroka and carve there. Goroka is a very nice place. Then he said come to Moresby and carve there. Oh alright. I come to Moresby. Next thing – Sydney. I get on a plane and I come to Australia. 'Oh yes,' I thought. 'So this is Australia.' Then another plane, and I come to Mexico. 'Oh yes,' I thought. 'Now I am in Mexico.' I did a carving in Mexico and I sold it. Mexico is a very nice place. Now I am back in Moresby again.

I have to finish carving this garamut. The garamut I am carving now is for a big ceremony. It worries me that I will not be able to finish it the way I want. I say to myself, will it make a good sound? Will it make a beautiful sound?

When I am not carving I don't do anything. I worry about my children back in the village. I have four children. My number one child is Albert and he is a carver.

Yesterday I have a letter from Albert:

Dear Papa August Karlan

Now it is time to write to you. Yes papa, I did not receive the money . . . Please send the money in the post. Papa, I have no long trousers. No shirt. Will you buy me long trousers and shirt, that's all. And please buy a tape recorder for me.

Good night and God bless you Papa August Karlan
Your son Albert Karlan Thankyou

Did you read it? Albert is eighteen and has a wife. Albert is the first one of my family who goes to school. I was never at school but I was baptized a Catholic so I am a Christian. We have a church. I go to church at home plenty of times, but I don't know what Jesus is. Is he a man – or what?

Did he die? I heard stories that he died. I don't know whether he is old or young. If I can only see him, I would know. I can see the spirits. Oh yes. When I am in my village I see them all the time. In my house there is a healing spirit. It lives in the house posts and it lives in the carvings. When you come to my house you can see spirits too.

I will take you into the spirit house. It is like a church. Sometimes the missionary priest puts his head in and looks at our things. He does not say anything – how would he know what to say? He doesn't stay. He comes in and looks around and then goes out again.

In my room are three masks. They belonged to my father. One has a spear through it; the

spear is sticking out of the nose. This mask was in the front of my father's canoe and when the spear struck the mask my father ordered the canoe to turn back. Otherwise the next spear would have struck him. I keep the masks in my room because the spirits in the masks protect me. Also the masks are the stories of my ancestors, I like to live among them.

I see the ancestor mask when I am lying down on my bed. I see the spirit in the mask and I can talk to it. When is that? Alright. Suppose somebody in the village is sick, that is when I talk to it.

The sick man comes to my house and I ask the mask to help me cure him. Oh sick – sick from poison, from sorcery, it happens all the time. I have cured a lot of people in this way by talking to the ancestors. I know what to say. I stroke the sick person. I stroke the mask. I offer it food. I kill a pig and cook taros, or I kill a chicken and cook it with yams. The sick man brings an offering too. I don't use herbs. I don't need herbs. What is it that actually does the curing? It is my spirit and the spirit of the ancestor. My father taught me and his father taught him. The Sepik people have always been carvers and healers.

The other day a schoolboy was brought to me fainting. He kept falling down. Then there was a boy called Paul: his mother brought him. She thought Paul was dead, really dead. Paul stayed with me for a week. I cured them both.

Oh yes, there is a hospital. But the people don't go there.

The spirits are good. They are *always* good. If the spirits are always good, how do people get sick from sorcery? Alright. People get sick from breaking the rules – like the boy who was fainting. The boy's father had broken a rule; he had disobeyed one of the rules of the village. The rules are for everything and they tell us everything. The rules tell us who to marry. I married into the same family that my father married into. If I had not done this, I would not be alive today. If you break one of the rules you can get sick – get dizzy, get fainting, get blind, get heavy, get paralysed. Then you come to me.

When you come to see me you will ask for the mission. Catholic Mission Timbunke Village Tambunum Wewak East Sepik Province Papua New Guinea. That is my address.

You don't need to write. When someone is coming to see me I know anyway. The spirit comes and tells me – so you don't need to write and say you are coming. I will know straight away.

– Port Moresby, Papua New Guinea

New Guinea

48. Head-rest from Tami Island in the Huon Gulf on the north-east coast of New Guinea. Length: 17.8 cm, late 19th century. These head-rests are used for sleeping but they are also ritual in portraying the ancestor who supports man and the world. They are the property of initiated men and are kept in the men's house. *National Museum*

NEXT PAGE
49. Carved figure on a wooden bowl from the Asmat area of Irian Jaya. The bowl is for mixing sago. *Otago Museum*

50. Wooden *mawa* mask, Torres Strait Islands. Height: 57 cm. It was used at the harvest dance during the ceremonies associated with the return of the ancestor spirits to the islands. The name of the wearer had to remain secret. The mask is decorated with human hair. *Otago Museum*

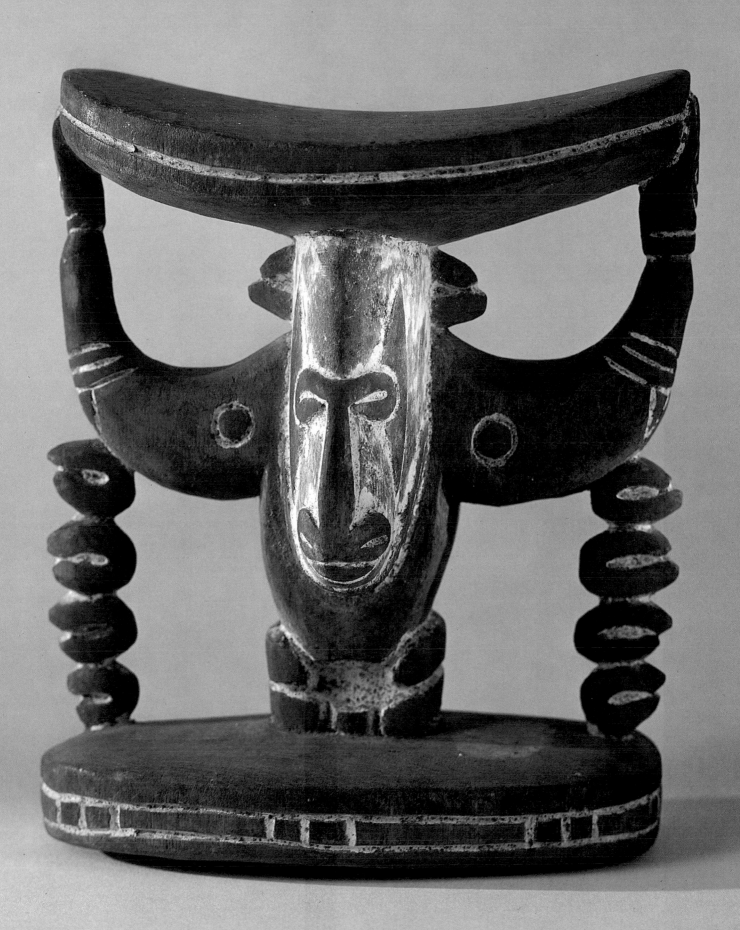

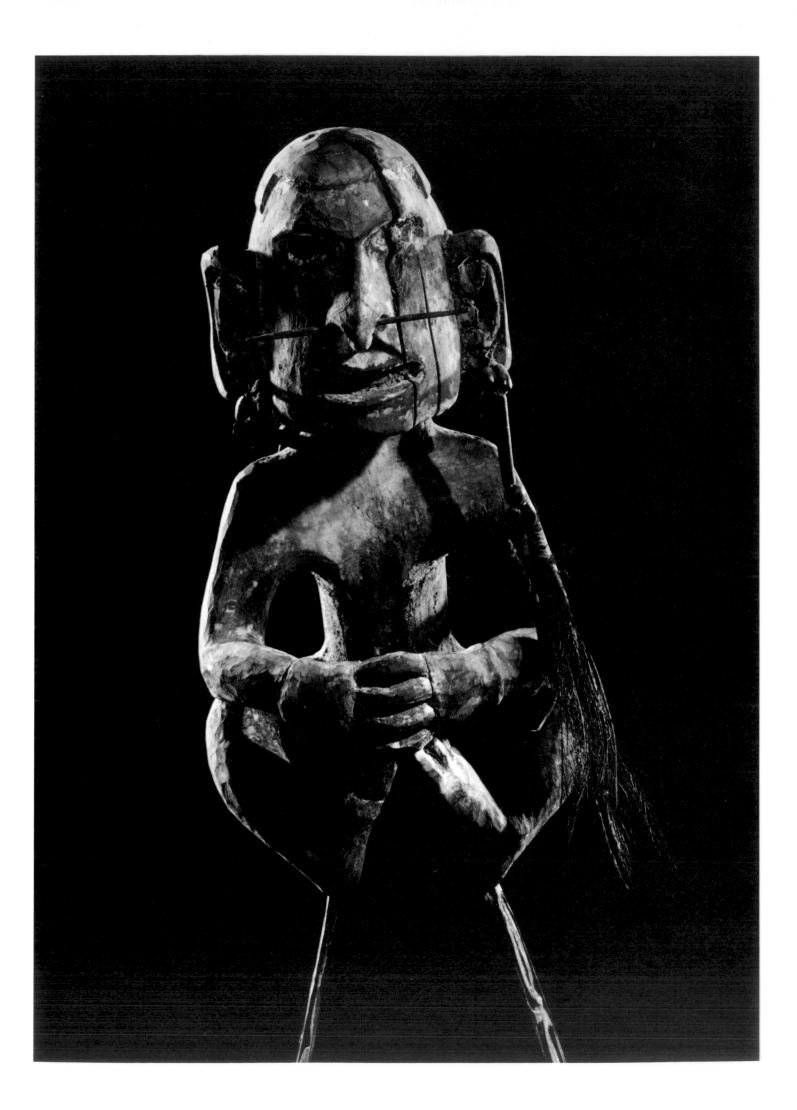

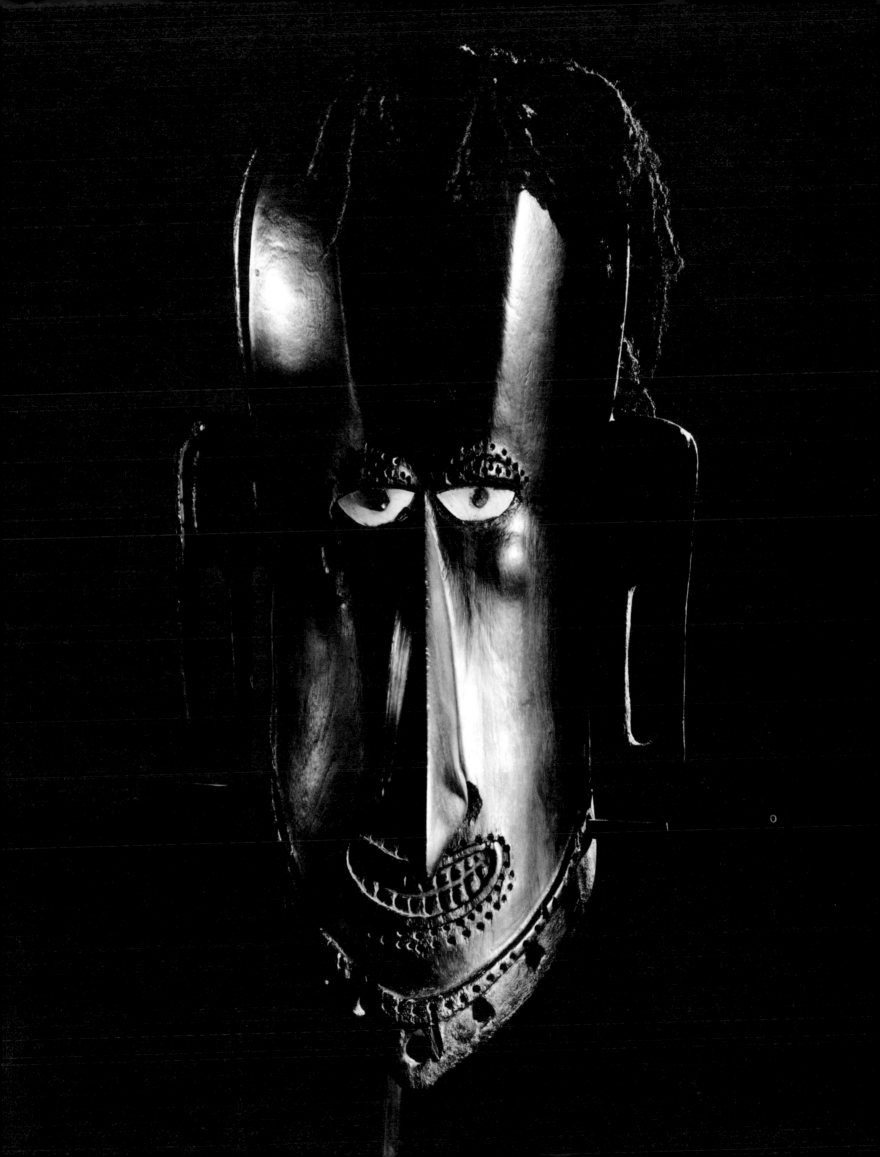

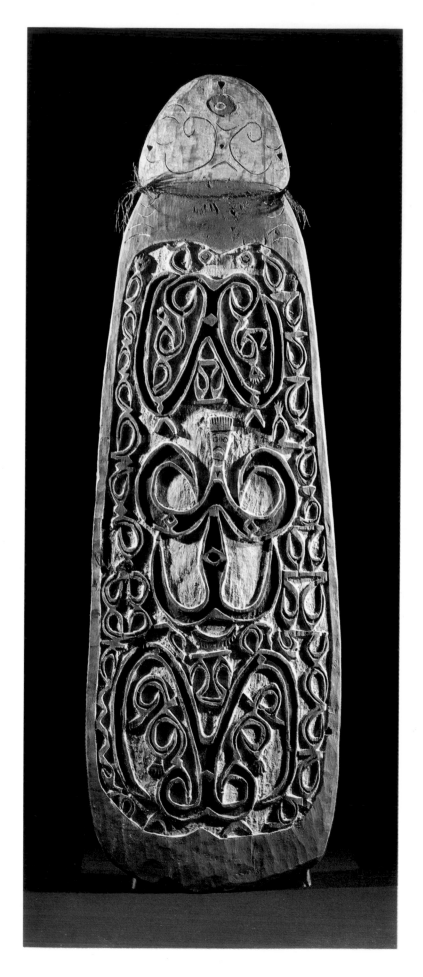

51. Painted wooden shield from Asmat, Irian Jaya.
Height: 195 cm. The stylized motifs are derived from
human faces and birds. *Otago Museum*

52. Mask made from plates of turtle-shell, Torres
Strait Islands. Height: 31 cm. The mask represents a
founding ancestor and would be worn only within the
sacred enclosure during initiation ceremonies. *Otago
Museum*

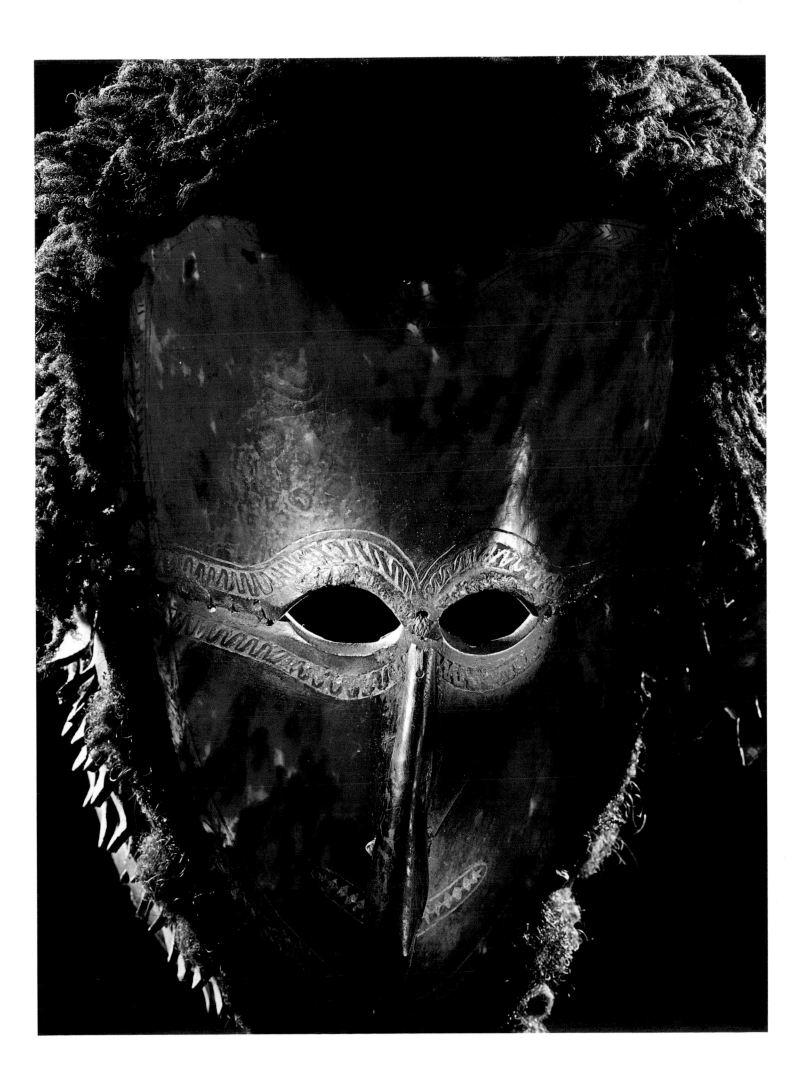

53. Carved and painted board from men's house, Fly River. Height: 182 cm. According to local myths, men are descended from sculptures brought to life by the ancestors. The ancestors are given gifts of slain pigs and the totemic animal of the clan in return for looking after the world. *Otago Museum*

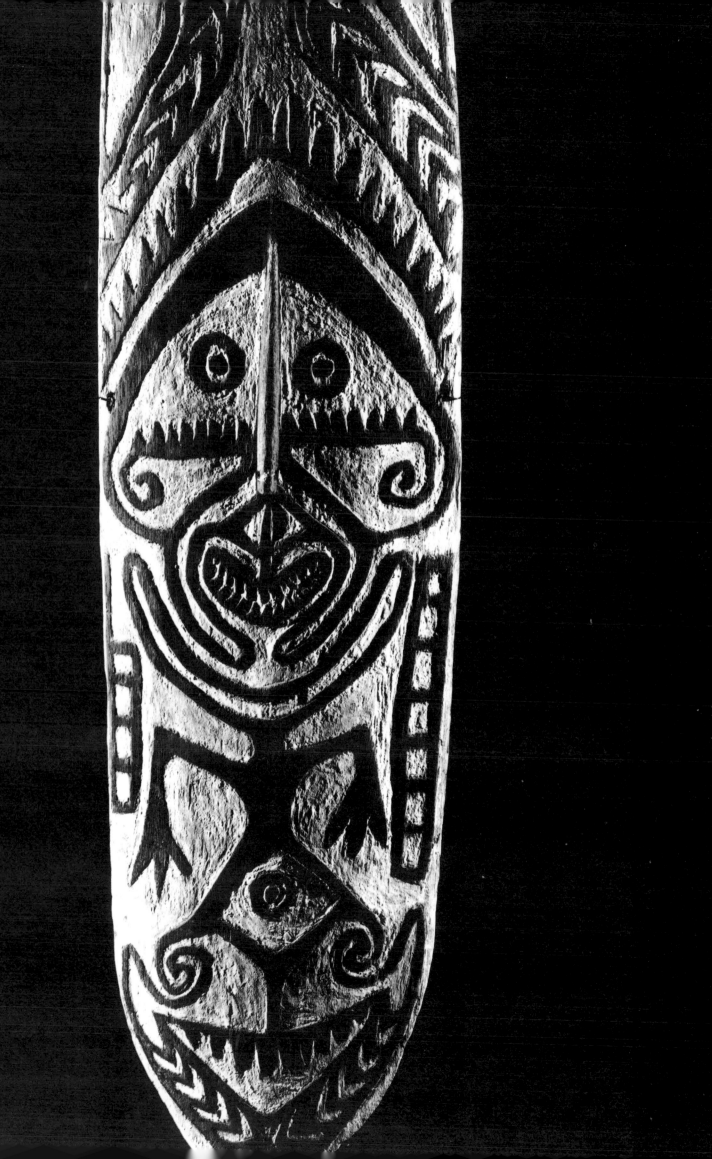

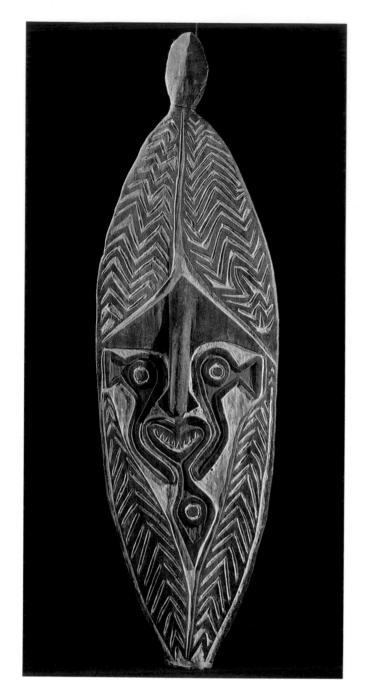

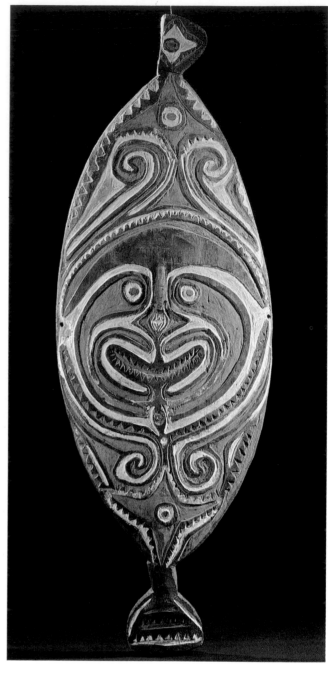

54. AND 55. Carved and painted boards from men's houses, Purari River delta. Heights: 107, 102.2 cm; c.1910 and 1920. The figures represent water spirits who have magic powers; the boards are their dwelling-place. Only the owners of the carvings know the secrets associated with a particular board. On ceremonial occasions the boards are taken from the men's house and carried in procession by the men of the house. The boards are also used to protect the living from harmful spirits, especially those of enemies whose skulls are kept in the men's house. *Auckland Museum*

56. Detail of painted wooden shield from Motu Motu village, Port Moresby. Height: 176.2 cm, c.1880. The design represents an abstracted human face and arms. *Auckland Museum*

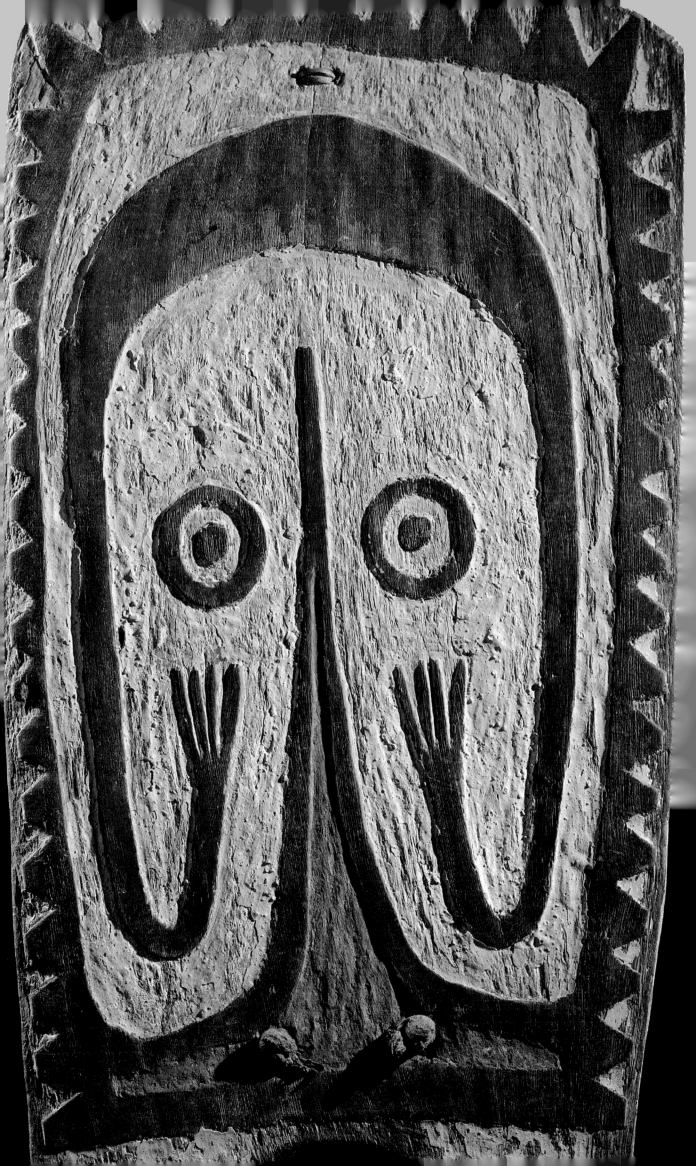

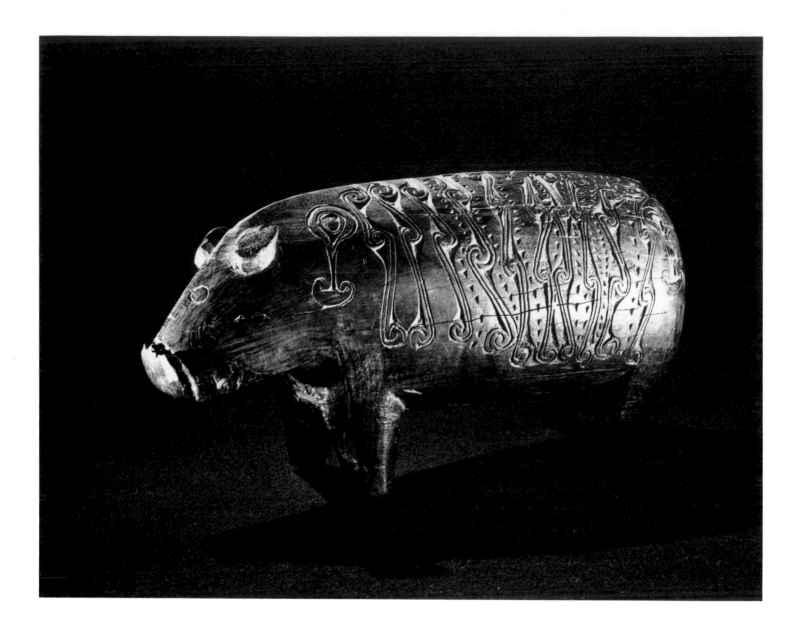

57. Wooden pig from the Trobriand Islands in the Massim district of Papua New Guinea. Length: 43 cm. The design on the body is derived from the heads of frigate-birds. *Otago Museum*

58. Dance paddle from the Trobriand Islands. Length: 70 cm. Paddles were twirled during the dance to enhance the appearance of the dancer and also to depict a stylized frigate-bird. In Trobriand myth the ancestors which return to the village to take away the spirits of the dead are seen as frigate-birds. *Otago Museum*

NEXT PAGE
59. Dish from the Trobriand Islands. Width: 49.5 cm, 19th century. Like that on the wooden pig (57), the design on the rim is derived from interlocked frigate-bird heads. *Auckland Museum*

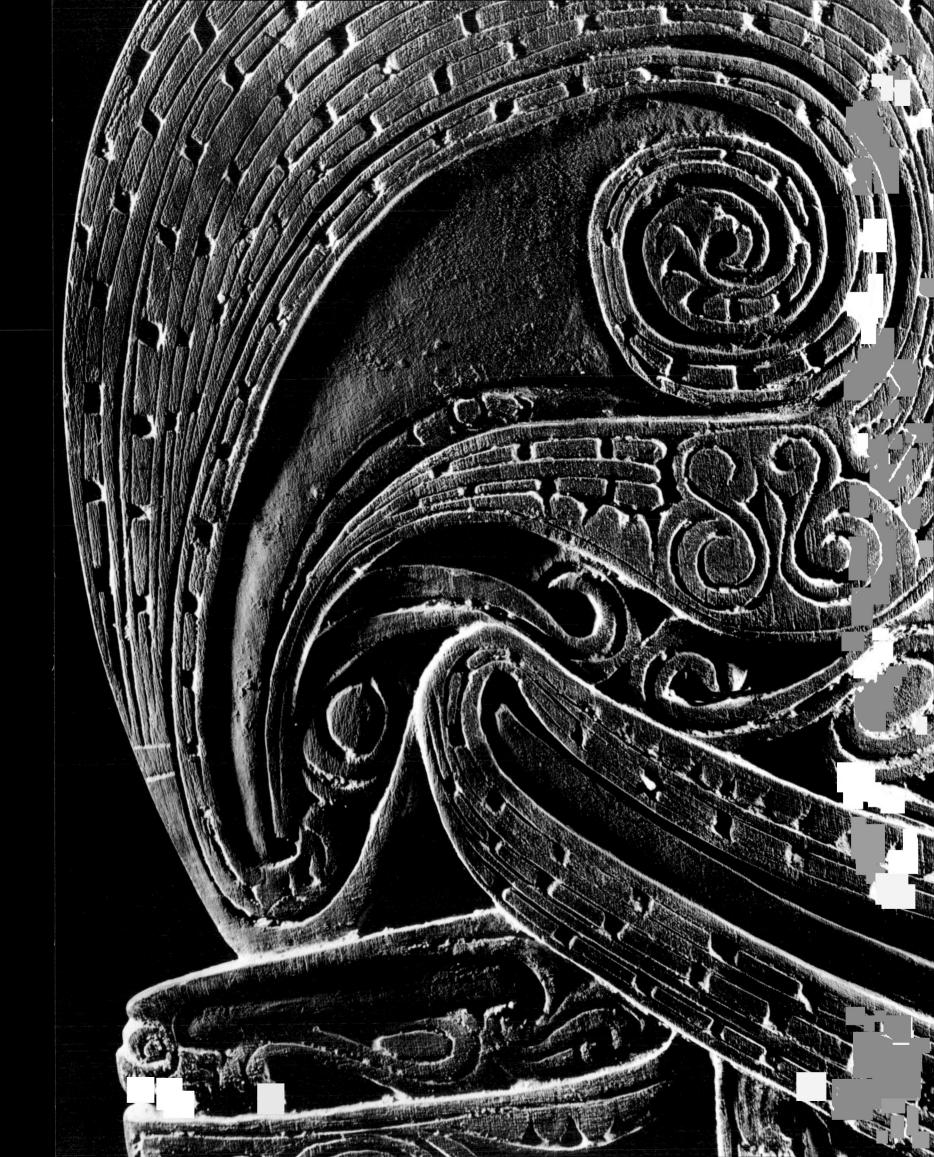

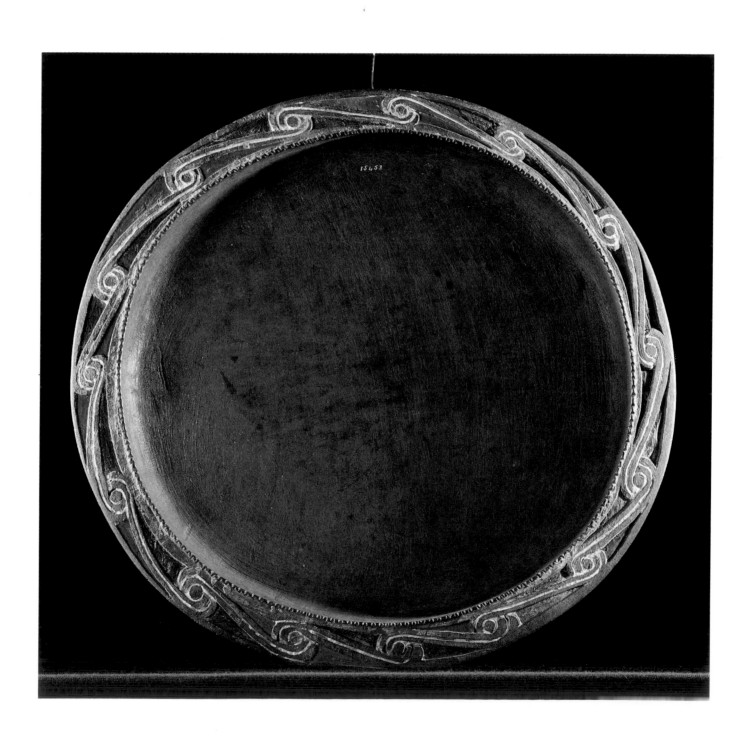

It is they who are the savages

The conversation is in French and takes place over several days in New Caledonia — first in Noumea, then in the interior on a tribal holding (tribu), and finally on the road driving back to Noumea.

Kanaka, a word used in the final sentence of this conversation, is a pejorative term once generally applied to South Sea islanders, especially Melanesians, by white colonizers in the Pacific.

Not everybody, you understand, has this charisma; only special people have it. Most of them however have gone, like the wood carvers and the makers of shell-money. But the healers have it — you will find them in the interior on the tribus. These are the seers, the women who heal, the ones who have received the gift from the ancestors. The ancestors are always with us.

Until recently you needed a permit to visit my tribu. Now it is easier. Everybody is allowed to vote in New Caledonia, that's true; we blacks can drink now. Nobody is going to stop a black who sits down in a French restaurant, and it is beginning to be possible to visit each other's homes. Black and French — it is all very recent.

It is pleasant to sit here enjoying the square, the taxis, the fine buildings, the *pâtisseries* — it's a fine thing, this Noumea. Only there are too few blacks. All the cars you see passing, these big cars, all this, it represents power, and this power is not in the hands of the people of New Caledonia. How many black lawyers are there? None. How many black doctors? None. Black accountants? None. Why? Colonial politics.

Ten years ago there were no blacks at all in our high schools and there are still very few Melanesian graduates in any field. Last year we had three, the year before that perhaps four. Maybe in the next five years you will begin to see students with doctorates.

How much land do I have? Not very much. I have a plot as big as this square. Near my tribu there are fields and allotments but they don't belong to me alone, they belong to the family. There is a small plot that belongs to me.

You say I am non-committal.

I am non-committal on the subject of land and alienation of land. Also on the political situation. Because everything that you see here is in fact what is happening. In our own way we have begun working for self-determination and there are obstacles. The greatest obstacle is economic — nickel. It all has to do with nickel. So one behaves like a Jesuit? Of course. And we try to be politic. Everything is against us, everything. As far as I am concerned, the more you talk the more you alert the enemy. That is why I am non-committal.

As a child no one ever said to me, 'One day you will have to start building your own nation. No one ever said that. The difficulty — it was in 1950 — was simply to leave the tribu, because to break with the tribu was to leave the community which confirms you as a person and to step into the unknown, into anonymity. In a small tribal group every person has an identity. Everything you encounter can be given a form and a name. To leave such a group, which is all you have ever known, for a world which is the exact opposite . . . Listen, I knew nothing of this 'world'. The *world?* I did not know what the word meant.

I remember the day when I said I was leaving. I was ten years old. The priest had asked my father if I was interested in going away. I wasn't interested, I said no. One minute I was saying no and then all of a sudden it was arranged. I was afraid. I was afraid to leave. How could I leave my grandmother who had raised me? It happened one morning when we were drinking coffee. My father brought it up again and I said, 'All right. I'll go.' And then: 'Too bad, it's too bad. Grandmother's crying.' I remember the moment because it was a horrible feeling for me to hurt my grandmother, to make her grieve. So I took this step telling myself, 'I'm going anyway. Too bad for old grandmother.' And that was an end of it.

One boy had left the tribu before me. He went twelve kilometres. I went three hundred.

My father had been baptized when he was eleven. He and the missionary were friends and it was the same missionary who chose me. The missionary would visit our house because my father was head of the tribu. Oh, I already knew how to read when I left, and I had begun to write. I could say 'oui' in French – 'oui', 'non', 'où vas-tu?' That was all.

At school they taught us that our ancestors were Gauls. I was taught the same lessons that French children were taught in Paris. I learned to say, 'Our ancestors the Gauls lived in the year so-and-so . . .' It meant nothing to me, it belonged to another era. I couldn't understand what it was all about. At school we sang songs, but I don't remember any. Maybe *A la pêche aux moules-moules-moules, Frère Jacques, Alouette* – yes, I remember quite a few. There was another song we sang to Saint Anne, a hymn to Saint Anne the Good Mother. It was called *Catholique et Français Toujours*. It is a traditional hymn and it dates from the time we learned about 'our ancestors the Gauls'. This hymn was part of the syllabus and it ended with the words, 'Catholique et Français toujours'.

We went to church twice a day, in the morning for mass and in the evening for vespers. It was a private Catholic mission school, a seminary. The priest had sent me to become a missionary. Did it cost anything? No, nothing. Ah wait. It did cost something, psychologically.

I became monitor at an elementary school, a junior teacher; then I went back to the seminary and then one day I gave it up. Later I met a university professor who encouraged me to try for a scholarship to go abroad. I sat the examination and then went to France to take my degree. If I had stayed in the seminary I would have become a priest? Yes. I would have become one of those who destroy our traditional myths, which is serious because these myths are not to be had for the asking. They don't float about in the air. They are fundamental to our social structure, to the daily life of the people. To question a myth, which is a kind of faith, is to undermine the culture which supports you. The early missionaries condemned our traditions as a matter of course, fine. But to put myself on the same level as these men would be to participate in the destruction of those myths which are the heart of our civilization. From the moment I realized this, I gave up the priesthood.

You say if I had had a *choice?* We are in 1840, let's say. In 1840 if I had the choice of being

colonized by the English, the French, the Dutch, the Italians . . .? No. Nobody, nobody. I don't want any of them.

Take my grandfather. When the Europeans walked onto his land he accepted them. It was only when they wanted to govern us, to rule over the blacks, that he said to his people, 'We have to kill them.' There were struggles, terrible battles. Here is France with her missionaries, her police, her colonists, her army, and we . . . We had no weapons. We had arrows made of willow stalks and axes made of stone like the Indians against the Americans. It was the same thing. However, it is we who are the chiefs. If they, the foreigners, want to be chiefs, we must kill them. Because they have committed *lèse majesté*. The theory remains valid: 'We agree that you come, on condition that you are the subjects. But if you want to be the masters, no!' In other words (and it is written into our culture from time immemorial), we will not be governed.

We Caledonians are an aristocracy, a people of chieftains. In our mythology there is a hierarchy which descends from the divine, which is linked to our myths and therefore subservient to *no one*. You submit to the Ancestor and not to the one who just happens to be the chief. In the final analysis it is to the Ancestor I owe allegiance and not to any authority from outside. Subservience has no place in our traditional structure and if you are born here you are part of that tradition. He who belongs, he who comes first, he who speaks, he who is the first inhabitant, *he* has the first claim to the land, to the right to speak. To everything.

It is necessary to leave behind something that lives in the memory of others? Of course. The creation of myths, the creation of gods, the creation of spirits which live in man's memory – all this belongs to the process of eternity. I mean myths, legends, carvings, all that. But I am talking about the creation of myths. Myths, what are myths? They are not illusions: that's something else. Illusions are in the future whereas myths are fundamental. They, and they alone are the key to the world, to the social structure. Why do chiefs exist? Why do subjects exist? It is written in the myths. *Myths came first.*

I'm sorry I was late this morning. It is my son, he is not well. His skin is blotchy. But it isn't serious. What did you say?

Noble? Do I know the expression *noble savage?* Yes, I know what you mean. But – excuse me – it is *they* who are the savages.

I didn't finish my studies. I was planning to be in France two years but my father died and I broke my studies and came back for the mourning. Once I stopped studying I never started again. I worked in the fields on the tribu as I had done as a boy. As a boy, as a man, as always. And again, just now, I have been there again. This is the season. The whole family comes for the planting, above all for the yams. The growing of yams now, *that* is noble. We grow the yam for feasts. It is one of the standards by which we measure ourselves. Either you have a plot of yams or you don't. If you have a plot of yams you are a man of substance. People owe you

respect because you have something to offer; if you have no yams you have nothing to offer. If you own a store you can offer a few bags of rice or sugar for the *fête*. But if you have yams, it's better.

You ask who it is I appeal to in moments of trouble or personal danger? Not Jesus Christ. With us prayer is within the family; we don't pray to an impersonal god. I call my ancestors.

My grandmother? It is true that she is the one who raised me and gave me my name; all the stories and legends come from my grandmother. But it is the grandfather who is the Ancestor. The grandfather, the great-grandfather, this is how it goes: it is always the father who is the starting-point. There are no dead ancestors. There is another level of existence, but the ancestors are always with us, even in the industrial world of today. The industrial world: how can I explain it? It is an accident. An accident.

When my grandfather died I was quite small. My father was buried in the Christian way, but not my grandfather. I was eight when my grandfather died. I was with my father. It was the time of mourning for my grandfather and we had red bands on our foreheads. It was a great ceremony. Two men carried us. Gifts were exchanged, yams were offered, there were speeches. A great event. It would take me too long to explain but on the tribu when there is an event, any event – a birth, a marriage, a leave-taking – no man stands aside. Everyone takes part according to a precise role dictated by the ties of the various families and clans. The significance of this remains today, even if the symbolic trappings have changed. For me everything remains, everything.

The missionary was upset when we buried my grandfather. He was upset because we didn't bury him in the Christian cemetery; we buried him where the ancestors lie. Was the burial secret? Not at all. I told you, there was a big ceremony. Ah, yes! As far as the missionary was concerned, it was secret.

There are no toys here. No toys on the tribu. The children play with pebbles, with pieces of wood, with the river. The river is over there. The river is full of shrimps, there are shrimps in the waterfalls too. A stream or the branch of a tree, these are our toys. Coconut branches for a horse, banana stalks for arrows. What I remember from my childhood are the *smells*. Flying fox, for example – fruit bats that fly in the night with an odour like monkey and delicious to eat. They taste like rabbit. Smell of owls. Smell of horses, because horses too are part of our childhood. Smell of yams when they come to the boil. You uncover the pot to say a prayer over the hot steam, an invocation to the ancestors, and at that moment there is the smell. The yams are not cooked, it is just as they are coming to the boil. There are tabus for this moment. Let's say you are a cousin and you arrive after the yams have boiled, after the prayer is said. You will not be invited to the table.

The tribu looks abandoned? It is abandoned. There is an old man who lives by his fire; it is the fire that keeps him alive. The others have scattered to the towns and villages. This fir tree

belongs to my father; it was planted by my father. The coconut palm also. It is forbidden to cut these two trees. If the coconuts fall, they stay. The local people may gather them but no outsider, because the coconut tree belongs to my father. Over there on that mound my grandfather is buried. All the old paths lead there.

He lies in a coffin, yes, but that is a custom that the missionaries brought. It was not our way to bury people in the ground, because to bury them in the ground is to run the risk of profanation. You don't lay the dead where the living walk. It is an insult to step on a man's head. Our dead are buried in crevices of rocks or they are wrapped in mats or in a banyan tree.

Do you remember when we were in the museum in Noumea that little box called a 'chief's coffin'? I think that this museum toy is something else; it is not a coffin at all but a small box in which the bones are finally laid. It is carved from wood and the carving depicts the Ancestor. The one who does such a carving is gifted. Skilled? It is a skill or a craft, certainly; but an art too. Our art has two functions. It is social and at the same time it is religious. The carver is schooled both technically and spiritually. Like the women who used to make our traditional pots. Like the woman I went to see this evening who prepares medicines and knows about healing people. Now *that*-that is a gift. Do I owe her respect? Of course I owe her respect.

I didn't go to her because my son is ill. He has come out in blotches, this is chicken-pox. This is white man's disease – for this you go to a doctor. I go to this woman when I feel I must. Either I will know from a dream or someone like my mother will tell me to go because of something that may happen to me. We go to hospital for the white man's diseases but we come back to the tribu to drink our herbal medicines. Yet even in hospital we send for the seer. That is what I mean by leading a double life: in town I eat bread, here I eat yams; in town I cook on a gas stove, here on an open fire; in town I sleep in a bed, here I sleep on the ground.

But to say we lead a double life is only theory. There is no such thing as a double life. There is simply one man who lives two lives, who has two faces. My children? Ah them. They must be *whole* – in their traditional world they must know who their brothers are, to whom they owe respect, to whom they can speak as equals. And in the modern world they must be ready to face its demands and at the same time know how to be at ease with themselves.

You think it will be easier for them than for me? Oh no different. The problem remains.

Perhaps you can live in two worlds because the two worlds are really one. Perhaps this is the basic truth that the white man cannot understand. The white man has many alibis. The alibi of wealth, how it glitters! The alibi of affluence – television, stereo, refrigerators. Electricity, ah. How it blinds you! Ice-cream, how it pleases the palate! Whisky, cigars – they all give me the illusion I am living a full life and am in harmony with my surroundings. And perhaps one day I die? So? Perhaps I am like a lettuce. A lettuce has a week and it is finished. And me? Nineteen forty to nineteen ninety. There is a difference in life span, but that's all. I have gained no greater respect in the group, I have not become a man. I have stayed on the level of a lettuce.

With us the group comes first. What you own you share, which means you own very little.

The idea of hoarding, of amassing wealth, of collecting alibis does not exist. A man who wants to hoard, must separate himself from the group. In the modern world there is no place for the old, nor even for the young. That is why I keep on coming back to my mother's place, because all her life she has lived within the group.

A community is a group of people around a fire with their faces in the light, and in order to feel secure I must know the faces of everybody reflected in that light. If there is someone sitting in shadow he threatens me, he threatens the whole group. So I have to recognize each face and only those who live within the group can do this. Those who don't have this experience can never know all the faces. There is always someone sitting in shadow. Some people within the group end up by knowing what exists even behind the faces. Like my mother? Like my mother, yes, and it is in this sense that I continue to learn from her. It is for this too that I work, so that others can go on living within the group.

Tomorrow, before we leave, my mother will prepare yams for you.

You were saying? That it is better to be a black in New Caledonia than a Maori in New Zealand or an aborigine in Australia? I don't know. The question does not interest me.

What does interest me... Listen. I am a Caledonian. I'm speaking now about these talks which you say will be published in a book, about a people who will have a chance to be heard. I am speaking of the idea that a man or a people needs to be recognized in order to exist. And the more he is recognized, the more he exists. A community which is recognized can begin to exist in the conscience of mankind.

Here in Noumea there has been a conspiracy, a tacit agreement, not to know each other. Now there is some attempt to meet and take an interest in the world of the Melanesian because we, *we* have made the effort to tell the French that we exist. I have French friends, many French friends. It is the French Government that sends its functionaries here to rule us, fine. I can still be a friend to one of these functionaries and at the same time consciously *reject* the power he represents. Because it is this power which prevents my people from being themselves. At the moment I am talking with many people. But talking isn't enough. One can be a Yasir Arafat: harangue the world, create a church. But it won't be a nation – the vessel remains empty. It is not enough to be right. What counts is having the power to be right.

The other day I met a Frenchman who said to me, 'Is it a problem for you to be French?' He had come from Paris. It was a question I had never been asked before. I said to him, 'French? To my mind there are several ways of being French – cultural, political, legal, patriotic. What did you have in mind?'

He had not thought of this. He had asked the one question he felt needed to be asked, as if to be French was a kind of honour.

I said to him, 'Excuse me, but for you, a Frenchman – is it a problem to be a Kanaka?'

– New Caledonia

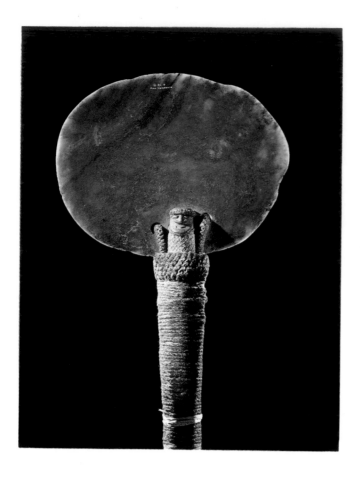

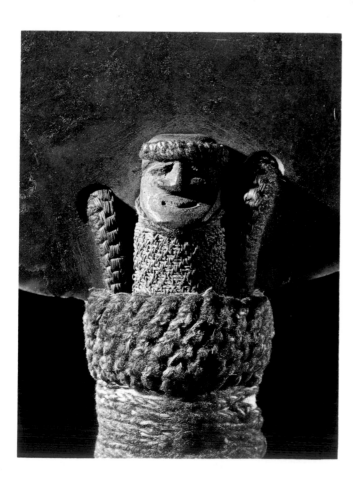

New Caledonia

This is a large island with a complete fringing coral reef. Outlying islands are the Loyalty, Huon, and Belep Islands. The people closely resemble New Hebrideans, but the mountainous nature of the islands combined with a tribal system under hereditary chiefs has led to the development of distinct dialects and cultures.

New Caledonian religion recognizes two types of spirits: those of ancestors invoked as guardians, and pure spirits in charge of certain realms. Ancestors are represented on the houses, usually being placed on door-jambs and roofs. Masks are used to represent ancestors returning to the village. The houses of the chiefs, usually larger than the normal house, also serve as men's houses. The complex of ceremonies designed to pacify the ghosts of the ancestors, around which all life revolves, begins in the chief's house.

PREVIOUS PAGE
60. Detail of house spire. Height: 178 cm. These figures enhance the house and remind the people of the presence of the ancestors. This ancestor has a bag of herbs above his stomach. Note that the chin, ears, and headband are represented in two dimensions and so project sideways as horns, while above the head-band is the back of the head. Thus in a sense the figure is hinged at the forehead with the back placed above the front. *Otago Museum*

LEFT
61. Ceremonial jade mace or axe. Height: 56 cm. This was a symbol of chieftainship carried in procession. It is decorated with small representations of ancestor figures (one each side) and lashing. The axe represents the human body and the jade, life. *Otago Museum*

OPPOSITE
62. Wooden ancestor figure. Height: 136 cm. At funeral ceremonies for a dead chief a new ancestor image is made. A sacrifice is given and the steam from the food carries to the image prayers that he return to the forest and leave his kin who have loved him and proved it by making his image. The image is then taken by the relatives of the dead man. Food and prayers are offered. The task of his spirit is to leave the living in peace. *Otago Museum*

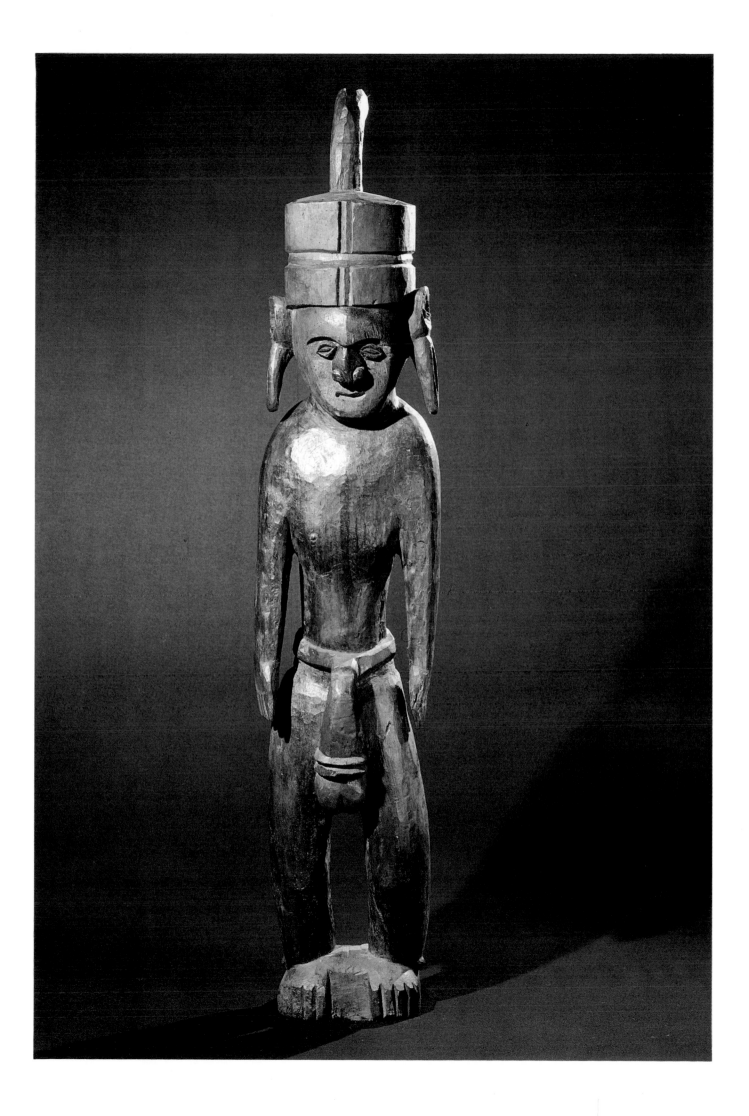

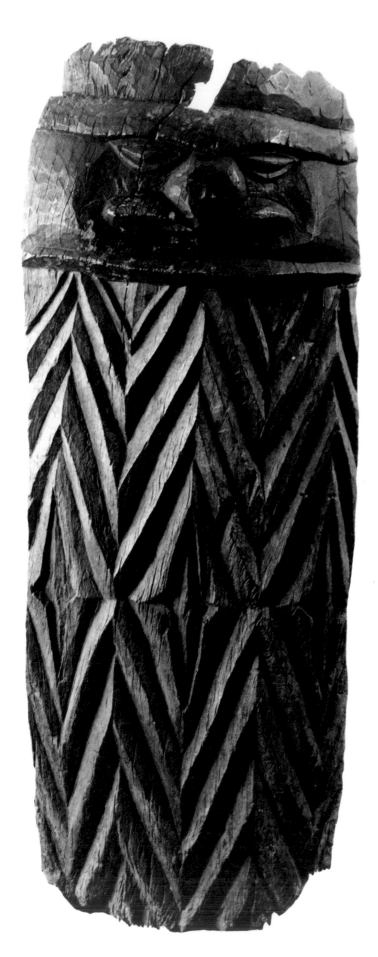

63. Door-post from a chief's house at Kobe. Height: 125.7 cm, c.1900. The carving represents an ancestor. *Auckland Museum*

64. Wooden ancestor figure. Height: 103 cm, 19th century. *National Museum*

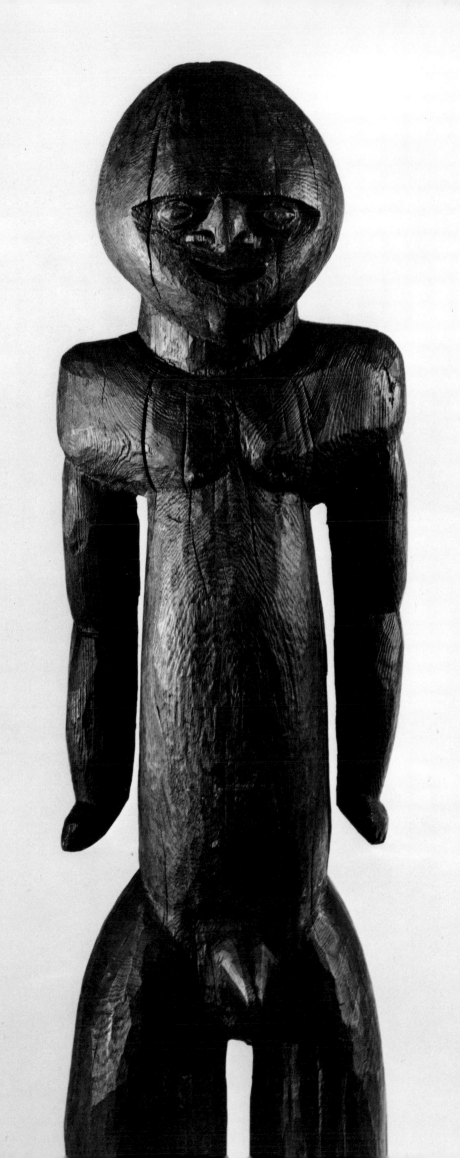

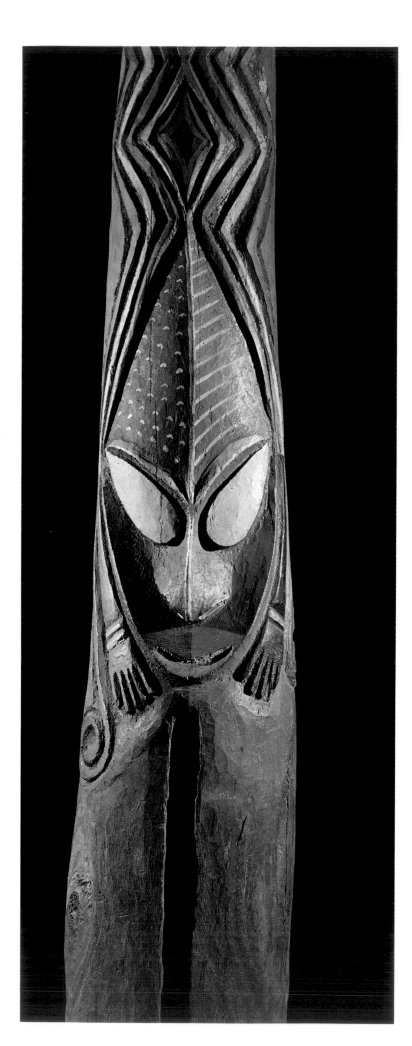

New Hebrides

There are eleven main islands in the New Hebrides, as well as the groups of the Banks and Torres Islands. Outlying islands like the Banks, Aniwa, and Futuna are either wholly Polynesian or Polynesian-influenced. Almost all social life in the New Hebrides is regulated by a series of secret societies (*sukwe*). The societies are organized into grades through which members progress. The men's house (*gamal*) has a number of divisions, each reserved for members of a certain grade. Those who can provide sufficient curved-tusked pigs and other goods can reach the highest grade at the back of the house. The candidate must also feast the whole community. The societies have a basic religious function: with consecration, a man ensures his after-life through the sacrifice of tusked pigs, and the presentation of carvings and other prestige objects in memory of the ancestors. Those in the highest grade are the religious, social, and political leaders of the community.

65. Slit gong from north Ambrym. As a slit gong has a voice, it is represented as human. The slit is the mouth. The figure is not named or venerated in any way. The gongs, set upright in the ground in groups, are grade society markers. *Otago Museum*

66. Grade society monument of tree fern, from Malekula. Height: 144 cm. This belongs probably to the sixth grade, being erected to mark a man's attaining the grade. *Otago Museum*

NEXT PAGE
67. Detail of a hafted shell adze. Handle: 40 cm, face: 16.5 cm, c.1880. This was an important possession of a grade society member. *Auckland Museum*

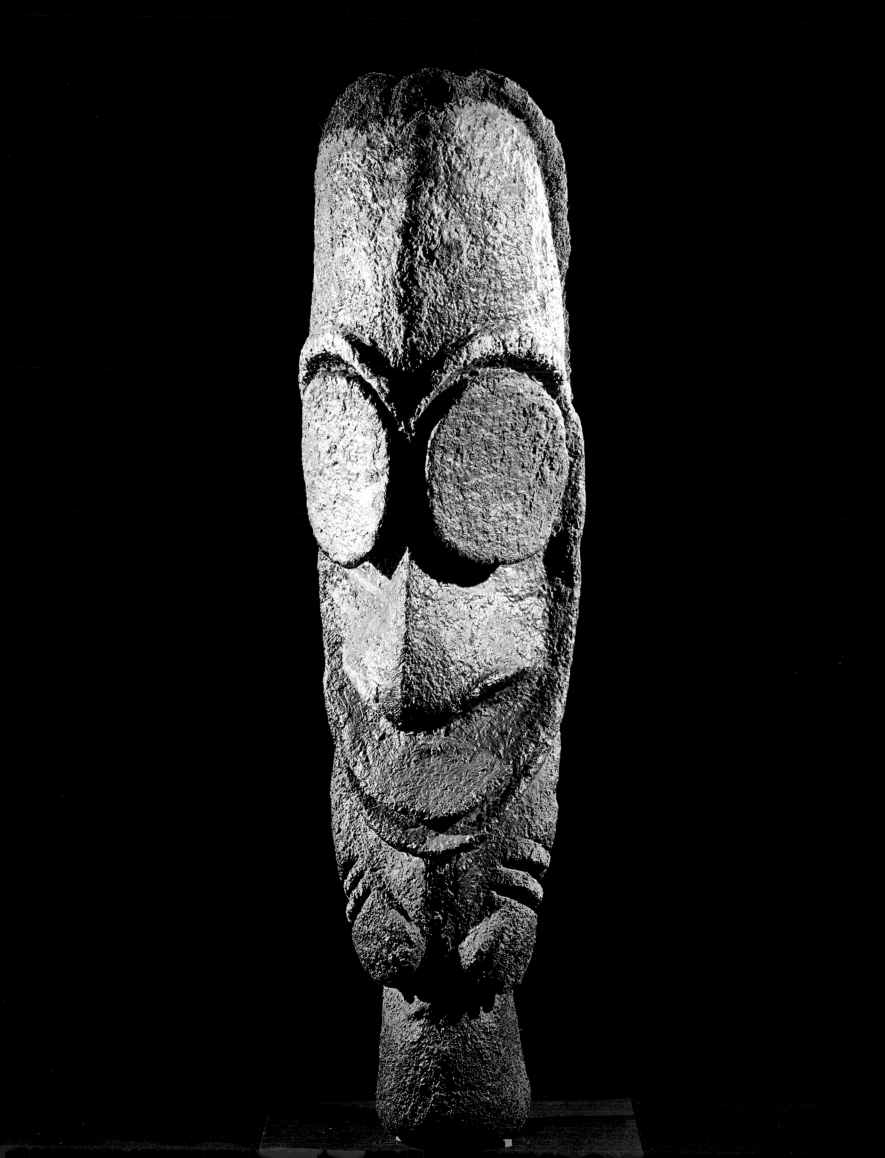

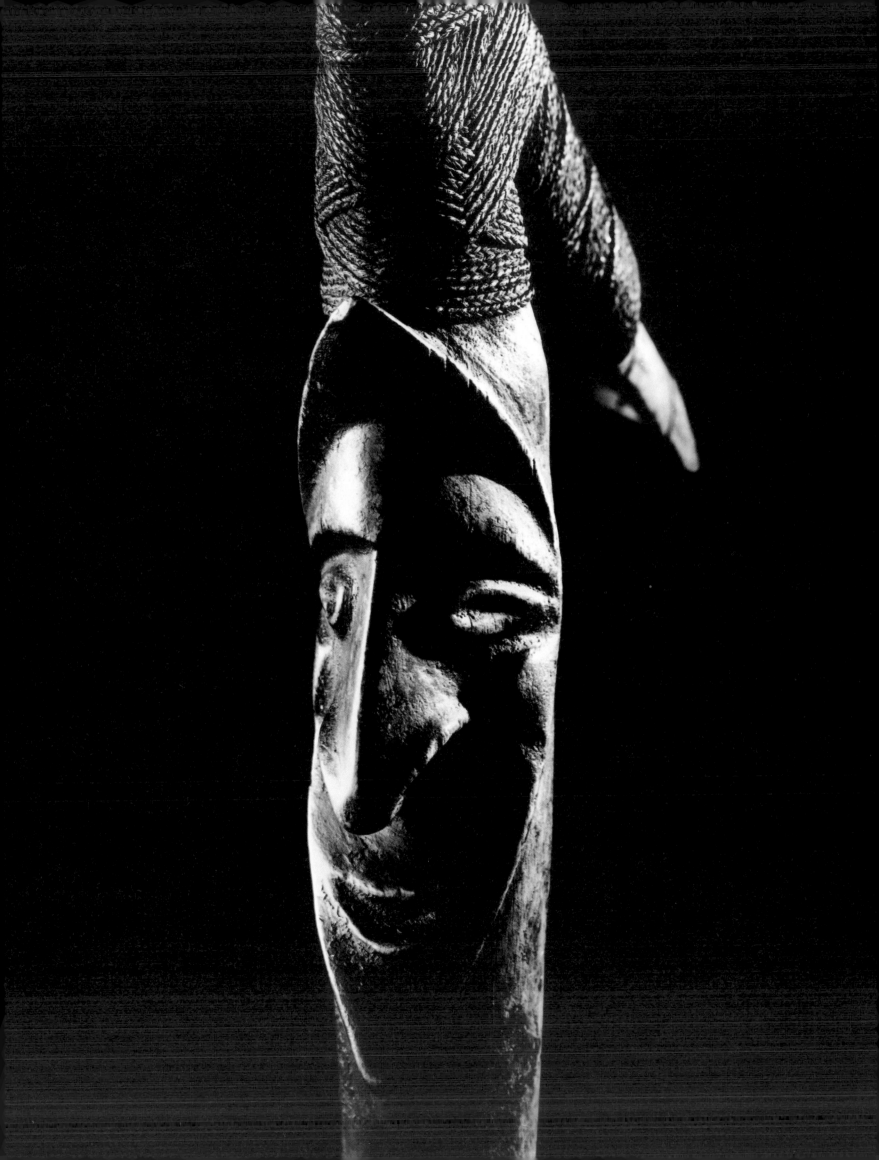

Something nothing

Aoba Island has many missions but, as Moli says, no roads. We travelled by four-wheel drive. It is typical of Moli that when he picked me up at the airstrip he did not mention that the truck was hired or that he was paying for it himself, an expense he could ill afford.

I am not sure why Moli ceased being a doctor. He did not tell me the real reason and I did not ask. We sat beside palms and croton bushes within a stone's throw of three missions and two schools and a hospital, and as he talked I thought of Tom Harrisson's words: 'If the missionaries had come to the islands and done nothing, they would still be the best people in the Pacific. For everyone else was doing worse than nothing.'

We have many different styles of people – you can see it by the way we act or from the colour of our hair. For example they say that I am coming from the coconut because my hair is like that, and that man over there with a very sharp nose they believe he comes from a rail. That man playing the drum with very small woolly hairs (very difficult to comb), he comes from a plant like a yam, but if you have soft short hairs, very soft, it means you come from a rat. People who are tall like you without much hair in the whisker, we say they come from the snake. Myself, I am from the coconut. But here on Aoba you will not find anybody who is not a Christian.

We are not a warlike people. I have never killed anybody. I have killed a pig.

I must have been five years old. It was a pig with a tusk reaching down to the lower jaw. I had to kill it with a club but that was just to make a sign on the head. After that the axe. I get the axe and tap it, tap it until the forehead breaks and then the brain comes out. Somebody was holding the pig for me. The pig was still alive but the people put a knife through the lung and he dies. When I saw the brain coming out from the skull I put my forefinger in and touched the brain of the pig and then I made a sign on my own head. Then step on the pig and I call my name, the name my father has chosen for me. 'This is my name,' I had to say. 'My name is Moli.' Until then I had no name. It is just like when you are Christian. Just like baptism.

That was the second pig I killed. In our custom I was taking the second step to rise up in social position. The more pigs you kill the more steps you take, but only a few people can reach the highest grade as my father did. It takes many years, and *then.* You have to be able to give back all the gifts in exchange that are presented to you along the way. Pig-killing: it is all about respect and exchange. To rise up you must be a man who has helped other people. Some people find it difficult to help others and so they find it difficult to reach the higher steps, even though they have killed a lot of pigs. After I killed that pig I wanted to be baptized an Anglican. I was baptized an Anglican and so I could not go on to the next step. The church forbids it.

On the other end of the island where the Bishop lives the pig ceremonies go on. And on Pentecost and on Ambrym and on Malekula. On these islands today they are still keeping the ceremonies, but not here. We have become democratic.

Until the end of last year I was a member of the Advisory Council in Vila. We are twelve, twelve Hebrideans. Then there are others, plus the two resident commissioners. One commis-

sioner is British, the other commissioner is French. They ask our advice. If they decide to do something they ask us to debate the thing, then we vote and it is carried. And the two commissioners decide. If the vote is against what they want, they don't consider it. The voting is for nothing. Something nothing.

In 1960s I see the independence they get in Western Samoa. So it came to my mind that one day we might have it too. I suggested it to the British Commissioner. He said to me, 'That word – that word independence is *no good.*' His name was Allen. He died of a heart attack afterwards.

I used to be a doctor. I was practising for ten years but at that time conditions were bad and no allowance for my family. I had four children, no money, we just find a room somewhere to sleep. I was working for the British. I asked the commissioner for a house but nothing happened. Then the people of the island started a local council and elected me to run it. So I came back to Aoba. Many times the British or the mission hospital ask me to return to their service, but no. I don't want to live in town.

I have been to a lot of places. I was in the Solomons for three years and then Fiji six years, several times to New Caledonia, I have visited Australia, Papua New Guinea, also I have been to Europe, England and France and Germany. I prefer the village. Better to live in a village. I remember the first time I stayed in a big hotel. I was frightened. Not frightened exactly but it seems to me like a dream. There were two towels in my room but I used only one. Same thing with the food – I didn't like to eat too much. I thought if I put too much on my plate I might not finish it. The government was paying, yes, the government was paying for everything, but each morning when I went out I tried not to spoil the sheets or disturb the bed.

I don't have a very big house, just a room for my children and one for me and my wife, and a small kitchen. We sit outside and cook with wood, but if it rains we have a primus.

We Aobans have the reputation, you say, of being the most civilized people in the Hebrides. That is right. The last village was converted in 1961. But the people are still bitter against the government: I mean the dual system of government in the Hebrides. The people will not allow the government to build any roads on Aoba so we make do with tracks. It is very hard to explain why the people feel like this. But it begins, I think, about 1900s when many of our people are returning from Queensland. Many Hebrideans were taken to Queensland to work in the sugar plantations. My uncle was one of them. Some were kidnapped. They were taken away heathens and they returned Church of Christ. In Queensland they got some education and became Christians. Some of these Christians the government put in as agents or chiefs over us. But these men behaved badly. Next thing, government sent a warship and arrested them and put them in gaol. There was a lot of feeling about this. The feeling stays today. That is why when the government formed the local council many people, like Church of Christ people, will not have anything to do with it. Will not have any roads either. The people say, 'The government gave us chiefs and then they put the chiefs in gaol and told us they were no good.'

How do the people look on me? Perhaps as some sort of leader. I don't feel they should look

on me as a chief. (Excuse me, please don't sit there. You must look up in New Hebrides before you sit down, otherwise something might fall on your head. You can lose your life from a coconut.)

Round here the people are very peculiar. They must look to you as a leader before they will follow you. It doesn't matter if what you are doing is for their benefit, unless you have their respect they will never vote for you. For example, in the last elections it was no good me standing for the National party even though I win automatically, because the people do not understand political parties. The only thing they understand is 'me', so I respect their wishes and stand as 'me' – as an independent candidate. Naturally I lost.

They are my people and I have to respect their wishes. We still have our respect.

Actually two of my uncles were taken to the plantations in Queensland. One died there. The other uncle was kidnapped at sea and put in a hold with a lot of others, women and small boys. He was quite young. He was out fishing in a canoe and he just never came back. The people thought he had been drowned and began to cry; they held a big funeral feast for him. Twenty years later when he returned they were surprised.

I went to school in the Solomons. I was nineteen when I returned to the Hebrides. That was in 1942. We were waiting to board a copra boat, and suddenly about midday there are Japanese planes everywhere and bombs are falling down. We hid among the mangoes. We came down to the ship and picked up some pieces – one of the bombs fell in the funnel. Luckily it was not a big bomb. We sailed by night. We came back to New Hebrides running zigzag on the sea and then later, end of forty-two, the Resident Commissioner sent me to Fiji to enter the medical school. In Fiji the Americans took over the school as a base hospital for the wounded and then the Americans ask some Solomons people, three of them, to go back to the Solomons to act as scouts against the Japanese. These three were my friends. I said, 'I'll be a scout too.' I went to the office and volunteered. 'But you are not a Solomon Islander,' the officer said. 'Never mind, I know the Solomons.' 'Oh don't be silly,' he said. 'Go back to school.' He sent me back to school. So my friends went and led the Americans in – and I stayed behind and became a doctor.

What I liked about the medical work was doing the anaesthetic. You are controlling the life, the surgeon does not control the life of a man. Once for a goitre operation I held a man under for four hours. I had chloroform and ether. When I give the anaesthetic I feel sympathetic with the patient: you know the patient's life is in your hands. When that goitre patient finally woke up I am feeling very proud and happy. It is a religious feeling if you like – I feel that I give to her life again. When I was on the island of Tanna some parents brought a little boy to the dispensary where I was working. A girl was spearing fruit with a bamboo and she missed – the point went through the boy's scalp and all the brains were coming out. It was night-time. I could not find the piece of bone which the bamboo broke because the parents didn't bring the end of the bamboo with them, they just brought the child. It is just skin hanging, and dirts. I took out

some of the brain that was spilled and a lot of dirts, put some medicine in – white man's medicine. The child was unconscious, but still breathing. I could not find the bone to put back over the brain. So I stitched the skin only. The child was unconscious for two days. After two days I changed the dressing and after a week the child is walking around again in the sun, with no bone there at all. Everything all right. But I told the parents he must put something like a hat on. I travelled a lot in the islands and I was able to save a lot of lives.

Travelling about I have seen many things but the thing I have seen all the time is the way our two administrations, British and French, have divided the people. Even though we are in a village, like this one, it has divided them in two. This village has say four hundred people. In our custom we can do things together: we can work together, we can go to church together, we can have our games and feasts and ceremonies together, no trouble. If I want help to smoke my copra, I get help; when it is the turn of my neighbours to ask me, I help them. We do this in our custom for generations. We have a peaceful life; we can dance a whole week; if we do not work for a month it makes no difference. Time with us is something nothing. Now, all changed. The rhythm is changed, the thinking is changed, the attitude is spoilt. Why do they come and spoil it?

For example on Mota Lava, that is one of the small islands near here, there is a school. It is a very good British primary school. Then the French came and alongside the English school they put a French school. Because, they say, the thing is to learn two languages. And the people of Mota Lava, they used to be one church – that is, Anglican. Now they are divided between Anglican and Roman Catholic. They used to work together in the community, now they do not cooperate. There is trouble and unhappiness. They are divided in terms of education and language and religion and village life, and politically too. It happens everywhere in the New Hebrides.

They tried the same thing with us. You remember that piece of land I showed you near the local council. The French wanted to take it over and build a school there. I opposed this because there is a school already – the British school is only two hundred yards away. We said no. 'You can build a post office or a police station. But we *do not want any school.*' We stopped that.

When I look back I can see that the two governments wanted to get something from us, but they did not want to pay for it. They never try to help us stand on our own feet. It is funny, these two people. The French speak our pidgin language just like we speak it and they mix with the people better than the English; but when they come to our ceremonies they behave like the anthropologists. All the French anthropologists want is to get the information out to write a book or a thesis and go away. They don't seem interested to help the people themselves. The English are more respectful, more tolerant. Same thing with foreign museums. Museums come and take our pigs' tusks and war clubs and bows and arrows and armlets and masks and carvings and gongs. I am not angry but I feel bad that they take all these things for nothing.

I don't feel like that about you. I help you – I have nothing to hide. Anyway all the things of

value have been taken; the damage is done.

Now that we realize what we have lost we are trying to revive these things, the weavings and decorations and so on. But the people are not skilled any more, they have lost the art. Even the old people have lost the art. Since the churches stop the pig-killing ceremony, they lose interest. Once you lose the ceremonies you lose the rituals, so you lose the costumes and the decorations, so you lose the arts how to make them.

The churches here are still converting. They are still converting the baptized Christians who do not bother to go and worship – Presbyterians, Anglicans. Catholics the same.

Where we are sitting? Well, they are all round us. Over there, that is the Church of Christ. Next to it, the Anglican mission – Anglicans all along this side of the island. Two Anglican churches one on either side of us. That way? To the north? First of all there is a Church of Christ village. Then Roman Catholic village. Then Anglican village. Then another Anglican village. Next village, Seventh Day Adventist. Towards the airstrip, where you landed, Church of Christ again. All Church of Christ villages. But only on one side of the airstrip, on the other side is the Apostolic Church . . . Within five miles? No, no. All within two, three miles of where we are sitting.

As I say, here on Aoba you will not find anybody who is not a Christian.

We lose everything.
 The pig-killing has stopped.
 The marriage ceremony has stopped.
 The kava drinking has stopped.
 The ranking system has gone.
 The dances are gone.
 The exchange of fine mats is spoilt.
 The sex tambus are not respected.
 The segregation huts are gone.
 The looms are lost.
 The weaving formulas are lost.
 The carving is no more.
 We cannot make fine shell-money any more.
 We cannot make the chiefly armlets any more.
 You cannot become a custom chief any more.

Mind you, we got some benefits. We have got schools and hospitals. But it is difficult to revive what you have lost when the people have become apathetic.

– Aoba Island, New Hebrides

Fiji Islands

The Fiji Islands comprise the main large islands of Viti Levu and Vanua Levu, the small Taveuni and Kandavu islands, and more than 260 small islands most of which form the Lau group to the south-east of Vanua Levu. Culturally the Fiji Islands are the outpost of Melanesia in Polynesia, but they are also the beginning of Polynesia.

68. Breast-plate made from pearl shell and sperm whale ivory. Diameter: 25.5 cm, c.1820. The stylized birds and star resemble Tongan decoration. *Auckland Museum*

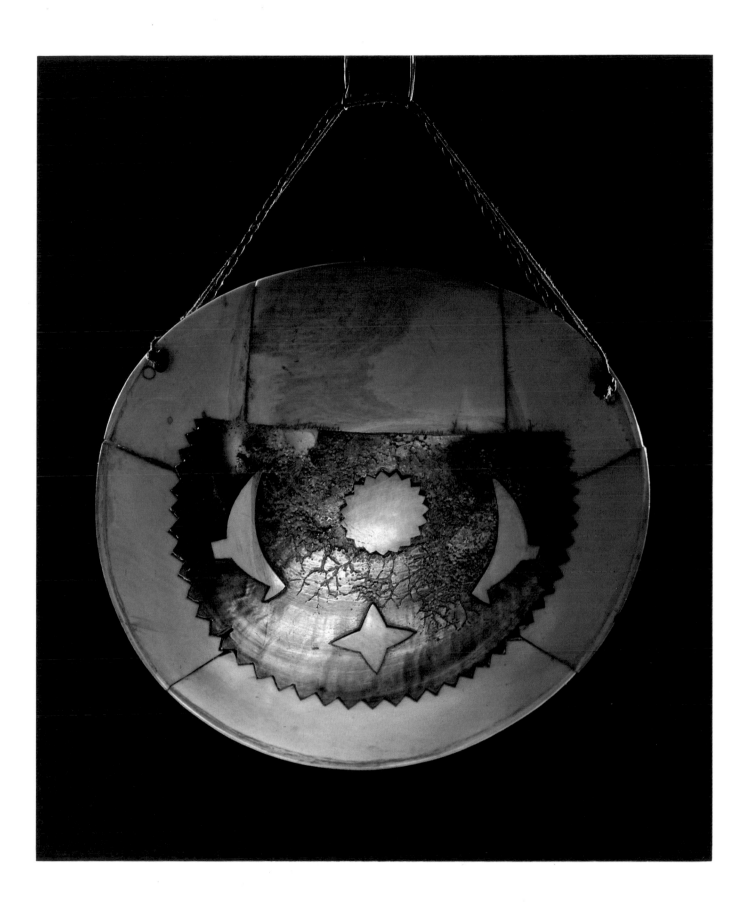

Polynesia

The ancestors of the Polynesians reached Tonga and Samoa from the Solomons, New Caledonia and Fiji in about 1000 B.C. From there they settled east Polynesia, from the Hawai'ian Islands to Easter Island, the Cook Islands and New Zealand. Except for the land mass of the islands of New Zealand, east Polynesia is a myriad of tiny islands, some volcanic but many just coral atolls.

In terms of language and culture Tonga, west Samoa, Niue, Rotuma and Polynesian outliers in Melanesia are usually described as west Polynesia. Fiji and the Lau Islands belong there too, but they also have strong affinities with Melanesia. However, in comparison with the diversity of that region, the differences between west and east in Polynesia seem merely to emphasize the cultural unity of the whole. The short prehistory, even with isolation on small islands as a factor, has not led to more than minor variations in the overall Polynesian culture.

Before marked European contact most of Polynesia practised a variable economy. Except in southern New Zealand and the Chatham Islands, the people were, and still are, farmers cultivating root crops (taro, yam, and sometimes sweet potato) and tree crops (coconut, breadfruit, plantain, arrowroot, and paper mulberry for bark cloth). At the same time they were hunters and fishermen. Usually there was a seasonal cycle of activities but, if conditions made it necessary, one or other aspect of the economy could dominate. The now vanished Morioris of the Chatham Islands and the people in the southern part of New Zealand were unable to practise agriculture because the climate was too severe, so they were hunters and fishers. Similarly on Niue, after a hurricane a few years ago had destroyed the trees and gardens, the people turned to fishing as their mainstay until the gardens were re-established. It is this adaptability which has enabled Polynesian culture in general to survive and flourish.

The religious system reflects a similar ability to provide for the unexpected. The gods were a pantheon of departmental deities created by the primal parents, Rangi the Sky father and Papa the Earth mother. They lived in a restricted space between the two, until they decided to separate their parents, pushing the Sky father up to where he is now. The Earth mother was turned to make a reasonably flat place on which to live. The various gods created the trees, birds, and eventually man. In most of east Polynesia the progenitor god of man is Tiki; in west Polynesia it is Tangaroa, who is also god of the sea. A culture hero, Maui (known throughout Polynesia), fished up the various islands and thus provided land for man to settle. One of the gods climbed to the uppermost of the heavens to seek the baskets of knowledge: of gods, of men and their genealogies, of agriculture and house-building. When such knowledge came to be taught in colleges of learning by experts in such things, the baskets determined the faculties.

Social systems ranged from the almost feudal hierarchies of Tonga and Hawai'i, through the tribal systems of the Marquesas and New Zealand, to the hunting band ruled by elders in the Chatham Islands. In the tribal societies warfare and heroes were important. District systems operated in Tahiti and Rarotonga. There, as in other parts of Polynesia, ceremonial centres or *marae* were important. In New Zealand this was an open space in front of the chief's house, in the Marquesas it was the stone paved *tohua*, on Easter Island the *ahu* image platform, and in Hawai'i the paved temple platform. In most places, the marae was the ceremonial centre for a chief and his family. A large imposing marae indicated an important chief, and smaller marae lesser chiefs. These were associated in a district, whether it be a valley as in the Society Islands or a land division as in some of the other islands.

Marae are still in existence and remain important reference points for local families, but the complex of religious ceremonies which took place there has given way to Christianity. In ancient times, before any undertaking the people called on the gods to take care of the unforeseen. When this was done and so long as the people employed all their skills, the enterprise would succeed. Experts in such matters called the gods to come and inhabit a symbol (which could be an image, a rock, or some other item) and, when the god was present, requested his aid. After the ritual the god went away but his symbol became *tapu* as a result of his residence there. Tapu means sacred or set apart,

not to be used for other things.

Tapu ordered most aspects of ordinary life, preventing the thoughtless use of a specific object or place. Each person had their own tapu which increased with their *mana* or prestige in society. A paramount chief had great mana from birth, when his genealogy showed direct descent from the gods. Thus he had the right to call on the gods for their goodwill in any enterprise involving his people. With the hereditary hierarchical systems of Hawai'i and Tonga, very great mana was conferred by birth while elsewhere mana could be hereditary or acquired by deed (for example, as a warrior) or by learning.

Art forms in Polynesia had two essential functions: to communicate and to increase the mana of the possessor, whether an individual, a family, a tribe, or a district. In communicating, art illustrated the stories of the creation of the world, of gods and men, depicting the founding ancestors and people of importance in the history of an area. These narratives not only decorated a house or a marae, but also appeared as everyday objects. A planting stick might be embellished with the symbol of the god of agriculture. In some areas the god's image was also placed in the garden as a visible reminder that his aid had been invoked. Similarly, canoes were decorated with carving or symbols appropriate to Tangaroa, god of the sea.

Beautifully made objects added to the mana of their owner. In Hawai'i and New Zealand a high chief's rank was shown by the cloak he wore and the weapons or symbols that he carried. In Tahiti the finest and most elaborate stone marae belonged to the most important families. In New Zealand today those tribes or families whose marae is embellished with a carved meeting house have great prestige and are proud to invite others onto their marae.

In general in Polynesia, things which were the possession of those who have gone before and who are now ancestors have their own mana. This may be so great that such objects are dangerous for any but the direct descendants to see and handle. They have become tapu as well.

NEXT PAGES

69. Necklace of whale's teeth. Overall length with cord: 76.2 cm, c.1840. *Auckland Museum*

70. Wooden oil dish. Height: 37.5 cm, c.1830. These dishes were used by priests when annointing themselves with scented oil before a ceremony. *Auckland Museum*

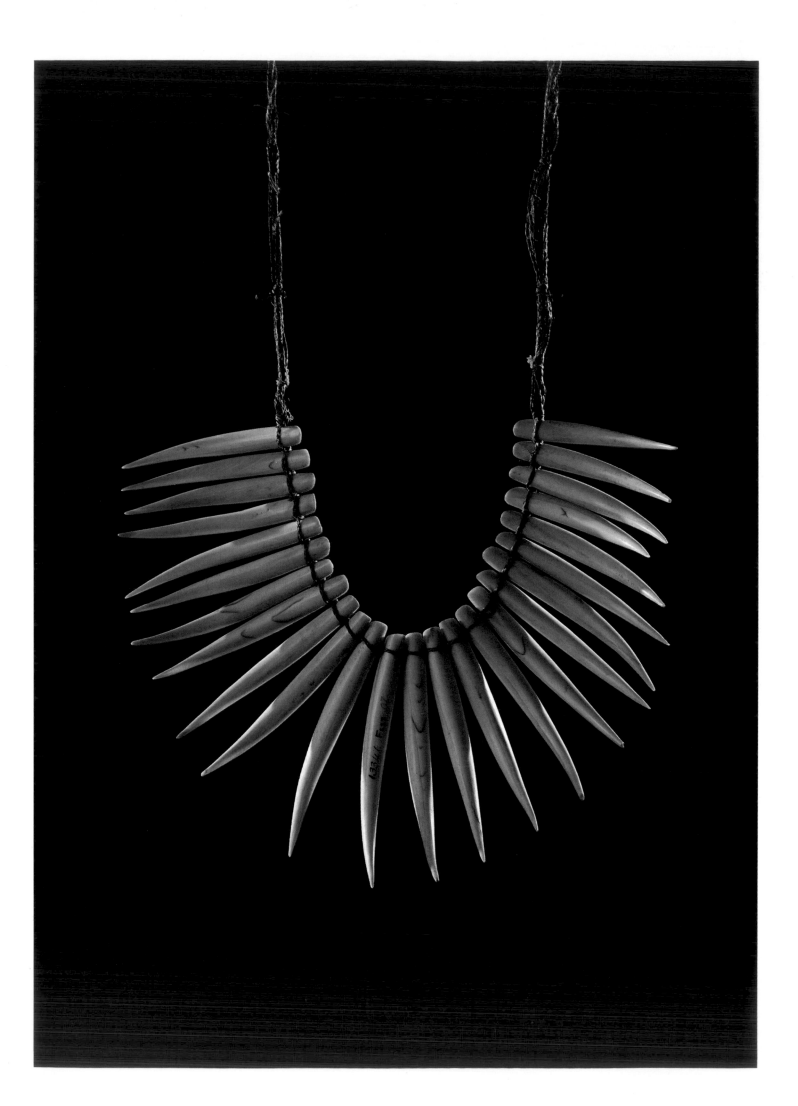

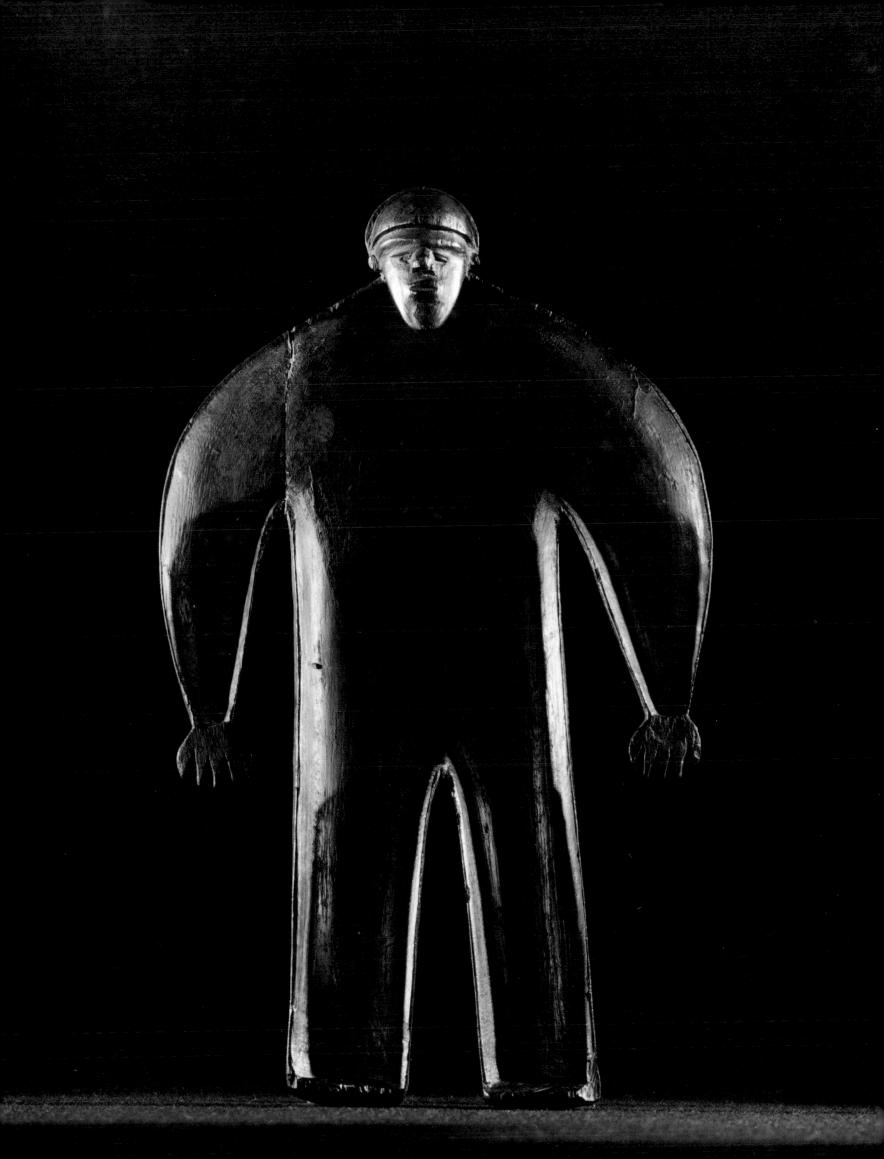

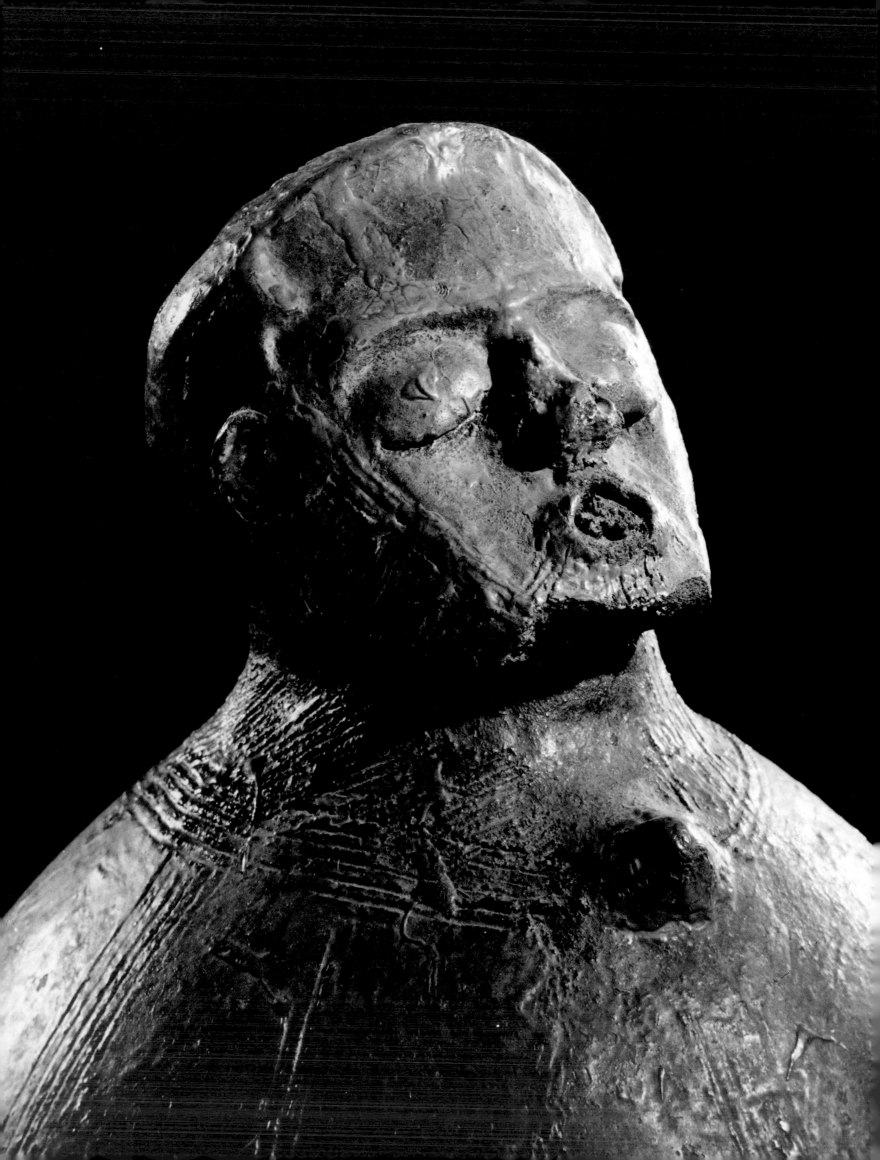

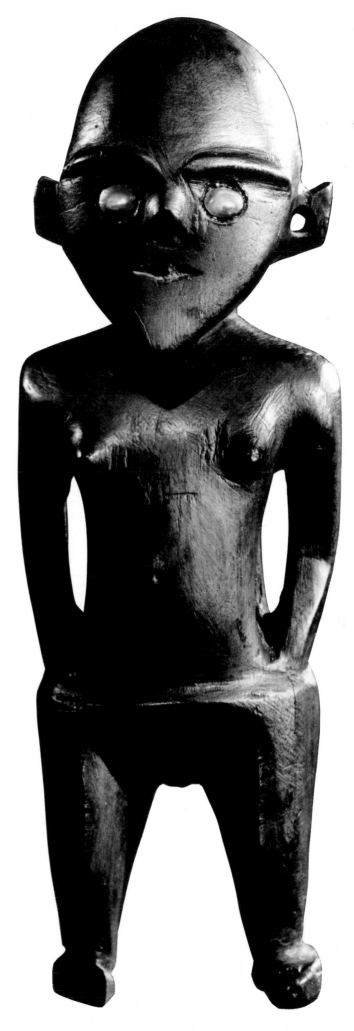

71. Detail of pot in the shape of a man. Height: 43 cm (head 13 cm). There are a number of pottery styles in Fiji but the technique is the same: coiling followed by beating with a paddle and anvil, a small stone being held inside the pot. The pot is fired on an open fire and glazed by the application of resin to the hot surface. *Otago Museum*

72. Wooden figure with shell eyes. Height: 21 cm. There is traditional evidence suggesting that such figures were carved by canoe-builders in Viti Levu who are referred to as Tongans. This may mean that they are real Tongans or Lau Islanders whose ancestry is part Tongan. The figures were said to represent the god of the carpenters. *Otago Museum*

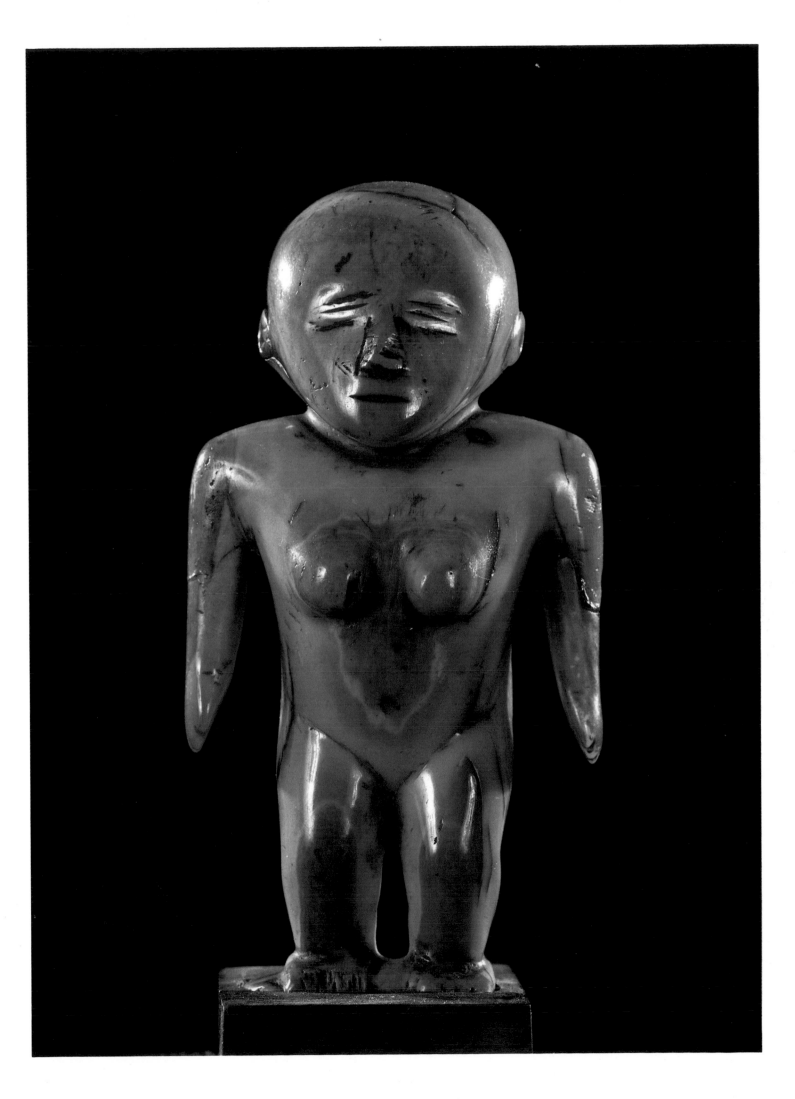

Tonga, Samoa, and Niue

Tonga, Niue, and Samoa are the main island groups in western Polynesia. Tonga includes over two hundred islands in three groups: Vava'u in the north, Ha'apai in the centre, and Tongatapu in the south. They form two chains: a recently and still active chain of volcanic islands to the west, and coral islands to the east. Most of the people live on the coral islands. The Samoan islands are high islands lying partly in Western Samoa and partly in American Samoa. The main islands are Savai'i, Upolu, Tutuila, and the Manu'a group.

Tonga and Samoa were settled from Fiji in about 1000 B.C. The societies they developed were quite different. In Samoa the system is based on a series of titles (*matai*) to which suitable perople are elected from within the kin group. These are partly hereditary and are stratified into village, district, and island titles. The latter go to those of the *ali'i* (paramount chief) class. An ali'i has an assistant, a *tulafale* (orator), whose badge of office is the fly-whisk. There are village, district, and island *fono* (council houses) with posts reserved for each matai. There matters of importance are discussed and the *kava* ceremony is performed by the *taupou* (village hostess, usually the daughter or niece of the highest chief in the fono). The kava is served in strict precedence according to rank.

Tongan society is an almost feudal system of nobles and commoners. The original Tu'i Tonga or King was descended from the god Tangaroa who had a child by a woman of the common people (who had evolved from worms). The nobility are all descended from this child ('Aho'eitu) and form the top rank of a hierarchy based on a series of lineages. All land in Tonga belongs to the King and nobles. As in Samoa the kava ceremony is important and serves to emphasize the strict hierarchy of nobles. In the 19th century the Tu'i Tonga was displaced by another lineage, that of Taufa'ahua. With the help of missionaries, he became King. He was able to keep Tonga free of annexation and develop a constitutional monarchy.

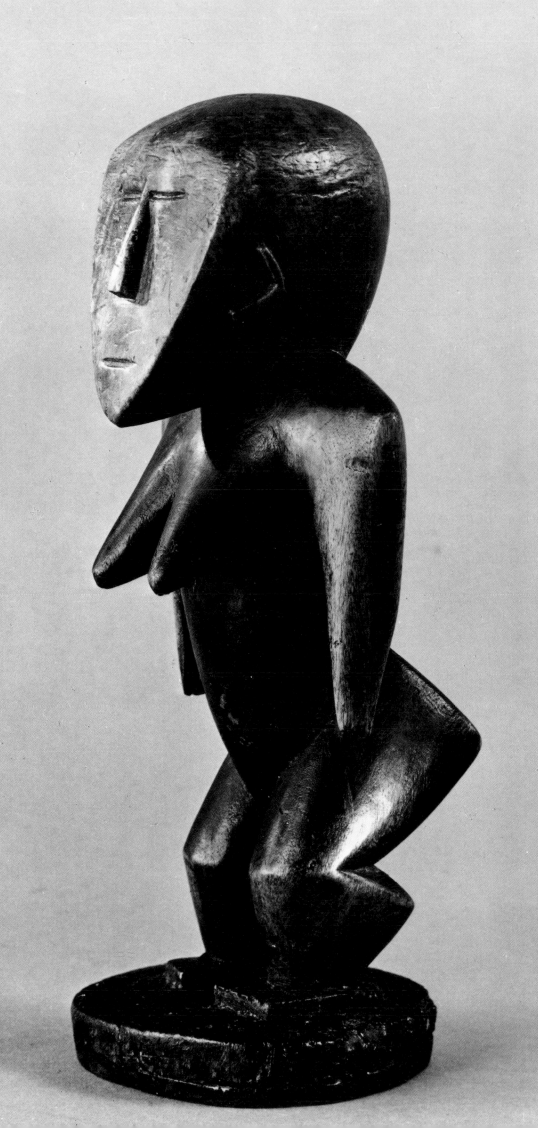

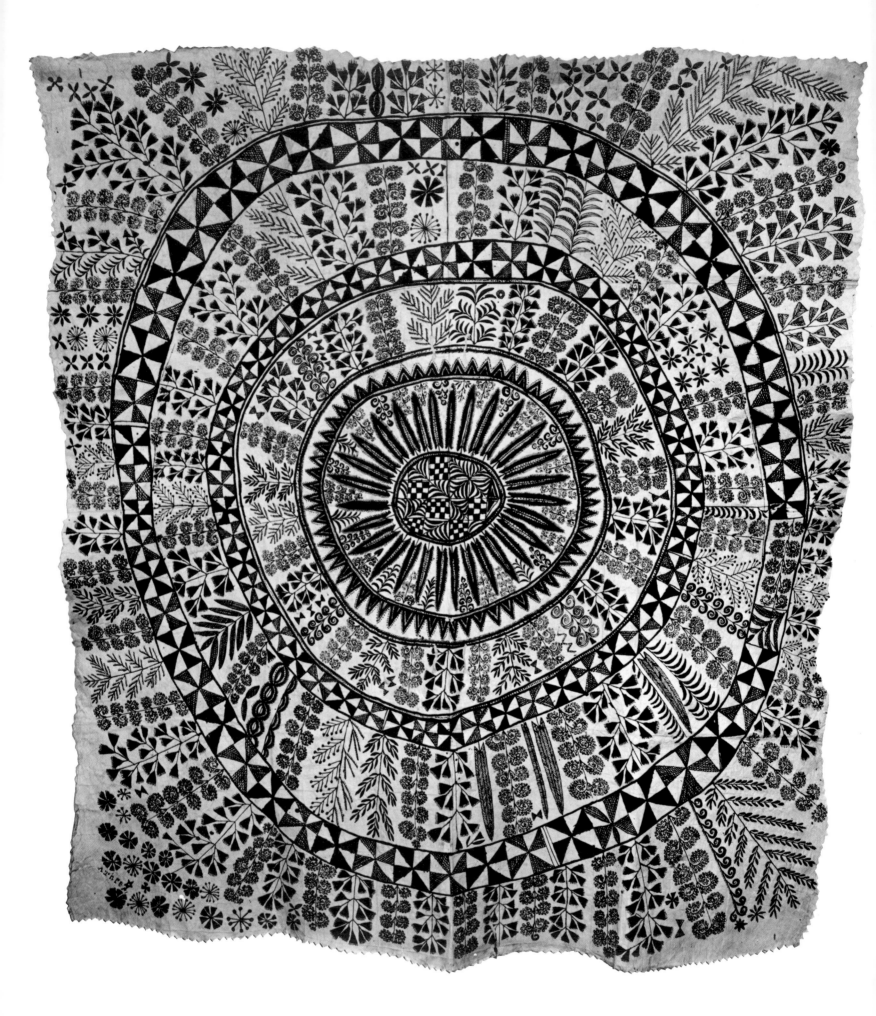

The sacrifice

Traditionally New Zealand has always been a sort of Canaan to the Pacific Islander. Today the status of the Islander in New Zealand is on a level with that of the West Indian or the Pakistani in England.

But Francis is a lawyer. Moreover he is 'an integrated New Zealander' – or so he told me at our first meeting.

When I decided to live in New Zealand it was a deliberate choice. Although I was born in Western Samoa, I never learned the culture when I was young and my English was better than my Samoan. I was brought up European because the uncle I was living with never bothered to learn Samoan properly. He was a Scotsman, a sort of adventurer who came over from America and married a Samoan girl. But he made money! He taught me English and paid for my education. He kept the family to one side.

I like to call myself a New Zealander. I'm integrated here and I am proud of my New Zealand citizenship.

For one thing, I always know where I am. Recently my daughter was bitten by a dog. I said to the owner, 'If you can't look after your dog, why don't you shoot it?' I was careful not to attack him, very careful; I know my place here. What would I have done in Samoa? Oh no argument. I just take a gun and shoot the dog. In Samoa I have the power.

If I went back to Samoa I would probably be guaranteed a seat in Parliament, but I'd rather live in this democracy. In Western Samoa the land is held by a few families and the ordinary people have very little. It's very feudal. If I went back I would immediately be of high rank but to me that is not a challenge.

My family are merchants and traders. They control several villages. My brothers (there are ten of us) have all got titles. My sister is the wealthiest; she's got acres of bananas and taro, she's got cattle, a high title . . . People are not supposed to sneeze at night in her village when she goes to sleep.

Last year I went back to receive a title. I didn't want it, but my family insisted. I believe title-holders should live at the place where they are needed. After all, you are elected by the people to serve them.

I spent a month in my village. I also spent some money. All the village came to welcome me and first of all the chiefs. Now I am obliged to give money according to their rank. After that first visit of the chiefs I was short of two hundred dollars. Then the wives came, then the unmarried women, and then the girls. Each time I had to give money and this was one village. I had to pay my respects in three villages and it cost me over a thousand dollars. Luckily one of the chiefs who got most of the money was my brother and afterwards I was able to pinch it back, but of course this wasn't known to the villagers. They would be scandalized if they knew.

We were brought up Catholics and as good Christians my parents decided to give me to the Church. They called me 'the Offering', because as the tenth son and the tenth child I was singled out as a tithe. A kind of sacrifice. You know in the Bible it says that the tenth part of

what you have, you offer to God. So every step I took was manoeuvred towards the church and I was supposed to become a priest. If I was going to school they would ensure I pass the church on the way. Or my mother will say, 'I'm going to say a few prayers, why don't you come?' Or she will wake at five o'clock and say, 'I'd like to go to early mass, but it's still dark. Won't you come with me for company?' It's a wish from her but you end up in church again. Books they buy on your birthday: everyone else gets a good story, I get a prayer-book.

I didn't object; I carried out my parents' wish. My uncle paid for my travel, I passed my exams. I went to a seminary and at one stage they sent me to Rome. I don't know what happened in Rome except that I rebelled. I called the thesis that I wrote for my licentiate 'There is no God', and they accepted it. I defended my thesis and they accepted the thesis, and then they kicked me out. I came back to New Zealand and resigned the priesthood and became a lawyer. Even so, to this day, my family still regards me as the offering. They still call me 'the Sacrifice'. And perhaps that explains some of the sacrifices I'm making now, as a lawyer, working with my people.

A man was here just now from Tonga. He came to New Zealand unskilled, but now after five years he is a foreman and has a standing in the white community. He is called an overstayer, meaning he has overstayed his work permit. He thinks the Government is going to deport him. He's married and he's frightened because if he is sent back he will go back to nothing, to unemployment.

Probably the New Zealand Government will deport him. Many people think the policy is unfair, but I have to explain the policy to this man and also as a New Zealander I have to defend it. I do this all the time. This is my country now.

At present many Islanders are being sent back, to Tonga, to Niue, to Rarotonga, to the Tokelaus, especially to Samoa – the Samoans come to me all the time for help and they have elected me to speak on their behalf. They see me as their representative, they don't see me as a New Zealander. As a matter of fact they don't *know* I am a New Zealander.

A lot of them come here to get out. At home they are stifled by this blind obedience which is demanded of them by the parents and the chiefs. But deep down they still obey authority. That is why in the present situation they are not questioning the Government. This man from Tonga who was here is not making a fuss. If he has to be sent back, he'll accept that.

Fortunately they are listening to people like myself and the voice of the churches. But a lot have gone to ground. They are frightened. It takes people like us who are New Zealanders to speak for them. The point is this: that by standing up to be counted they might lose their necks. So which is more important – dignity or survival? Survival. Dignity, unless I survive, means nothing. If I was that Tongan, I wouldn't stand up and be counted.

Some Islanders have been here for twenty years and they are still living as if they were on their little islands in the south seas. I know a lady from Niue who has been here thirty years and

she still boils her kettle in an open fire. In the middle of the city! She beats her washing with a stick. I once offered to get her a washing-machine but she said, 'I like to do it my Island way.'

This is because they are not integrated, they are only assimilated. Assimilation is little pockets of people. Assimilation is holding onto your own little group, in your own little ghetto. And holding onto your own culture? Yes, that too. Perhaps the Maori can do this and get away with it – after all New Zealand is his country. Perhaps the Maori has the privilege of holding onto his culture. But for us it doesn't work. This is why I advocate integration.

Integration is the working of everyone to become one people, a fusing into one, one family. One society. I don't like to see the Islanders keep to their own little place.

Here at home I don't speak Samoan because my wife doesn't understand it and my children of course, they go to New Zealand schools and they all speak English. My wife is a New Zealander. If I try to teach the children Samoan, they only forget it. I think in English. If I am talking to a *Palagi* – a Pakeha – like the Police Commissioner, I think in English. I dream in English, make love in English. That's what integration is.

I'm not saying that I am not still gregarious – the Islander is a very sociable person, very gregarious; he likes to live within a community, it's his nature. There is nothing wrong about that. I like it too. As a matter of fact where we are living is a very poor area, and we're surrounded by Islanders, but this is only natural since these are the people I'm working with. Sometimes however I feel it's unfair to my wife because she doesn't like this and her family don't like it – her people owned restaurants and hotels and for her to come here, in the middle of a poor area, she feels it's a come-down. She gets annoyed because I have clients coming in and out of the house all the time. Islanders don't make appointments, they don't ring up; they just walk in. I say to her, 'They can't help it. It's just their way.' I can't help it either – I'm their lawyer.

I don't belong to the Law Society. Mind you, they know about me because of the work I do. People are always trying to discredit our firm because we seem to get all the Island clients and so they think we are hoeing into the money, whereas in fact most of our clients can't pay at all. At the moment we are in debt.

This is why I joined the firm, because of the fact that people come first, not money. I like that principle. Originally I wanted to be a psychologist, but my father pointed out that it would be a waste of time. 'You'd be out of a job back home.' He was right. There's almost no mental disturbance in Western Samoa. After I resigned the priesthood, I was driving a taxi. One day I met a man who was starting in law practice by himself – he had ideals about helping people, so even though I wasn't qualified (I'm what they call a legal executive) I joined him.

We began with an overdraft. For the first year we couldn't afford lunch. I used to park the taxi outside the office, work through the morning and spend the lunch-hour driving fares to earn the money to buy our lunch. I would work through the afternoon at the office and then drive

the taxi at night. For a whole year I supported my family like that. Neither my partner or I got paid. At Christmas we shook hands and that was that.

My wife doesn't work. I don't approve of women working; I believe their place is with the children. I have four children. It's true that I sometimes read them Samoan stories and whenever we go for an outing I teach them Samoan songs, but at the same time I wouldn't want them to grow up too extreme, too Samoan. This racial thing can be overdone. They are obedient children, very obedient. As a matter of fact I will demand their obedience.

They go to church with me on Sundays. I go to the Samoan church. Of course I *could* go to the English church where my wife goes, but I prefer to go to the Samoan service because it is important for me to be there and give an example. A Samoan service is a very different one form a service conducted in English. I mean, it's a different spiritual experience.

Sandra is ten, she is the oldest child. Who would I like her to marry? Oh well, if you ask Sandra she says she won't ever marry, but if you are speaking about Sandra grown up, speaking personally, I wouldn't mind if she married a New Zealander – I wouldn't mind. It doesn't bother me. Would I *like* her to marry a New Zealander? Oh well. I can't answer that.

I was brought up on don'ts: 'Don't play with gangs', 'Don't mix with just anybody'. One of the first things my parents said to me was, 'Don't trust a Palagi.' Palagi, like Pakeha. 'Don't trust the white man.' I didn't understand what they meant, or why, until they told me that one of my ancestors, an uncle, was killed during the Samoan rising against New Zealand. He was shot and killed. Ever since then my family don't trust the Palagi, especially the New Zealander.

There is something in me that can't trust a Palagi and I can't help it. It worries me, just as it worries me that I didn't enter the church as my parents wanted. Obey, always obey; you can't get away from it. I would rather not think about it.

When I left home I cut myself off from my family. Even now my brothers and my sister accuse me of 'becoming Palagi' because I married a Palagi. I kept getting letters from home saying, 'You're not doing what we told you.' I decided that what was important to me was my wife and child. I even wrote to my father justifying this by quoting the Bible: 'Whosoever is married should leave his father and mother and cling to his wife.' I never heard from my parents and the next thing, my father died. And my mother died not long after.

You come here to a new land. You're seeking a new life, new friends, new culture – so really you are not losing anything, you're gaining. Integration, it's not a loss. I always think of myself that at least I have progressed out of my uncivilized stage. I always consider myself more fortunate than others of my race. I may have lost the priesthood, but look what it's given me: it gave me education, a trip round the world and it brought me here. It's given me an advantage on my brothers. Really, I have the best of both worlds.

I must admit there are times when I miss my Island food. Sometimes the craving is so strong I just *have* to have it, a raw shellfish or *ina*, that's sea-egg. Or *bêche-de-mer*, that's sea slug. We

have a special mussel that you don't find here. When I get this craving I go out and buy the ingredients and bring them home and prepare the meal the way I like it. My wife sits down with her ordinary New Zealand meal and I sit on the other side of the table and enjoy my Island food. Just *got* to have it. I can't explain it.

My wife can't understand it. Sometimes I say to her, 'I miss my relatives. Why can't you invite some of them in for a meal sometimes?' Food is very important to a Samoan. I miss my friends and it upsets me that I can't invite them home as I'd like to. She can't understand that either. So I just – just forget about it.

At night when I come home from work I don't do anything very much. I watch the television. What I really love doing is playing billiards – I've got a billiard-table below the house. The trouble is, I've got no one to play with, so I go down and play with myself. I'm getting tired of playing by myself. That's one of the reasons why I go to the pub at week-ends, to find someone to play with. We have a drink and come back and have a game of billiards together. Usually it's a Samoan, very rarely a Palagi.

If my children ever hold it against me that I have moved away from my family, I will simply tell them that I came here for my education and decided to stay. But that doesn't mean they have to cut themselves off as I did – even if they can't speak Samoan when they grow up, it doesn't mean they can't go back one day and receive a title. Actually, I would like my son to go back and become a chief while I am alive. If there is one thing my children should hold, it is the custom we have at home of respect for their elders. I am always telling my children this.

Actually, we got a plan. The other day my wife and I agreed that the children at some stage should spend at least a year in Samoa learning the language and the custom – we agreed on that. Sort of strengthen the Samoan side. Who suggested it? I did.

– Western Samoan living in New Zealand

Polynesian Outliers

78. Wooden goddess figure named Kawe de Hine
Ali'gi, from Nukuoro. Height: 220 cm, early 19th cen-
tury. Nukuoro is a Polynesian outlier atoll in the
Caroline Islands. The surrounding peoples are basi-
cally matrilineal and their influence may be apparent
in the carving of such figures as this, about a dozen of
which are known. Most are small. Kawe stood in an
amalau (godhouse) and is reputed to have had human
sacrifices offered to her. *Auckland Museum*

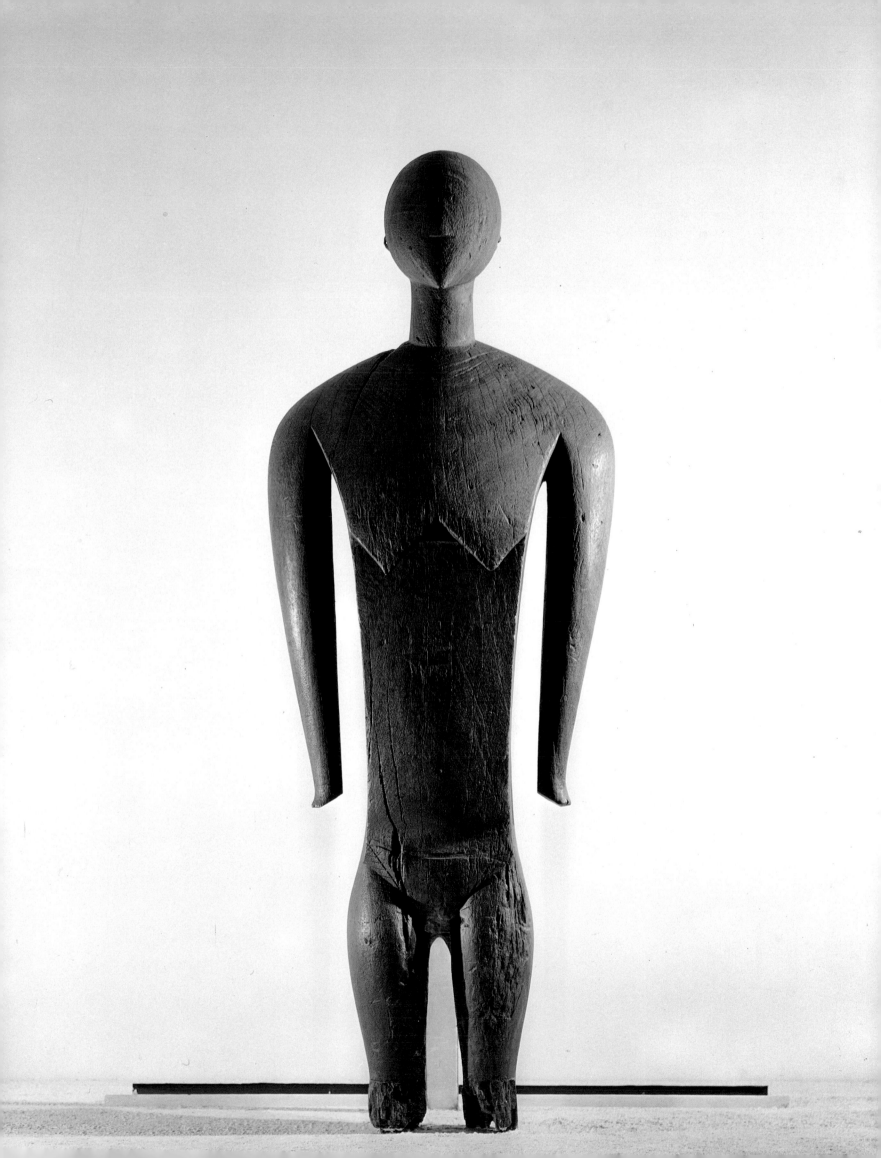

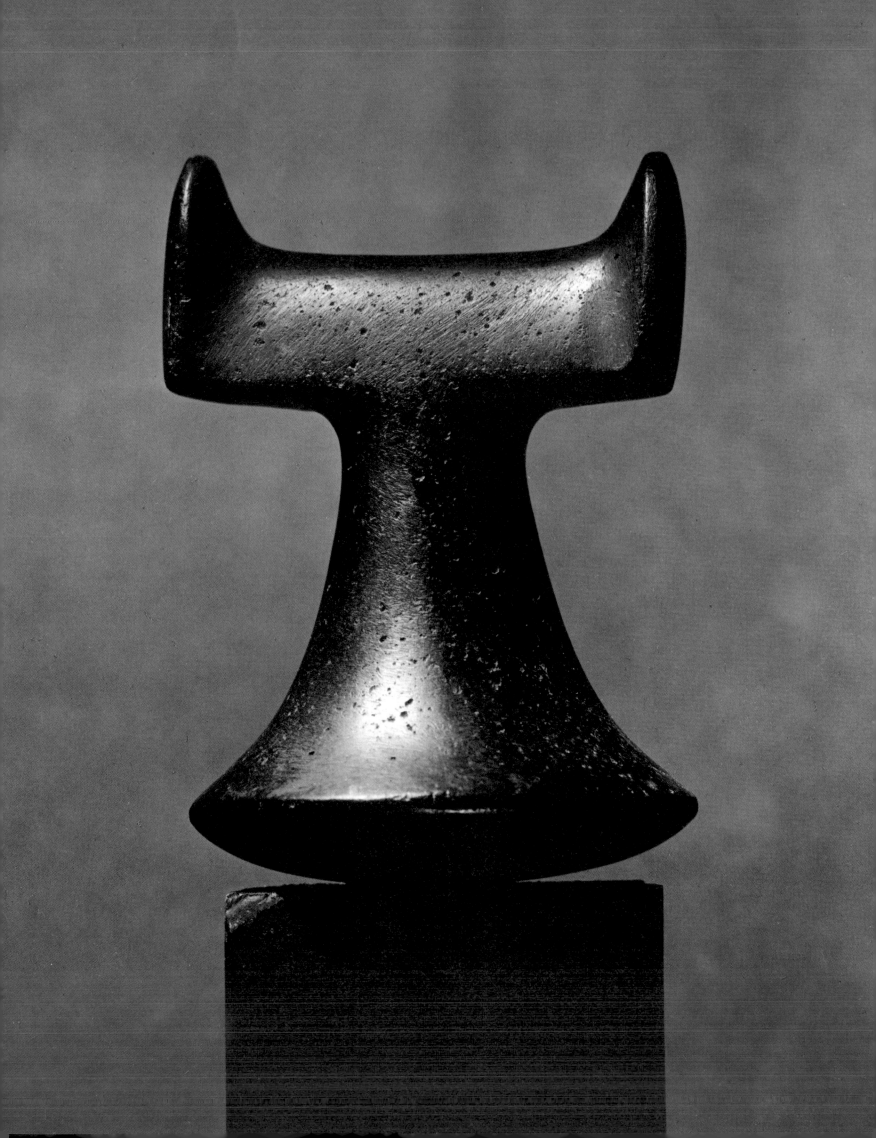

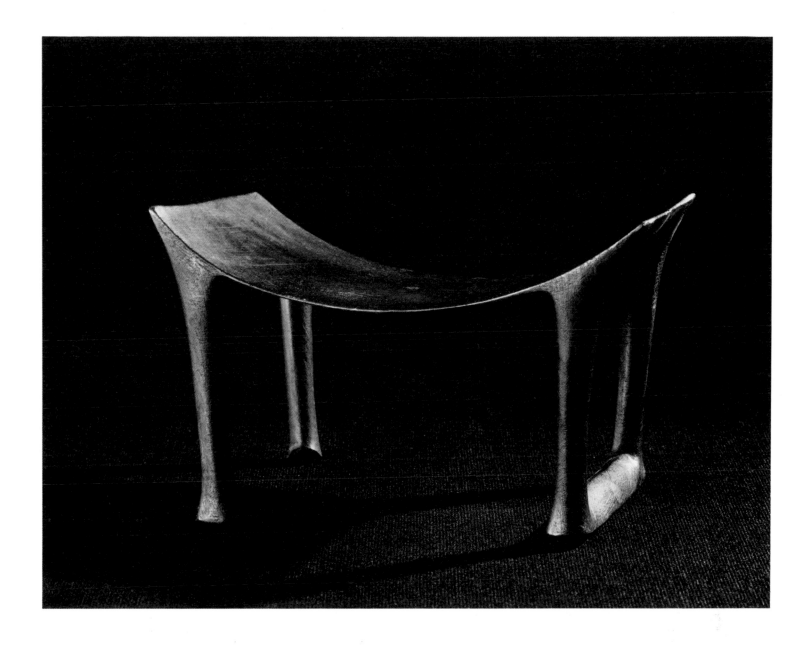

Society Islands

The islands form two groups, the Windward and the Leeward. All except two are high volcanic islands. Tahiti is the largest island in the Windward group. The Society Islands developed a distinct form of Polynesian culture but in prehistoric times there was communication with the Austral and Cook Islands. This is indicated by items found in all three areas. In the Society Islands, important families built their own stone *marae* or temple platform consisting of a stone-paved court with raised altar at one end. In important marae the altar (*ahu*) had a hut on it to house objects associated with the gods.

79. Stone pounder from Tahiti. Dimensions: 16 x 11.5 cm, 18th century (collected in 1881). Pounders were used to mash bread-fruit and other foods on a pounding table. This one is made from a close-grained basalt. *Auckland Museum*

80. Wooden head-rest from Tahiti. Height: 14.5 cm, 18th century (taken to England in 1823). Wooden head-rests or pillows were used throughout Polynesia. Beds consisted of piles of woven pandanus mats with tapa (bark cloth) blankets. *Auckland Museum*

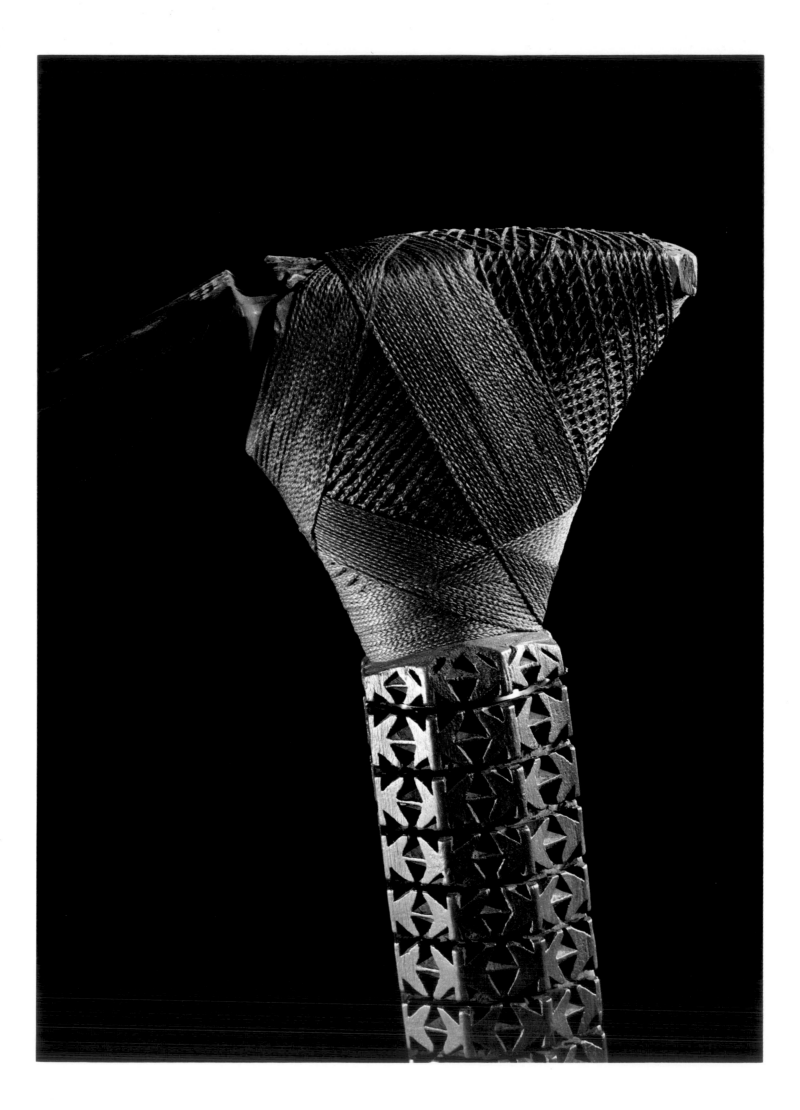

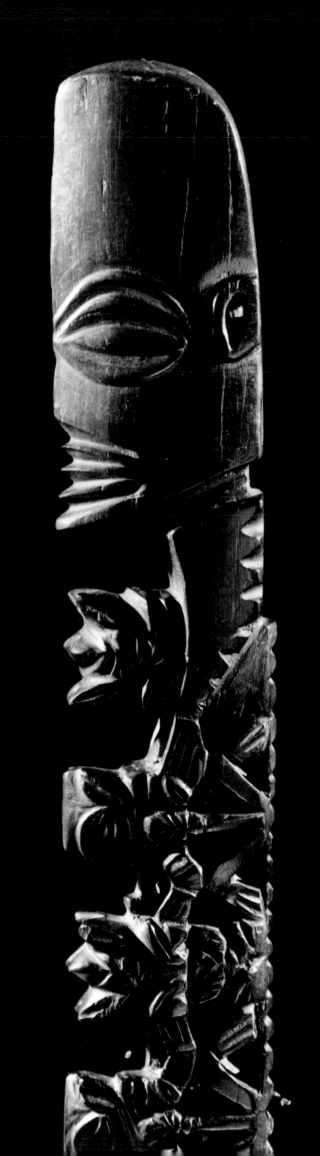

Cook Islands

The main islands are the southern group of high vol-
canic islands which include Rarotonga, Atiu, Mauke,
Mitiaro, Takutea, Manuae and Aitutaki. The northern
group is distinct culturally. Social organization is tri-
bal with the main tribes being described as *vaka*
(canoes). There are three tribes in Rarotonga, each
with its own *ariki* (paramount chief), *mataiapo* (land-
owning sub-chiefs) and *unga* (people). As in other
Polynesian groups, *ta'unga* (experts) were important.
Paved stone marae with stone back rests for chiefs
were the cultural centres and are still an important
feature of life on Rarotonga and Aitutaki. In olden
times *pi'a atua* (priests) conducted religious cere-
monies on the marae. Symbols of the gods were used
in the ritual but later these were mainly destroyed or
removed by Christian missionaries.

PREVIOUS PAGES
81. Detail of a ceremonial adze from Mangaia.
Length: 61 cm. Adzes such as this were either the
personal possession of a chief or they were used to
make the first few chops while invoking Tane Mata
Ariki, the god of the carpenters. At a later date they
were in demand as tourist items (described as 'peace
adzes'). The pattern on the handle is based on human
figures. Extremely delicate lashing is a feature of these
adzes. *Otago Museum*

82. Top section of a staff god image from Rarotonga.
Length: 61.7 cm (overall length of staff about 420 cm),
1800. God symbols, including staff gods, were kept in
special houses on the marae altar and brought out for
ceremonial occasions. The middle section of the staff
was wound around with tapa cloth tied with cords in a
decorative pattern. The lower section consisted of
some more small figures and an enormous penis. *Au-
ckland Museum*

ABOVE
83. Stool-seat (*no'oanga*) from Atiu. Length: 48.1cm.
This was shaped from a single piece of Tamanu (*Cal-
lophyllum*) wood, reserved for the use of chiefs. *Can-
terbury Museum*

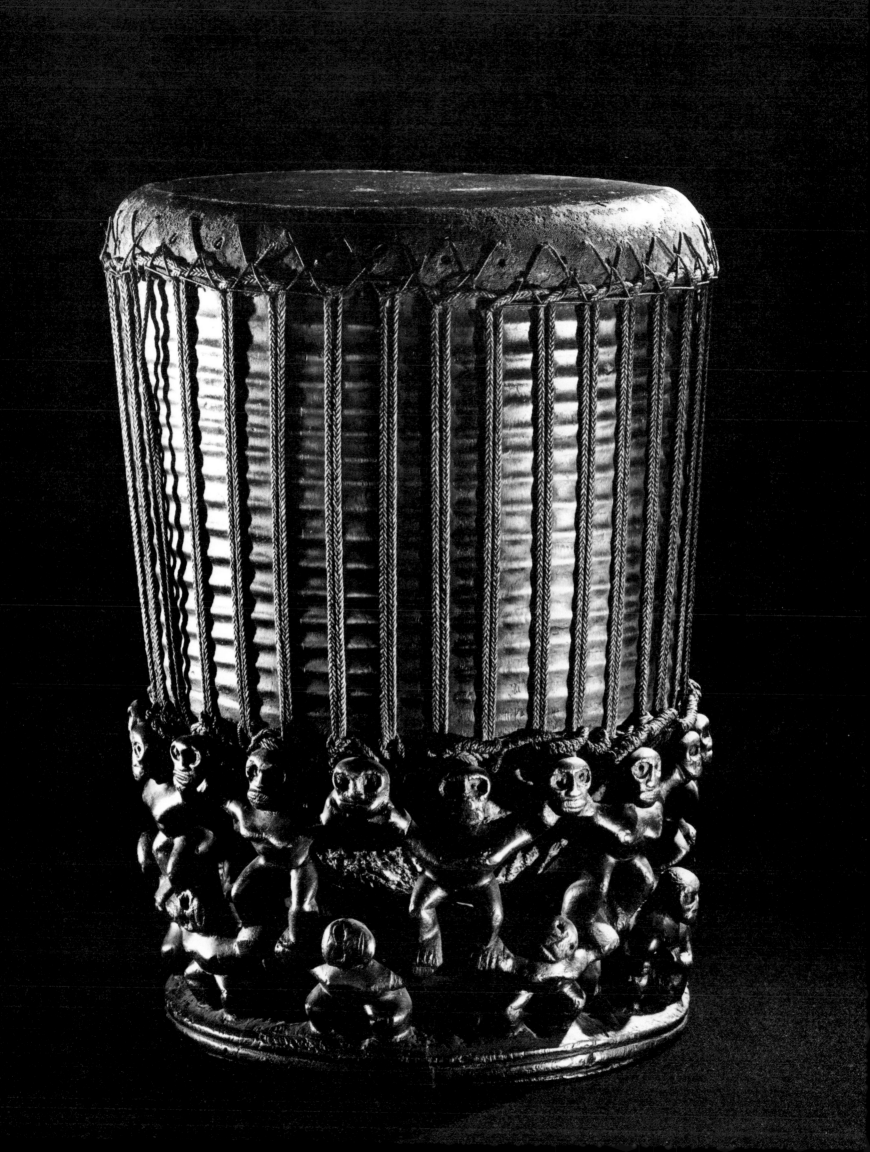

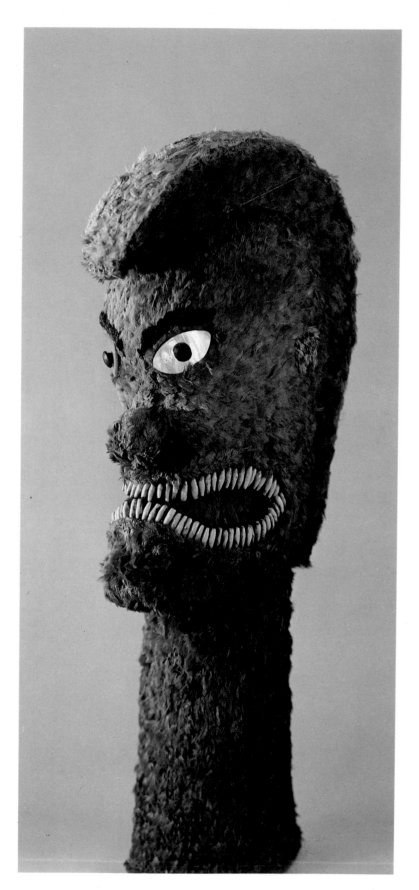

Hawai'i

The Hawai'ian islands stretch over a distance of three thousand kilometres. The main inhabited islands are the high islands of Hawai'i, Maui, Molokai, Oahu, Kauai and a number of smaller islands. These have been occupied since about the fifth century A.D. The first settlers may have come from the Marquesas Islands. Ancient Hawai'ian society was highly stratified with ali'i (nobles) who, in each island or district, were ruled by the *mo'i* (high chief), a noble with the clearest line of descent from the gods. At all levels in the society tribute of pigs, dogs, fish, kumara, taro, *kapa* cloth, and other produce was paid. The religious centres were the *heiau*, stone structures with a house in which representations of the gods were kept. Human sacrifice was offered by ali'i on these heiau.

PREVIOUS PAGE
84. Dance drum (*patu hula*) from Hawai'i. Height: 47 cm, late 18th century. The resonance chamber and stand are shaped from one piece of wood. The shark-skin diaphragm is held by tension cords of braided five-ply coconut fibre. On the stand an upper row of nine dancing figures (showing nine extra heads to double the impression of number) is supported by a second row of nine whose heads are side-turned to indicate the strain. Originally the eyes were inlaid with shell. *Canterbury Museum*

85. Feather image of a god named Kukai'limoku (Ku, the snatcher of islands). Height: 55.5 cm, c.1810-19. Ku was the personal god of Kamehameha and so became the principal or state god when the latter established the Kingdom of Hawai'i in 1810. Ku was also the god of war. Feather images (with fibre-netting base) were portable representations of gods. *National Museum*

86. Kapa cloth collected by Captain James Cook, 1779. The design was made by a combination of lining with bamboo pens and hand painting. *National Museum*

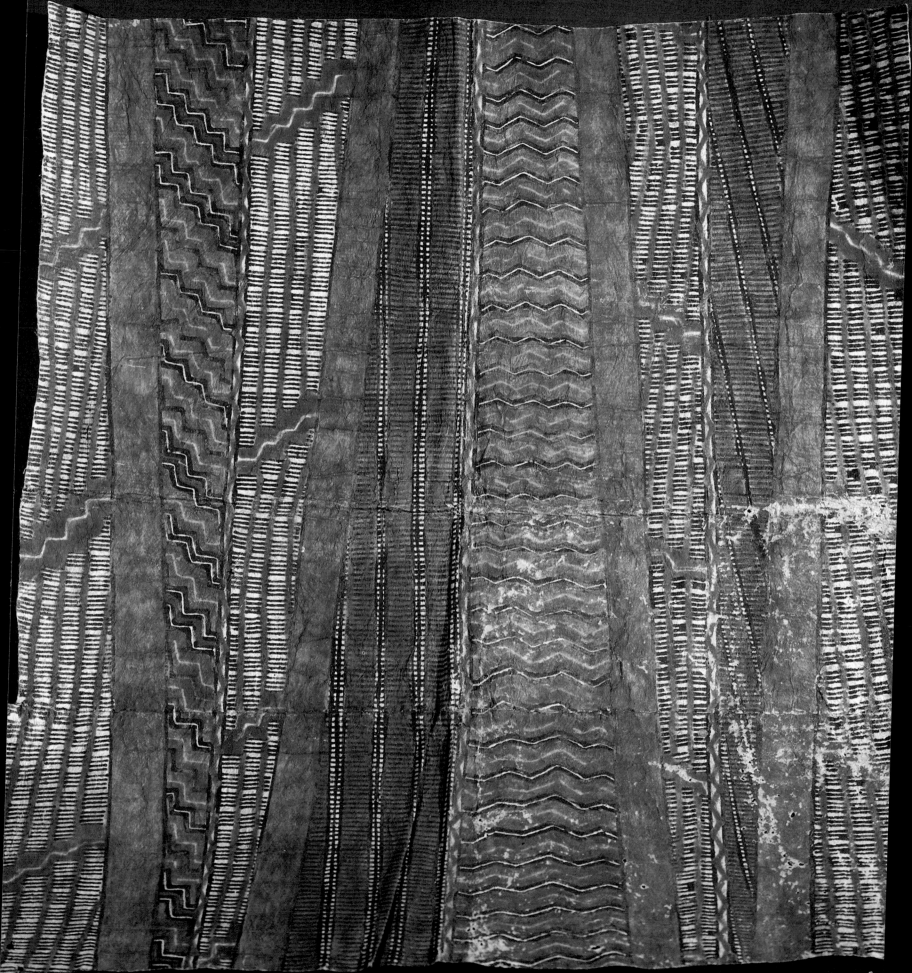

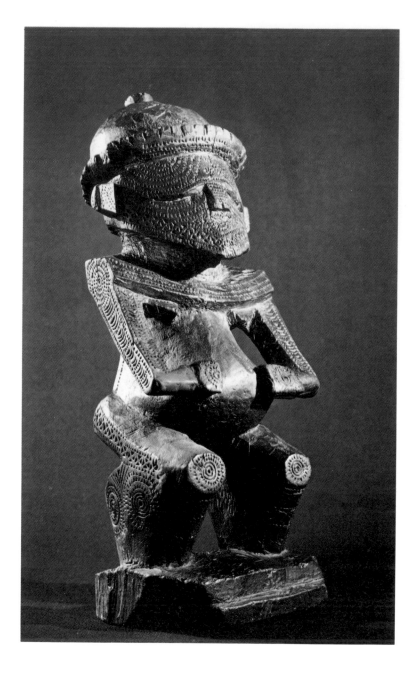

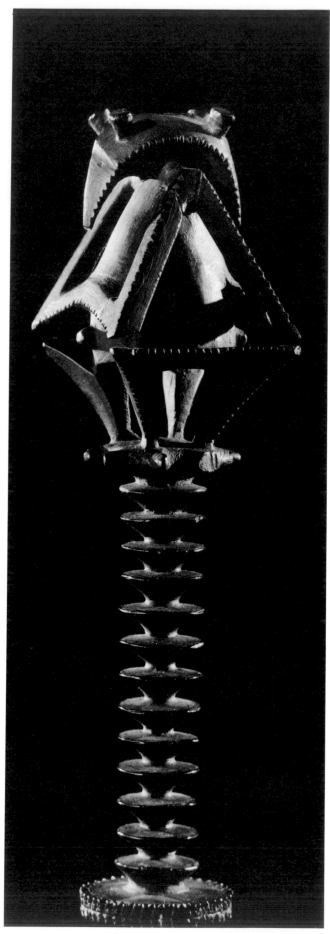

Austral Islands

These are a chain of islands lying between the Cook and Society Islands. There are four volcanic islands: Ra'ivavae, Tupua'i, Rurutu, and Rimatara, and one un-inhabited atoll. As in other eastern Polynesian societies the people lived in districts under chiefs. Priests (*ara'ia*) presided over ceremonies on the marae. Religious art and ceremonial objects were important in these rituals. On Ra'ivavae large stone statues were made. Following European contact in the early 19th century, and the introduction of iron and steel tools, there was a flourishing trade in replicas of these objects.

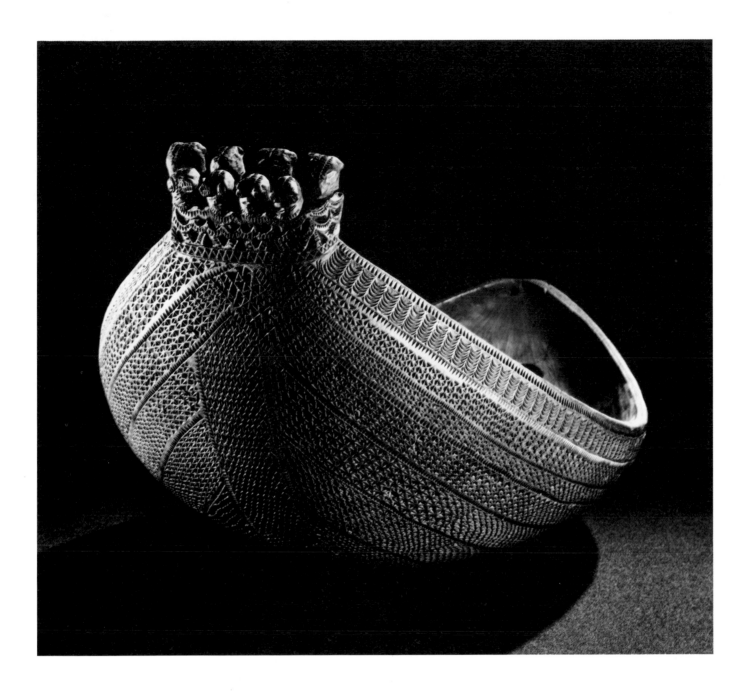

87. Wooden goddess image from Ra'ivavae. Height: 65.5 cm, 18th century. This image was taken to England in about 1834 by the Reverend John Williams who used it to illustrate lectures raising funds for the missions. The figure has the characteristic collar and small chest of images from Ra'ivavae. *Auckland Museum*

88. Handle of a chief's fly-whisk. Length: 37 cm, early 19th century. *Auckland Museum*

89. Kava bowl in the style of Ra'ivavae. Length: 65 cm, width: 30.5 cm; early 19th century. The bowl is made from Tamanu (*Callophyllum*) wood, with the elaborate surface decoration of the early European period. The holding lug is composed of four linked human figures. *Canterbury Museum*

NEXT PAGE
90. Detail of ceremonial paddle, probably from Tupua'i. Total length: 60 cm, blade at widest point: 36 cm. The blade is thin and tapers to a fine edge. *Wanganui Regional Museum*

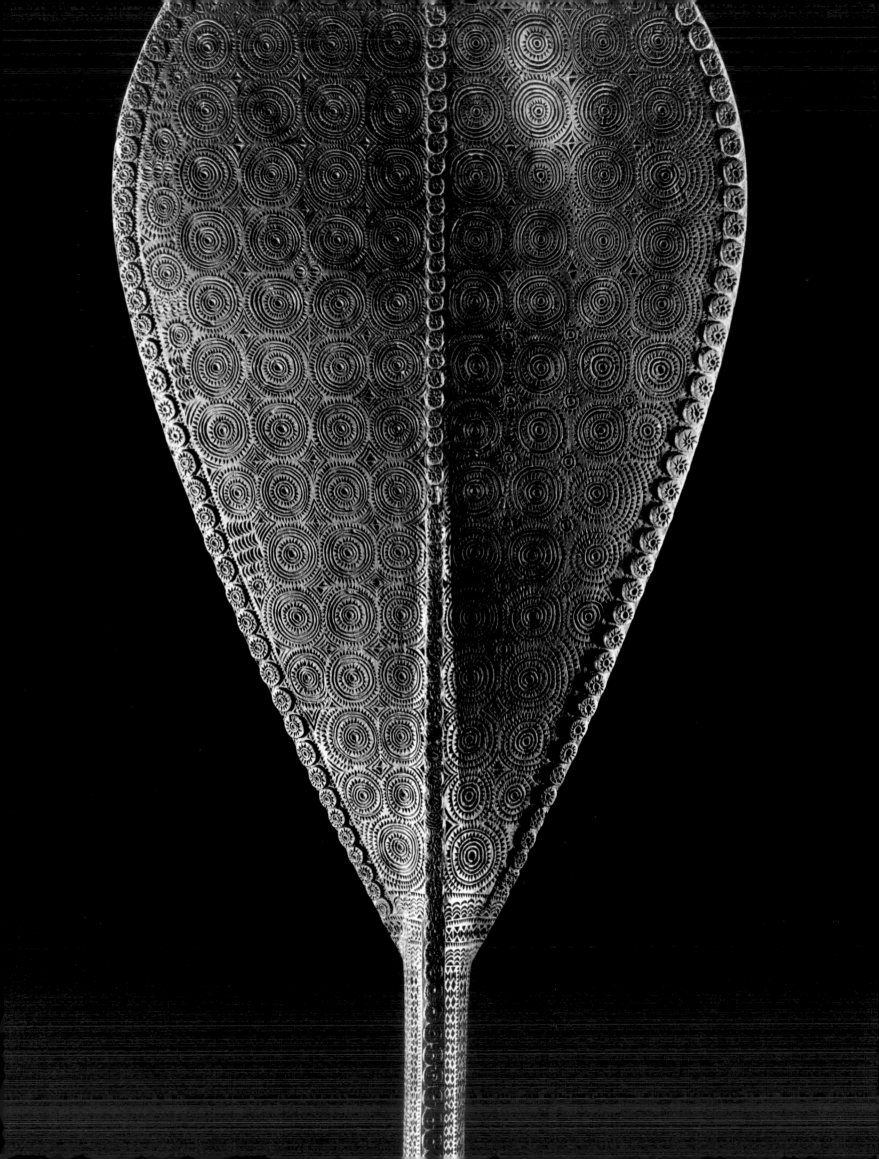

Only a shadow

'Kia orana & greetings in the name of Our Lord & Saviour Jesus Christ. I have received your letter with much appreciation. My dear, any time you want to come I'll be very happy to receive you on our island, especially at my home . . . May the good Lord keep & bless you till we meet again.
Yours love, Twin'

I was forty-seven when I had this daughter. But oh, the trouble is my brothers. You know how brothers are. I said to my brother Carl, 'Well, I've got a child by him. Why don't you my brothers let me get married?' They wouldn't let me. They just go and give my boyfriend a terrible hiding. So I think to myself: 'I don't want to go against my brothers. It's not a happy life.' 'All right, Carl,' I say. 'I will never marry. But you my brother shall be my father and mother for ever.'

My father was dead. 'What about my little daughter?' I say to my brothers. Oh, they'll look after my daughter.

So I never married the man. I told him to go off and get married with someone else and he went off. I stayed with the family.

The family is very important to me. More important than the man I love? I think so. Instead of marrying, I have spent my life looking after my brothers' children. At present I'm looking after six of them. I have to do it, because I'm only a woman. And again: you got to respect your brother because he's higher. He's greater than a girl. I was taught by my father, 'You must respect a brother because your brother, it's above you.' What else could I do?

My daughter doesn't know her own father. She was very small. She was one-and-three-quarters of a pound when she was born. I waited a whole year for her to grow up to be a nine months' child. My brother brought us home to his place, then later – when I was sick and nearly blind – he paid for me to go to New Zealand to be cured. That brother of mine supported me. So that's why I say, 'A brother, he's like a father.'

Why am I called Twin? In my father's family we are eleven – eleven that stay alive – and the eldest is Carl. On the day Carl left our atoll, our home, and came to Rarotonga to school, that's the day I was born. So first I was named for Carl, *'Tereapii-o-Carl-ki-Tereora'* – the Coming-of-Carl-to-School'. But then a month later Edward my little brother died. Edward and me were twins. So when Edward died they didn't call me after Carl any more, they called me Twin to remember my brother Edward.

We all have dead names too. When my grandfather died everything that he had, he named on his children and grandchildren. His table. His fork. His glass, his mirror, his clock – that's my grandfather. One of my cousins is called Spoon, Joe Spoon is his name. I forget who is Glass – I think my brother next door. He is either Glass or Clock. And the parts of grandfather's body: his knee, his foot. Another brother is named Time, after the time when my grandfather died. It's because you belove that person. We still got these names. My name it's Head, that means my grandfather's head. That's the custom here.

Too many customs. I don't follow them because they are heathen customs. I don't have faith in those things. The only customs I keep are the customs of my father. Like being kind and not hating people and going to church. His church is my church, that's Zion church. I was baptized in that church by my father. Also I keep his language – English language. On Palmerston atoll our home we were taught to speak only his language. It's the English from England of our grandfather.

My grandfather built a house and a school with timbers from shipwrecks on Palmerston. That's where he taught us to make prayer on the Bible: read the Bible and say the prayer to God – the one and only true God which is in Heaven. And in the morning when you get up, you call out to the Lord. That's my custom.

I've got no father and no husband, except my best husband which is the Lord. I'm a Christian. We are all Christians in the Cook Islands.

I was born on Palmerston atoll. My grandfather was the first to live there. That's in the year 1847. We used to have feasts with masks and dancing, but I don't like to talk about masks – that's heathen. When my grandfather got to Palmerston he was a civilized man. He came from England, Birming-ham. He is brought up in the Church of England and he was our minister in church. He was a runaway sailor and he came to Palmerston with brass buttons and big-bottom legs as a ship's captain. He had three wives. He comes with a wife, a cook and a wash girl, all island women. He's got children from his married wife (that's my grandmother), he's got children from his cook and he's got children from his wash girl. So we are three families, three clans, and we all learn to speak his dialect from England.

Actually there are four families, but we don't talk about the other line. We own the atoll now. Altogether it's about three thousand of us living from grandfather's three families.

He had only one wife, mind you.'That's bad,' I said to my father. 'You talk about not committing adultery, but look – look at our grandfather.' 'But he only had one wife,' father says. 'That's the trouble,' I say.

It's better to be married if you have a child, then everything is pure. It's more clean. Not like I am – I'm still unclean. I wasn't married when I had my child.

In 1926 I left Palmerston and I came to Rarotonga to educate my brothers' children. I was twenty-one. I had long hair right down to my ankles. There was a hurricane in that year and Palmerston atoll was nearly destroyed. Everybody ran to the top of a little hill. We had a two-storey house – all washed away; but that night a baby was born, my niece. She lives next door. Her auntie was lost in the storm and she was born the same night. She was born on that hill.

When someone is born you plant a tree. You take the afterbirth, put perfumed leaves over it, wrap it up, bury it and plant a coconut tree. When Edward, my twin, was born my uncle took the afterbirth and covered it with leaves and was about to bury it when he found out there was

another child-that's me. I was in the afterbirth. Very tiny. Uncle called to my father: 'Brother, look. *I've* got a child of my own.' My uncle adopted me and my grandmother nursed me and brought me up. They've got their own ways of doctoring to keep the child safe. It's like a god-doctor. That's all gone now. I don't believe in that.

We used to make sandals to walk on the reef out of coconut husks, that's gone. And mat slippers. Traps for catching fish and eels, necklaces from pigs' teeth and shark, *tamanu* bowls, tamanu vases, tapa cloth – we don't do that now, all gone. All lost.

Mind you, *I* can make these things. Slippers, tapa from pandanus, skirts from *kiriau* and from the coconut, thatch roof. Oh, no trouble about that. Necklace, bracelets, hats with ribbon from banana-leaf dye, baskets . . . Weaving? It's called weaving? Oh no trouble, but I'm the only one here that does it. I'm *happy* doing these things just because it's the custom of my mother. I get that from my mother's side.

Island custom, yes.

I'm happy, just like I'm happy to look after my brothers' children. Sometimes children just walk in – they're welcome. Once I welcomed a man from New Zealand who was frightened of the sea. He was paralysed from polio. 'Look here, man.' I said. 'Don't you be frightened. The sea will cure you.' 'Oh no no no no no!' He's very frightened. I don't care. I take his walking-stick and make him sit in the sea. Massage him in the sea. Take him home, massage him again right down his legs. I do this many times and he's cured. When he went home he left his stick amd walked straight on the plane. He wasn't here long.

I just used oil – oil that I make. I learned to massage back home from my mother. Island recipe.

I think it must be the salt, the sea-water that does the curing.

Not the oil? This is nothing, just coconut oil.

It's made with a flower, *tiare-Maori.* It's a native flower. Just take the coconut, scrape it, dry it out, get the flowers, put them in. That's when it's melted. There's something to cook also, small crabs – you pick them up on the beach. Scrape them, get the waste off, melt them . . . you have to get the cream out. Don't forget to pound it up and put it in a cloth and pour sea-water in and sprinkle it around the waste to get the oil. That's all.

I cured all my adopted children when they were small. Cure the stomach-ache, cure the canker. The cure for canker is from the ironwood tree. For some things it's fern root; sometimes it's herbal. Once I cured the chief of police. His water turned to milk and in hospital it got worse, so I fixed it. Ghost medicine, he said.

Well, it's nothing. Just leaves.

I cure so many people I have to keep quiet about it, otherwise people think you are a god. But you got to believe in it or it won't work. Got to have faith.

When you go down to the sea you have to be there before anyone else. Be there before the sun comes up and then, when the sun just peeping up, you carry the sick child and bury his limbs

in the sand where the sea is breaking. The power is in the mana, the *manuia* – the power and the luck: the luck of the achievement, the luck of the medicine. The mana is from the forefathers.

So the salt is really only part of it? That's right. It's by your mind that you get well. That is our faith in the mana.

Where's my line? *Anita!* I get the girl to bring me a piece of line. Here. We call this cat's cradle. This is the hole where the turtle lays her eggs. The turtle is sleeping and we girls catch the turtle and turn the turtle when she crawl up to lay the eggs. I can make many stories with cat's cradle. This one represents a legend. It tells how a god separates two islands and from the two comes one island: this is my mother's island. That's how our island was created. Listen:

> *Begotten. It is daylight.*
> *The four corners are beginning to shake.*
> *They are calling out*
> *That Manihiki and Rakahanga will be separated.*
> *They are separated.*

It's a chant. When you string the cat's cradle you got to sing this song, that's how we keep our history with these games. Every place got its history.

If you ask me who began the creation in our islands, I'm not sure. Maybe Tangaroa. He's the god that created everyone here.

You see my mother's father wasn't civilized. He was a heathen. He was taken off to slavery in Peru, but then he escaped. He jumped over the ship and swam ashore. He was like a god-doctor, he cured people and that's what I do. I exactly follow the ideas of my mother and her father.

You see that stone wall? This land was given to me by a friend, she gives it to me from the heart. 'But don't let anyone take the stones from the wall,' she said. One day a man came and took the stones. I couldn't stop him. It was her uncle. Well he died. He took the stones away in his buggy and four days later he's dead. Same thing with the boy next door – *he* start taking the stones. 'Who are you to stop me, you pig – Palmerston pig.' That's what he said to me. Where is he now? He died a week later.

This is the custom of my friend – you can't go against it. My friend comes and chants on the graves up there, telling her people to look after me when she is gone. 'Don't be afraid,' she says to me, 'You're protected.' So I'm always protected.

So the spirits of the ancestors are powerful after all?

Well. I don't know about that because I don't believe in that. I know they still believe in that in Papua New Guinea, but it's wrong isn't it, it's only a shadow. It's not the true God. The Lord is pure, but the heathen hate that because they don't know light. They don't know good and they don't know bad. They're uncivilized.

My daughter is married now. My brother Ned is living at our home in Palmerston. About eighty of them live on Palmerston.

When I get homesick I just pack my bag and go home. It's two days by boat. In the house that my grandfather built we keep our own bedrooms. On one end is Ned and myself, and Carl is on the other end. Carl is dead now. Carl is the one that made me lose my boyfriend. It's all broke up. I've forgotten about it now.

You know how the world goes. You want to follow your own way of wants, but you can't go against a brother – you just can't. What will come, it's tears. Never mind, I say, it's one God. The past is past. The time is past. My boyfriend he went off and married somebody else and it's all broke up.

This other business I was telling you about – the curing with medicines – that's another problem. The trouble is, I don't know who to pass it on to. I won't pass it to my brothers' children because they are not interested. Maybe I will keep it to myself. If I die, it dies with me.

But I've been thinking. Maybe I will pass it to my daughter, I think she is interested. Maybe she is the one, because – look. When I came to register the birth and write the name in the book, I didn't put my daughter under the name of my brother – I put her under my name. I'm the father *and* the mother.

– Rarotonga, Cook Islands

Easter Island

Rapanui (Easter Island) is also known to its people as Te Pito o Te Henua, the navel of the world. It is the most isolated of all Polynesian islands, a barren land covered with coarse grass. In the past it was wooded, but the trees were destroyed by Polynesian settlers (probably from the Marquesas in about the sixth century). In their isolation the people developed a form of Polynesian culture which, in the late period before contact with Europeans, included the erection of giant ancestor figures in stone. Each tribe or *hanau* erected their own *ahu* platforms with figures on them. These became the target for tribal wars which raged over the island.

91. Detail of dance paddle with stylized human face. Length: 85 cm, 18th century. These paddles are still used in dances. In ancient times they are said to have been used to ward off evil spirits from the sweet potato crops, or in bird cult ceremonies. *Auckland Museum*

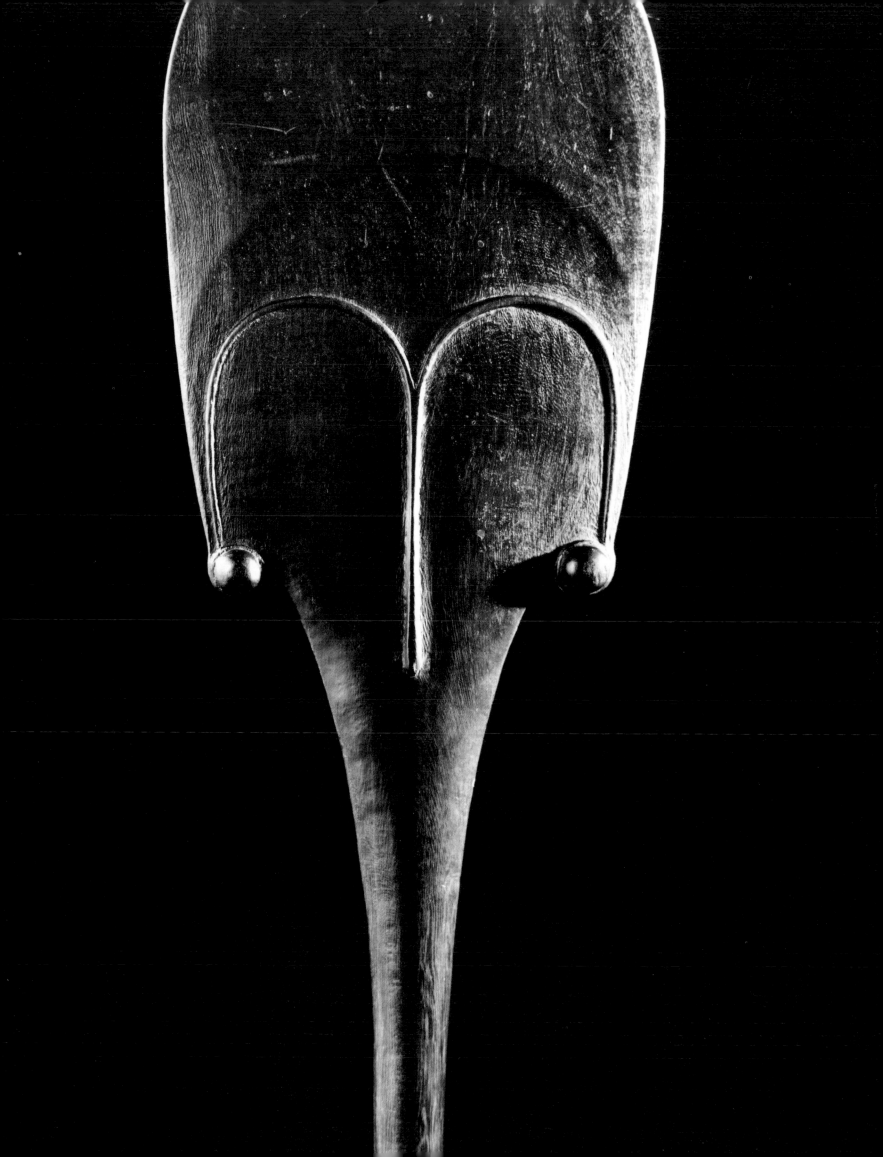

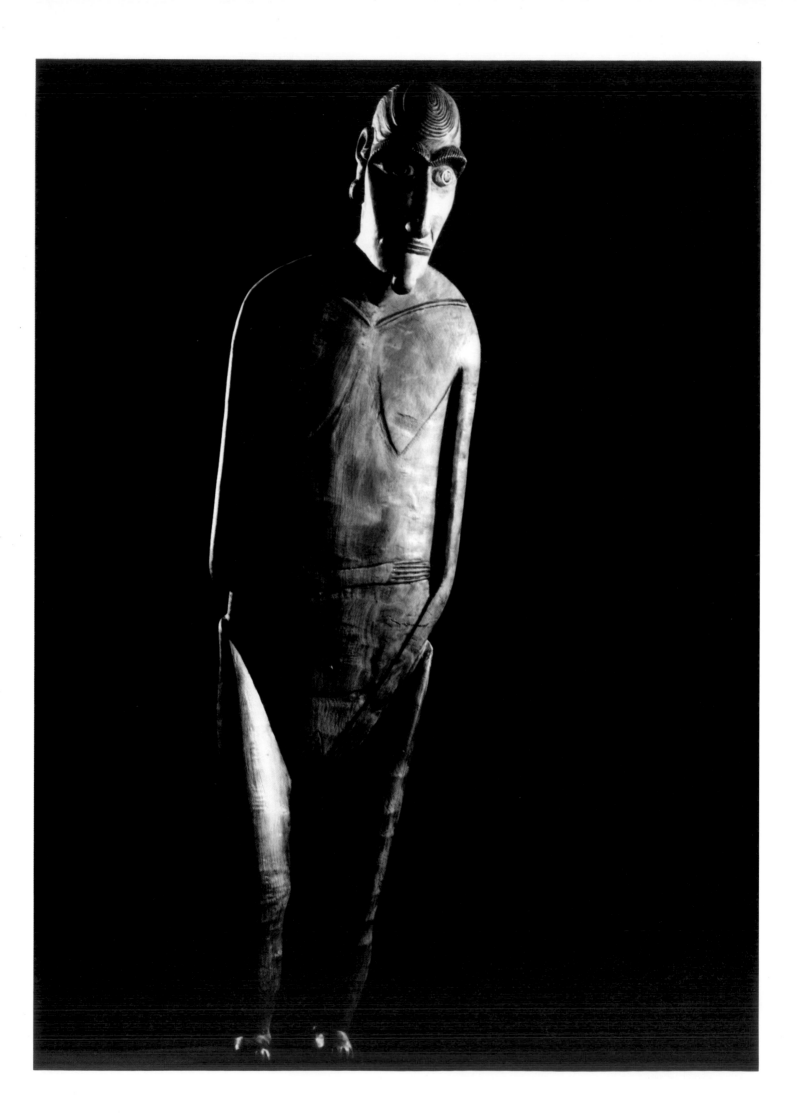

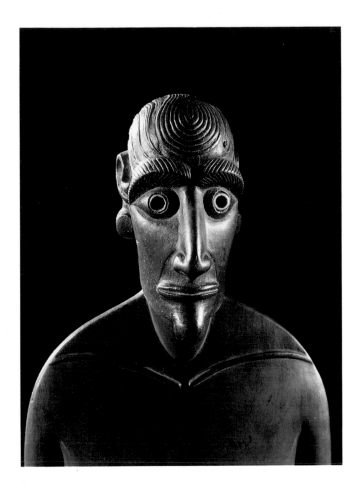 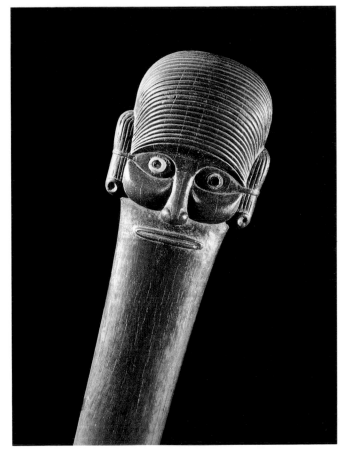

92. Female ancestor figure with beard. Height: 64 cm. The raised design on the forehead represents an octopus, with the spiral forming the body. The design is probably related to tribal affiliations. This figure has a pattern on the back which may have been part of her back tattoo. *Otago Museum*

93. Female ancestor figure. Height: 64 cm, early 19th century. This wooden carving represents the same woman as in 92 (she has the same octopus design on her forehead and tattoo pattern on her back) but is by a different artist. *Canterbury Museum*

94. *Ua* club, the Easter Island form of a two-handed club common throughout Polynesia. Overall length: 174 cm, early 19th century. During the frequent wars ua were used as quarterstaffs. In times of peace they were carried by chiefs as symbols of authority. *Canterbury Museum*

NEXT PAGE

95. Lizard-shaped club made of wood. Length: 36.5 cm, 19th century. These are said to have been protective figures used in dance feasts and at the doors of houses. The reptilian head and human limbs could also refer to the tribal group *hanau mokomoko* (lizard family; *moko* = lizard). In many parts of Polynesia lizards represent illness and death, the gods being thought to inflict illness by sending a lizard to gnaw the vital organs. By the same token, a lizard can represent life. *Auckland Museum*

96. Carving of a woman giving birth, 19th century. The figure has a slot in the back of the projection, and may have been part of a pair of tongs or an ornament. *Otago Museum*

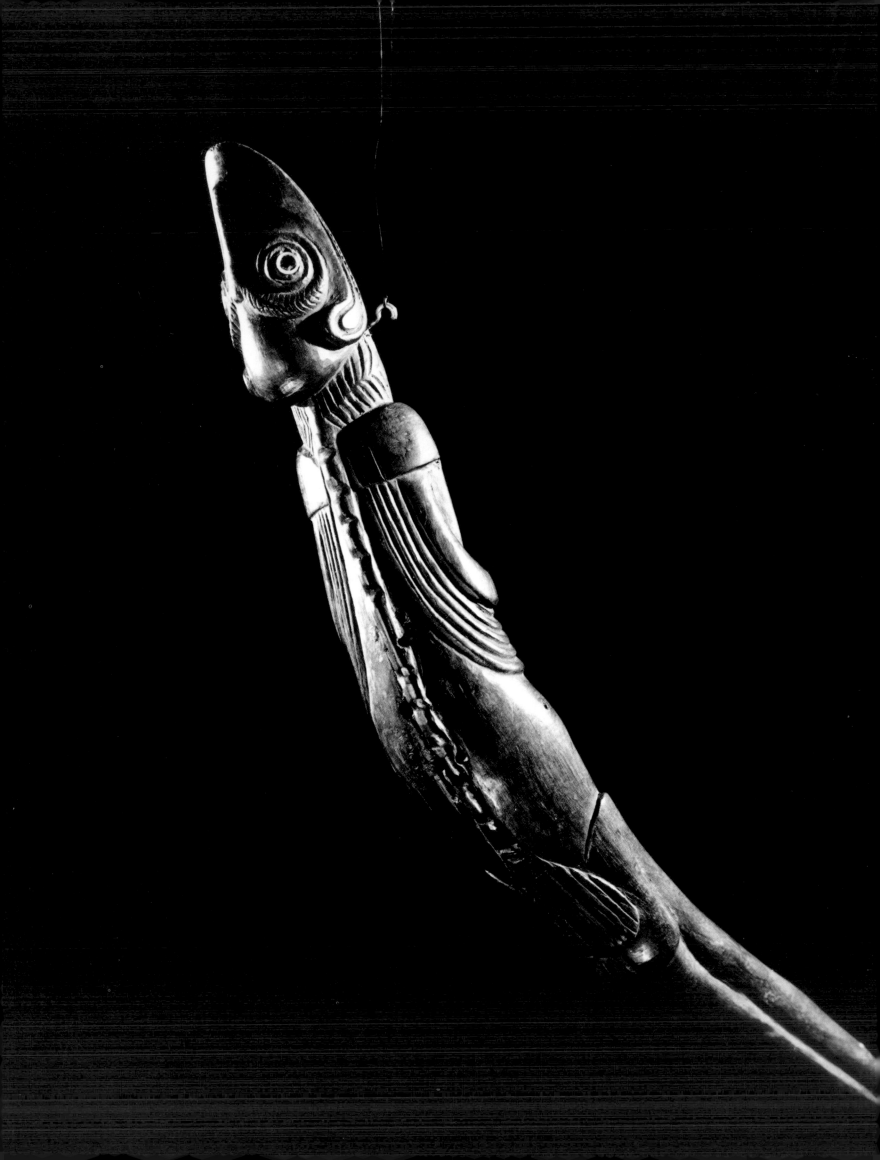

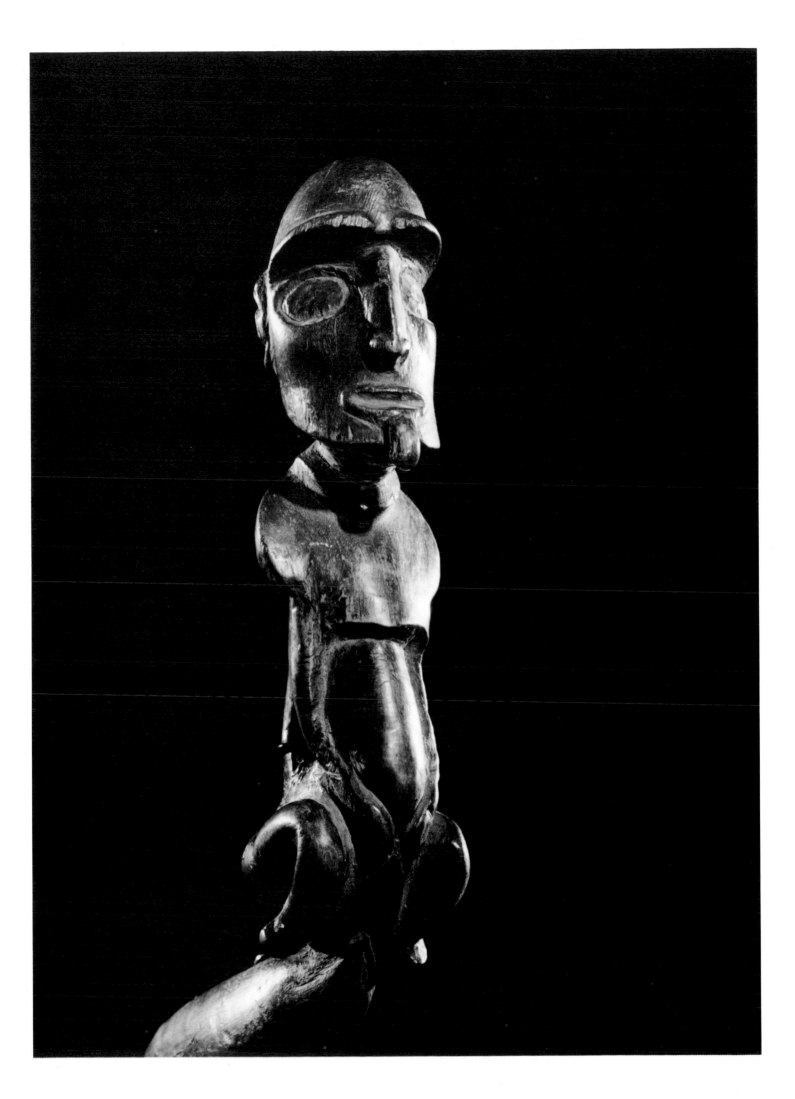

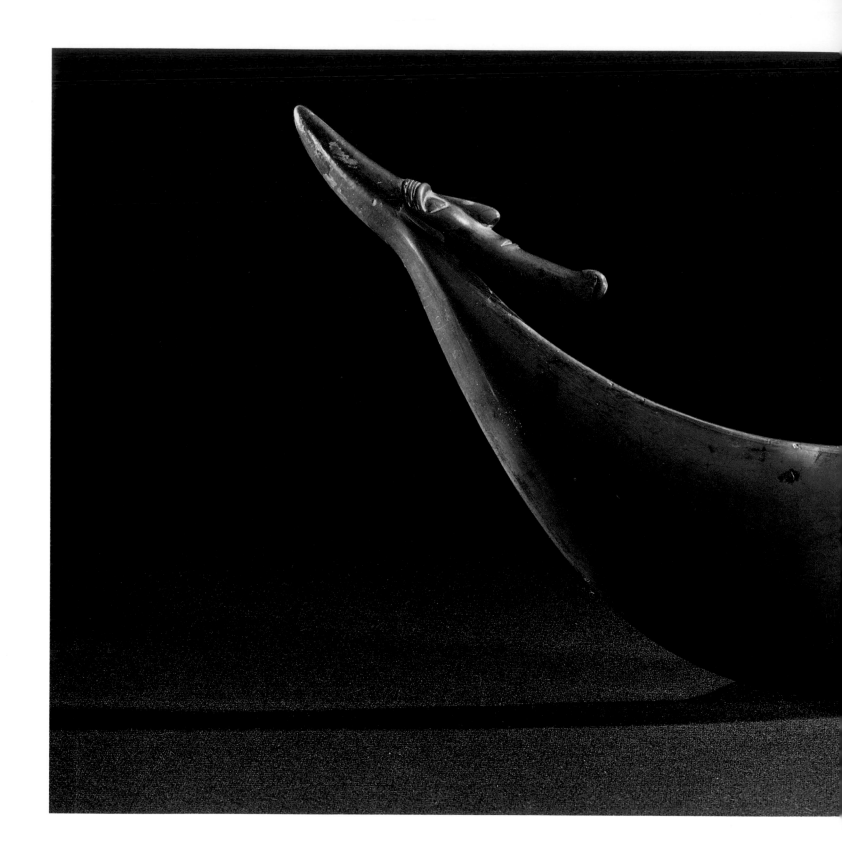

97. Breast pendant (*rei miro*) made of wood. Width: 42 cm, early 19th century. These were prestige ornaments worn by men of rank. They evoke the shape of the new moon. This pendant is pierced at the top for suspension around the neck. *Canterbury Museum*

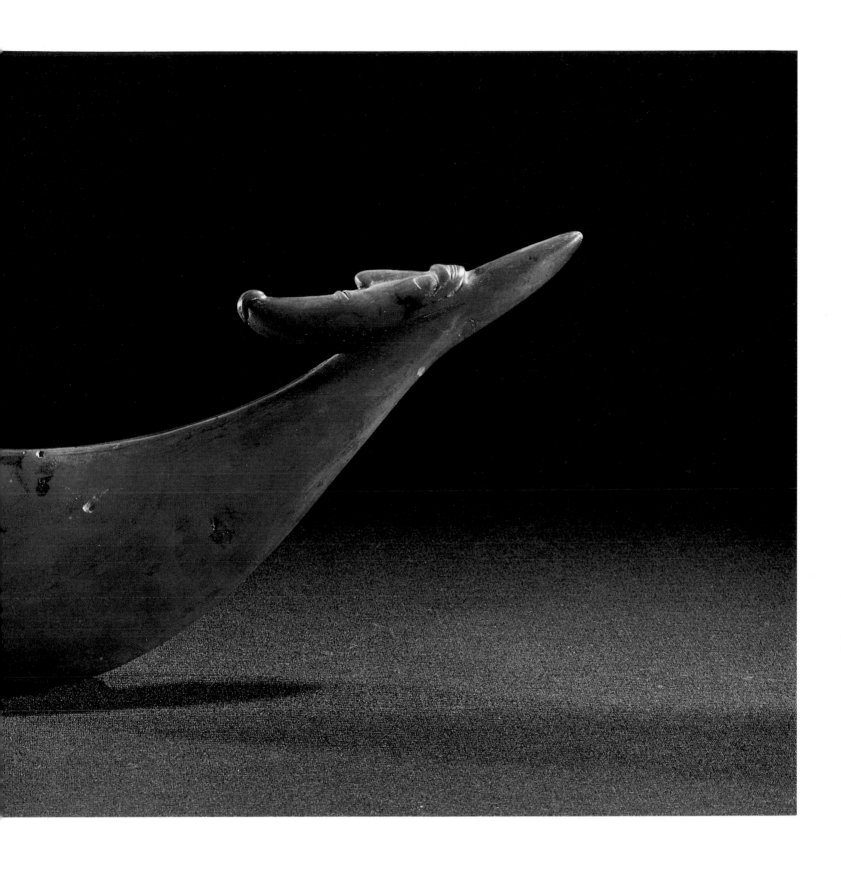

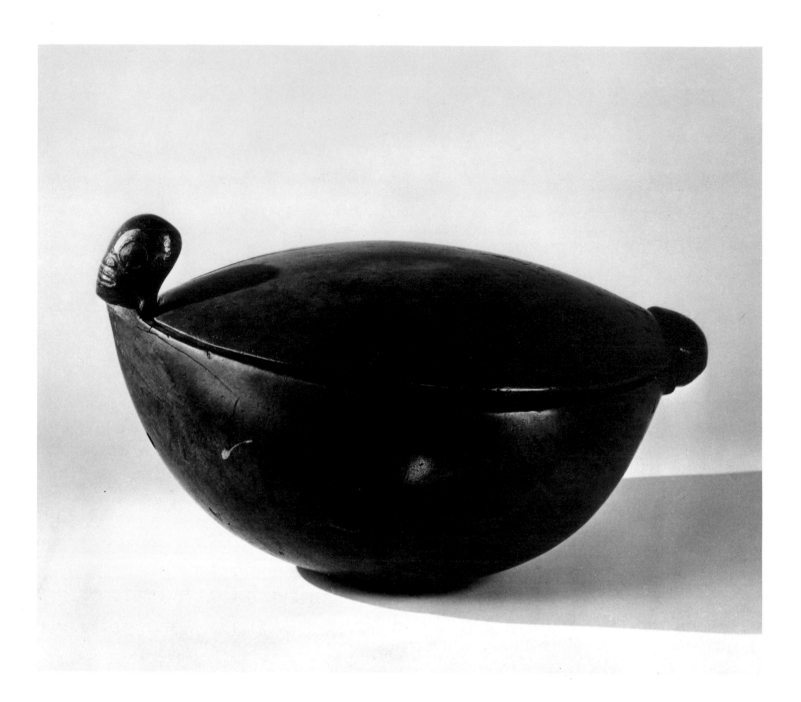

Marquesas Islands

The Marquesas are a chain of ten large mountainous islands and some islets. On the larger islands the terrain is a series of steep-sided valleys leading to a central ridge. Travel between valleys is difficult and it is dangerous by sea. The isolation of one valley group from another led to a tribal system in which warfare and cannibalism were normal activities. Chiefs were usually of respected descent, but leadership ability was more important than lineage. In the valleys people were dispersed but they had a common cultural centre, the *tohua*. Part of the centre was the *me'ae*, a stone-paved marae decorated with sculptured stone figures.

98. Wooden bowl. Length: 53.5 cm, early 19th century. Such bowls were probably used in serving food to a chief on ceremonial occasions. Similar lidded oval bowls were also used for storing valuables. This bowl is shaped like a turtle, despite the human head. The tail end has a recessed lip for pouring. *National Museum*

99. Wooden step for a stilt. Length: 42 cm, early 19th century. Carved steps were used in ceremonial contests between tribes which consisted of stilt races or individual knock-down contests. The centre for the more formal contests was the me'ae. *Auckland Museum*

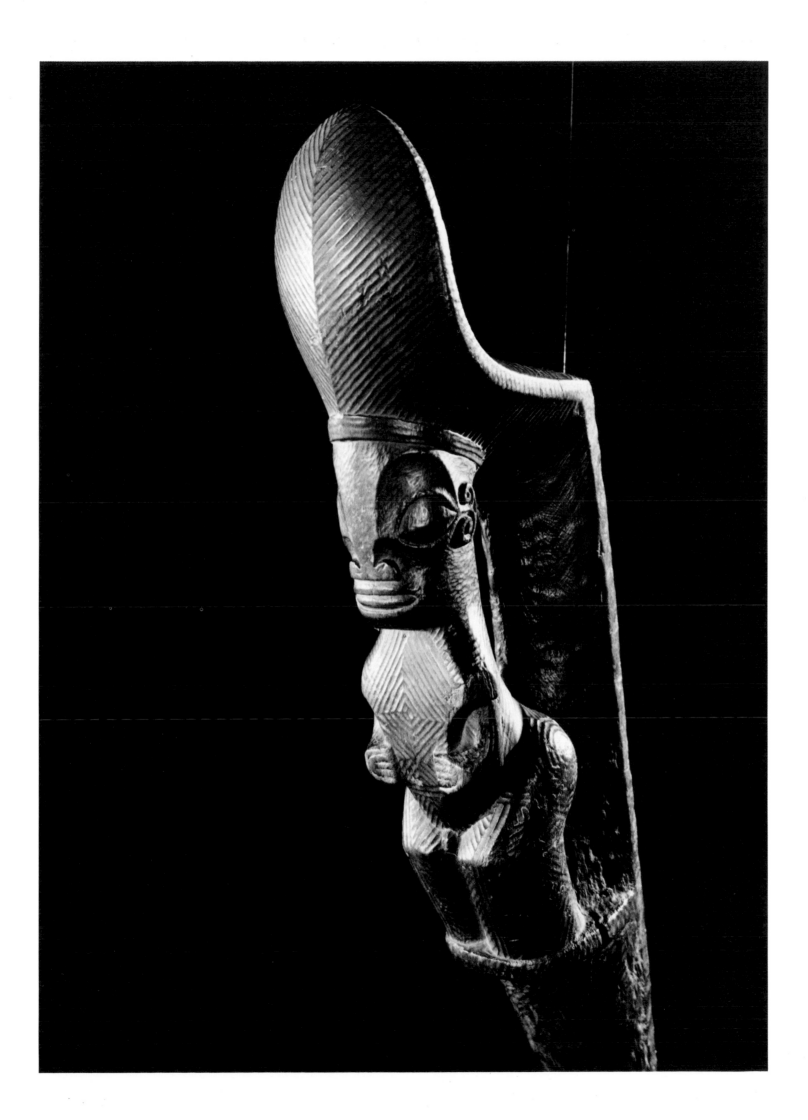

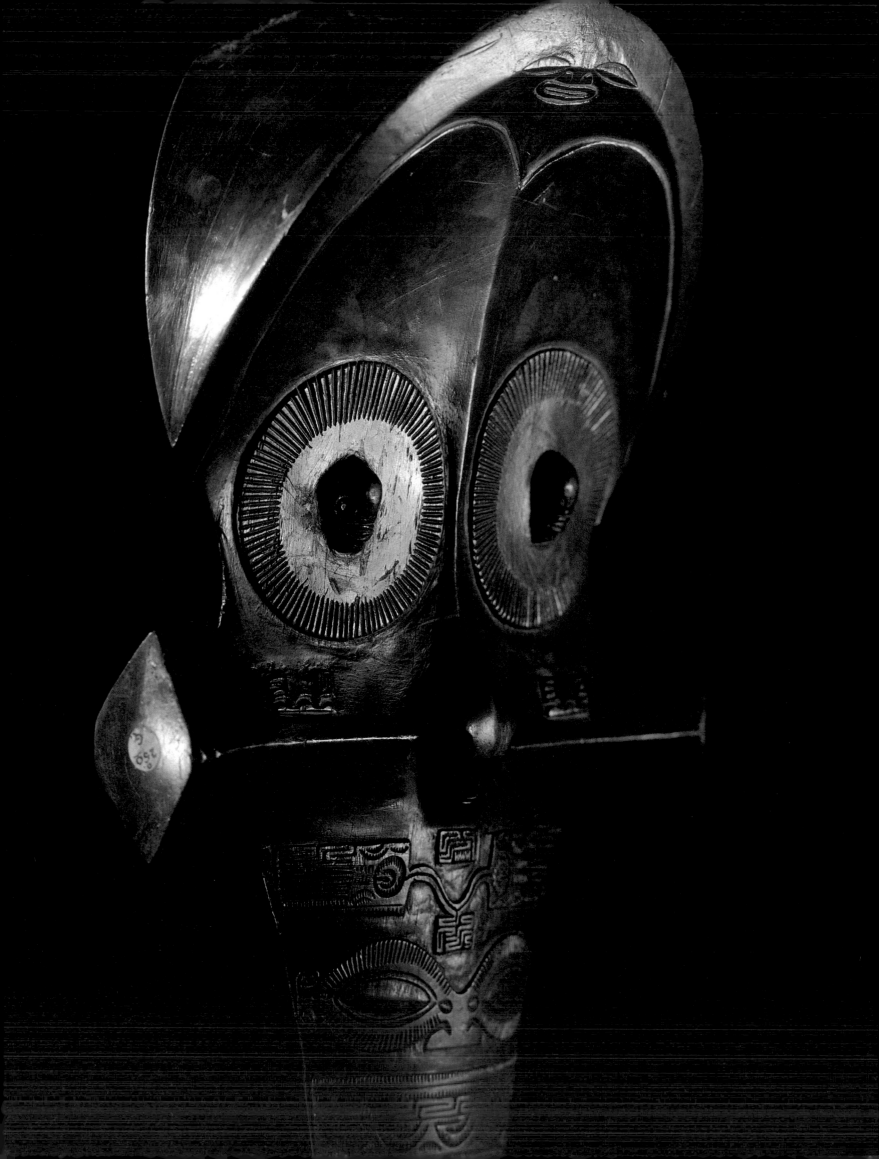

100. Detail of ceremonial club. Overall length: 150 cm, c.1800. There is a standard shape for the heads on clubs such as this, but below the nose the carving becomes individual. They were the work of specialist carvers, each of whom had his own interpretation of an essentially stylized form. *Wanganui Regional Museum*

101. Double stone figure in basalt. Height: 12.5 cm. The low relief goggle-eyes, open mouth, and flexed body with hands on abdomen are characteristic. These figures have a suspension hole in the centre and were used by priests in healing, the images being suspended on a cord carried by the priest. Similar paired figures were made in New Zealand as fishing sinkers which were *mauri* or talismans carried on canoes after propitiation of the gods to ensure safe passage and a good catch; or as sacred tribal symbols of the guardianship of the gods. *National Museum*

New Zealand

Aotearoa, now known as New Zealand, is the largest island group in Polynesia. There are three main islands: the North (Te Ika a Maui), the South (Te Waka a Maui) and Stewart (Rakiura). The first two are over a thousand kilometres long and up to four hundred kilometres wide.

The environment found in New Zealand by the original settlers in about 800 A.D. was one which required cultural adaptation. The climate was cooler; most of the tropical plants which provided the staple foods of Polynesia could not be grown; the sweet potato (kumara) did not naturally overwinter and so storage techniques had to be developed; and the forests supported a rich bird life but, except for the bat, no indigenous mammals. Nevertheless, the land was rich in food resources, and in large trees for building and canoe-making. This different environment was perhaps one of the reasons why Maori art and life came to be so distinct from that of the rest of Polynesia.

The settlers brought with them an eastern Polynesian form of culture. At first they concentrated on hunting birds but eventually cultivation of the sweet potato became a major activity. With increasing population, competition for the best garden land led to warfare. Great earthern forts (pa) were built on hills near the cultivations. At the same time, the generally mountainous terrain and space were reflected in a tribal organization of society and the development of marked variations in art forms and language between different parts of the country.

Early carvings which have been preserved in swamps illustrate a similar progression in art. These carvings, more than anything else in Polynesia, show the development of an east Polynesian art form into a local one. In fact, they suggest that before 1000 A.D. there was a generalized east Polynesian style from which each island group selected and developed their own. There are three particularly important carvings, two of which are included here (102, 104); the third is a bird-shaped bowl found at Ongare Point in the Bay of Plenty (now in the Auckland Museum). These pieces compare directly with items from Ra'ivavae in the Austral Islands, or from Hawai'i, the Cook Islands, or Tikopia. At the same time the source of later Maori forms can be seen in these carvings. It is possible to trace a development from the Kaitaia terminal figures (102) to the Doubtless Bay prow (105) to the *manaia* motif in 138.

Generally in Maori art there appears to have been a development from the geometric design of east Polynesia to a curvilinear style. This is evident in decorated combs found in a stratified site, in tattooing, and in changes to carving chisels. Later Maori carving emphasized the curvilinear to produce the serpentine styles of Northland, Hauraki, and Taranaki (for example, see 111, 113 and 128-132). Most of the serpentine carvings known were made with stone tools.

Soft iron tools were introduced by Cook in 1769 and metal tools were in general use by 1820. The other major style of late Maori carving, the square or frontal style, saw its greatest development with metal tools and is rare in stone tool work. Its vehicle was the enlarged chief's house, which in about 1840 developed into the present ceremonial meeting-house. New meeting-houses were bigger and bigger and the carvings monumental. They stimulated the development of other styles and further marked regional variation.

102. House carving, from Lake Tangonge near Kaitaia. Length: 225 cm, c.1300. This carving has been thought to be a door lintel but since it is carved on both sides with a slotted attachment in the base it is probably some kind of roof combing designed to be seen from both sides. The decorative notching and 'Polynesian' appearance of the central figure suggest that this carving is early in the development of Maori art styles. The concept, with central figure and outward-facing manaia or lizard-like forms at each end, can be compared directly with that of later lintels. *Auckland Museum*

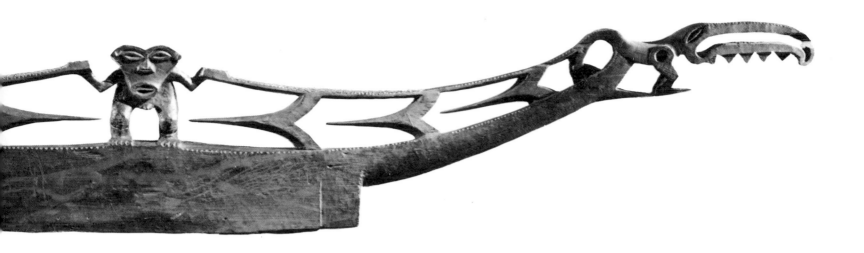

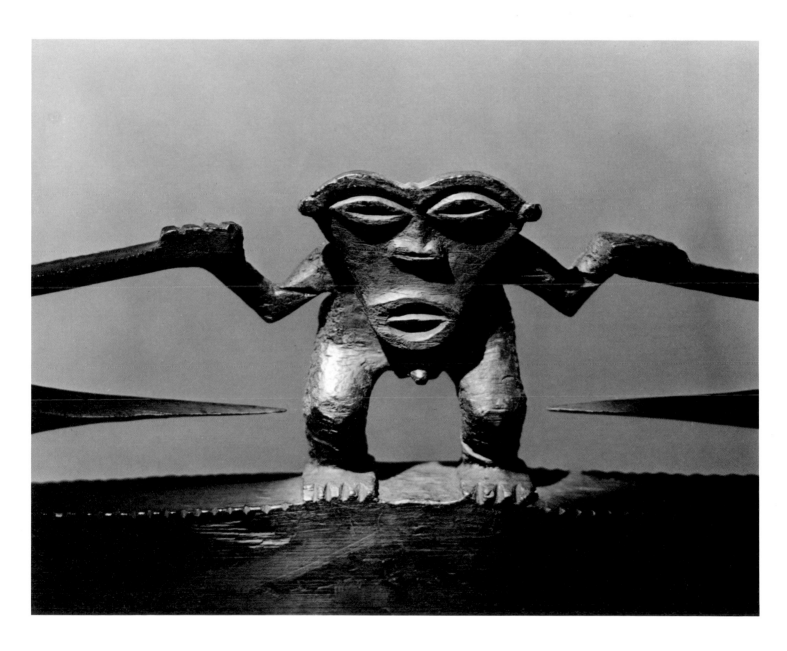

103. Upper section of a carved post, dwelling-place for the spirit Uenuku, found at Lake Ngaroto near Te Awamutu. Overall height: 267 cm, early Maori. According to tradition Uenuku was carried to New Zealand in the Tainui canoe in a wooden carving about 25 cm tall. The guardianship of the carving was entrusted to one family. At some time the spirit was transferred into this post which was used as its official home. When the safe-keeping of the post was threatened by tribal war, or if the guardians were making war, the spirit was taken from the post and re-invested in the small carving which was then carried into battle as a powerful force for conquest. A third carving was also used as a dwelling-place for Uenuku and is today the home of the spirit, protected by the descendants of the appointed guardians. *Gavin Gifford Memorial Museum*

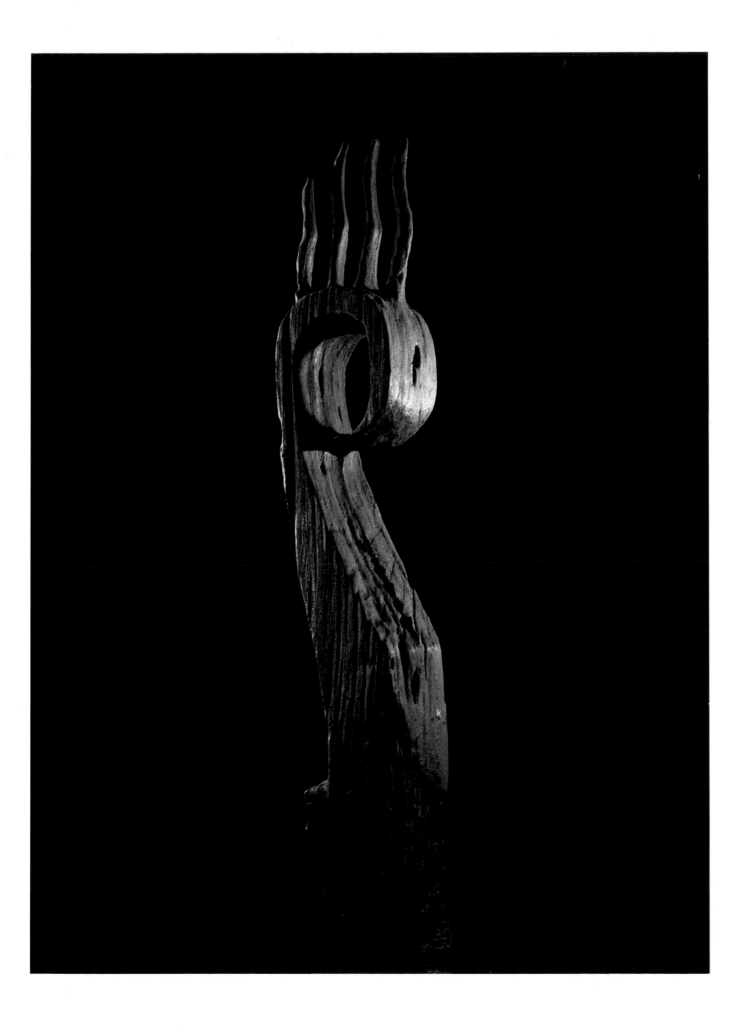

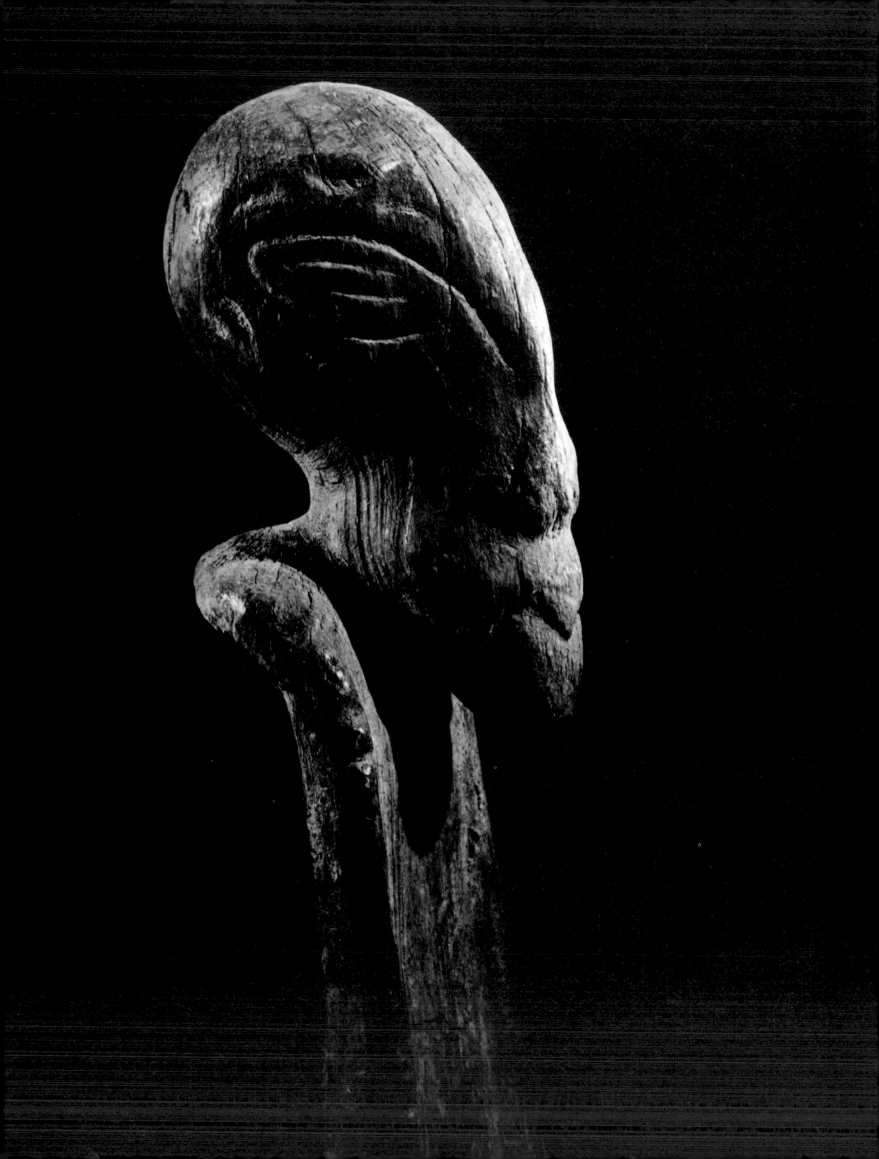

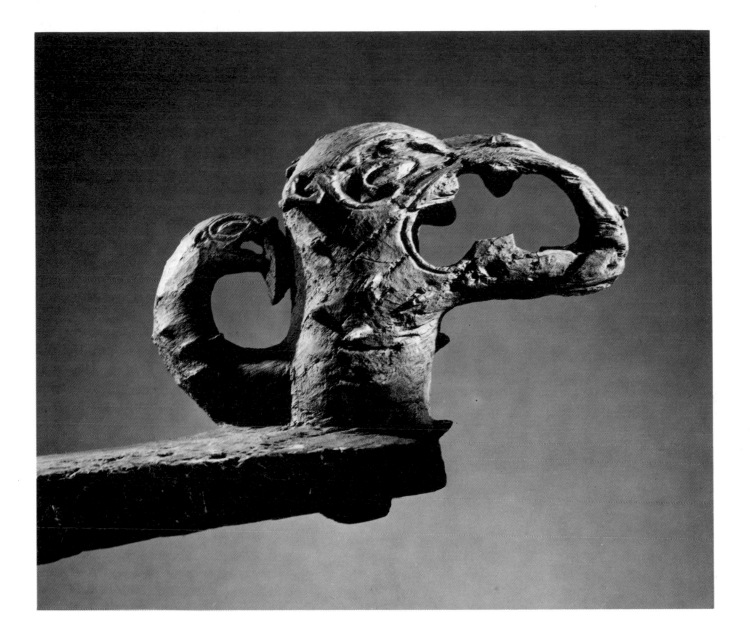

104. Step for a digging stick (*ko*), from Mahurangi near Auckland. Height: 9 cm, c.16th century. *Auckland Museum*

105. Canoe prow figure, found on Tokerau Beach, Doubtless Bay, Northland. Overall length: 107 cm, c.16th century. As in the carving in 104, the shape of the eye relates this figure to the Polynesian styles. But as a whole the figure recalls the manaia of later carving and so this prow is transitional, being neither Polynesian nor Maori. *Auckland Museum*

NEXT PAGE
106. Wooden bone box, from Northland. Dimensions: 65 x 18 x 22 cm, c.16th century. Bone boxes were used for secondary burial after exposure of the corpse on an *atamira* (platform). This box was for the bones of a child. *Auckland Museum*

107. Carving of a dog, from Monck's Cave at Sumner, near Christchurch. Length: 7.6 cm, c.1675. This is a stylized treatment of the fox-like New Zealand dog. The figure may have been an amulet. *Canterbury Museum*

108. Breast amulet, shaped from the tooth of a sperm whale, from Okain's Bay, Banks Peninsula. Length: 13.7 cm, early Maori. The carving features a parrot. *Canterbury Museum*

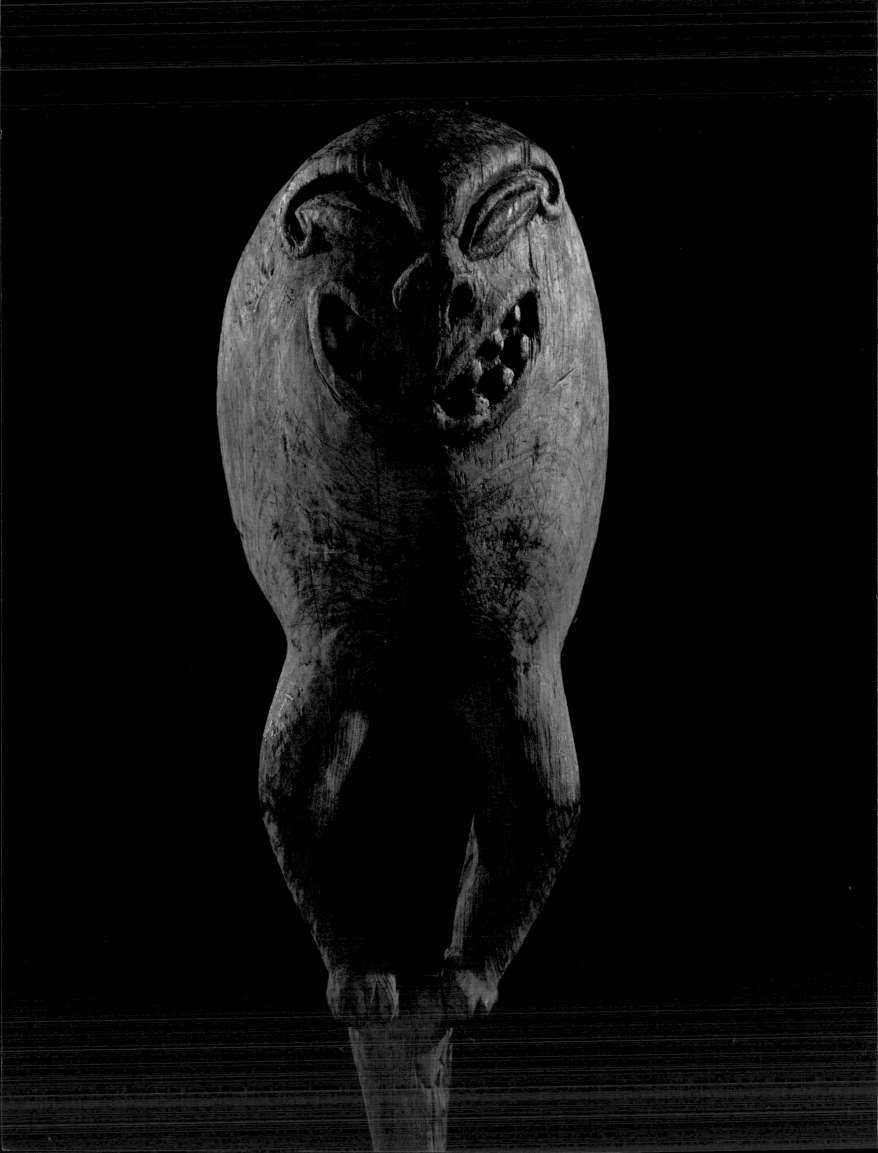

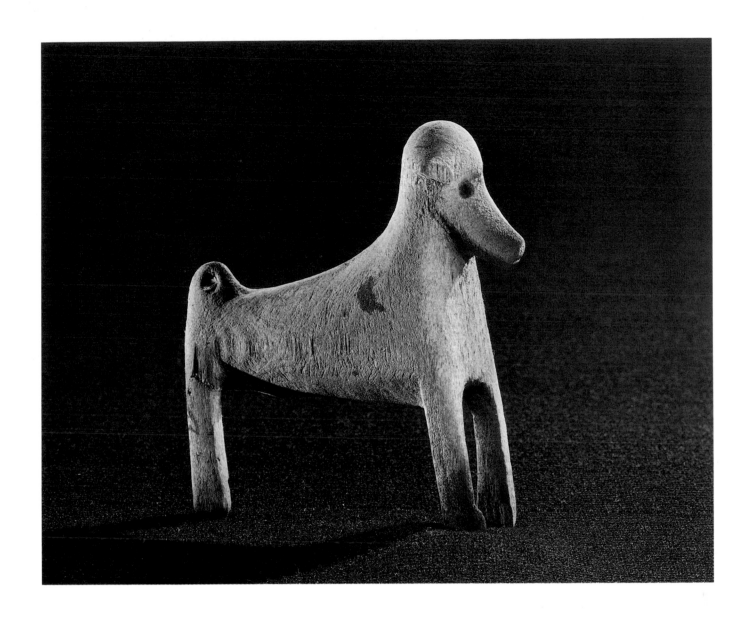

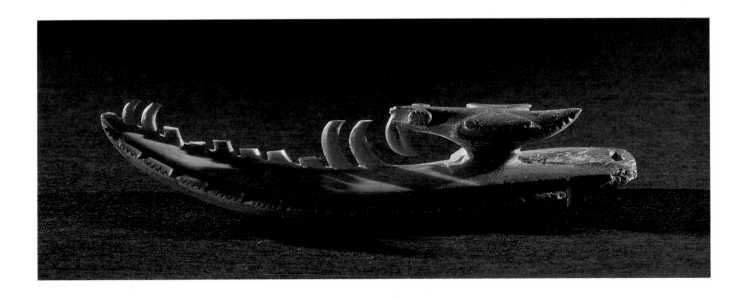

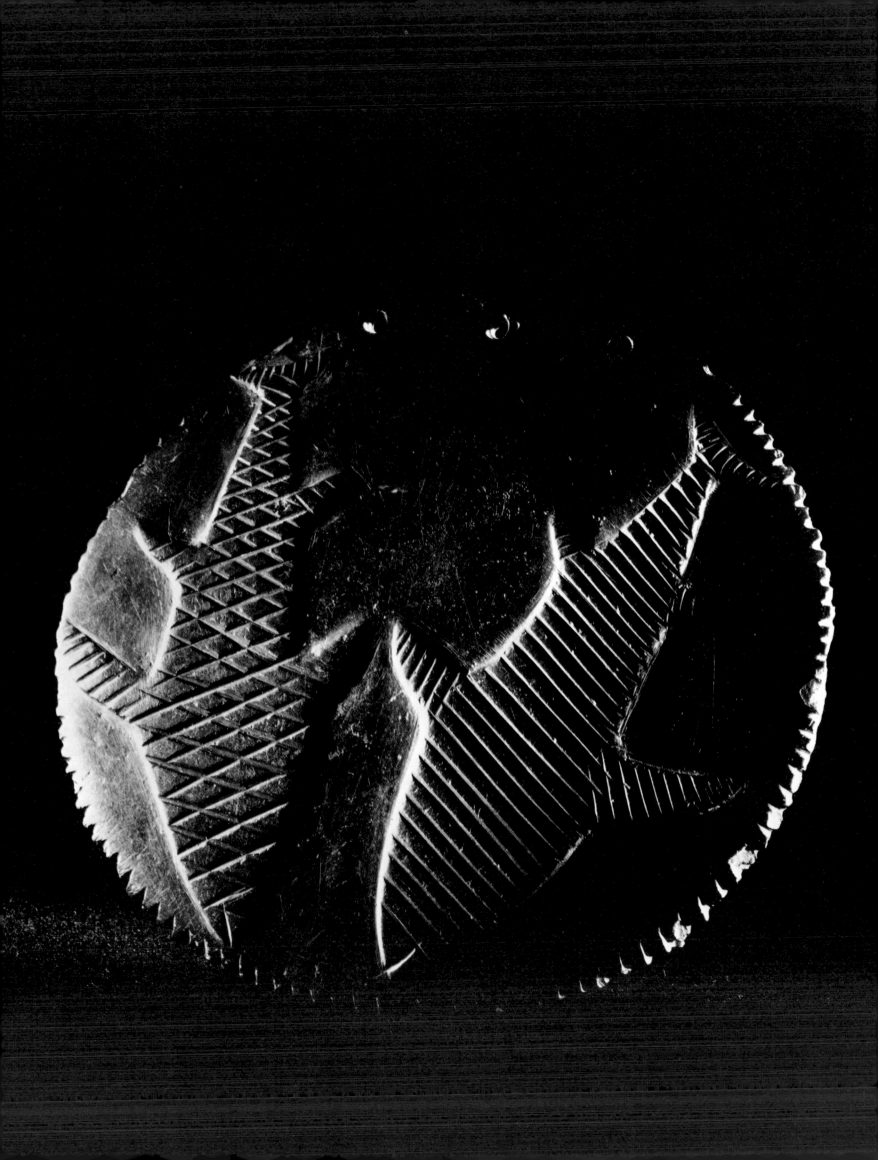

109. Breast-plate ornament, from Okain's Bay, Banks Peninsula. Diameter: 17.8 cm, early Maori. It is a copy in stone (dark serpentine from Nelson-Marlborough) of the pearl shell breast-plates of island Polynesia (see 68). The notched edges are typical of early Maori art. The stylized fish are tunny. *Canterbury Museum*

110. Adze found in a cache at Ellesmere Spit, Canterbury. Length: 29.8 cm, c.1200. This adze is of east Polynesian type but is made from baked argillite rock found at the northern end of the South Island. Adzes made from this rock were traded over the full length of New Zealand between 1100 and 1400. *Canterbury Museum*

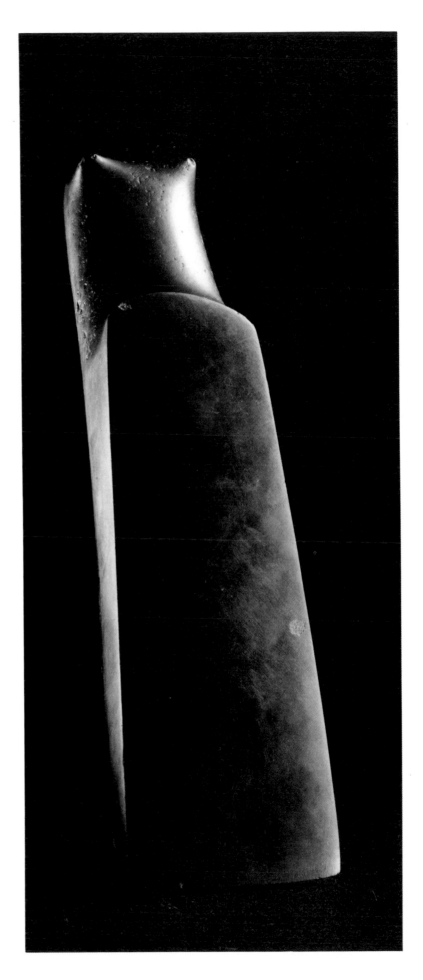

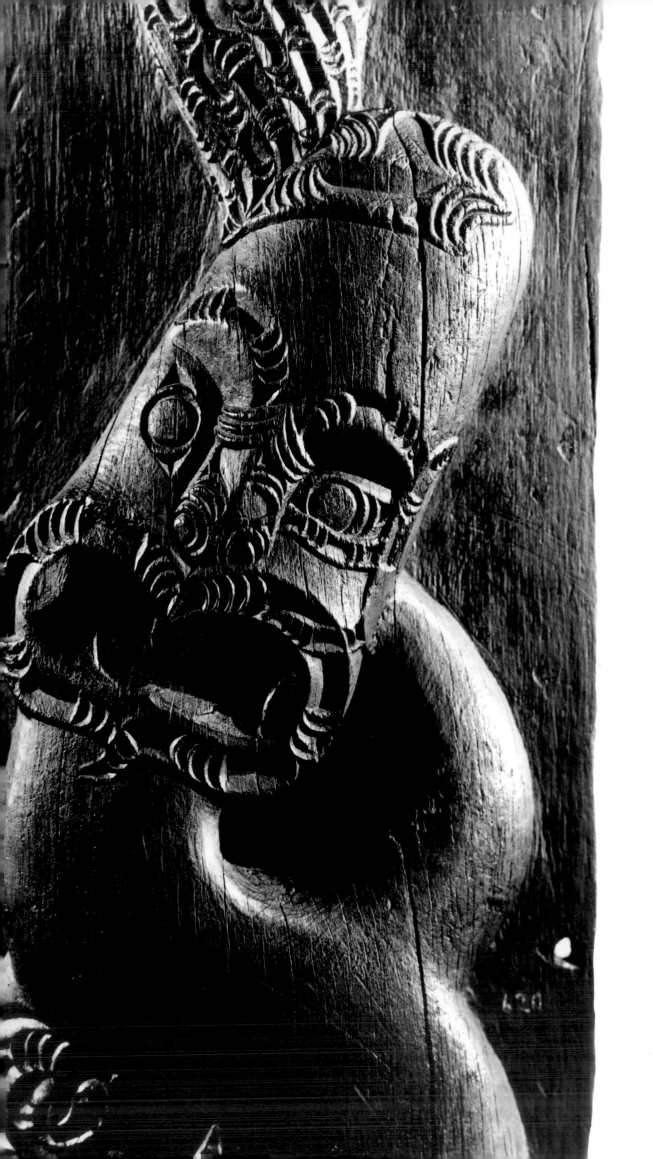
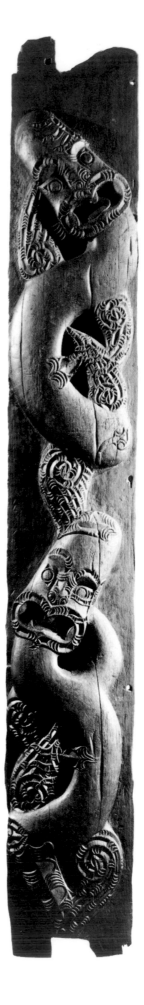

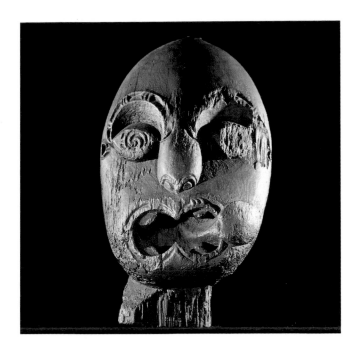

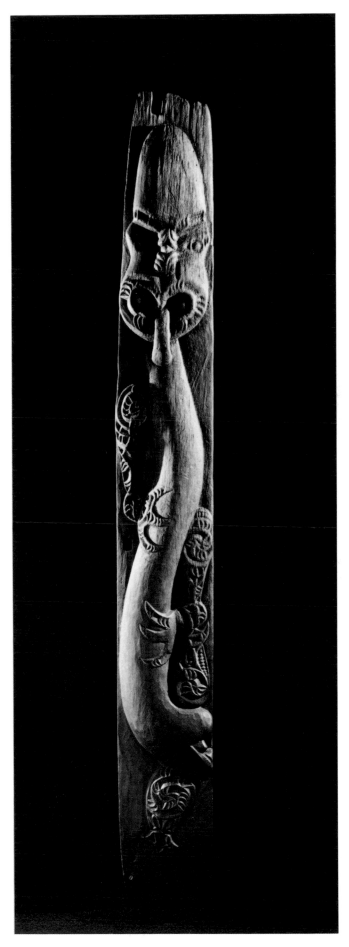

Northland

This is the narrow part of the North Island north of the Auckland isthmus. The west coast from Auckland to Kaipara is the domain of the Ngati Whatua tribe. The central area and the Bay of Islands are occupied by the Ngapuhi confederation with Kapotai, Ngati Wai and other tribes on the east coast south of the Bay of Islands. Doubtless Bay is the territory of the Ngati Kahu, with Te Rarawa at Kaitaia and Te Aupouri in the far north. One of the major carving styles of the Northland area is the serpentine style of Hokianga and Kaipara where the human figures have a sinuous tubular body and heads with high domed foreheads. The other major style is the square style of the Bay of Islands, where human figures are frontal with rectangular heads.

111. Carved door-jamb. Height: 245 cm, 1650. Traditionally this is a door-jamb for a house called Tutangimamae which stood at Manakapua in the central Kaipara. It was later re-erected at Otakanini Pa near Helensville where it remained until it was hidden from Ngapuhi raiders in about 1820. The figures represented are *maraki*, legendary water monsters which were sometimes the scourge, sometimes the guardians, of the local people. *Auckland Museum*

112. Carved head from the northern Wairoa River at Dargaville. Height: 42 cm, 18th century. The head is possibly from a bone box. *Auckland Museum*

113. Carved door-jamb. Height: 89.5 cm, 18th century or earlier. This is from a kumara (sweet potato) storehouse which stood at Takahue near Kaitaia. Kumara storehouses were one of the prestige structures in a village. *Auckland Museum*

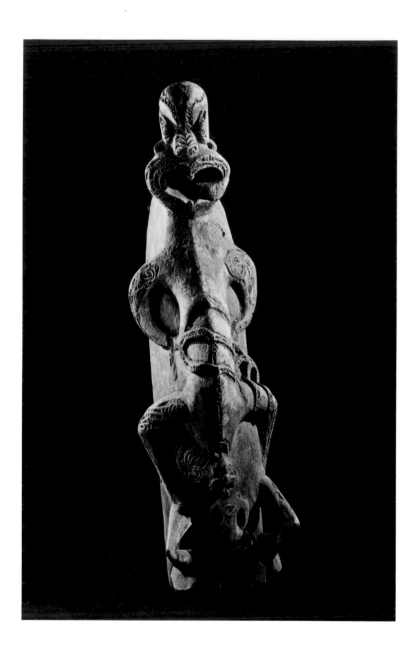

114. Carved bone box from the Bay of Islands. Length: 102 cm, 18th century or earlier. The figure represented is Hine-nui-te-po, goddess of the underworld. The small figure between her legs is Maui, the culture hero who attempted to reverse the process of birth. He failed because his bird friend the fantail laughed just when his head was inside his grandmother. She awoke and crushed him, thus ending the attempt to conquer death. Bone boxes held scraped and painted bones, but were also designed to frighten anyone who might accidentally come across a cave burial place. *Auckland Museum*

NEXT PAGE
115. Carved bone box from the Bay of Islands. Length: 100 cm, 18th century or earlier. *Auckland Museum*

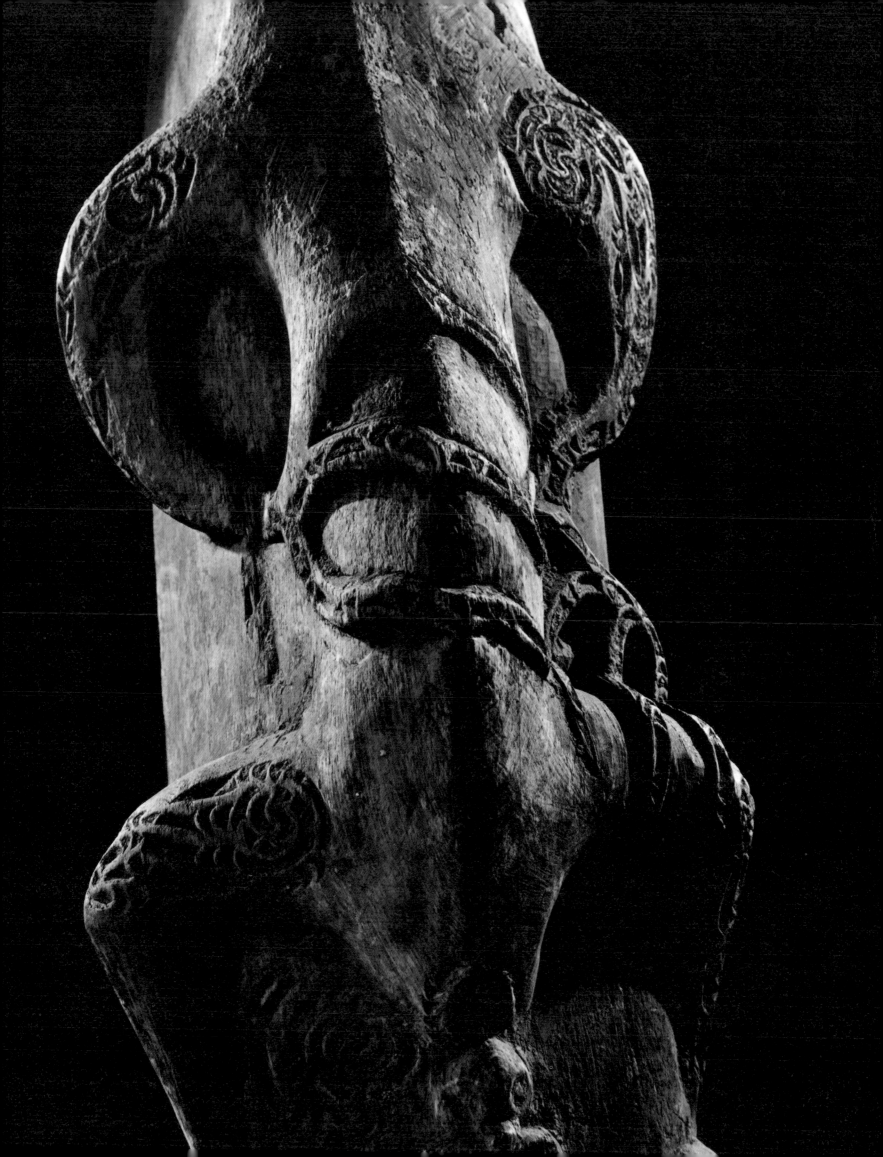

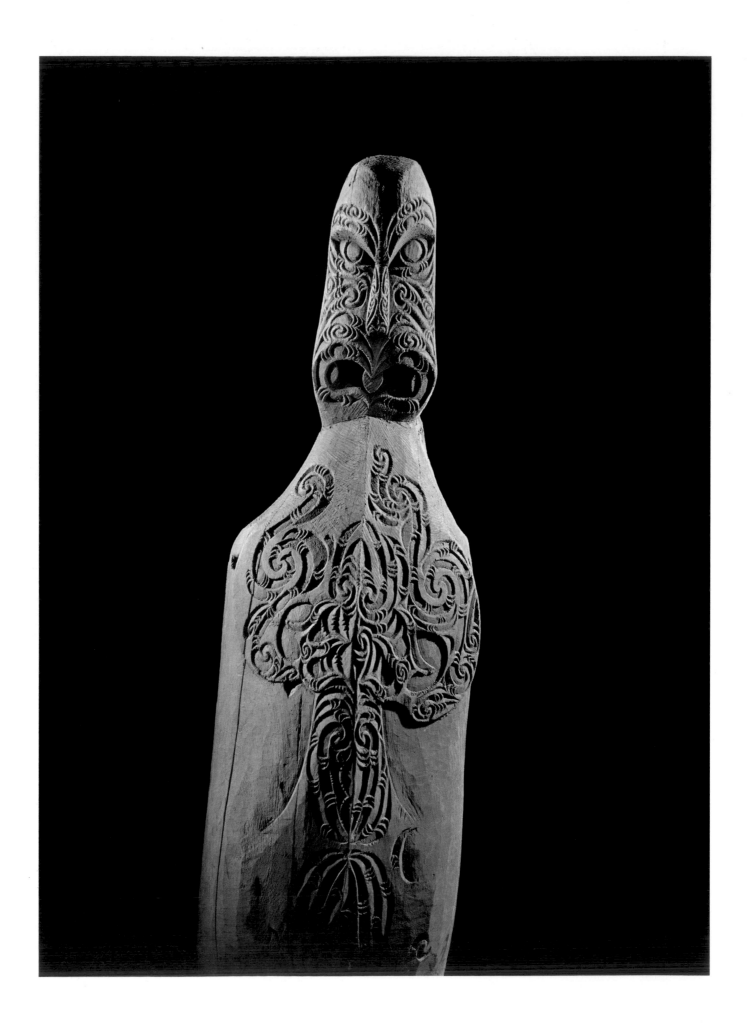

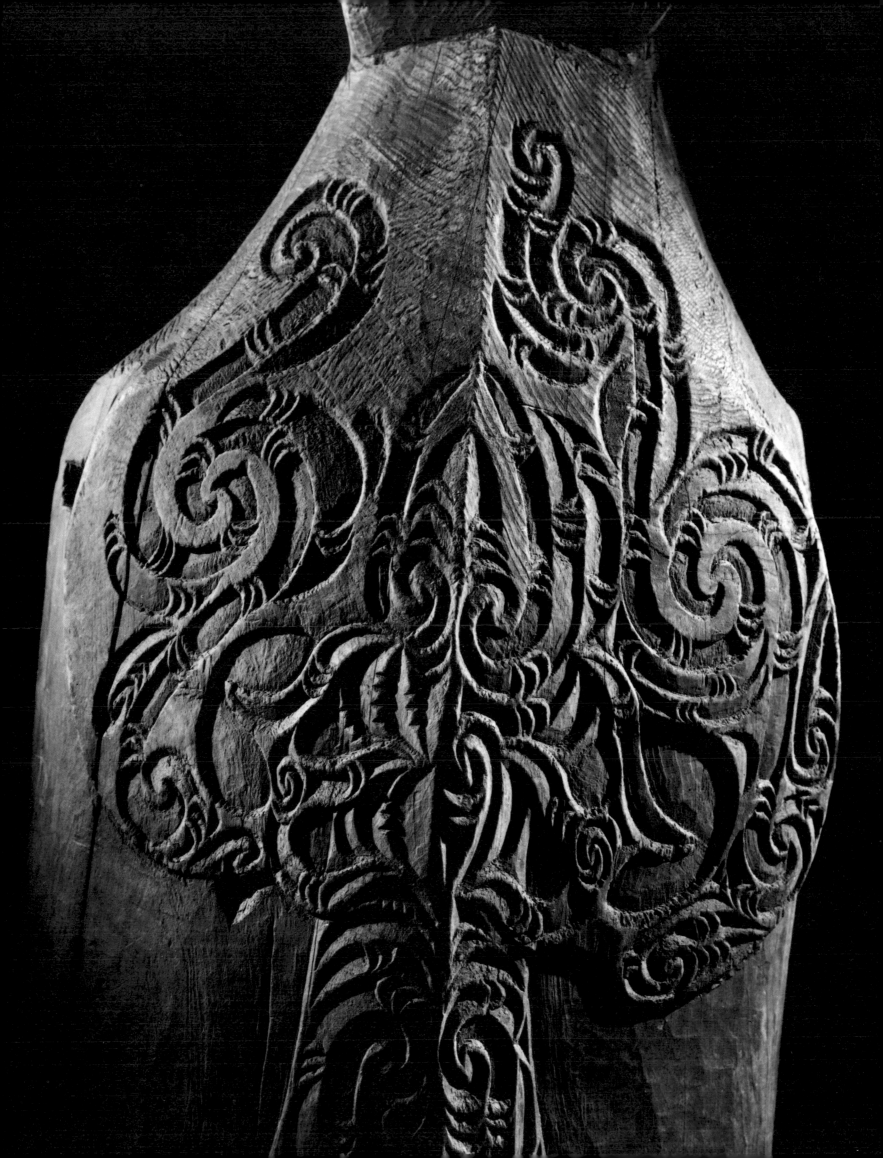

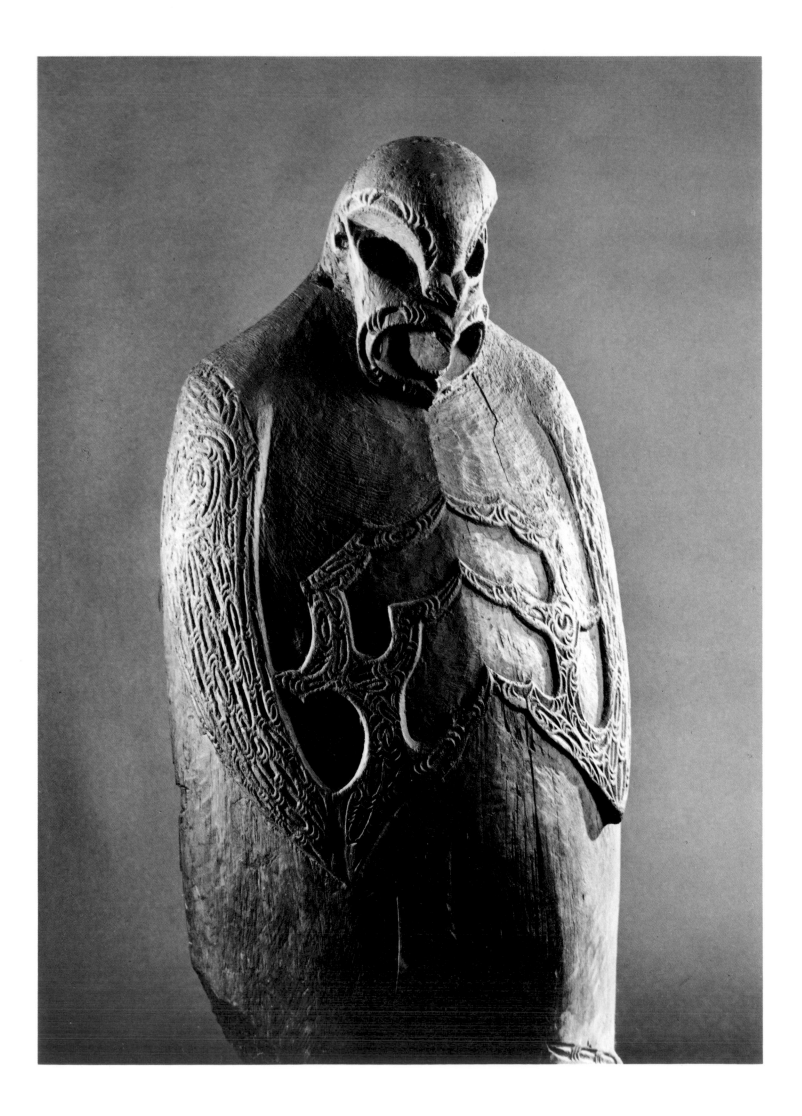

116. Carved coffin box. Length: 99 cm, late 18th century. This box, said to be from Raglan, is in a Northland style. Raglan is the furthest south these boxes have been found. *National Museum*

117. Carved *putorino*. Length: 36 cm, 18th century. This instrument can be played as a flute or bugle. In either case it will produce two notes. Putorino are said to have been used to signal the people when a chief was returning to his village after an absence. *Auckland Museum*

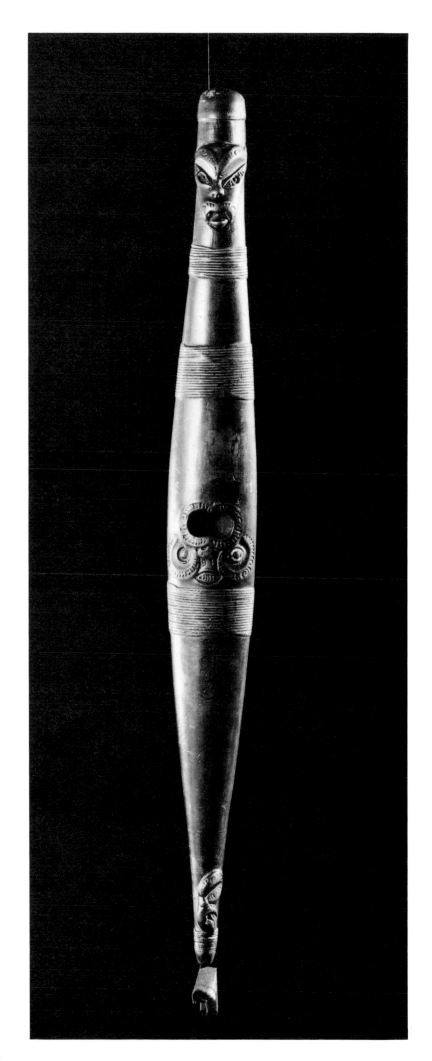

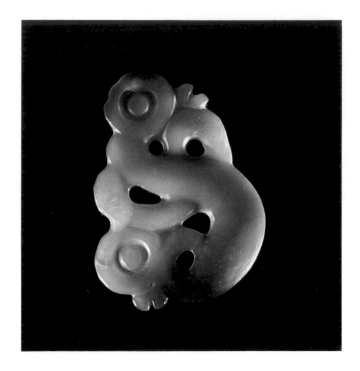

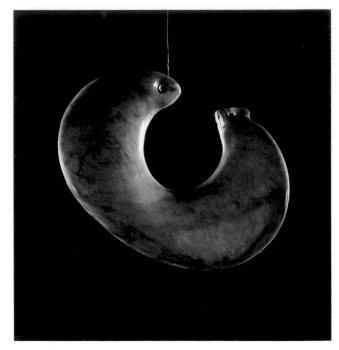

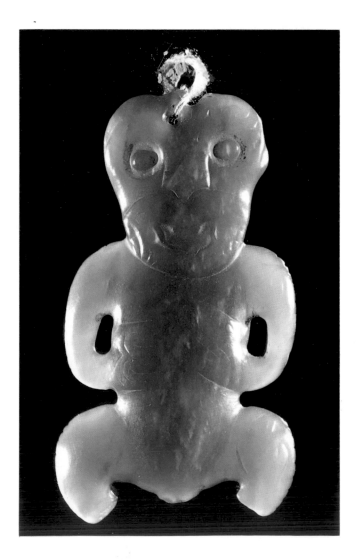

118. Greenstone *pekapeka*, from Hokianga. Length: 6.8 cm, 18th century. The style of this neck ornament relates to wood carving styles in the same area. *Auckland Museum*

119. Greenstone *hei tiki*, from Ruapekapeka. Length: 9 cm, probably early Maori. Tiki is the progenitor god in most parts of New Zealand. He is also the personification of the male genital organ. Any carving in the shape of a man is called a *tiki* whether it be in stone, wood, or other material. Here it is a *hei*, or pendant, tiki. If a tiki has been owned it has gathered mana, prestige. An heirloom tiki may have more mana than any living member of the tribe. The person who has the keeping of a tiki, if the rightful descendant, will gain mana from it. It is not uncommon for a tiki to be welcomed onto a marae in its own right as the carrier of the mana of the ancestors. The upright stance of this tiki is characteristic of what is possibly the earliest tiki form in New Zealand. *Otago Museum*

ABOVE
120. Greenstone *hei matau*, from Pukepoto near Kaitaia. Height: 9 cm, 18th century. This is a ceremonial fish hook form. Possibly the hei matau was the prerogative of especially skilled fishermen or perhaps the form recalls the hook with which Maui fished up the North Island of New Zealand. *Auckland Museum*

121. *Rei puta* (man's breast pendant) of sperm whale tooth. Length of tooth: 16.2 cm, 1769-70. Rei puta were seen by Captain Cook but were not common after his time. The northern form has two eyes and no other features. In the south a complete face is etched on the end of the tooth. *Canterbury Museum*

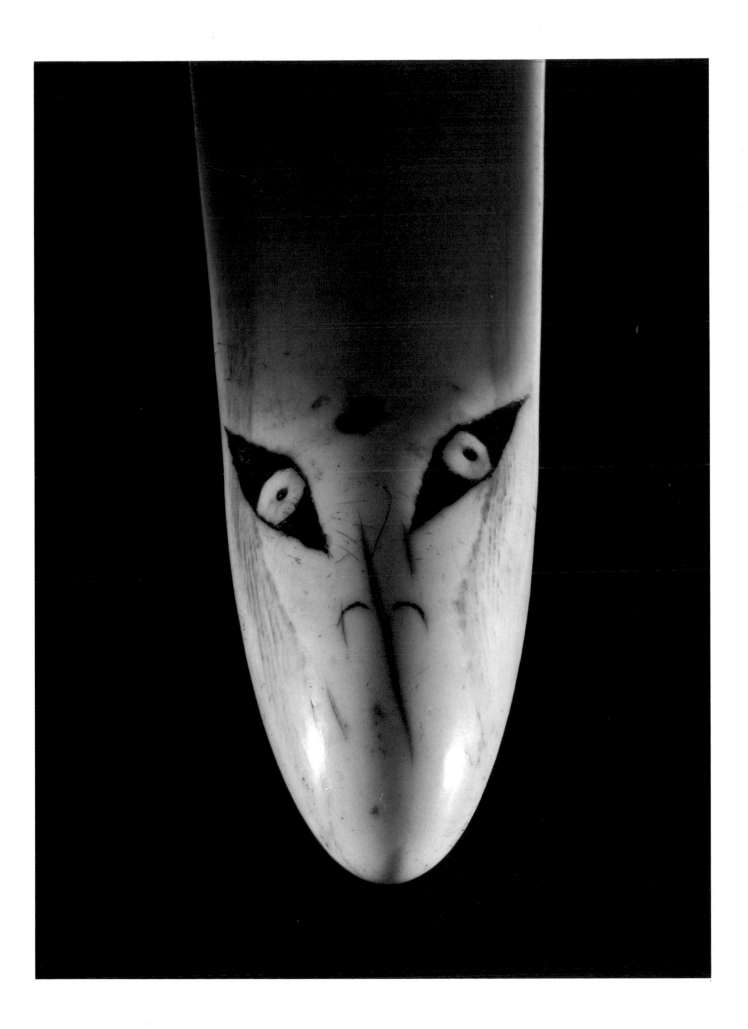

122.	Detail of a *wakahuia* (treasure box) found at Rangiahua, Hokianga. Overall length: 42.5 cm, 18th century. Wakahuia were designed to be hung in the rafters of a house. In them were kept the very personal objects: greenstone tiki, feathers and other adornments which were worn on the body and therefore embued with the tapu of the wearer (see also 136). *Auckland Museum*

123.	Detail of a carved feeding-funnel in the style of the Bay of Islands. Length: 17 cm, early 19th century. The funnel was used when the face was swollen after tattooing of the mouth area. *National Museum*

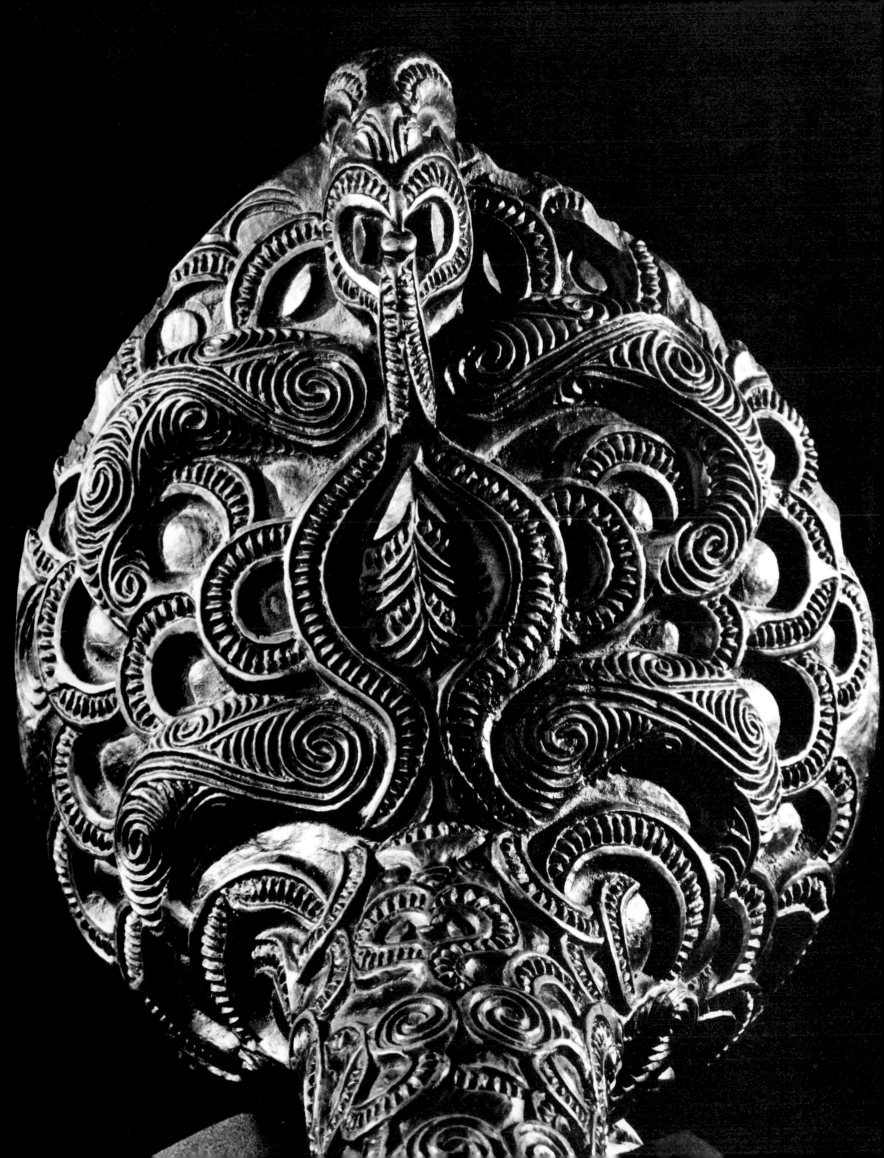

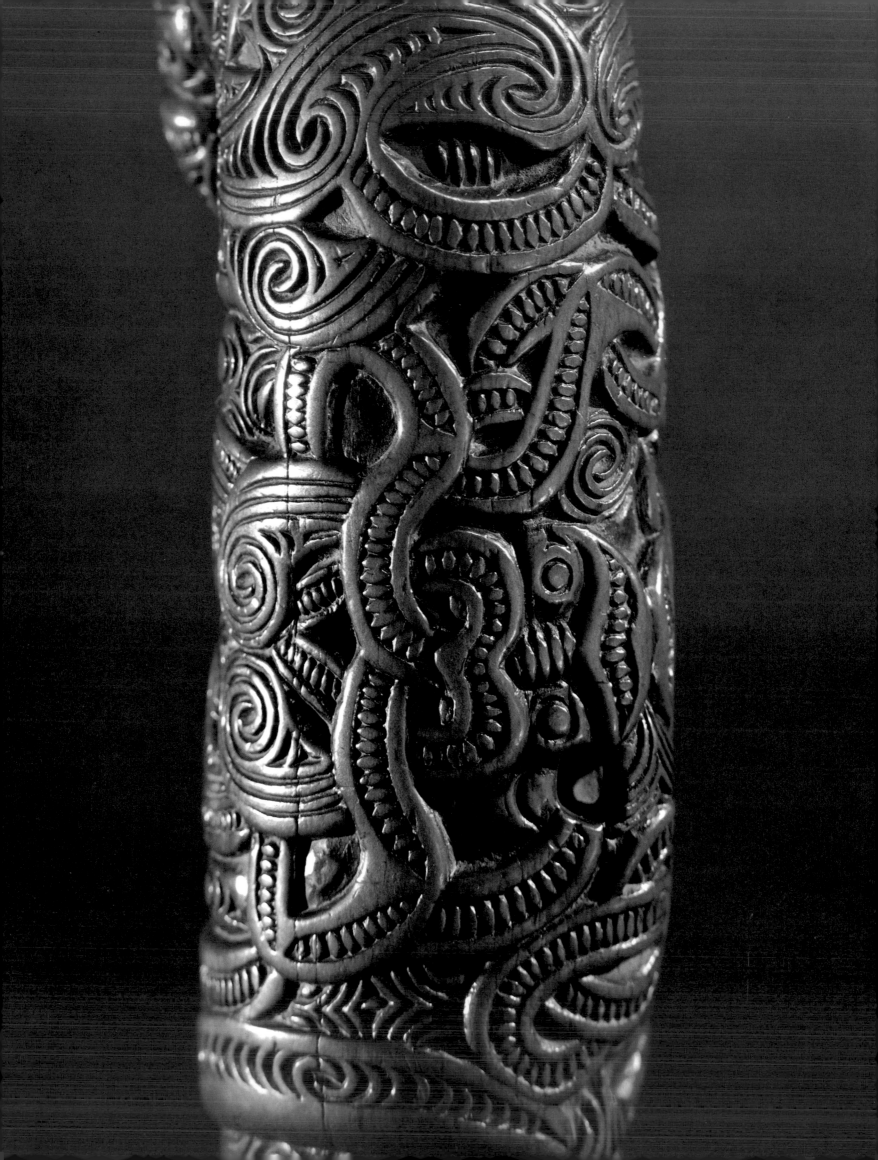

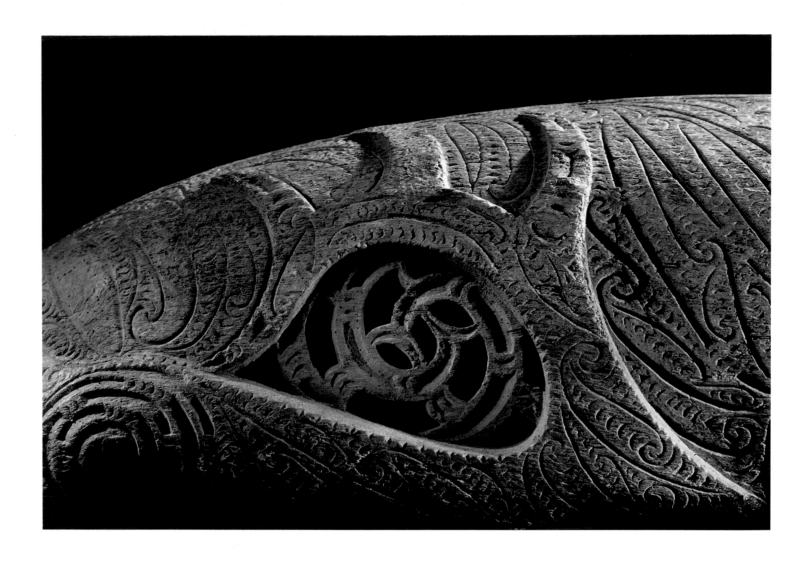

124. Detail of a carved *nguru* (flute). Length: 14.8 cm, early 19th century. The flute is in the shape of a penis. *National Museum.*

125. Detail of a bone box from Waimamaku, Hokianga. Overall length: 180 cm, 18th century or earlier. This detail of the arm area shows the rolling and fretted spirals used on the treasure box from the same area (122). *Auckland Museum*

NEXT PAGE
126. Detail of a *wahaika* (club). Overall length: 40.5 cm, late 18th century. *Auckland Museum*

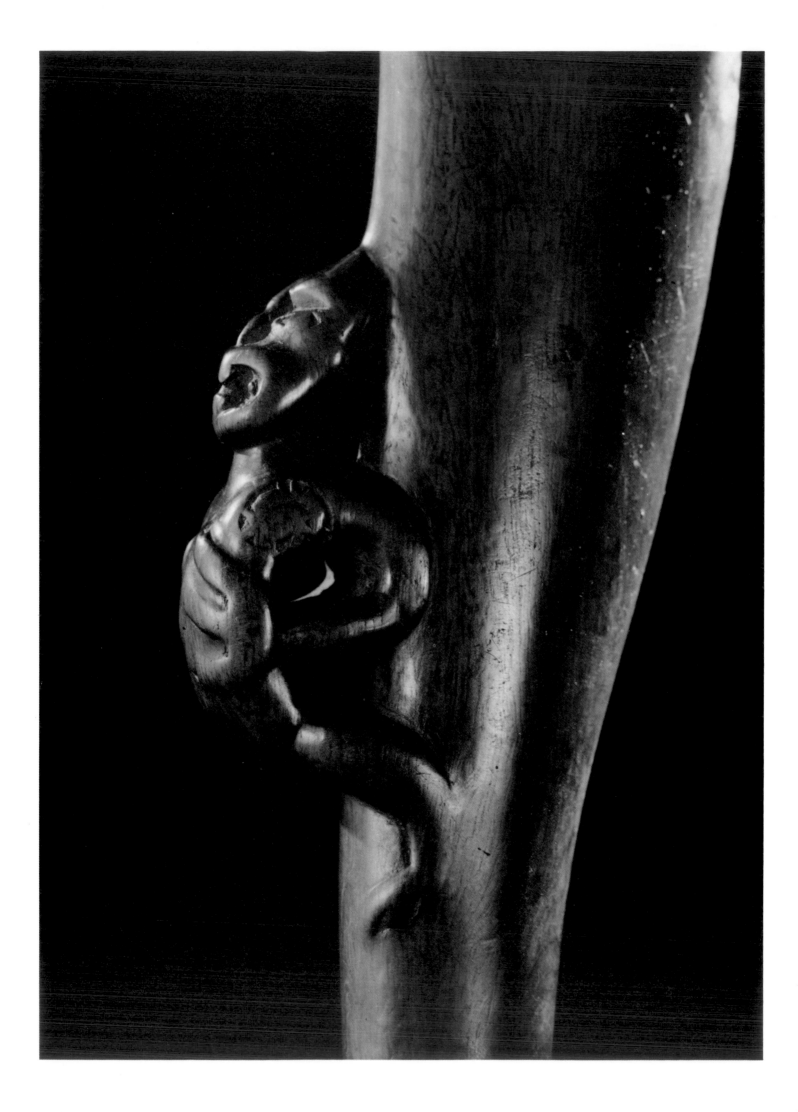

The pedestal

The New Zealand Maori is one in ten in a majority European culture. Until recently, because of freedoms practised for more than a century – especially the freedom for Maori and Pakeha to intermarry – it was thought that differences would vanish and the two races eventually blend.
The speaker is a craftsman living in a provincial town.

Ten of them chose me and I was put in charge of the meeting-house. I was already carving – I started carving at nineteen. We were all new at it. Then I was put in charge of the meeting-house over my uncles and my older brother – I didn't like it. I said, 'What are you fellows trying to do to me?' I was afraid. Carving, it's such an unusual job anyway and then to *assume* the position of master carver over my older brother was very scary. It's a very spooky thing.

They put me on this pedestal and I was in charge of the ten of them. It's a very lonely place.

It's hard for someone to whom the knowledge isn't given freely. And after being called 'dumb' at school. And being a younger brother in a family of fifteen – you don't get the support of the elders like the first-born does. When I was ten I wanted to be a cowboy. I was driving a truck at sixteen. It's only now – I'm forty-eight – that I'm beginning to understand a lot of the things I'm doing.

I hated my school-days.

There's only one teacher I love – she is still alive.

She was my art teacher. When I was nine I made her a clay model and it won a competition. My model was King George the Fifth, his head and beard. I brought it home. My grandfather was sitting in the chair and I showed him the model. He praised me. Then he got up, went outside and buried it in the garden. He took that thing and buried it.

None of us dared go out. Nobody watched him. I didn't realize how important it was, even though we half understood what he was going to do. Nobody questioned it.

I only questioned my mother about it when I was thirty. She said, 'You're dumb, all right.' She expected me to understand. I said, 'This is why I'm asking *you*, mum.' See, dad was dead, so I couldn't ask him. My mother said, 'Your grandfather was giving back to God what was His.' That figure was the first thing I created. My grandfather buried it, she explained, to enable me to carry on what I was doing, because the Maori believes that if you are unable to give away your first thing, you will learn nothing. Now, when I look back and realize the importance of that whole act, I say to myself, 'Now I see.' And I feel good.

I say to myself, 'No wonder I'm carving.' It's through my grandfather that I have this talent; not my father. My father was a woodsman, a bushman, but I preferred my grandfather. He never said much and anybody that had a loud voice I didn't like. Because my grandfather was very quiet I loved him for it. And he never told me I was dumb.

I'm lucky to have toes on my feet, so I can count up to twenty. I failed all my exams. I got to Standard Three when I was twelve and I couldn't get out of it. We were just poor. There's eight

of us alive now and seven dead. Some I can remember dying very young. We were just poor, that's all.

I had double pneumonia and my grandfather carried me all night on his back. I remember that. It was the only time I was comfortable. He just walked about the house with a blanket over me on his back, he did that all night. No medicines.

My brothers and sisters who came later had medication but what happened: we lost all the treasures from our house to pay for the doctor. We had kiwi cloaks and carvings that my mother gave to the doctor because she couldn't afford a cough mixture. When I look back I think, 'Kiwi cloaks. What a payment.' And that doctor, he had a good collection.

At school I could speak English but I couldn't write it. Even now I find it difficult to write a letter. I've made friends all over the world and it upsets me that I can't write to them in my own writing. At school I wouldn't learn anything because we weren't allowed to speak Maori. 'There's nothing in the Maori language,' I was told, 'that can help the country. Some learned fellow told me this, Pakeha fellow. You talked Maori to the boy sitting next to you and you got a hiding. Got a strap. 'Ooh, he's speaking *Maori*' – the girls would tell.

I was twelve in Standard Three and I was in Standard Three for three years. When I was seven it was already hard, because from seven to nine I was sick with a hernia. I would get an attack walking to school and have to lie down in the gutter and stick my legs up on the bank and let it all run back. I never had an operation because of the fear of operations that my parents had. Later I treated myself.

As I remember those times, I'm embarrassed. We used to take dried shark and rotten corn for lunch and hide it on the side of the road and eat it later. This wasn't accepted for lunch at school. Used to go begging off the other kids for a piece of bread. I was embarrassed, having to ask for it. The hole in my trousers that was never patched. My bum was open. We didn't just feel poor. We *were* poor. Anyway that's the only life I knew. You take a Maori kid out of his environment and put him in a European one, and everyone else is wearing nice clothes, you soon notice the raggedy clothes you're wearing. So anyway I failed my exams and never got out of Standard Three.

How *did* I get out? Age. I was getting bigger and the kids were getting smaller and the rest of the school called me a dummy. They couldn't keep you there over fifteen. By then I wanted to leave anyway.

I've spent the rest of my life proving that I can do something.

This canoe I was carving – it's one complete tree. This is twenty-two months of carving, but it isn't a long time if you're feeling good. I've had this feeling for a long time now – I mean, concentrating. Concentrating alone and seeing the problems come clearer. My master told me that he had the same feeling. A strangeness surrounds you. I'd never made a canoe before. The tree itself was donated, but I selected it. I knew by the rings it was three hundred years old and I picked the best tree which wasn't the best at all – it was twisted and there was a limb half-way

up. There were many ceremonies: one for the felling, one for pulling the tree out of the stump, a blessing for the journey . . . But when it was split the tree wasn't long enough. You can't get a whole loaf from two halves. The join, the join – I'm talking about joining the two halves of the canoe so it will fit exactly without parting. Nobody told me how to make the join and I couldn't get it from books. I know now how many angles I cut, nine angles. But I didn't know it when I started.

You're on your own and terrified and then suddenly – it's like your hands were guided. Somebody is helping you. You're not doing it alone any more.

The carving process is secret? Not at all. Listen. I don't carve under the ancient laws – I don't practise the tapu. I don't meddle with *that*.

My teachers never practised the tapu. Unless you were initiated into it, you left it alone. I don't work under the tapu. A lot of carvers pretend to work under tapu but they don't understand it. Tapu is sacred, sacred laws. If you're under a bond of tapu you don't break any of the laws, and one of the laws is: *you shall not sleep with your wife*. You don't know your wife until that job is finished, but carvers can't do that today. 'Okay, we'll carve this meeting-house. house. We'll close it; make it tapu. No women allowed.' That's as far as they go. Soon as that man gets in there he lights up a cigarette, smokes away, carves away, then he goes home and sleeps with his wife.

I'm speaking against my own people? Not against them. I'm saying they are ignorant because they don't abide by these laws. People say to me, 'I know a man who carves under tapu.' 'Who is?' I say. 'If I don't know his name he is telling lies.' 'Never mind, he respects the tapu.' Respecting and understanding are two different things.

I respect it because I don't understand it. There's a lot I don't understand. And people have died.

A family of five died because of this. Here in my town.

They asked me to carve a meeting-house. The old one was falling down. I had barely started, I'd done two carvings on the house when there was a dispute. Before I started the leaders of the marae came to me and said, 'With this house we would like to observe all those things that should be observed.' These are people twice my age, elders, and they're coming to me for advice, *me*, a boy! Who's never had the privilege to stand up on a marae and speak – 'Hey, you get out. You go round the back and cook the food.' And now they're asking me how to run the project. I said, 'You're the leaders, you decide.' 'Right,' they said. 'We'll close the place. Make it tapu.'

Fine, I thought. Thinking they knew what they were doing.

Then, a dispute. I was carving for a fee. One of the leaders came to me and said, 'You're too expensive. I can pick up six carvers like you on my bus any day of the week.' I said, 'Right. Do it.' I packed up my tools and left. I can do this because it's my people.

They performed more rituals and finally engaged other carvers to carry on. I didn't mind; I

was safe. I hadn't broken any laws. But during all this time a family was dying. They were leaders of the marae. The first one to die was the man. Then his son. Then his nephew, his sister, a second sister. Another brother, and another . . . There is only one member of the family left today.

Within two years they were all dead. They died suddenly; mostly heart attacks. Funny thing, they weren't fat people.

You can't cross these forces. They're stronger than you are. If you're initiated, you know these truths.

In 1926 the last school of Maori carving was opened in Rotorua. My master was a student. The teacher was an old *tohunga* and this old gentleman *fenced himself off* from his students symbolically. He had a rope stretched across the hall. He was on one side and they were on the other. This was the symbolic barrier and he said: 'I belong to the old world. You of the new world, stay where you are.' He said, 'I observe the tapus' – meaning the rituals of cleansing. He would put away his pipe. Clean his pockets of crumbs, the dust from his tobacco pouch. Never blow the chips from his work – see, when you make a thing sacred, it is sacred until the sacredness is taken away. Until it is *noa*. Noa means ordinary, free of tapu. He even told them, 'Bring your wives and food into the workshop while you carve.' Food is the quickest thing to make a thing noa. 'Eat your food,' he said, 'right here where you work. I observe the tapus, but you don't have to.' He told them this in 1926.

He said this to his students because nobody had initiated them when they were young. Once, when a boy was ten, eleven, he was taken to the place of learning and taught the mysteries. Taken down to the river at two o'clock in the morning with a stone in his mouth to recite the rituals, so he learnt what's right and what's wrong, and eventually it became like second nature. Who is there now?

That's what the old gentleman meant. He was warning them, don't play with fire; then the mana won't hurt you. The tapu won't hurt you. So who am I to say, 'This is tapu and this is not'? I've never been initiated.

I respect the tapu and I leave it alone.

If I had my life again, I wouldn't choose to be a carver. In my grandfather's day there was a dignity and respect for the carver; not only was the carver taken care of but his family as well. That's gone now, but people still look on the carver as if he was a village carver doing everything for free. The problem now is money.

I've been a wharfie, a bushman, a truck driver to support my family. Last week I put myself on the dole.

My brothers can't see these problems. They think that because I am famous, I'm rich. They put you up on this pedestal and then come to you for a handout. 'Well, brother. You can give *me*

a car now.' Because I had given my sister a car. She had a bad hip and I gave her an old car I had. I'm the one who is being sued for unpaid bills, yet it's my brothers who climb on my back and lean on me. It makes me sad that they don't see my problems.

I'm sitting in two worlds and I don't have the support my grandfather had. I'm sort of isolated and it's not even of my own choosing, being a Maori isn't. If you throw a tin of whitewash over me that won't change me as a Maori. Being famous in a white man's world is one thing and being yourself is another.

When I am carving a canoe I am being myself.

The real problem isn't money: the problem is living in two worlds. I have always lived in two worlds. I'm very happy when I'm doing the work of my ancestors, but a lot of things have crept into my life that I would like to be without.

If I had my time over again I would like to be speaking just Maori. I would like to be sitting on a beach holding onto a fishing line and gathering my food when I want it, that's what I'd really like. And not be a carver at all? Right.

– New Zealand

Taranaki

Taranaki is on the west coast of the North Island, lying to the north and south of Mount Egmont or Taranaki, from which the region takes its name. The tribal group living to the north is Te Atiawa. Their carving is serpentine: human figures have a ridged, twisting tubular body. Heads are normally triangular in shape with a point rather like the mountain on the forehead. Arms and legs intertwine and penetrate the head.

Living inland from the mountain is the Taranaki tribe, and to the south, Nga Rauru and Ngati Ruanui. The south Taranaki style is similar to that of Te Atiawa but there is no peak on the forehead.

127. Stone sculpture found near the Werekino stream, Okato, in 1905. Width: 57 cm. Traditionally the sculpture is of Hine-O-Tanga, a renowned and deified chieftainess of the Pukehoe Pa of the Taranaki tribe which she defended against an attacking war party. This is one of several large stone sculptures from the Taranaki and Atiawa areas. They have been variously described as kumara gods or *taumata atua* (resting-places of the gods). *Taranaki Museum*

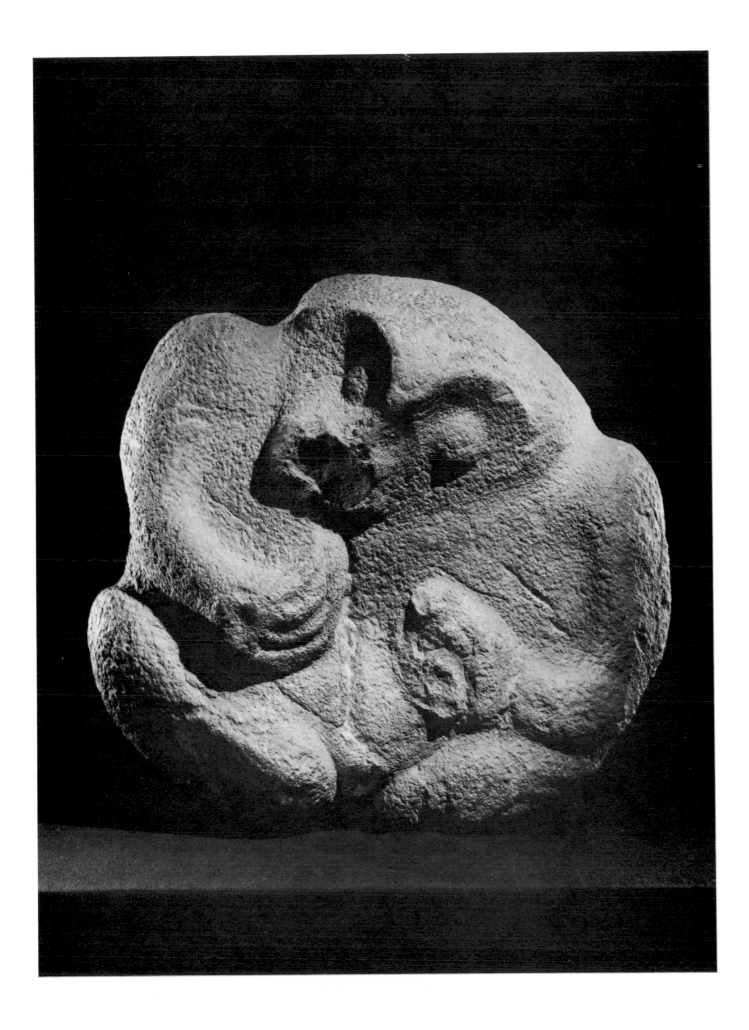

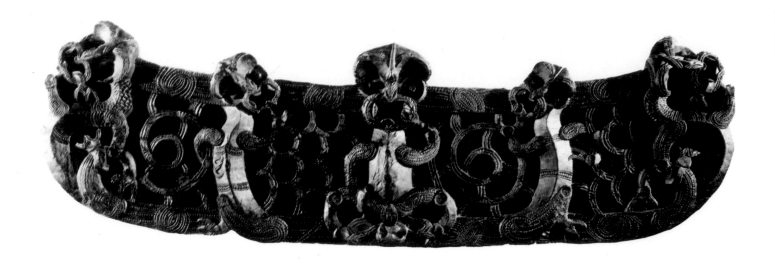

128. *Paepae* (threshold) from an elevated storehouse. Length: 175.2 cm. This carving is almost certainly associated with the large Te Atiawa pa, Manukorihi, which is now Owai Whaitara marae on the northern bank of the Waitara river. Typically, the carving of the limbs is convoluted, with arms and legs intertwined or through the mouth. As is common on these paepae, the central figure is female. The flanking figure to the right is male, while that to the left is of indeterminate sex. The enlargement shows details of carving designs: a fish scale pattern on the neck, limbs decorated with *tuara kuri* (the dog's backbone), and *puwerewere* (flower of the *puhi* maiden) design on the lips and eyebrows and on the surrounding fish-net (*mata kupenga*). *Taranaki Museum*

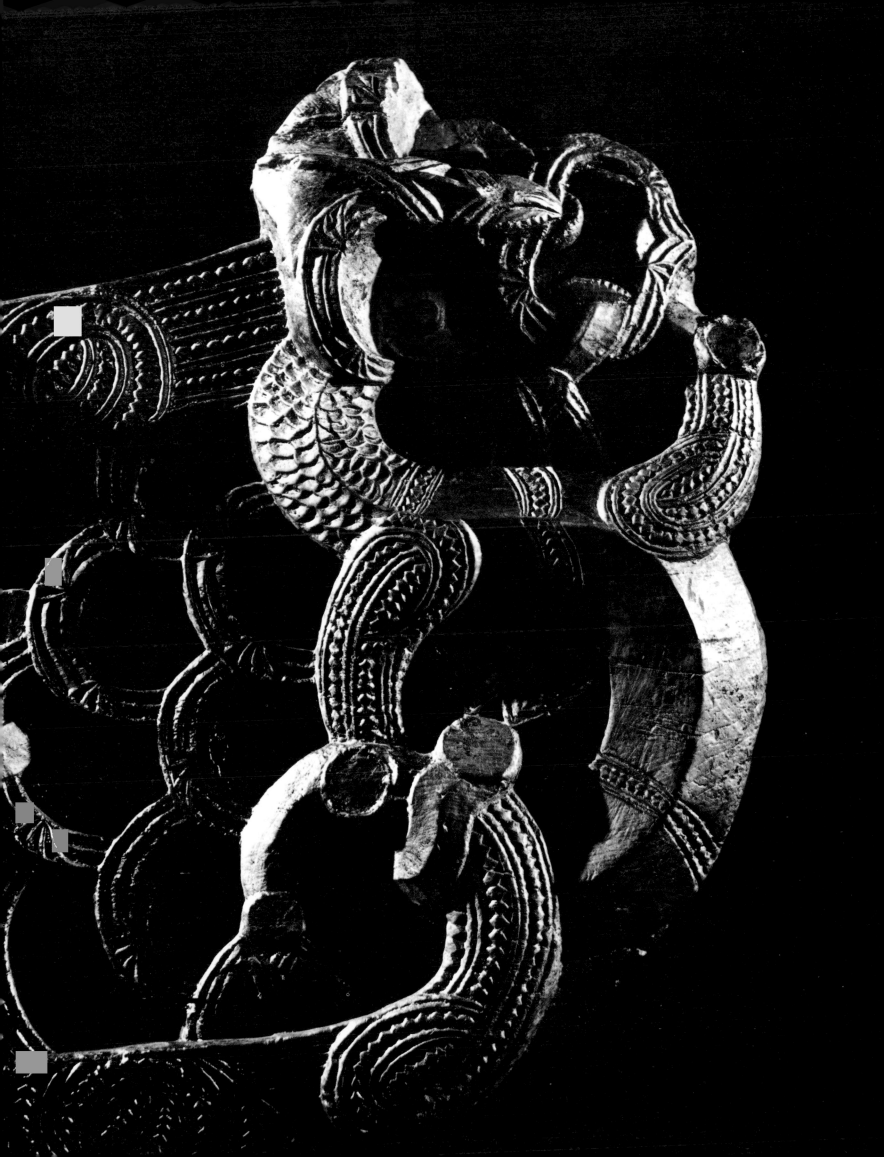

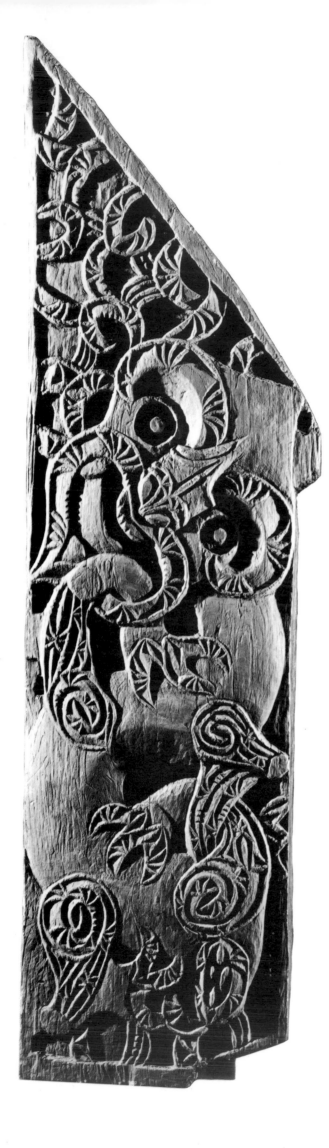

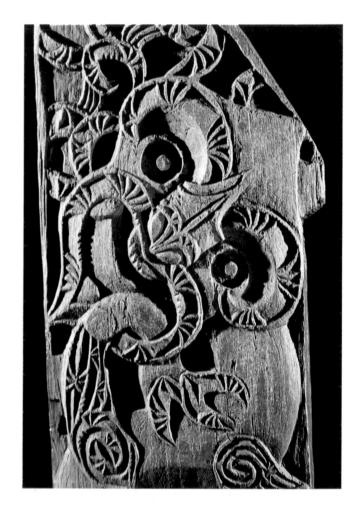

129. Panel from the front of a carved storehouse, found in a Waitara swamp. Height: 91.4 cm, ?pre-1826. This carving is almost certainly associated with the Te Atiawa pa mentioned in 128. The panel shows a single female figure with fish-net design surrounding. The head is pointed, and the body carved with the puwerewere design. *Taranaki Museum*

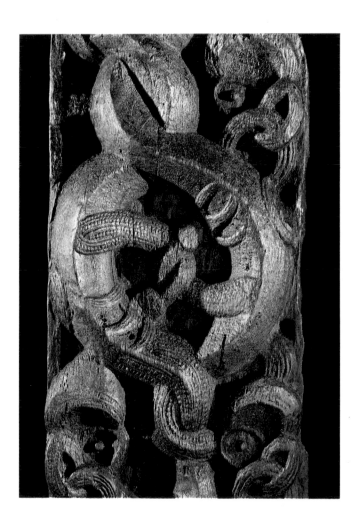

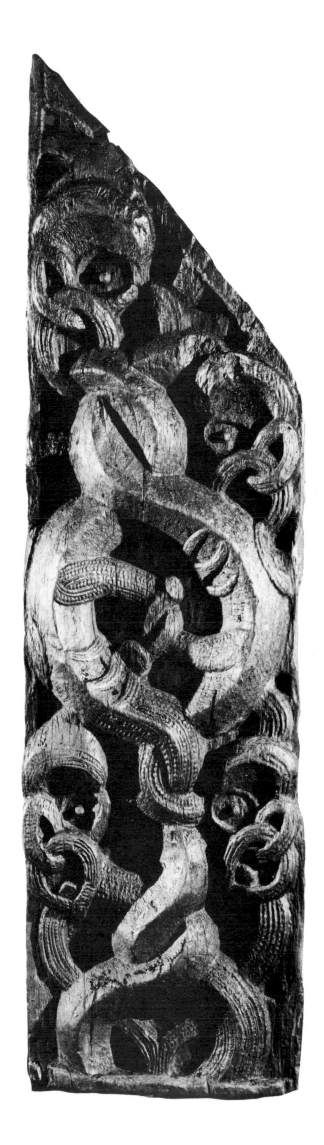

130. Panel (*epa*) from the front of a carved storehouse, Te Atiawa style. Height: 125 cm, ?pre-1826. There are four figures on this panel, shown in profile. This and the deep relief carving are uncommon in the local style. Perforations for lashings may be seen on the apex and down each side. *Taranaki Museum*

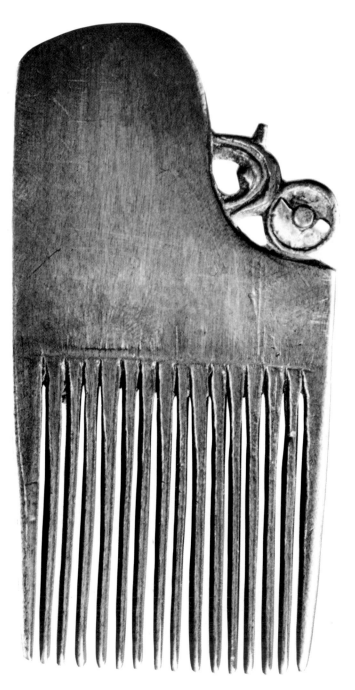

131. Wooden comb. Length: 7.9 cm, late 18th century. Early Maori combs had a flat top with geometric decoration. They evolved to this knobbed form with manaia head cut at one side. *National Museum*

132. Detail of a canoe prow from Mokau district. Length: 77 cm, 18th century. Canoe prows usually display three figures and two spirals (see 137) as this one does. The open cusp-like form of the spirals on this prow is quite different from the tightly rolled spirals of other areas. *Auckland Museum*

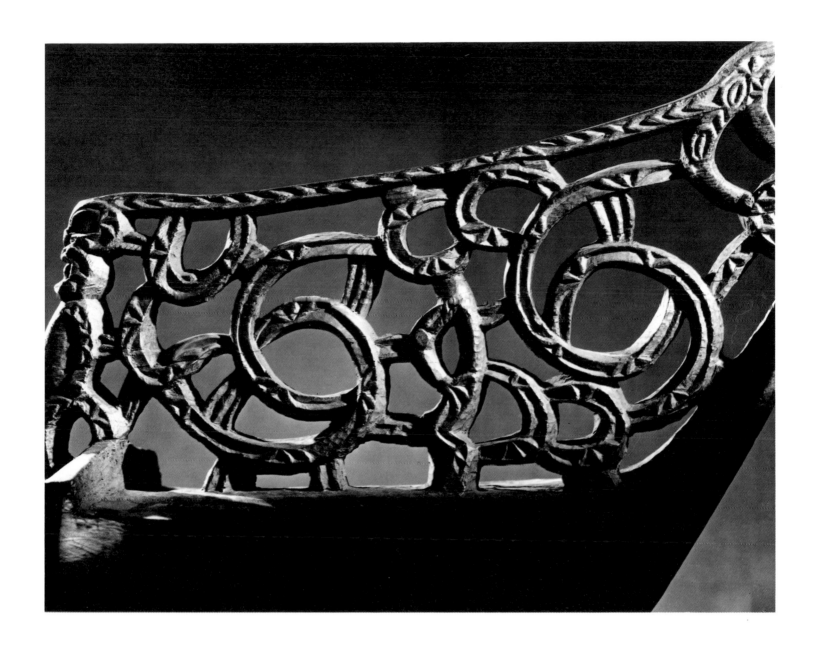

133. Greenstone *mere* (club). Length: 39.8 cm. The mere was the prestige weapon of a chief. This one has a stone-drilled perforation for a thong, and two concentric rings carved on the butt. *Taranaki Museum*

134. Greenstone hei matau (pendant), probably made in Taranaki. Height: 6 cm, c.1860. *Auckland Museum*

135. Whalebone wahaika (club) from south Taranaki. Length: 31.3 cm. *Taranaki Museum*

136. Wakahuia (personal treasure box), carved in
south Taranaki style. Length: 44 cm, mid 19th cen-
tury. As these boxes were usually hung in the rafters
of a house the underside, as on this box, is richly
carved. There is a central female figure copulating
with a male, while a second male is at her head. The
mythological significance of these figures has been
lost. *National Museum*

137. Detail of a canoe prow, Te Atiawa. Height: 150
cm, c.1860. This prow was carved by the chief Wiremu
Kingi Te Rangitake, and later given to HRH the Duke
of Edinburgh in 1869. It is in the south Taranaki style
with rolling spirals (see 132). *Auckland Museum*

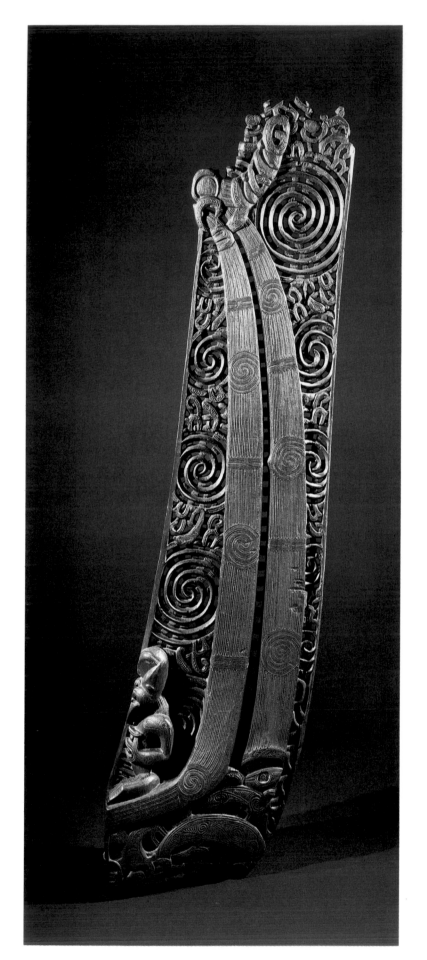

138. War canoe stern-post. Height: 165.2 cm, 1831. This post was carved at Koputaroa, Levin, for the Ngati Raukawa canoe Te Whangawhanga. The design is said to symbolize the two ribs of existence. At the top they are being attacked by a manaia which represents the spirit world, and at the base by a manaia representing the mortal world. Often in these designs a small human figure is placed at the foot of the ribs, close to the mortal part and to the hull of the canoe. The life of man is thus a struggle between the immortal spirit world of the gods and the mortal world of the under-world. The spirals represent light and knowledge, but again these are under attack from manaia representing the natural world of life/death, god/man. The designs of canoe stern-posts are very stylized, even though strong regional variations occur in the carving. *Canterbury Museum*

139. Detail of putorino (flute), carved in the south Taranaki style. Overall length: 35.5 cm, c.1820-30. *Canterbury Museum*

140. Carved knife with shark tooth cutting edge, in the Wanganui style. Length: 22 cm. This knife was collected on Captain Cook's first voyage and is similar to knives he describes being used to cut up human flesh. Probably it was obtained in the Queen Charlotte Sounds. *National Museum*

OPPOSITE BOTTOM
141. A *toki poutangata* (chief's ceremonial adze) with greenstone blade, south Taranaki style. Length: 44 cm. The wear apparent on the handle suggests that this is an ancient object. Along the edges of the blade are groups of notches. These were a memory aid for the chief in reciting his genealogy. A chief's adze was a symbol of mana. It emphasized his position within the tribe as well as his right as direct descendant to call on the gods and ancestors for their favour in tribal enterprises. Such an adze would be named and its history well known to the tribe. *Otago Museum*

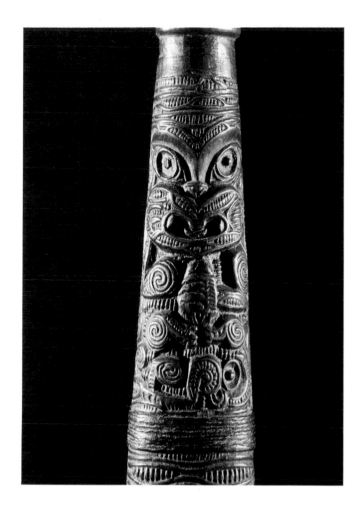

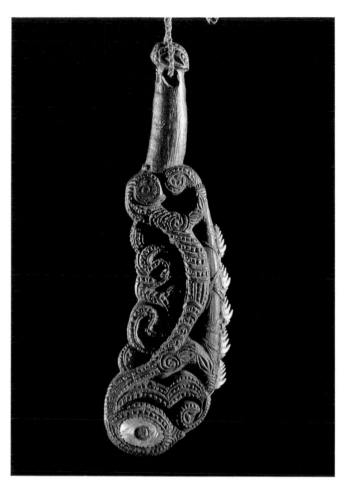

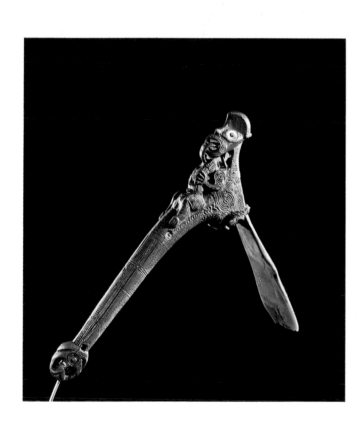

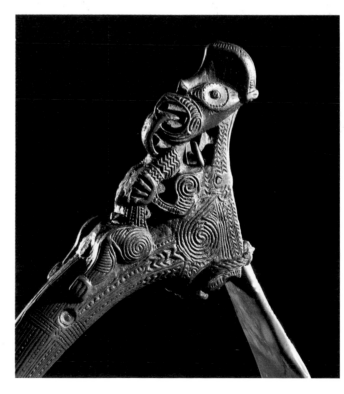

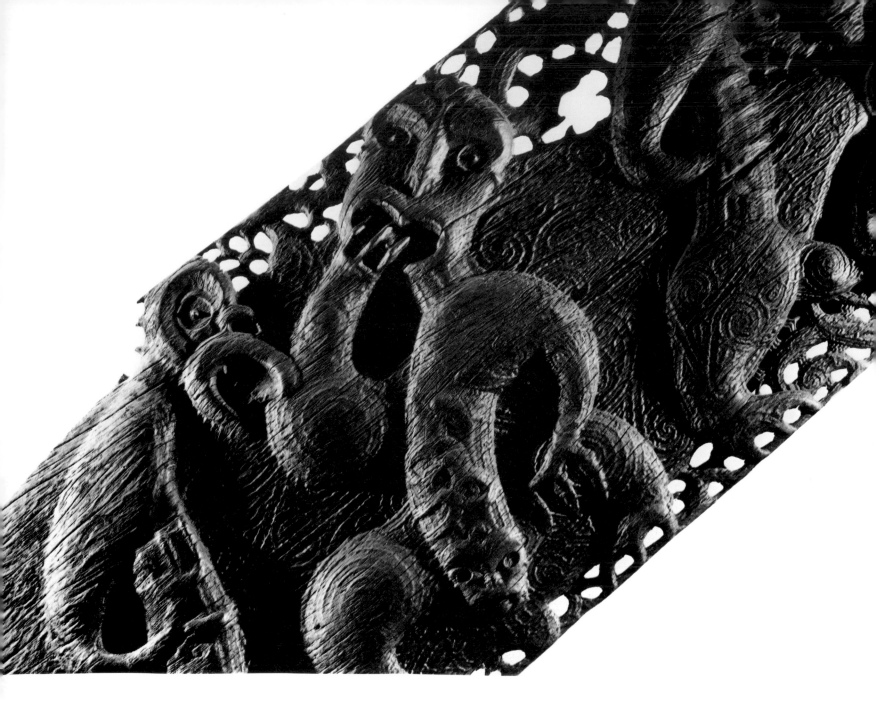

East Cape

This is the area from south of Opotiki to the East Cape of the North Island. It is the home of Te Whanau Apanui tribe. Their carving is in a square style. Figures have rectangular heads with long noses, and often the bodies are long with pronounced round shoulders and hips. Characteristic decoration is a raised notched line, *taratara a Kae* (the notching of Kae). After his pet whale had been stolen and eaten, Tinirau recognized Kae as the thief by his missing teeth.

142. *Maihi* (barge-board) carvings from a storehouse named Te Potaka erected at Maraenui. Length: 305 cm, 1780. Te Potaka is probably the oldest known storehouse and may have been the inspiration for the building of similar storehouses in other regions. The Northland and Taranaki storehouses are from separate traditions. From Maraenui it was later moved to Raukokore and in about 1820 the carvings were hidden from northern musket raiders, in a sea cave at Te Kaha. At that time a new barge-board and other carvings had been completed to replace weathered pieces. The new board (right) is more elaborate. Alternate manaia and human figures are hauling a rope (made of figures) to pull a whale ashore. The left-hand (older) maihi shows the whale's body behind the figures. The whale's eye and mouth are represented as spirals. The whale, a symbol of plenty, is probably from the myth of Tinirau and his pet whale which was eaten by Kae. *Auckland Museum*

143. The figure above the doorway of Te Potaka. *Auckland Museum*

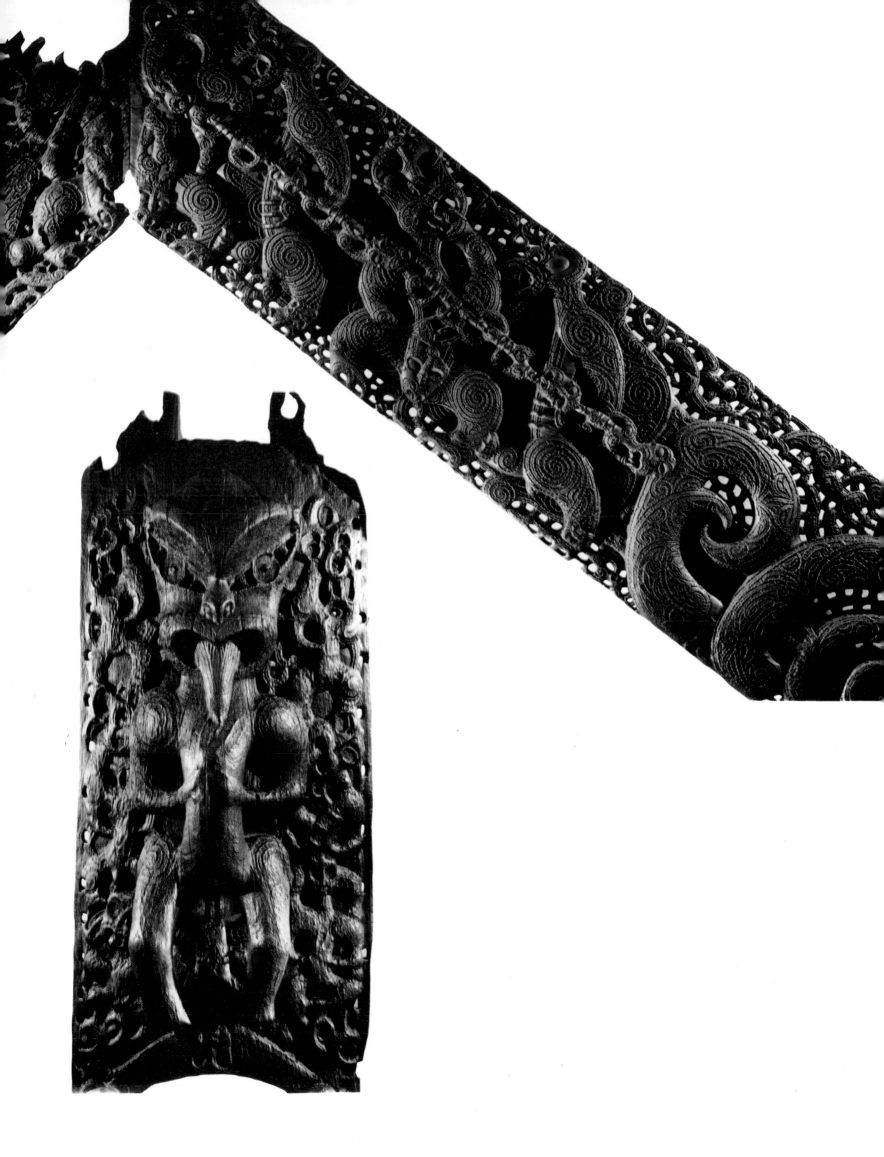

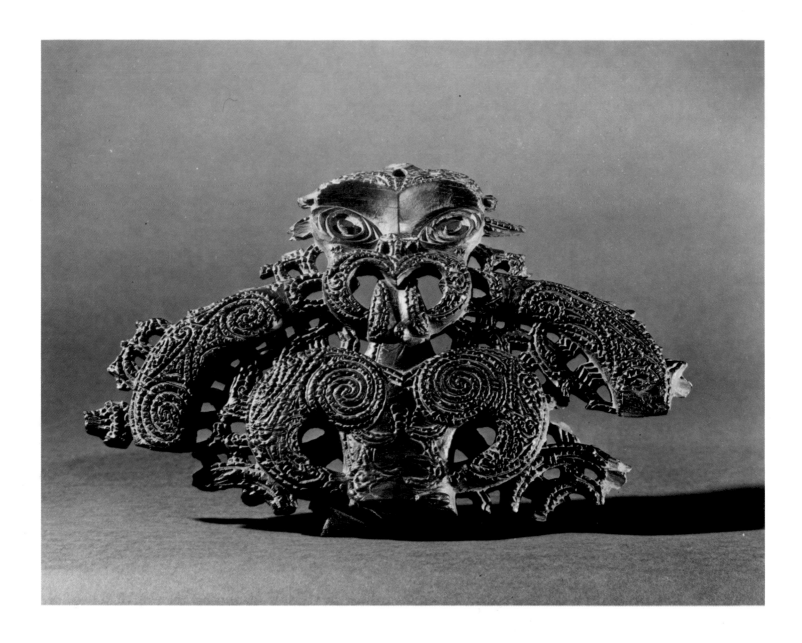

144. Central figure from a small house lintel carved in the style of the East Cape. Length: 45 cm, early 19th century. *National Museum*

East Coast

This is the coastal region south of the East Cape extending to Gisborne. It is the home of the Ngati Porou, Aitanga a Mahaki and Rongowhakaata tribes. There are two related carving styles: Ngati Porou or East Coast, and Turanga or Gisborne.

OPPOSITE
145. Wooden *tekoteko* carved at Kaiti in the Gisborne style. Height: 104 cm; late 18th, early 19th century. A tekoteko is the figure which stands on the apex of a house gable. Usually it represents the ancestor whose body is the house below. *Hawkes Bay Art Gallery & Museum*

NEXT PAGES

146. Detail of a carved standing figure. Height: 45.5 45.5 cm, early 19th century. This carving was made to be placed at the base of a main support pole within a chief's house. It represents an ancestor whose tattoo was not completed before death. *National Museum*

147. Detail of an ancestor portrayed on a centre pole in a house from the Waiapu valley. Overall height: 115 cm, c.1850. The figure was carved during a period when West Coast style tattoos were considered the height of fashion. This figure has such a tattoo. The house belonged to a chief, Te Wharehinga, of the Ngati Porou tribe. *Auckland Museum*

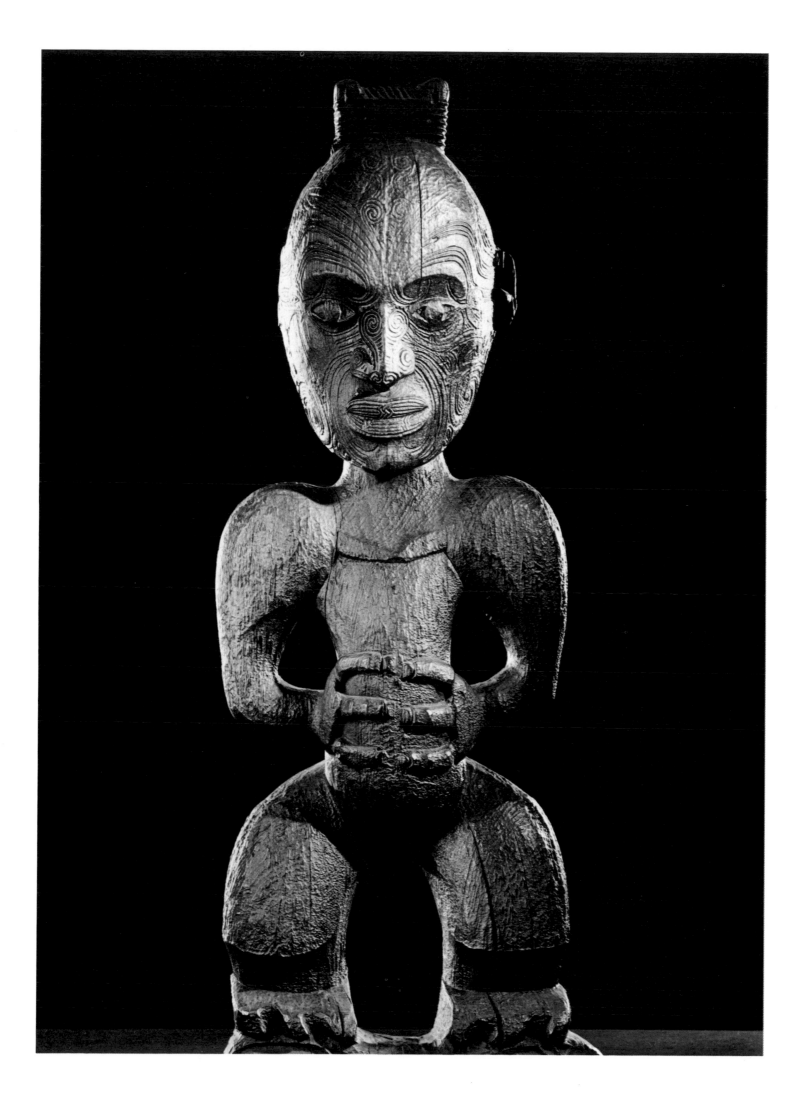

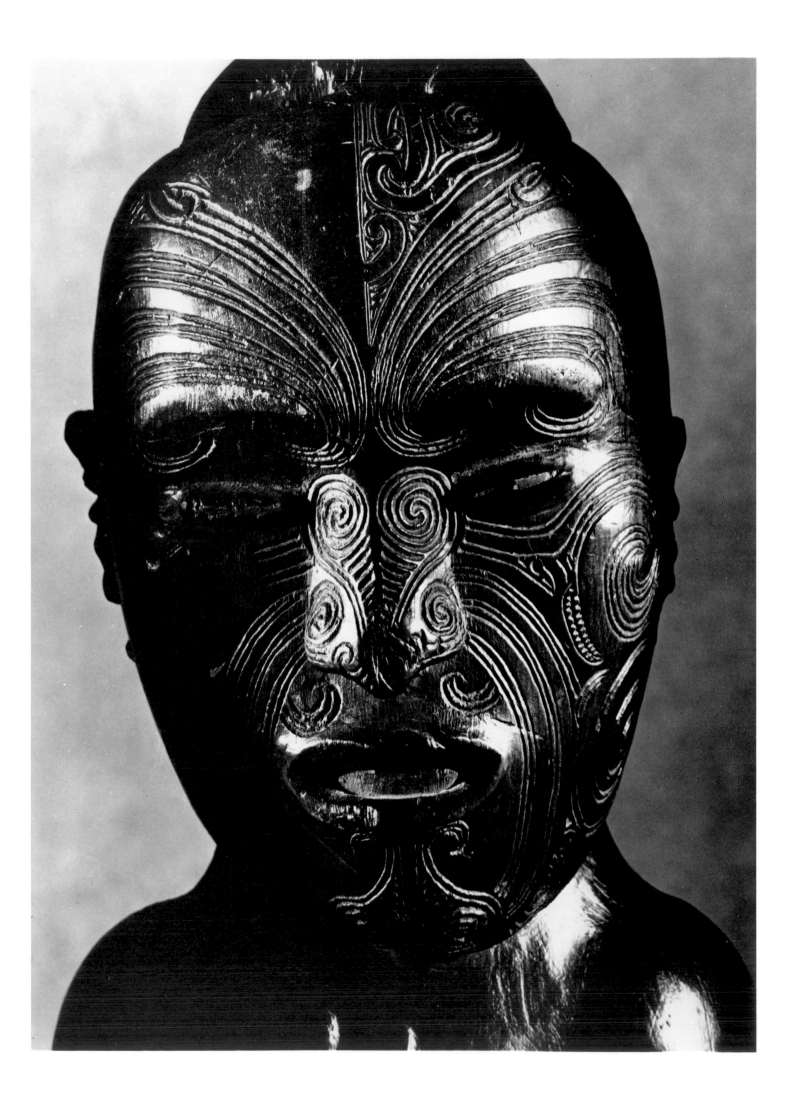

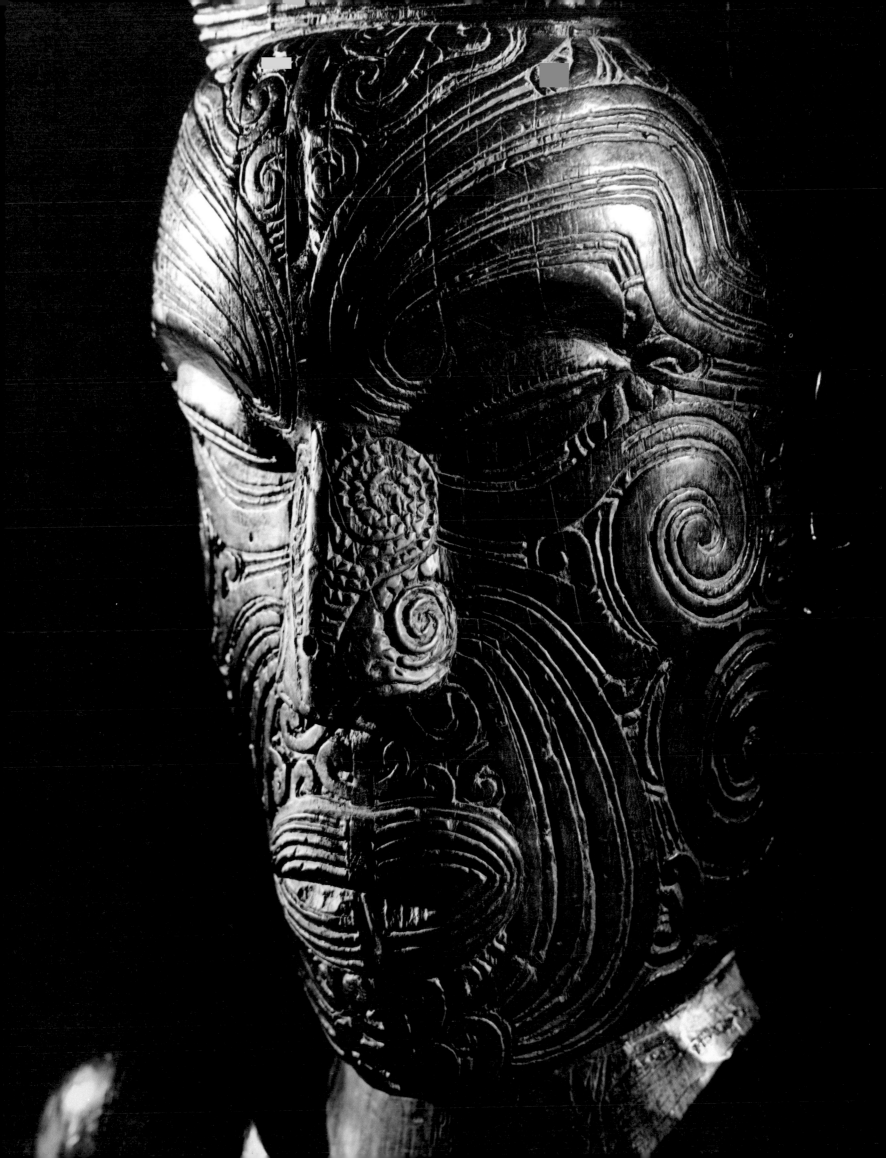

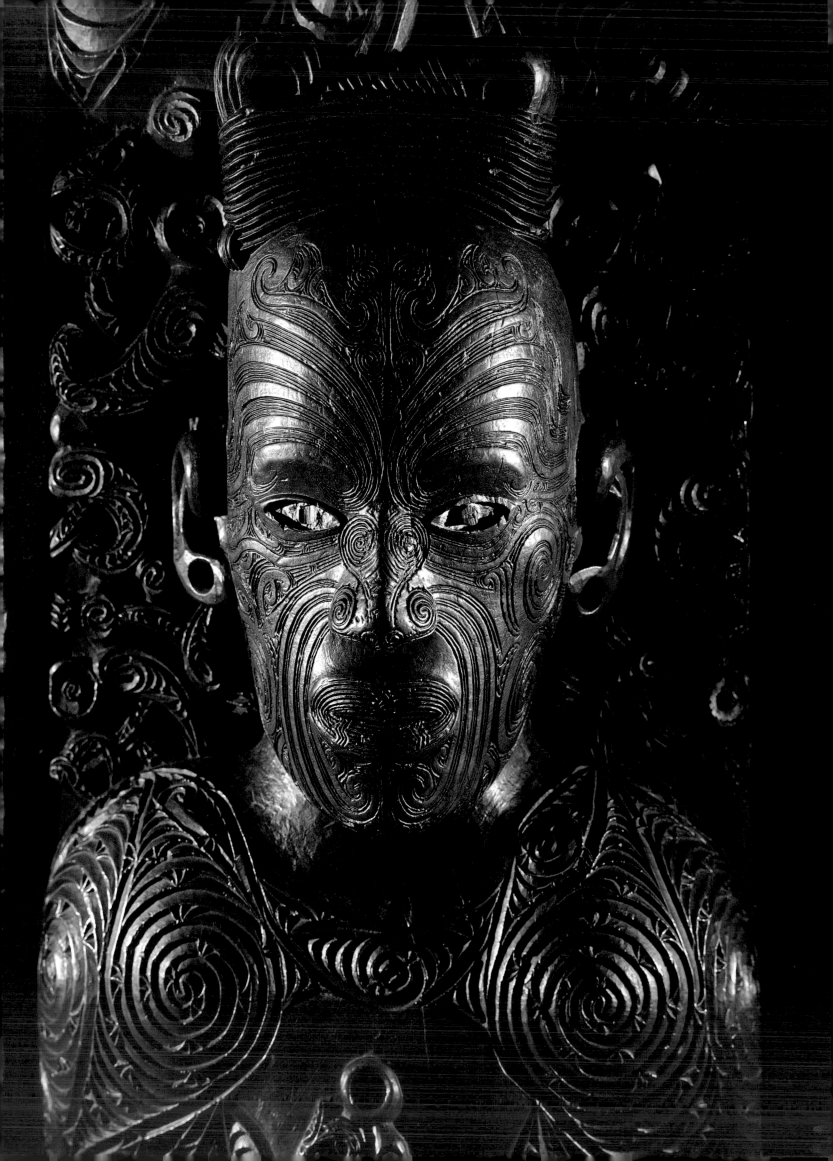

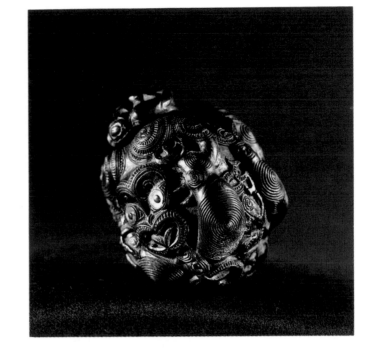

OPPOSITE
148. Detail of a house carving. Overall height: 108 cm, 1842. The carving is the self-portrait of Raharuhi Rukupo, master carver of the house of Te Hau ki Turanga, carved at Manutuke near Gisborne. Rukupo is said to have had a full set of European carving tools. With these he set off a new development of styles in his area. The meeting-house as a separate ceremonial and guest house with huge carvings saw its earliest expression in Te Hau ki Turanga. The development of house carving since stems directly from his work; the carvers of the East Coast and later those of Rotorua have carved the majority of the houses standing today. Steel tools permitted more freedom in piercing, decorating, and relief work. The hard-edged line of steel carvings has a very different quality to the earlier stone tool work. *National Museum*

149. Pot for tattooing pigment, probably from the Waiapu district. Height: 11.2 cm, c.1820. This is another example of metal carving. The repeated human head motif, together with the elaboration of surface detail, symbolizes the tattooist's art with its principal emphasis on the human face. *Wanganui Regional Museum*

150. Detail of a chief's ceremonial adze, carved in the East Coast style. Overall length: 49 cm, late 18th century. The blade is of greenstone, and like that in 141 has notched edges. *National Museum*

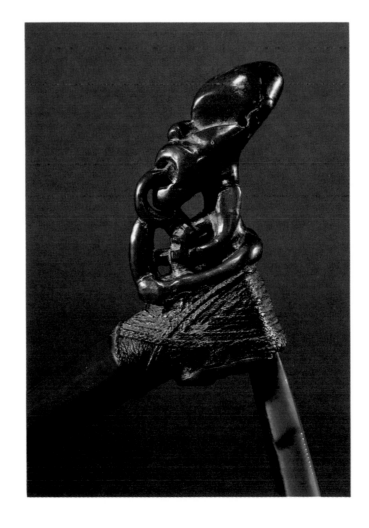

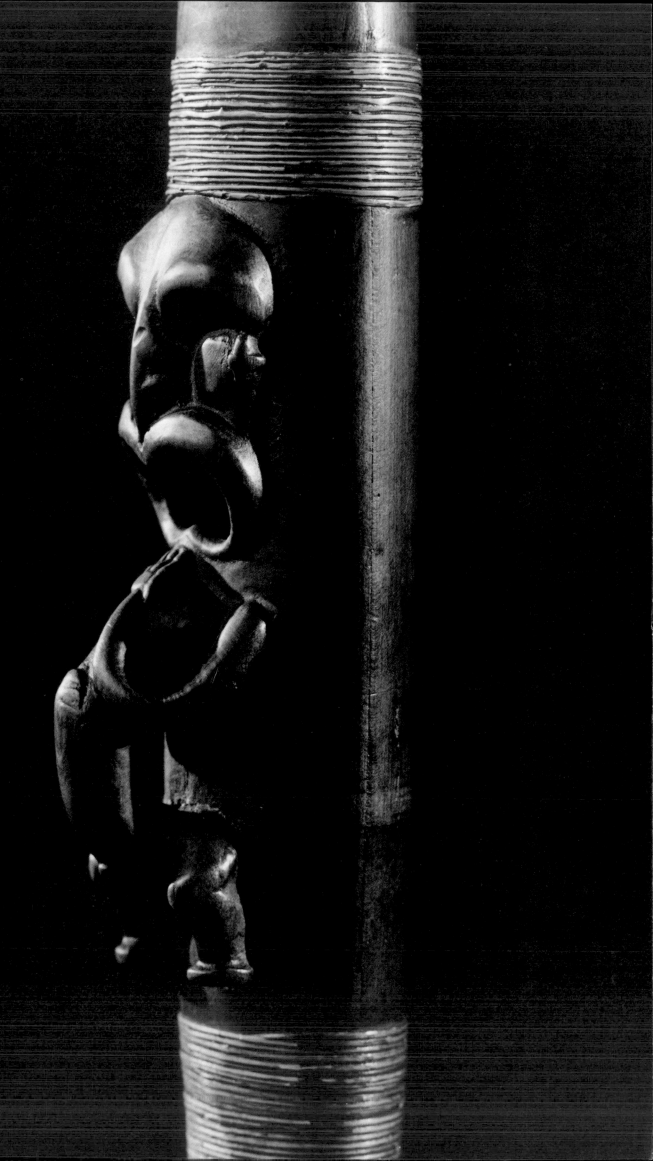

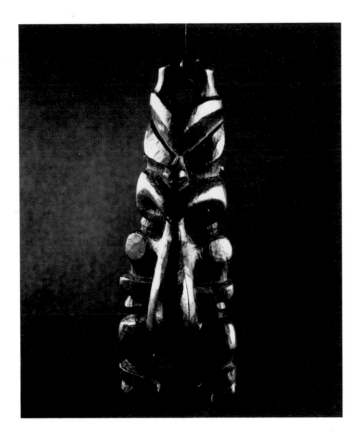

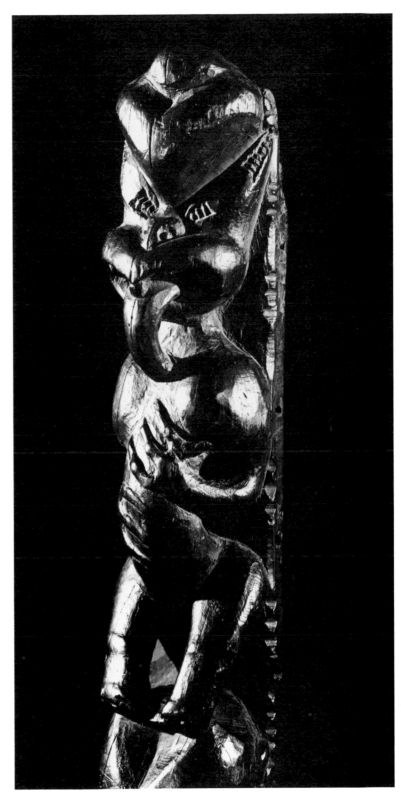

151. Detail of putorino (flute), in East Coast style. Overall length: 52.7 cm, late 18th century. This flute may have been collected on one of Cook's voyages. *National Museum*

152. Detail of door-post carved in East Coast style. Overall height: 76 cm, early 19th century. The carving is one of a pair for a chief's house which had a small door (76 x 36 cm). It was topped by either a plain flat lintel (notched as on the edge of the door-jamb), or a carved upright lintel. *National Museum*

Bay of Plenty

The Bay is on the east coast of the North Island and extends from Opotiki and Whakatane to Tauranga and inland to Rotorua. The latter is the centre of the Arawa confederation of tribes (who also live on the coast). Whakatane is the territory of Ngati Awa, and the Ngaiterangi live at Tauranga. The basic Arawa carving style is a head form which varies from almost square to wide-browed. One form has very long slanted eyes and brows on a long rectangular head.

153. *Poito* (fishing-float) from Lake Rotorua. Height: 25 cm, c.1800. It was probably used on a net to catch *inanga* or white-bait (a small minnow-like fish). *Auckland Museum*

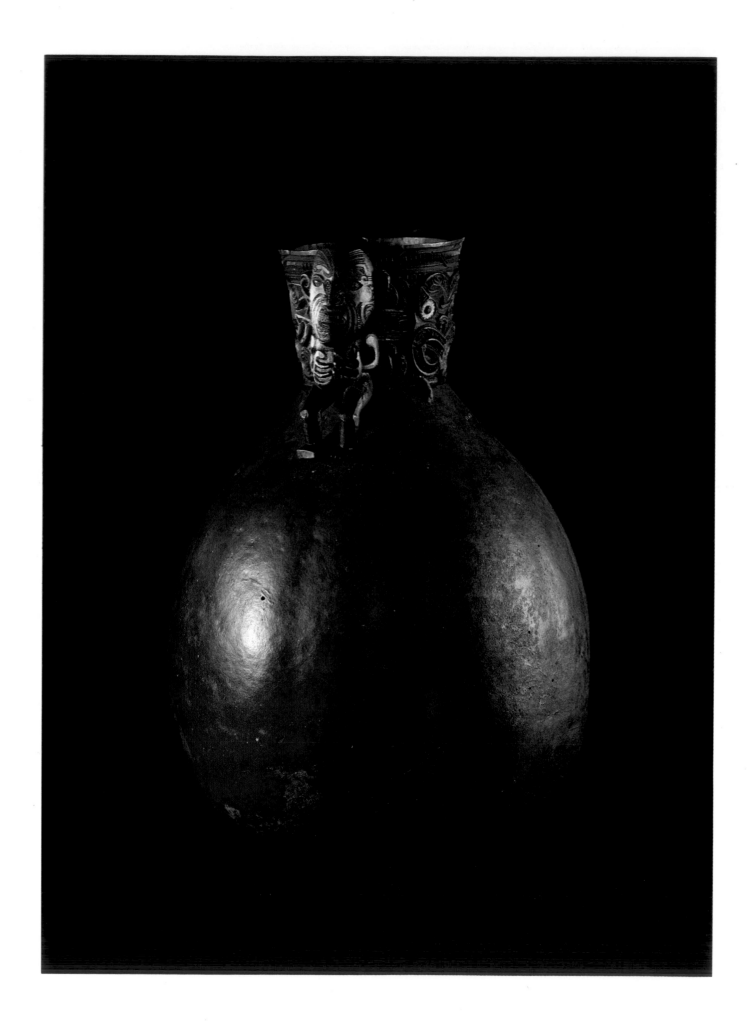

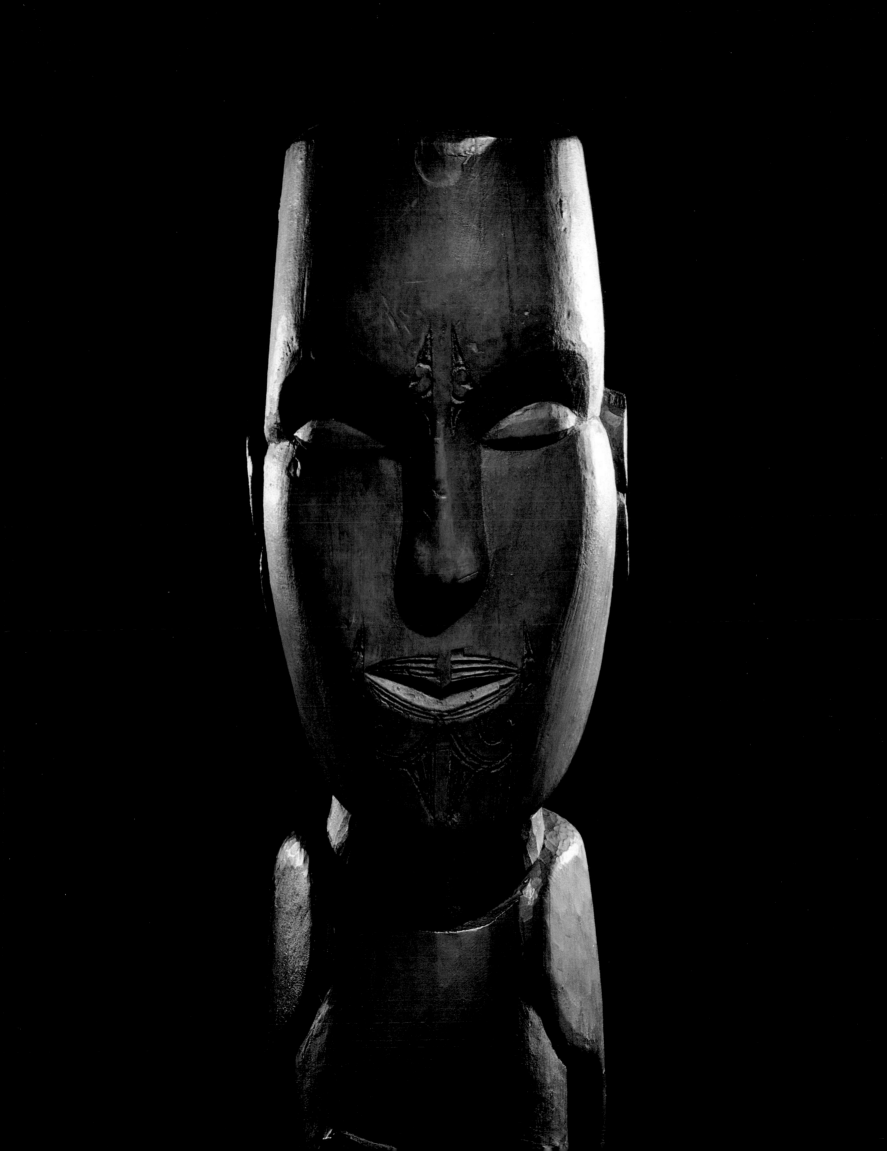

PREVIOUS PAGES
154. *Hue,* a gourd (*Lagenaria vulgaris*) used as a preserved food receptacle. Height: 32 cm, c.1860. Carved wooden necks were fixed to the rim of the gourd. Some gourds were raised on legs and decorated with feathers. *Wanganui Regional Museum*

155. *Poutokomanawa* (centre pole) figure from a small house at Taupo. Height: 81 cm, c.1860. This carving was executed with steel tools. It represents a *wahine ariki,* a woman of high lineage who had a *moko* (tattoo) on her chin and between her eyebrows. The latter was reserved for women of high rank. In this part of the North Island the tattooing of women became a feature of life early in the 19th century. From there it spread until its use was general by approximately 1865. Male facial tattooing had been discouraged by missionaries and, while there was a brief revival during the Anglo-Maori wars, it was eventually discontinued. The male tattoo as a status symbol was replaced by female members of the family wearing the moko. *Otago Museum*

OPPOSITE
156. House panel (*poupou*) from Taupo. Height: 146 cm, mid 19th century. The carver was from Ngati Pikiao of Rotorua and may have been Puwhakaoho. The panel depicts an ancestor. *Auckland Museum*

NEXT PAGES
157. Carved gateway from Pukeroa village, Rotorua. Overall height: 350 cm, c.1850. It depicts an ancestor with his children as small figures. *Auckland Museum*

158. Upper part of the gateway from the Te Ngae pa, Rotorua. Height: 196 cm, early 19th century. This is one of the largest carved figures known. Represented are Pukaki, progenitor of the local tribe, and his two sons. *Auckland Museum*

159. Gateway mask from Okarea Pa, carved by the Ngati Manawa people of the Whirinaki river in the Urewera. Height: 64 cm. Ngati Manawa are of Arawa origin, but the pierced eyes and mouth of this mask are a style peculiar to their area. Only a few pa had these mask gateways. *Otago Museum*

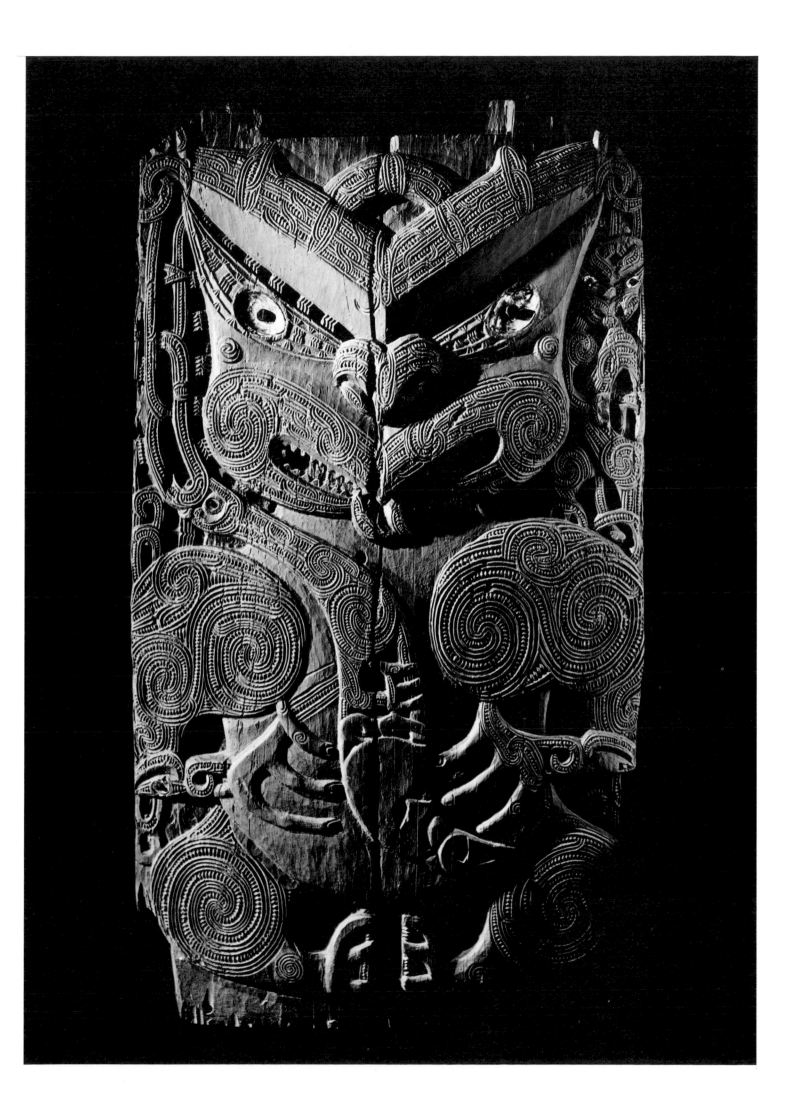

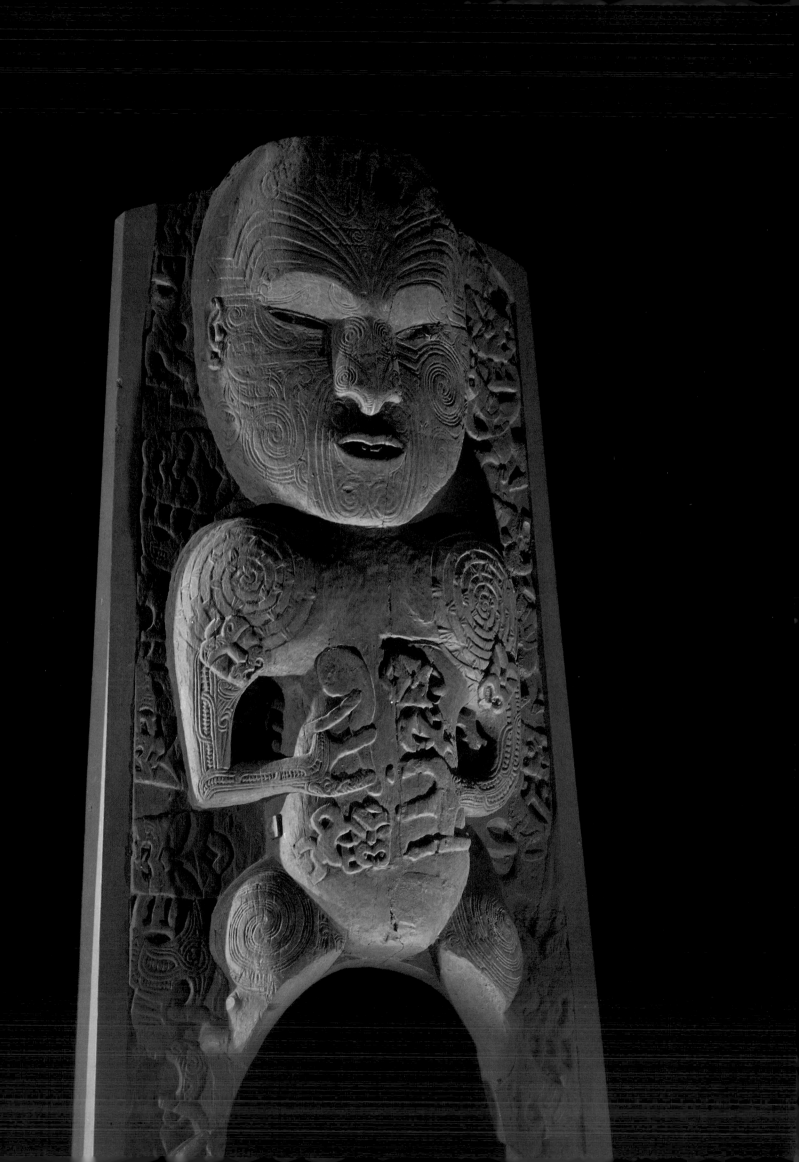

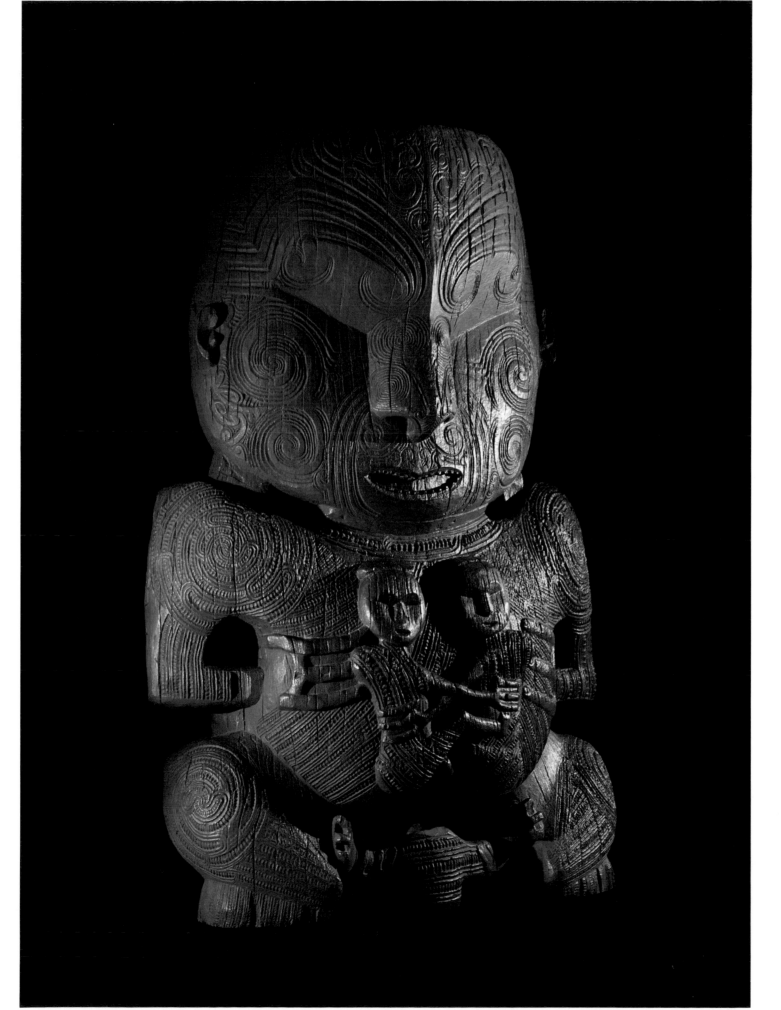

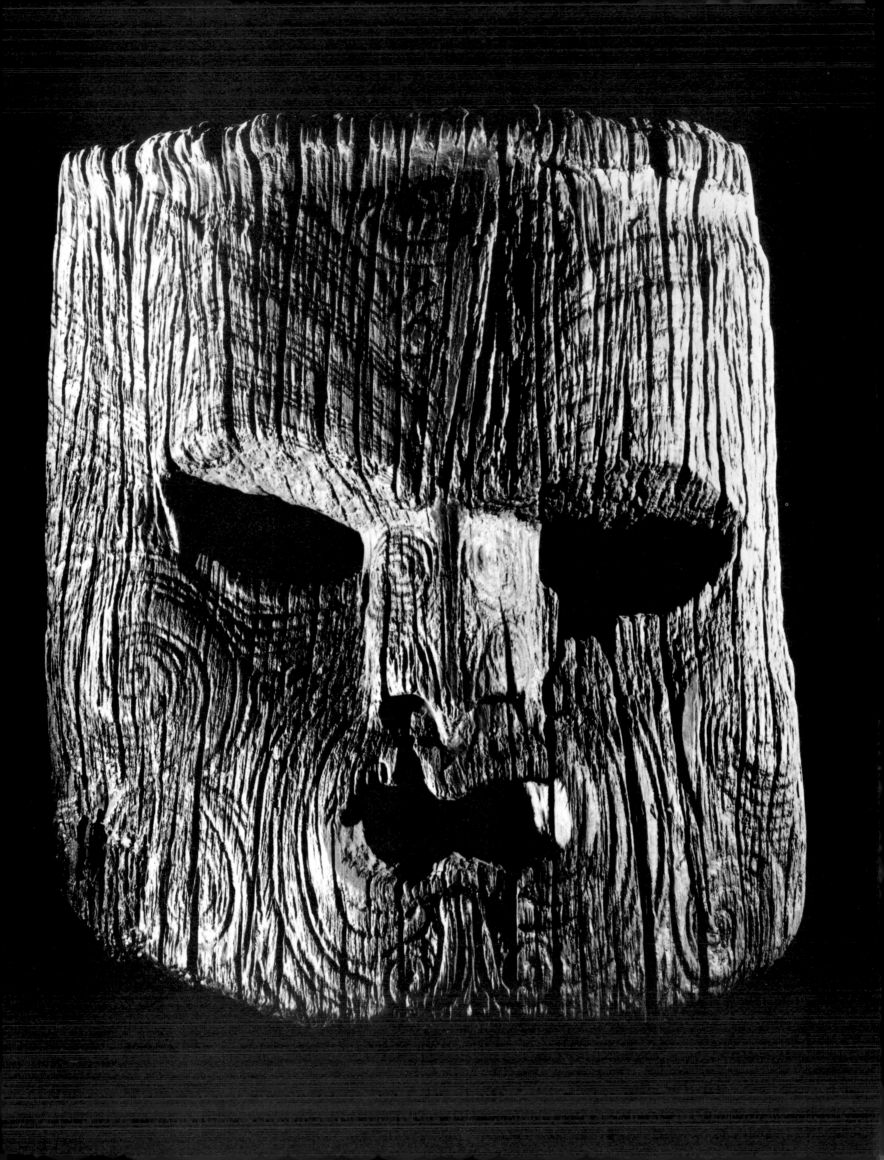

You cannot live in two worlds

Mari is thirty-eight, a teacher, a mother and a city-dweller. But she was born in a village, over the hill from a valley where her grandmother lives and where this conversation takes place.

When I was eleven it was decided I should be married off to a man who I thought was older than my father. I didn't cry. I did try 'no talks', but I got a thrashing for that. In the end I said to my father, 'Well if that's what you want, that's what I'll do, but I'll die – I'll die,' I said, 'in a matter of months.' He must have seen I meant it because then it was that they decided I would not be married but instead I would be sent away and educated out in the Pakeha world. All I can remember is being taken round the district from meeting-house to meeting-house and being kept awake by words and speeches. They said I was being taught who I was before I left the village.

Instead of being sent to board with normal people I was put in with a Scots lady, Nanna Campbell. Nanna Campbell had one leg and the other one was a horrible stump. For three years I cried myself to sleep every night. Finally in desperation Nanna rang my father and my father said, 'Stick her in the cowshed.' So I became queen of the farm and I ran that farm for Nanna. I've always known about the land – just as I've always known how to help people.

When I was twelve Nanna Campbell fell. Every day I had to bolt her stump in, onto a false leg, and one morning she fell out of the bed reaching for her leg. Her son went to pick her up but she didn't want him. She couldn't move. She screamed for me instead. I went in and she showed me where the pain was and I just rubbed it. I was scared to death anyhow. I don't know what I did or what happened but I rubbed it and she got up straight away, and from then on I was the only one allowed to touch her. It happened by accident, like everything else in my life.

One Christmas Nanna got me a job working at the hospital. When the next holidays came round I wanted to go hairdressing and dye my hair – I wanted to dye it red. Nanna said, 'Yes, you can dye your hair. But the first colour must be green.' So I didn't dye it, I went nursing again, and that's how I became a nurse. I never wanted to be a nurse, just as I never wanted to be a teacher. All I wanted to do was come home. I wasn't allowed to come home. But then, when I became a nurse, my father objected to that. He felt that I must not carry anybody else's excreta, shit. I said, 'But who better than I?'

He never agreed I should become a nurse because of my signs. There are people who are born to *be* something and from the minute they are born – conceived – natural signs are read which say that that child is special. This is what happened with me. My mother's every breath was watched, everything she did was noted. When I was born there was no labour, none. One minute mother was sitting on a horse, the next I was – presented. She was half-way off the horse when I was born; she hadn't reached the grass even. All my signs say that I should not carry other people's shit. And not only in my father's eyes; in everyone's eyes.

When my eldest son was killed, I found myself automatically reading the signs. I have done this with all my children, even with Mereana. Mereana is my adopted child – she isn't Maori,

but I have given her a Maori name because she wanted it. That's one of the reasons I've come home now from Wellington, to this valley: because of Mereana. There comes a time when you can't ignore the signs and I have always done this, not as a Maori or even as a mother but simply as a person. Can I say that I *know* my children? I know what they are, what they will be, and how they will be. I know it because of the signs I must have been taught as a child: the same signs that I myself have tried to break.

But I can't break them. Once I tried to leave this country, but it didn't work; I couldn't do it. What happened was that when I was nursing I was selected to go to Australia and open a children's wing. 'Oh great, great.' I was thrilled. I packed my things and got to the port, got on the gangplank. Got onto the ship. Here was all this coloured paper floating about, streamers, everyone shouting and screaming, and all I could see were women round me with red mouths. They looked awful, as if their throats were cut. I looked down and there was Mama, my old grandmother. I call her Mama. She didn't wave or cry, but I looked down and the next minute without thinking I was off that ship, straight off. The ship sailed without me. I don't know how I got off, but I couldn't leave her – it was just fear. Yesterday I was trying to explain to Mereana about fear – about the different kinds of fear there are – and I could no more explain to her the fear I felt when I was looking down at Mama than I can to you.

Oh, my luggage. It went around the world. We waited six months for it to come back.

So I went back to the hospital and carried on nursing, although my father did *not* approve. He told me this and then, shortly afterwards, he died. Ever since then I've felt guilty about it because I found out afterwards that all he wanted me to be was a schoolteacher. Later, when I graduated from teachers college, it was right. I was meant to be a teacher.

It seems to me that everything is just a prelude to something else. It was right for example that I have come back to this valley. You could say I came back to be with Mama and help her over her bereavement – last month her husband, my grandfather died. This is on my mother's side. But this is only the outward reason. It's hard to explain what I'm doing here. You could say that I am resting before I move on. The silence is beautiful; it's so beautiful it screams at you. When I arrived it was a whole day before I noticed the birds.

So this is just a resting place, a prelude? If you like, because this valley belongs to my mother's people and I don't know my mother's side so well – when I was small I feared them greatly. I still do. I can remember my horse bolting and throwing me when I wasn't even small – I was eighteen. I lost all my marbles, seventy-two glass marbles, and I was frightened to stop and look for them. I was so scared I ran all the way home. This place is full of fears.

I knew the moment I came back I hated it here. It's always been like this. I do hate it among my mother's people because I belong over the hill where my father's people are. I was brought up as my father's child. Mama's people say I fit here, but *I* say I don't. It's worse here than living away down in Wellington, because I have no right here.

I arrived on a Friday afternoon and the moment I got off the bus I was surrounded by people with problems. I hadn't told Mama or anybody I was coming, but there they were. They were waiting for me with their problems of land, of roading, of finance, of family splits. One of the problems is that the valley has never been unified and my uncle, who is now the elder, sees me as the person who can unify the people. There have always been family aches and family grief and because I was born of both families he says I am the one to unify them. If the people are not unified, they are not going to be able to save their land.

Just over the hill are areas of naked bush which were set aside for a purpose by my father's people. As a child I didn't understand it, but I remember my father saying, 'The time will come when someone will want these trees.' The trees are kauri, totara, rimu – native trees. It isn't just my land that is involved, it's everybody's. I inherited a certain amount of land from my father and what I didn't inherit I've bought from others. My father fought for this land and he worked it. My grandfather fought for this land and he worked it, and so on back through the generations. My brothers carry the family surname, but they were not brought up on the land – I was the one that dad took round and belted; I was the one who patched him up when he got dragged by a horse; I was the one who rode out with him and scattered paspalum seeds from the back of a horse. Even though I'm not familiar with all the places, I can remember areas being pointed out to me – 'That's the pa', 'That's the burial ground', 'That tree must never be touched', 'That grove is for so-and-so'. Each boulder has a significance; each crevice is associated with people who have lived and died there. Who lives there? No one. No one has lived here since dad died in 1956, the land and trees are just sitting there. I told you, I'm trying to unify the ownership because the land is now under threat.

All of a sudden I get a letter from the Government saying they want to meet the owners with a view to 'afforestation'. This is the threat. They want to plant pine trees.

I went to see them in Wellington and this guy in the Forestry Department actually believed that *I* was the one who wanted to plant pines. 'I don't want pines anywhere near it,' I said. He said, 'But what do you want your land to *do*? Surely you want it to make money for you.' I said, and I will always believe this, that even if my land is only growing ti tree – scrub – it is valuable.

The Maori has been called a 'natural conserver', I know, but up here it isn't seen as 'conservation'. They don't see it like that at all. It's simply the way of life – and it isn't even an issue, it's just a fact. In the same way that the carving my people did from the timber was a way of life, another fact. Call this carving a craft – it was a craft. Yet I wouldn't even call it created.

People say to carve is to be creative just like to write verse is to be creative, but with carving it wasn't like this. It was a natural event. It was as natural for a member of the family to carve as it was for the youngest member to go fishing. Carving wasn't just working with a tool on a canoe or a meeting-house, it was a process that began with the land before the tree was planted.

Take my father. Dad was a carver, but I would never call him a carver – and he would never say that himself. I would call him an expert on trees. Dad's expertise lay in knowing *exactly*

about trees – the life of a tree, the habitat of a tree, what a tree needs to make it grow, which was the right tree to select to make a canoe . . . That's one part of it. The carving itself isn't simple either – I mean there is carving, and there's carving. The individual carved items you see in meeting-houses are not what we call carving – in other words it's not a tiki or a tekoteko or a lintel or a door-post or the big-guy-who-sits-on- top-of-the-house. It's not just that. When we talk about carving we're referring to the whole completed idea, the body of the work, which is a work of art, and it isn't all necessarily 'carved'.

Unless you know where to look, you won't find any original carvings in this area. They were burned or hidden. Among other Maoris we have the reputation of being the most expert at hiding our face. The carvings of my tribe as I say are hidden, but before that I believe they were burned. The stories are still being retold and the songs are still being sung about the missionaries who told our people to burn down their houses because they were a worship of the devil. So the people burned them. People come here and say, 'Gee, you people – you don't carve.' But it's not that.

You will find that in some areas there is *nothing*, just nothing in existence. I'm talking about pre-European carving, stone-age carving. People will take issue with me for saying this, but as far as I'm concerned most of what you see up and down the country isn't real at all but modification. A Christianized version.

I came back with trepidation. The one thing that a Maori who is brought up in the country is prone to is fear of the dark, and that's true of me. Maybe my fears are childhood fears. My great-grandmother lay in this house before she was buried. My mother lay here, and it was my mother's death I couldn't cope with. My grandfather died here and was laid out here. Yet this time in a strange way – perhaps because I have come home for a purpose – this time there is no fear in me at last.

My children haven't got these fears. There are certain things I can't shake: it isn't just fear of the dark. You may think that for me to enter a carved meeting-house is the most natural thing in the world. It's not. Even for older Maoris, for them to go on to another marae and sit in the meeting-house is as strange and fearful as it would be for them to sit in the House of Parliament.

We look for something that is common with us – this is what I do. When I go into a meeting-house I scan the walls and only when I find my own ancestor, *then* I feel at home.

If I keep coming back to this place, to Mama, it is because the pull to come home is always stronger than any fear. I can't shake this thing of respect for elders. You remember the night you arrived? That little ceremony when I showed you all the pictures of the aunts and uncles on the wall? I was introducing you to the family.

This morning I was very proud of my adopted daughter. Mereana came with me to the cemetery and before we went in she remembered to strip her pockets of apples and lollies and

put them down outside. I don't know what would happen to me if I walked into a cemetery with my cigarettes still in my pocket. I'd probably drop on my knees. For the same reason I will never go to the top of a hill. Certain things I don't do – and won't do. There are certain hills which say to me 'I'm different'. It has to do with ancestors? 'The ancestors are always with us'? – but they are! Hence your introduction to the family your first night here. It's very important. You are a guest in their house.

My father used to say to Nanna Campbell, 'Don't let Mari come home, don't let her come home.' And it's the same with me and my own children. I said to Moana in Wellington, 'Darling, it's no use asking me to bring you home to live.' And she lay there crying and said, 'Why? Is it the same reason?' Yes, I said, and the reason is this: I don't want my children brought up hating the Pakeha. I don't want to hear from their mouths the common phrase here, 'bloody Pakeha'. I will accept it from my own mouth, from my grandmother's mouth, from anybody else, because we don't know any better. But from my own children, who are part-Dutch, no, I won't.

They don't speak Maori; they don't read Maori either. And yet, because they are part-Pakeha, because in their veins runs their father's European blood, I hope that my children will form the first real bridge between our races. I can't do it.

Mereana has already felt what it is to be the butt of common sayings up here. My husband has had to put up with it. He was never 'my son-in-law' or 'my grandson-in-law'. It's always been 'Mari's Pakeha' – like 'that's Mari's dog.' In the end my husband just stayed away.

Was I brought up to mistrust the Pakeha? Absolutely. It's true of every Maori I know. I wish that Europeans would look at a person and wonder what they are, instead of imposing what they think a person should be. People don't see. Maybe they look at someone and there for a brief moment they see into a person's eyes. They see something they fear, therefore they shut off.

Logically, since I am a teacher, I should want one of my children to be the same, but I don't want that. My children are already teachers in their way: the way they treat their friends, the way they are reminded to treat their grandparents. Their whole lives are teaching.

At present they live with their father in Wellington. It's a different world. But as far as the future goes, they haven't a choice – they will go where I say they go for as long as they will obey me. I'm thinking of going somewhere neutral where I can build a new home for us all. If they are to benefit from their Maori side, they must first know who they are and where they come from. You cannot live in two worlds. It's spiritually impossible.

The older you get, the more you need to know who you are.

I only went teaching because of my kids – because of what they were suffering at school and I suppose because of what I suffered and my father must have suffered when he was at school. I don't remember a single teacher from my school-days. In all my life I will not learn, I will not

hear, I will not see if I don't trust the person. Nothing sank in. The hatred of it did. Being continually on detention – I was put on detention for speaking Maori. By a Maori prefect.

Another reason I went teaching was because it was considered an impossibility to enter teachers college – for me. In my mind it was impossible. So I did it.

And you ask how difficult was it for me to study! Par-don? Look, I never learned to read until I was thirty-three. I'm thirty-eight now. Yes, of course I went to teachers college. Enrolled and graduated. Graduated with (excuse me)... with honours.

I am very selfish. Maoris are very selfish in that all they are really concerned about is themselves. We're not curious about the Pakeha? Correct. So? So I shouldn't blame Pakehas for not being curious about us? But that's what they *are*, isn't it. Excuse me, but would you have come all this way to see me if you weren't curious? Oh curious. Poking pin-pricking nosey-parkers, they pinprick. They peep round your corners. You take a cup of coffee and they watch and say 'Gee, they drink just like us.' Curious? They're rats. (I mean, in the inquisitive sense.)

We consider that all our lives we have been subject to intrusion. We are taught that we've suffered: that we can either sit and moan about it, or we can get up and fight. People say 'What did you think of the protest – the glorious Waitangi Treaty protest march?' Well, fine. But all they see are the militants who formed after the march, they can't see that these selfsame militants were there before the march began. That today's world must be fought on today's terms. That we must go to universities to learn how to – to fix the Pakeha. Two-thirds of the Maoris in tertiary education today are there because they want to get at the Pakeha in the way the Pakeha got at them. Why else? I've looked around me. I've looked at our so-called educated people. What do I see? I see that they took off the coat of what they were and laid it aside in the cupboard, then they went out into the world to get that other overcoat.

Sounds as though I am advocating separate development. Maybe I am. Maybe what I'm preaching is revolution. I certainly think that teachers should be more mature – I mean, put the teachers out in the field. Let them sweat behind a shovel! So it's time we had revolution.

I don't know what the ideal is, but it isn't plastic tiki. Plastic tiki is window-dressing. Plastic tiki is like our Maori Affairs Department where out of a staff of two hundred there used to be one Maori, so that when people went in to inquire about their land they couldn't communicate because the only Maori on the staff was out the back drinking coffee. That's what plastic tiki is.

My ideal – it isn't protest marches. Acceptance maybe: acceptance that we are different. There is no such thing as integration, not even with intermarriage. Not in a million years.

People say we don't have the discrimination that exists elsewhere like in New Caledonia or South Africa. So we don't. But the point is, I don't care about any other part of the world. I care only about New Zealand, this is mine; this is where my children are growing up. I honestly don't care if black Africans in Rhodesia are given majority rule. I don't give a damn.

So when you say to me 'Am I curious' or 'Can I think myself into the skin of Pakeha?' I answer you, no way. I wouldn't presume. How can I think like a Pakeha? How can I know what a Pakeha feels? I'm not a Pakeha. I never have been and never will be. If this is a form of arrogance, then I am arrogant. You can learn so much more about me by watching me: by observing and feeling what I am feeling through your own instinctive feelings. Those things you don't understand, okay, ask. If I can, I'll answer; if I don't, it's my right.

– New Zealand

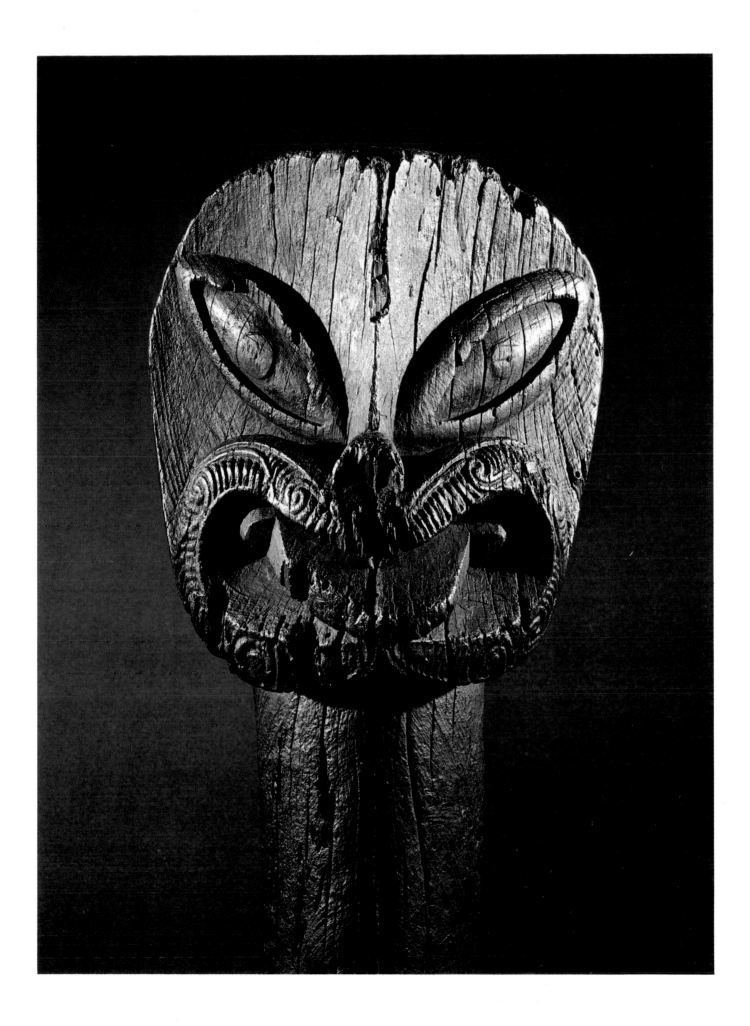

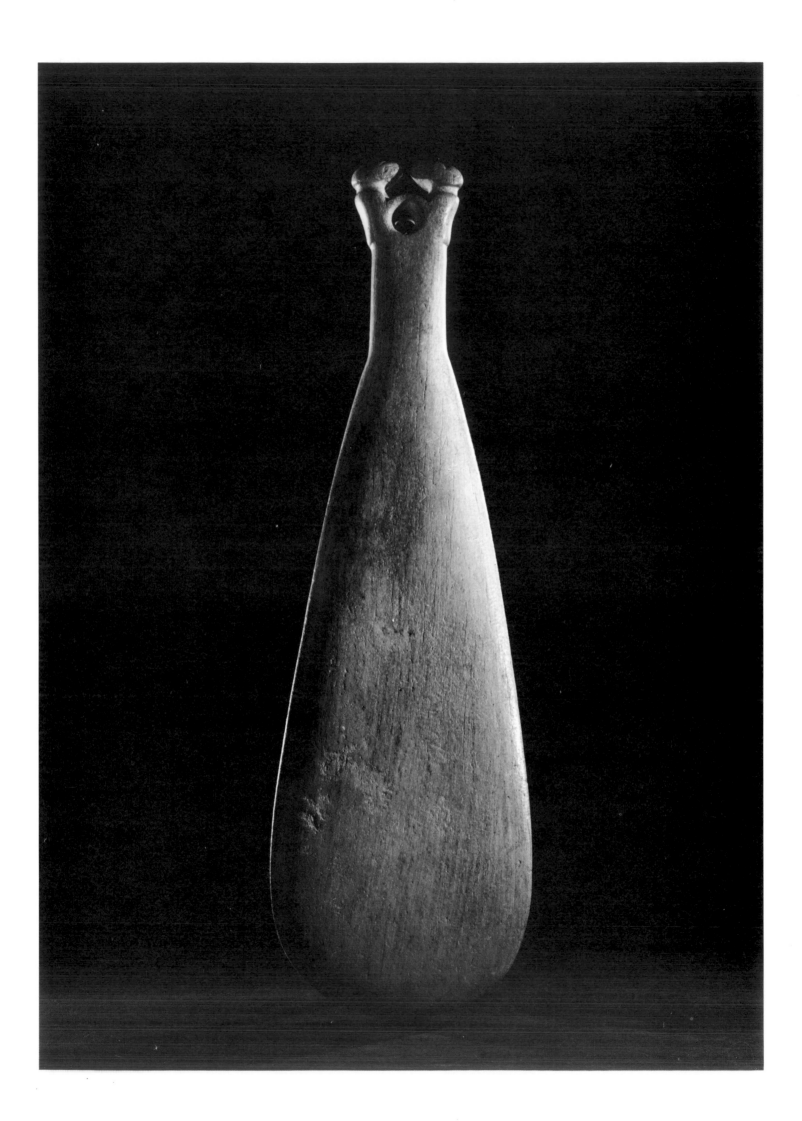

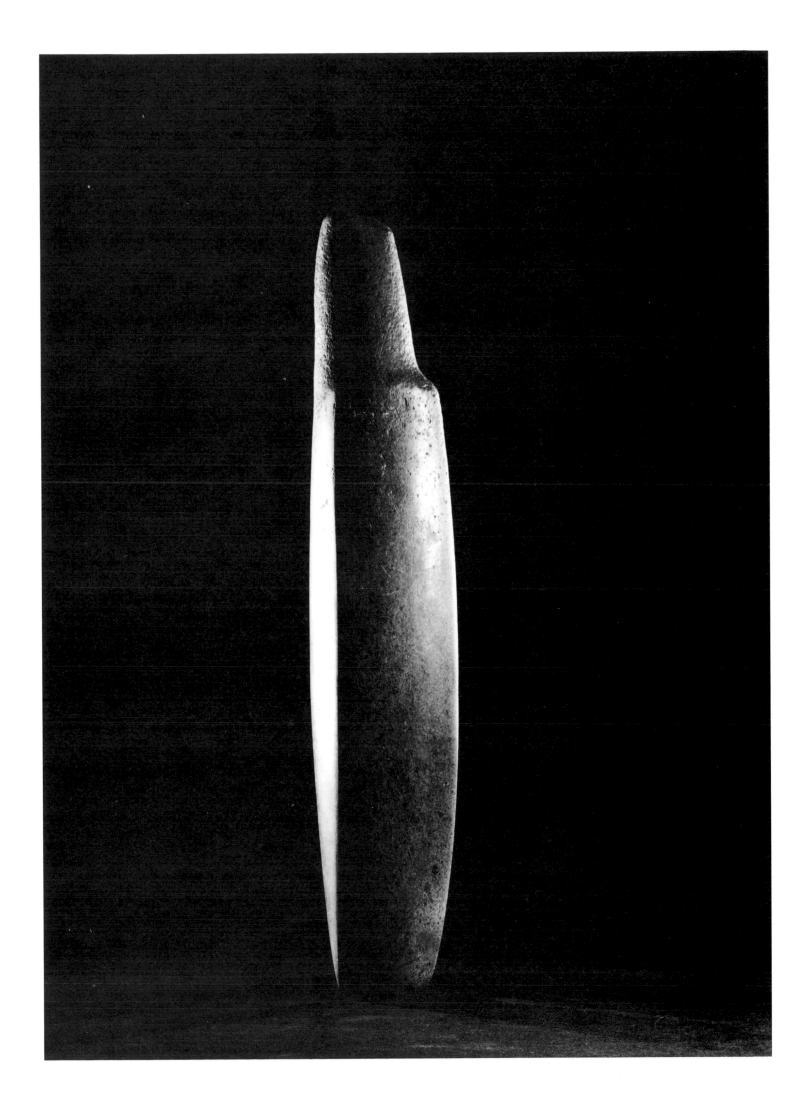

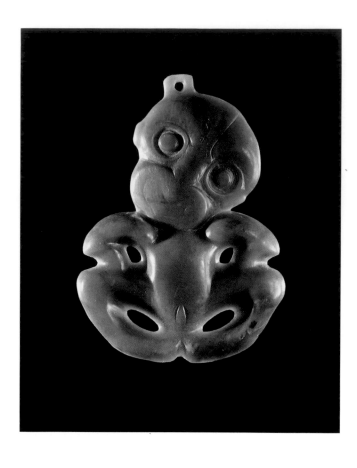

South Island

The three main cultural regions are Canterbury, on the east coast between Blenheim and Timaru; Otago, from Oamaru south to the Catlins; and Southland, to the south of Otago. Canterbury is the land of the Ngai Tahu or Kai Tahu tribe, who are also dominant in Otago and Southland. In the two latter regions there is also an element of the earlier Kati Mamoe people. The Canterbury style of carving is related to Gisborne. What is known of the Otago style relates it more to earlier Polynesian styles than to later Maori styles.

PREVIOUS PAGES
160. Canoe prow from Long Beach, Otago. Height: 48 cm. The prow was designed to look down into the water to frighten malevolent spirits. The overall form of this head recalls island Polynesian styles. This is particularly noticeable in the keeled and lidded eyes (see 82). On the other hand, the lips are decorated in a Canterbury style. *Auckland Museum*

161. Whalebone *patu* (club) found on the bank of the Mararoa river near Mossburn, Southland. Length: 40.5 cm, c.1800. The end is decorated with two opposed birds (seen here from one side), whose legs meet above the perforation. Viewed from above the faces are strongly humanized. *Southland Museum*

162. Adze found near Tuturau, Southland. Length: 40 cm, c.1500. This adze is a typical Southland form which has been found in numbers along the eastern seaboard of the province. The high mass to small cutting edge ratio enabled the user to achieve a deep cut with a minimum of effort. *Southland Museum*

TOP LEFT
163. Greenstone hei tiki from Kaiapohia Pa in Canterbury. Height: 13.3 cm, pre-1832. It is in one of the distinctive Canterbury forms, with head much wider than the body, and a general rounded shape. *Canterbury Museum*

164. Greenstone hei tiki from Murdering Beach, Otago Heads. Height: 10.2 cm, pre-1817. This tiki is in the Otago style, with head slightly smaller than the body and marks showing the ribs, fingers, and toes. *Otago Museum*

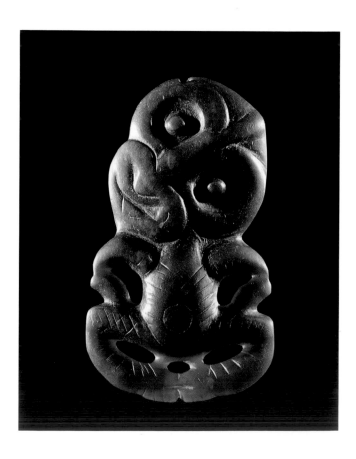

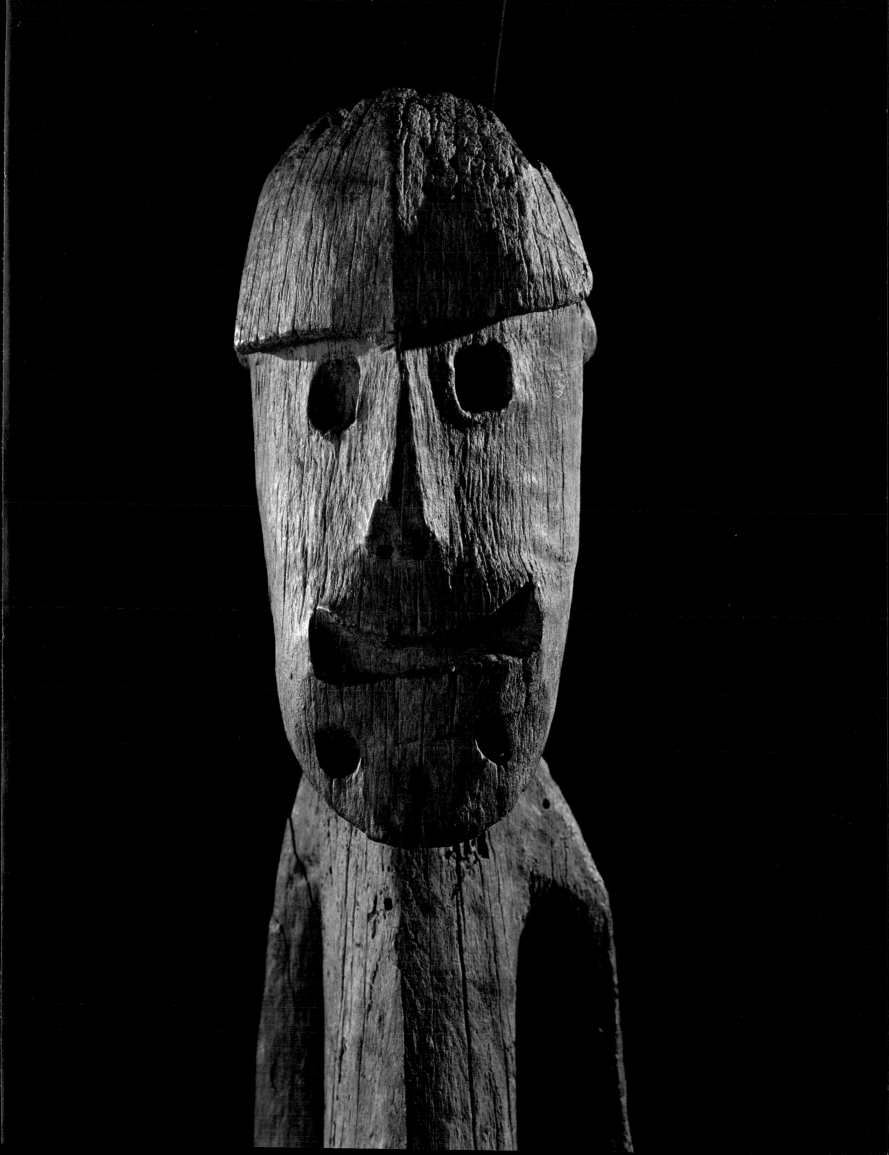

The Chatham Islands

Six hundred kilometres to the east of New Zealand lie the Chatham Islands, home of a distinct Polynesian group generally called the Moriori. The main island, Chatham, is fifty kilometres long and fifty broad, with a large lagoon in the centre. Around this is a thin strip of low-lying land. In the north-west there is a high area including extinct volcanoes, and to the south another high area fringed with cliffs. Much of the island is peat land. The climate is cool temperate, unsuitable for the cultivation of sweet potatoes.

The ancestors of the Moriori arrived in the Chathams before 1200 and appear to have come from the eastern Polynesian area. They lived by hunting and gathering in a fairly rich sea environment. The Moriori had many prohibitions regulating their daily life as they depended on the goodwill of the gods and their ancestors to provide them with food. They had many rituals to perform to ensure that favour.

Thus the Moriori developed a rich and distinctive culture. Some time before they were contacted by Europeans in 1791 they had outlawed war and settled all disputes by personal combat with quarterstaffs, the fight stopping at the first blood drawn. In 1835 Maori of the Atiawa tribe who had moved to Wellington from Taranaki, heard of the islands from two of their number who were whalers. Sections of the tribe went to the Chathams in a whaling ship, conquered and enslaved the Moriori people. Despair followed by disease saw the Moriori reduced in numbers to the point where they could no longer survive. The last Moriori died in 1933.

PREVIOUS PAGE
165. Detail of ancestor figure from Tupuangi. Overall height: 105 cm. The face mask and skeletal features of this figure echo east Polynesian carvings (see 93 and 96). The chin has been provided with holes to attach a false beard. Probably the figure represents a founding ancestor. *Auckland Museum*

166. *Patu okewa* (club) from Matarakau. Length: 38 cm. This club is heavy and unwieldy as a fighting weapon. It may have been a ritual weapon carried during ceremonies invoking the goodwill of the gods before a bird or seal hunting expedition, or a symbol of chieftainship. It has a distinctly bird-shaped body with a human head. It is made from schist. *Otago Museum*

Catalogue

Santa Cruz Islands

1. Shark god 'Menalo'. Wood, fibre, shell. Height: 126 cm (49⅝ in.). *Otago Museum No. D31.91*
2. Food bowl from ghost house at Nemba. Wood. Length: 72 cm (22⅜ in.), c.1900. Gift D.L. Francis. *Auckland Museum No. 13947*
3. Ornament. Cuttlefish shell. Length: 22.3 cm (8¾ in.), c.1930. Gift Miss Burgess and Mrs J.F. Wilson. *Auckland Museum No. 18158.6*
4. Shark god. Wood, turtle-shell, fibre. Height: 39 cm (15⅜ in.). *Otago Museum No. D29.131*
5. Shark god. Wood. Height: 40 cm (15³/⁴ in.), late 19th century. *National Museum No. FE1147*

Solomon Islands

6. Nguzu Nguzu canoe front piece. Wood inlaid with shell. Length: 31 cm (12¼ in.), c. 1850. T.W. Leys Memorial (ex Edge-Partington Collection No. S404). *Auckland Museum No. 15277*
7. Figure from bonito house. Wood. Height: 287 cm (113 in.), c.1920. Presented Miss Isaacs. *Auckland Museum No. 14270*
8. Figure. Wood. Height: 72.4 cm (28½ in.), c.1900 Gift Mr J.W. Coleman. *Auckland Museum No. 29746*
9. Fretwork pendant. Pearl shell. Dimensions: 7.6 x 7.6 cm (3 x 3 in.), c.1910. Gift W.J. Rutherford. *Auckland Museum No. 31668*
10. Fretwork pendant from Roviana. Clam shell. Dimensions: 9 x 7.5 cm (3½ x 3 in.), 1930. Rev. A.H. Voyce. *Auckland Museum No. 29464.2*
11. Kapkap ornament from Vella Lavella. Turtle-shell, clam shell. Diameter: 12 cm (4¾ in.). *Otago Museum No. D44.160*
12. Fretwork plaque from Choiseul. Clam shell. Height: 39 cm (15⅜ in.). *Otago Museum No. D38.538*
13. Comb from Bilua, Vella Lavella. Wood inlaid with shell. Length: 17.5 cm (7 in.), c.1930. Goodfellow Collection (ex Voyce Collection). *Auckland Museum No. 13627*
14. Combs. Black palm wood inlaid with mother-of-pearl. Lengths: 44.5, 27.0, 40.1 cm (17½, 10⅝, 15¾ in.), c. 1925. Presented Rev. C. Palmer and E.E. Vaile Trust. *Auckland Museum Nos. 28078.1, 32345.2, 32345.8*
15. Combs from Mala. Black palm wood and plaitwork. Lengths: 21.2, 18.6, 17.2 cm (8⅜, 7½, 6¾ in.), c.1900. T.W. Leys Memorial (ex Edge-Partington Collection). *Auckland Museum No. 15197, 48125.1, 48125.2*
16. Ornamental shield from Nggela Island. Fibre, shell. Length: 65 cm (25⅝ in.), c.1880. Kinder Collection. *Auckland Museum No. 2813*
17. Head-rest. Wood. Length: 88.3 cm (34¾ in.), height: 33.7 cm (13¼ in.). Dr B.M. Moorhouse, 1916. *Canterbury Museum No. E116.10.33*
18. Paddle from Buka Passage. Wood, incised and painted. Length: 154 cm (60⅝ in.), late 19th century. Turnbull Collection. *National Museum No. FE694*
19. War canoe paddle, Buka Island. Wood. Length: 183 cm (72 in.), early 19th century. Lady McLean Collection. *Hawkes Bay Art Gallery & Museum No. 40|67*
20. Paddle from Santa Isabel. Wood. Length: 125 cm (49¼ in.). *Otago Museum No. D27.935*
21. Kapkap pendant from Malaita. Clam shell, puttynut. Diameter: 14 cm (5½ in.). *Otago Museum No. D26.408*

New Ireland, New Britain, and the Admiralty Islands

22. Dance mask (Siassi), Moeive Haven, west New Britain. Fibre, cane, feather. Height: 104 cm (41 in.) Presented Mr P.B. Armitage. *Auckland Museum No. 32757.*
23. Funerary figures, southern New Ireland. Chalk. Height (largest): 56 cm (22 in.), 19th century. *Otago Museum No. D18.35-6*
24. Female funerary figure, New Ireland. Chalk. Height: 41.5 cm (16⅜ in.), c.1890. Gift Rev. G. Brown. *Auckland Museum No. 11559*
25. Dance wand, New Ireland. Wood. Length: 27 cm (10⅝ in.) *Otago Museum No. D35.724*
26. Dance wand, New Ireland. Wood, shell. Length: 45.5 cm (18 in.). *Otago Museum No. D18.31*
27. Dance wand, New Ireland. Wood. Length: 53 cm (20⅞ in.). *Otago Museum No. D77.19*
28. Malanggan figure with pan-pipes, New Ireland. Wood. Height: 116.8 cm (46 in.), 1922. *Auckland Museum No. 9294*
29. Lintel, New Ireland. Painted wood. Length: 142 cm (55⅞ in.), c.1920. Gift Mr W.R. McGregor. *Auckland Museum No. 4365*
30. Tatanua mask, New Ireland. Wood, shell, lime, fibre. Height: 44 cm (17⅜ in.). *Otago Museum No. D45.179*
31. Canoe prow, Anchorite Islands. Wood. Length: 46.3 cm (18¼ in.), mid 19th century. Oldman Collection No. 748. *National Museum*
32. Ancestor figure, Admiralty Islands. Wood. Height: 107 cm (42⅛ in.), c.1880. Hon. J.B. Turner Collection. *Auckland Museum No. 13518*
33. Marandan mask, Big Tabar Island. Wood. Height: 47 cm (18½ in.), c.1920. E.E. Vaile Trust. *Auckland Museum No. 32757*
34. Canoe stern-post, Hermit Island. Wood. Height: 43 cm (17 in.). *Otago Museum No. D24.702*

New Guinea

35. Decorated pot, Zumin, upper Markham River. Pottery. Height: 18 cm (7⅛ in.), 1975. E.E. Vaile Trust. *Auckland Museum No. 46107*
36. Pig (Marawat), Dimiri, Sepik. Pottery. Length: 16 cm (6½ in.), 1973. Collected S. Bulmer. *Auckland Museum No. 46121*
37. Male figure (Marawat), Dimiri, Sepik. Pottery. Height: 22 cm (8⅝ in.), 1973. E.E. Vaile Trust. *Auckland Museum No. 46124*
38. Female figure (Marawat), Dimiri, Sepik. Pottery. Height: 22 cm (8⅝ in.), 1973. E.E. Vaile Trust. *Auckland Museum No. 46123*

39. Figure, lower Sepik style. Wood. Height: 18 cm (7⅛ in.), c.1900. *Auckland Museum No. 2574A*
40. Food hook, Gjurrea, middle Sepik. Wood. Height: 71 cm·(28 in.). *Otago Museum No. D70.518*
41. Skull (Iatmul), middle Sepik. Bone, pottery, fibre, seeds, ochre. Height: 26 cm (10¼ in.). *Otago Museum No. D23.1123*
42. Food hook, middle Sepik. Wood. Height: 151.5 cm (59⅝ in.), c.1900. *Auckland Museum No. 9194*
43. Mask (Iatmul), middle Sepik. Fibre (plaited wickerwork). Height: 53.5 cm (21 in.), c.1880. *Auckland Museum No. 48126*
44. Mask (Iatmul), middle Sepik. Fibre (basketwork). Length: 223.5 cm (88 in.). *Otago Museum No. D24.1854*
45. Mask, Wogeo Island, Sepik. Wood, rattan fringe. Height: 29.2 cm (11½ in.), c.1900. W. Goodfellow Collection) (ex Voyce Collection). *Auckland Museum No. 33982*
46. Mask, Sepik. Painted wood. Height: 63 cm (24¾ in.), c.1880. *Auckland Museum No. 9200*
47. Mwai mask (Iatmul), middle Sepik. Wood, shell, seeds, tusks. Height: 71 cm (28 in.). *Otago Museum No. D65.447*
48. Head-rest, Huon Gulf. Wood, lime, ochre. Length: 17.8 cm (7 in.), late 19th century. *National Museum No. FE3773.*
49. Sago bowl, Omandesep, Asmat, Irian Jaya. Wood, bone, fibre. Length: 67 cm (26⅜ in.). *Otago Museum No. D71.205*
50. Mawa mask, Saibai, Torres Strait. Wood. Height: 57 cm (22½ in.). *Otago Museum No. D20.482*
51. Shield, Piramat, Asmat, Irian Jaya. Wood, pigment. Height: 195 cm (76⅞ in.). *Otago Museum No. D71.219*
52. Mask, Torres Strait Islands. Turtle-shell. Height: 31 cm (12¼ in.). *Otago Museum No. D55.8*
53. Board from men's house, Fly River. Wood. Height: 182 cm (71⅞ in.). *Otago Museum No. D23.795*
54. Board from men's house. Purari River delta. Painted wood. Height: 107 cm (42⅛ in.), c.1910. E.E. Vaile Trust. *Auckland Museum No. 37856*
55. Board from men's house, Urika, Purari River delta. Wood. Height: 102.2 cm (40¼ in.), 1920. Gift Mr G. Moir Smith. *Auckland Museum No. 3817*
56. Shield, Motu Motu, Port Moresby. Wood. Height: 176.2 cm (69⅜ in.), c.1880. Edge-Partington Collection. No. U186. *Auckland Museum No. 15463*
57. Pig, Trobriand Islands. Wood. Length: 43 cm (17 in.). *Otago Museum No. 59.404*
58. Dance paddle, Trobriand Islands. Wood. Length: 70 cm (27⅝ in.). *Otago Museum No. D23.1009*
59. Dish, Trobriand Islands. Wood. Diameter: 49.5 cm (19½ in.), depth: 4.8 cm (1⅞ in.); 19th century. T.W. Leys Memorial. Edge-Partington Collection No. U176. *Auckland Museum No. 15453*

New Caledonia

60. House spire. Wood. Height: 178 cm (70⅛ in.). Oldman Collection No. 663G. *Otago Museum No. O50.247*
61. Ceremonial axe. Nephrite, wood, fur, fibre, tapa. Length: 56 cm (22⅛ in.). *Otago Museum No. D24.9*
62. Figure. Wood. Height: 136 cm (53½ in.). *Otago Museum No. D24.660*
63. Door-post from Kobe. Wood. Height: 125.7 cm (49½ in.), c.1900. Mr C.E.A. Buller. *Auckland Museum No. 27402*
64. Figure. Wood. Height: 103 cm (40⁹⁄₁₆ in.), 19th century. Oldman Collection No. 661c *National Museum*

New Hebrides

65. Slit gong from north Ambrym. Wood. Length: 239 cm (94 in.). Pres. A. Hamilton 1895. *Otago Museum No. D.174*
66. Grade figure. Tree fern. Height: 144 cm (56¾ in.). *Otago Museum No. D.173*
67. Hafted adze. Wood and shell. Handle: 40 cm (15¾ in.), face: 16.5 cm (6½ in.); c.1880. Oldman Collection No. 692. *Auckland Museum No. 31495*

Fiji Islands

68. Breast-plate (Civa). Pearl shell and whale tooth ivory. Diameter: 25.5 cm (10 in.), c.1820. Oldman Collection No. 523. *Auckland Museum No. 31498*
69. Necklace. Whale tooth ivory and sennit. Overall length: 76.2 cm (30 in.), c.1840. Hon. J.B. Turner Collection. *Auckland Museum No. 13341*
70. Oil dish. Wood. Height: 37.5 cm (14½ in.), c.1830. Oldman Collection No.585. *Auckland Museum No. 31541*
71. Pottery vessel. Height: 43 cm (17 in.). *Otago Museum No. D39.3191*
72. Figure. Wood, shell. Height: 21 cm (8¼ in.). Oldman Collection No. 426. *Otago Museum No. O50.063*

Tonga, Samoa, Niue

73. Club. Wood. Length: 120 cm (47¼ in.), 18th century. Oldman Collection No. 510. *Otago Museum No. O50.207*
74. Figure. Whale tooth ivory. Height: 13 cm (5 in.), 18th century. Oldman Collection No. 533. *Auckland Museum No. 31895*
75. Female figure. Wood. Height: 33 cm (13 in.), 18th century. Oldman Collection No. 531. *Auckland Museum No. 32652*
76. Barkcloth *(siapo)*. Length: 278 cm (109½ in.), width: 158 cm (62 in.); 19th century. Gift Mr G.A. McMillan. *Auckland Museum No. 21925.5*
77. Barkcloth *(hiapo)*. Length: 195 cm (76¾ in.), width: 173 cm (68 in.); early 20th century. Gift Mr Warren. *Auckland Museum No. 27292.*

Polynesian Outliers

78. Goddess figure, 'Kawe de Hine Ali'gi', Nukuoro, east Caroline Islands. Wood. Height: 220 cm (86½ in.), early 19th century. Gift G. Cozens, October 1878. *Auckland Museum No. 38740*

Society Islands

79. Food pounder, Tahiti. Stone. Height: 16 x 11.5 cm (6¼ x 4⅜ in.), 18th century. Oldman Collection No. 457B. *Auckland Museum No. 31549*
80. Head-rest, Tahiti. Wood. Height: 14.5 cm (5⅝ in.), 18th century. Oldman Collection No. 398. *Auckland Museum No. 31545*

Cook Islands

81. Ceremonial adze, Mangaia. Wood, stone, sennit. Length: 61 cm (24 in.). *Otago Museum No. D09.3*
82. Staff god, Rarotonga. Wood. Length: 61.7 cm (24¼ in.), 1800. Oldman Collection No. 422. *Auckland Museum No. 31487*
83. Stool-seat (no'oanga), Atiu. Wood. Length: 48.1 cm (19 in.). *Canterbury Museum No. E151.243*

Hawai'i

84. Drum. Wood, shark-skin, sennit. Height: 47 cm (18½ in.), diameter at top: 33.7 cm (13¼ in.), late 18th century. Oldman Collection No. 301. *Canterbury Museum No. E150.1185*
85. God image, 'Kukai'limoku'. Fibre netting, feathers, mother-of-pearl. Height: 55.5 cm (21⅞ in.), c.1810-1819. Lord St Oswald Collection. *National Museum No. FE325*
86. Barkcloth *(Kapa)*. Late 18th century. Turnbull Collection. *National Museum No. FE1475.*

Austral Islands

87. Goddess figure, Ra'ivavae. Wood. Height: 65.5 cm (25¾ in.), 18th century. Oldman Collection No. 413. *Auckland Museum No. 31499*
88. Fly-whisk. Wood. Length: 37 cm (14½ in.), early 19th century. Edge-Partington Collection No. D5. *Auckland Museum No. 14509*
89. Kava bowl. Wood (Tamanu: *Callophyllum*). Length: 64.8 cm (25½ in.), width: 30.5 cm (12 in.), depth: 10.2 cm (4 in.); early 19th century. *Canterbury Museum No. E149.651*
90. Ceremonial paddle, probably from Tupua'i. Wood. Length: 143 cm (56⅜ in.), c.1860. *Wanganui Regional Museum.*

Easter Island

91. Dance paddle. Wood. Length: 85 cm (33½ in.), 18th century. Oldman Collection No. 1113A. *Auckland Museum No. 31475*
92. Female ancestor figure. Wood inlaid with obsidian and bone. Height: 64 cm (25¼ in.). Oldman Collection No. 347. *Otago Museum No. O51.1*
93. Female ancestor figure. Wood inlaid with obsidian and bone. Height: 64 cm (25¼ in.), early 19th century. Oldman Collection No. 341. *Canterbury Museum No. E150.113*
94. Ua club. Wood (Toromiro: *Sophora*). Length: 174 cm (68½ in.), early 19th century. Oldman Collection No. 1117. *Canterbury Museum No. E150.1143*
95. Lizard-shaped club. Wood. Length: 36.5 cm (14¼ in.), 19th century. Edge-Partington Collection No. G5. *Auckland Museum No. 14554*
96. Carving. Wood. Height of figure: 14 cm (5½ in.). Purchased 1936. *Otago Museum No. D36.985*
97. Breast pendant (rei miro). Wood (Toromiro: *Sophora*). Width: 42 cm (16½ in.), height: 45.8 cm (18 in.). early 19th century. Oldman Collection No. 359. *Canterbury Museum No. E150.1124*

Marquesas Islands

98. Bowl. Wood. Length: 53.5 cm (21¹/₁₆ in.), early 19th century. Oldman Collection No. 193. *National Museum*
99. Stilt step. Wood. Length: 42 cm (16½ in.), early 19th century. Oldman Collection No. 245B. *Auckland Museum No. 31476*
100. Ceremonial club. Wood. Length: 150 cm (59⅛ in.), c.1870. *Wanganui Regional Museum*
101. Double figure. Basalt. Height: 12.5 cm (4⅜ in.). Oldman Collection No. 185. *National Museum*

New Zealand

102. House carving, Ahipara. Wood. Length: 225 cm (88½ in.), c.1300. Mr J.T. Clark. *Auckland Museum No. 6341*
103. 'Uenuku', Lake Ngaroto. Wood (Totara). Length: 267 cm (105 in.). R.W. Bourne, 1906. *Gavin Gifford Memorial Museum*
104. Step for digging stick, Mahurangi. Wood. Length: 9 cm (3½ in.), c.16th century. Mrs Eaton. *Auckland Museum No. 16790*
105. Canoe prow figure, Doubtless Bay. Wood. Length: 107 cm (42⅛ in.), c.16th century. E.E. Vaile Collection. *Auckland Museum No. 3078*
106. Bone box, Northland. Wood. Dimensions: 65 x 18 x 22 cm (25½ x 7 x 8⅝ in.), c.16th century. *Auckland Museum No. 19458*
107. Dog figure from Monck's Cave, Redcliffs, Christchurch. Wood. Length: 7.6 cm (3 in.), c.1675. *Canterbury Museum No. E158.356*
108. Breast amulet, Okain's Bay, Banks Peninsula. Whale tooth ivory. Length: 13.7 cm (5⁷/₁₆ in.), early Maori. *Canterbury Museum No. E148.80*
109. Breastplate, Okain's Bay, Banks Peninsula. Dark serpentine from Nelson-Marlborough. Max. diameter: 17.8 cm (7 in.), early Maori. *Canterbury Museum No. E148.79*

110. Tanged adze with horned butt, Ellesmere Spit cache. Metamorphosed dark argillite. Length: 29.8 cm (11¾ in.), c.1200. *Canterbury Museum No. E131.18.1*

Northland

111. Door-jamb, Otakanini Pa, Helensville. Wood. Height: 245 cm (96½ in.), 1650. Mr A.S. Bankart. *Auckland Museum No. 6206*
112. Head, northern Wairoa. Wood. Height: 42 cm (16½in.), 18th century. Mr E.S. Brookes. *Auckland Museum No. 244*
113. Door-jamb, Takahue. Wood. Length: 89.5 cm (35¼ in.), 18th century or earlier. L.M. Neilson Collection. *Auckland Museum No. 37396.2*
114. Bone box, Bay of Islands. Wood. Length: 102 cm (40⅛ in.), 18th century or earlier. Spencer Collection. *Auckland Museum No. 5660*
115. Bone box, Bay of Islands. Wood. Length: 100 cm (39⅜ in.), 18th century or earlier. Hon Vernon Reid. *Auckland Museum No. 6405*
116. Bone box. Wood. Length: 99 cm (39 in.), late 18th century. Turnbull Collection. *National Museum No. ME2659*
117. Putorino. Wood. Length: 36 cm (14⅛ in.), 18th century. E.E. Vaile Trust Fund. *Auckland Museum No. 36721*
118. Pekapeka, Makura Valley, Hokianga. Nephrite. Length: 6.8 cm (2⅝ in.), 18th century. *Auckland Museum No. 17376*
119. Hei tiki, Ruapekapeka, Northland. Nephrite. Length: 9 cm (3½ in.). *Otago Museum No. D24.1224*
120. Hei matau, Pukepoto, Kaitaia. Nephrite. Height: 9 cm (3½ in.), 18th century. Mr A.W. Masters. *Auckland Museum No. 16675*
121. Rei puta. Sperm whale ivory, flax-fibre sennit, bird-bone toggle. Length of tooth: 16.2 cm (6½ in.), 1769-1770 (Cook's First Voyage). *Canterbury Museum No. E177.274*
122. Wakahuia, Rangiahua, Hokianga. Wood. Length: 42.5 cm (16½ in.), 18th century. R. Ogle. *Auckland Museum No. 17195.1*
123. Feeding funnel, Bay of Islands style. Wood. Length: 17 cm (6¹¹/₁₆ in.), early 19th century. Webster Collection No. 1503 *National Museum*
124. Flute. Wood. Length: 14.8 cm (5⅝ in.), early 19th century. Webster Collection No. 1887 *National Museum*
125. Bone box, Kohekohe Cave, Waimamaku, Hokianga. Wood. Length: 180 cm (70⅞ in.), 18th century or earlier. Deposit by Maori of the district. *Auckland Museum No. 5652*
126. Wahaika. Wood. Length: 40.5 cm (16 in.), 18th century. Oldman Collection No. 67. *Auckland Museum No. 31516*

Taranaki

127. Female figure, 'Hine-O-Tanga', Okato. Stone. Width: 57 cm (22½ in.). Mr F. Grant. *Taranaki Museum*
128. Storehouse threshold (Atiawa). Wood. Length: 175.2 cm (69 in.). *Taranaki Museum*
129. Storehouse panel (Atiawa). Wood. Length: 91.4 cm (36 in.), ? pre-1826. *Taranaki Museum*

130. Storehouse panel (Atiawa). Wood. Length: 125 cm (49¼ in.), ? pre-1826. *Taranaki Museum*
131. Comb. Wood and paua shell. Length: 7.9 cm (3⅛ in.), late 18th century. Webster Collection No. 529 *National Museum*
132. Canoe prow, Mokau district. Wood. Length: 77 cm (30½ in.), 18th century. Mr C. Robison. *Auckland Museum No. 5676*
133. Club. Nephrite. Length: 39.8 x 9.7 cm (15¾ in.). J. Houston Collection. *Taranaki Museum*
134. Hei matau. Nephrite. Height: 6 cm (2¾ in.), c.1860. Mrs Walsh Collection. *Auckland Museum No. 19256*
135. Wahaika. Whalebone. Length: 31.3 cm (12⅜ in.). Mr J.S. Hatherley. *Taranaki Museum*
136. Wakahuia. Wood. Length: 44 cm (17⁵/₁₆ in.), mid 19th century. Oldman Collection No. 2 *National Museum*
137. Canoe prow (Atiawa). Wood. Height: 150 cm (59 in.), c.1860. From Science Museum, South Kensington, by Royal Command. *Auckland Museum No. 7375*
138. War canoe stern-post. Wood (Totara). Length: 165.2 cm (65 in.), 1831. *Canterbury Museum No. E158.936*
139. Putorino, south Taranaki style. Wood. Length: 35.5 cm (14 in.), c.1820-1830. *Canterbury Museum No. E149.648*
140. Knife. Wood, shark tooth, paua shell, flax binding. Length: 22 cm (8⅝ in.), 1769 (Cook's First Voyage). Lord St Oswald Collection. *National Museum No. ME2493*
141. Tokipoutangata. Wood, nephrite, flax. Length: 44 cm (17⅜ in.). *Otago Museum No. D51.509*

East Cape
142. Storehouse maihi, Te Kaha. Wood. Length: 315 cm (124¹/₈ in.), 1780. Mr E. Spencer. *Auckland Museum Nos 22063.1 and 22063.2*
143. Storehouse doorway, Te Kaha. Wood. Height: 156 cm (61½ in.), 1780. Mr E. Spencer. *Auckland Museum No. 22063.3*
144. Lintel. Wood. Length: 45 cm (17¾ in.), early 19th century. Webster Collection. No. 377 *National Museum*

East Coast
145. Tekoteko. Wood. Height: 104 cm (41 in.), late 18th or early 19th century. Waipare Collection. *Hawkes Bay Art Gallery & Museum*
146. Standing figure. Wood, sealing-wax eyes. Length: 45.5 cm (17⅞ in.), early 19th century. Oldman Collection. No. 148 *National Museum*
147. Centre-pole figure, Waiapu Valley. Wood. Height: 115 cm (45½ in.), c.1850. Presented Mr E. Walker. *Auckland Museum No. 163*
148. House figure. Wood. Height: 108 cm (42½ in.), 1842. *National Museum*
149. Pigment pot. Wood. Height: 11.2 cm (4⅜ in.), c.1820. *Wanganui Regional Museum*
150. Ceremonial adze. Wood, nephrite, flax. Length: 49 cm (19⁵/₁₆ in.), late 18th century. Oldman Collection No. 491 *National Museum*

151. Putorino. Wood, kiekie. Length: 52.7 cm (20¾ in.), late 18th century. Lord St Oswald Collection. *National Museum No. ME2502*
152. Door-post. Wood. Length: 76 cm (29¹⁵/₁₆ in.), early 19th century. Webster Collection. No. 488 *National Museum*

Bay of Plenty
153. Float, Lake Rotoiti. Wood. Dimensions: 25 x 9 cm (9⅞ x 3½ in.), c.1800. Captain G. Mair Collection. *Auckland Museum No. 40*
154. Food receptable. Gourd body, wood rim. Height: 32.0 cm (12⅝ in.), c.1860. *Wanganui Regional Museum*
155. Poutokomanawa figure. Wood. Height: 81 cm (32 in.), c.1860. *Otago Museum No. D10.285*
156. Poupou, Spa Hotel, Taupo. Wood. Length: 146 cm (57½ in.), mid 19th century. *Auckland Museum No. 4719*
157. Carved gateway, Pukeroa Pa, Rotorua. Wood. Total height: 350 cm (137½ in.), height of figure: 220 cm (87 in.), c.1850. Mr Justice Gillies. *Auckland Museum No. 160*
158. Gateway figure, Te Ngae, Rotorua. Wood. Height: 196 cm (77⅛ in.), early 19th century. Mr Justice Gillies. *Auckland Museum No. 161*
159. Gateway mask, Okarea Pa, Whirinaki River. Wood. Height: 64 cm (25¼ in.), *Otago Museum No. D34.455*

South Island
160. Canoe prow, Long Beach, Otago. Wood. Height: 48 cm (19 in.), 18th century. *Auckland Museum No. 6156.* On loan to Otago Museum
161. Patu, Mossburn, Southland. Whalebone. Length: 45.4 cm (17⅞ in.), c.1800. *Southland Museum & Art Gallery*
162. Adze, Tuturau, Southland. Green volcanic breccia. Length: 40 cm (15¾ in.), c.1500. *Southland Museum & Art Gallery No. B69.147*
163. Hei tiki from Kaiapohia Pa, Canterbury. Nephrite of translucent Kahurangi variety. Height: 13.3 cm (5⁵/₁₆ in.), pre-1832. *Canterbury Museum No. E163.254*
164. Hei tiki, Murdering Beach, Otago. Nephrite. Height: 10.2 cm (4 in.). *Otago Museum No. D49.446*

Chatham Islands
165. Ancestor figure, Tupuangi. Wood. Height: 105 cm (41¼ in.). *Auckland Museum No. 18567*
166. Patu okewa, Matarakau. Schist. Length: 38 cm (15 in.). *Otago Museum No. D21.342*

Index